Bowie, Beckett, and Being

Bowie, Beckett, and Being

The Art of Alienation

Rodney Sharkey

BLOOMSBURY ACADEMIC
NEW YORK • LONDON • OXFORD • NEW DELHI • SYDNEY

BLOOMSBURY ACADEMIC

Bloomsbury Publishing Inc, 1359 Broadway, 12th Floor, New York, NY 10018, USA
Bloomsbury Publishing Plc, 50 Bedford Square, London, WC1B 3DP, UK
Bloomsbury Publishing Ireland, 29 Earlsfort Terrace, Dublin 2, D02 AY28, Ireland

BLOOMSBURY, BLOOMSBURY ACADEMIC and the Diana logo
are trademarks of Bloomsbury Publishing Plc

First published in the United States of America 2024
This paperback edition published 2025

Copyright © Rodney Sharkey, 2024

For legal purposes the Acknowledgments on p. 200 constitute
an extension of this copyright page.

Cover design: Louise Dugdale
Cover images: Left, Photo by Michael Ochs Archives/Getty Images
Right, Photo by I.C. Rapoport/Getty Images

All rights reserved. No part of this publication may be: i) reproduced or transmitted in any form, electronic or mechanical, including photocopying, recording or by means of any information storage or retrieval system without prior permission in writing from the publishers; or ii) used or reproduced in any way for the training, development or operation of artificial intelligence (AI) technologies, including generative AI technologies. The rights holders expressly reserve this publication from the text and data mining exception as per Article 4(3) of the Digital Single Market Directive (EU) 2019/790.

Bloomsbury Publishing Inc does not have any control over, or responsibility for, any third-party websites referred to or in this book. All internet addresses given in this book were correct at the time of going to press. The author and publisher regret any inconvenience caused if addresses have changed or sites have ceased to exist, but can accept no responsibility for any such changes.

Whilst every effort has been made to locate copyright holders the publishers would be grateful to hear from any person(s) not here acknowledged.

A catalog record for this book is available from the Library of Congress.

ISBN: HB: 978-1-5013-9124-8
PB: 978-1-5013-9128-6
ePDF: 978-1-5013-9126-2
eBook: 978-1-5013-9125-5

Typeset by Integra Software Services Pvt. Ltd.

For product safety related questions contact productsafety@bloomsbury.com.

To find out more about our authors and books visit www.bloomsbury.com
and sign up for our newsletters.

Contents

I	On Methodology	1
II	Inside … Outside … Counterculture	19
III	The Philosophy of Alienation	43
IV	The Aesthetics of Alienation	69
V	Interzone	103
VI	Struggling Against the Straight	111
VII	Alienation & Ruination	139
VIII	On	165
IX	Becoming Quantum	183
X	Beyond and Becoming: The Men Who Fled from Earth	189

Acknowledgments	200
Notes	201
Works Cited	214
Index	231

I

On Methodology

In 2016, before I gave a preliminary talk that became this study, a sprightly young academic asked me "but what is the methodology?" before bouncing away without waiting for an answer. The query confirmed that the incongruous nature of the proposed comparison required a clear statement of methodology, and certainly something more structured than the series of interesting but scattered observations I had in my hand back then. Addressing his concern now, the underlying structure of the comparative approach I employ in this study is Marxist, or to be more theoretically and historically accurate, post-Marxist, as most of the thinkers I engage succeeded Marx and adapted his ideas. Yet it is also retro-Marxist insofar as it harks back to Marx's original and now rather obvious claims regarding the alienation born of capitalism, suggesting that these claims might be reviewed with renewed urgency rather than dismissed as quaint reflections of a bygone age. My reasoning is that in the current capital moment, supported and enabled by a sweeping neoliberalism, Marxism, in a variety of forms, seems not only newly relevant but immediately timely. As such, I employ both old-school Marxism and more modern variations in an attempt to say something worthwhile about the work of Beckett and Bowie. That neither of them were Marxists is not significant. Such context would be necessary if I read their work as a conscious and deliberate articulation of Marxist concepts and associated activism. Instead, I employ an interpretive framework that is Marxist in orientation in order to frame both the genesis and the effect of their work in a particular way. If, in these instances, Marx proves a useful philosopher to articulate what Beckett and Bowie are saying and expressing creatively, then this indicates that Marx's concerns—social equality and universal freedom from the bind of a rapacious and exploitative capitalism—are also, to some degree, their concerns.

In presupposing such a framework, it is worth taking a moment to examine if either artist intended a critique of the political economy of his day. Although it may not be necessary to prove that they were Marxists, identifying some political investment on their part would nonetheless lend credence to the argument that they were socially conscious and understood their art as having a role to play in social change. After all, Beckett has always been thought of as disinterested in politics, once even selling his Irish vote for "a quid" (a quid being one Irish punt, or pound, see McNaughton 61) while Bowie, for his part, once announced unequivocally that he was "apolitical" (Jones, "Goodbye to Ziggy"). At first glance these are not auspicious conditions for advocating a political critique of their work. At the same time, it is interesting to note

that on the occasions when Beckett felt compelled to distance himself from politics it was almost invariably from an attempt by others to position him within an Irish nationalist narrative; to present him as part of a collectivist political project that he fundamentally rejected. In a somewhat similar fashion, when Bowie felt obligated to say he was apolitical it was to deflect suspicions that he might have quasi-fascist leanings, despite the fact that he had always played games with the "style" of politics. In other words, Beckett's spoiled vote and Bowie's declaration of political disinterest were made in response to socially antagonized situations in which both artists were deeply imbricated and invested.

Bowie's politics became a source of interest to the public world in the mid-seventies. On *Station to Station* (1976), he materialized as "the thin white duke" and a combination of alleged Aryan supremacist references in the song "Station to Station" ("the return of the thin white duke/making sure white stains"), a live tour with monochrome lighting reminiscent of Leni Riefenstahl's Nazi propaganda films, and damning interview sound bites all seemed to suggest that Bowie harbored dubious political aspirations. For the record, he said in 1976:

> As I see it, I am the only alternative for the premier in England. I believe Britain could benefit from a Fascist leader. After all, Fascism is really nationalism.
>
> (Buckley 289)

And he added:

> Adolf Hitler was one of the first rock stars. Look at some of the films and see how he moved. I think he was quite as good as Jagger ... He was no politician. He was a media artist himself. He used politics and theatrics and created this thing that governed and controlled the show for those twelve years. He staged a country.
>
> (289)

Three years later, and in response to questions regarding these political statements, Bowie said:

> It is not my position for the kind of artist I am, who tries to capture the rate of change, to adopt any given policy or stance politically because my job is an observer of what is happening and any statement made in that direction [vis-à-vis fascism] were a general reaction and a theatrical observation of what I could see happening in England.
>
> (292)

This would explain why he outlined his political viewpoint in the following way to Allan Jones months after the proto-fascist quotes drew global attention:

> All I can say is that I have made my two or three glib, theatrical observations on English society and the only thing I can now counter with is to state that I am not

a fascist. I'm apolitical. The more I travel the less sure I am about exactly which political philosophies are commendable. The more government systems I see, the less enticed I am to give my allegiance to any set of people, so it would be disastrous for me to adopt a definitive point of view, or to adopt a party of people and say 'these are my people.'

("Goodbye to Ziggy")

Quite clearly, here, Bowie wishes to distance himself from what he perceives as the limitations of institutional politics in a manner similar to Beckett when he sold his vote. The statement also reveals that Bowie believes taking a political position somehow must involve identifying with a political party, and his claim that he is apolitical is a way of saying he cannot, or will not, identify with any collective party line. Conversely, it is clear from his explanations that Bowie considers himself an observer, a witness, if you will, to political shifts he somehow tries to translate into art. Fundamentally, the politics of culture, of art as witnessing, recording, shaming, and/or transforming, is largely at odds with the demands of allegiance to political parties (something Beckett was profoundly aware of every time one of his creations was consigned to the Republic of Ireland's list of banned books). Indeed, to undertake the role of witnesses, both Beckett and Bowie are often obliged to take artistic positions and/or adopt artistic personas designed to disrupt and even enrage the comfortable hypocrisy of the status quo.

For example, early in his career on "Cygnet Committee," Bowie attempted to express his frustration with the nineteen-sixties hippie politic insofar as he understood it to be both ineffectual (the song is a veiled attack on the lethargic hippie philosophy that dominated the Beckenham Arts Lab where he often wrote, practiced, and performed in 1969 and the early seventies) and, in the shape of Jerry Rubin and other Yippie activists, unnecessarily confrontational. In the early seventies, and in a rather rambling attempt to explain the genesis and mood of the song, Bowie said:

I basically wanted it to be a cry to fucking humanity. The beginning of the song … was saying—Fellow man I do love you … O.K., that was the first section. And then I tried to get into the dialogue between two kinds of forces. First the sponsor of the revolution, the quasi-capitalist who believes that he is left wing … People like Mick Farren, Jerry Rubin, etc. … The hippies, I'm afraid, don't know what's happening … I mean Marx didn't live to see what Roosevelt did with that depression. He pulled everybody out of that … and everybody hated Roosevelt. I would like to believe that people knew what they were fighting for and why they wanted a revolution, and exactly what it was within that they didn't like. I mean, to put down a society or the aims of a society is to put down a hell of a lot of people and that scares me that there should be such a division where one set of people are saying that another set should be killed … The emphasis shouldn't be on revolution, it should be on communication. Because it's just going to get more uptight. The more the revolution goes on, and there will be a civil war sooner or later.

(Salvo, "Interview")

Interested in the idea of a cultural revolution consonant with the countercultural youth values of the time but appalled by easy sloganeering and activist calls to overthrow the status quo, Bowie's "Cygnet Committee" features the lines:

> And I open my eyes to look around
> And I see a child laid slain on the ground
> As a love machine lumbers through desolation rows
> Plowing down man, woman, listening to its command

Borrowing from and building on Bob Dylan, Bowie's character understands that some sort of revolution against privilege is necessary, but the singer also mobilizes infanticide as a stain on any potential revolutionary movement. Instead, he wants to celebrate life and believe in love, even if that be madness, as an alternative to the screams of the dying. At the same time, he imagines a razing love machine that incorporates a symbolic violence against economic privilege. Here, Bowie is being political on his debut album in ways that while not obvious, reward closer scrutiny. His 'on the record' endorsement of Roosevelt's New Deal as a form of progressive socialism locks horns with the idea of a revolutionary Marxism that, paradoxically, is defenestrated by posturing hippie culture advocates.

If in a Dylan-inspired song composed in 1969 Bowie appeared to place his faith in love as a vitalism to challenge the negative ontology of revolutionary bloodshed, as his career developed over four decades such vitalism was subsumed in an emergent landscape of ruination and corresponding mood of frustration. Although he rejected Marxism in 1971, by the nineteen-eighties, Bowie was less enamored about the growth and progress of a capitalism far removed from Roosevelt's social roots. After John Lennon's assassination in 1980, Bowie told Kurt Loder that he felt as though

> a whole piece of my life seemed to have been taken away; a whole reason for being a singer and songwriter seemed to be removed from me. It was almost like a warning. It was saying: we've got to do something about our situation on earth … I've got a certain position, I want to start utilizing that position to the benefit of my … brotherhood and sisterhood … there's a lot of injustice. So, let's … say something about it.
>
> <div align="right">(Loder)</div>

Subsequently, Bowie's political persuasions became increasingly more obvious. He characterized the video to "Let's Dance" (released in 1983), featuring Terry Roberts and Joelene King as indigenous Australians suffering a symbolic deracination of their landscape and culture, as "very simple, very direct, almost like Russian social realism, very naive. And the message … is very simple—it's wrong to be racist!" (Loder). By the mid-nineteen-eighties, he was explicitly advocating for cultural inclusivity as a communitarian politic coextensive with the minority left-wing sensibilities of the period and using social realism as his touchstone. His credentials as an advocate for the alienated were further on display when he reprimanded MTV host Mark Goodman

regarding the dearth of African American musicians on the show's white-heavy rotation schedule, pointing out in the process that these decisions were economic and had a deleterious effect on the moral and economic security of the excluded cultures ("Bowie Criticizes MTV").

At the same time, and as instanced by his manifestation as the thin white duke character in the nineteen-seventies, the various characters in Bowie's performed universe do not have to be consistent with his own point of view, and its value system, if the aim is to explore the world in all its troubling complexity. He understands that to illustrate how fascism works is not to be a fascist but may require adopting fascist attitudes through character or aesthetic mood. Take, for example, the song "Valentine's Day," in which the narrator informs the listener:

Valentine told me who's to go
…
The teachers and the football stars

Clearly, the song is told from the perspective of a student shooter with mental health problems and given that Bowie places such emphasis on environment in terms of influencing behavior, he is obviously using this character to explore gun culture in the United States. Saint Valentine, an archetypal martyr executed for his faith, is transformed into a callow and emotionally disfigured adolescent and employed as a cypher to contextualize the political reality of the USA in the second decade of the twenty-first century; a society where schools must screen high school children to prevent them bringing guns to class. To suggest, on the contrary, that Bowie is indulging some right-wing fantasy of blood and soil triumphalism is to fundamentally misunderstand how he operates as an artist, and how the artist, as witness, can frame culture in ways that do not mirror the artist's own political position, but rather communicate her/his position on the issue by adopting personae in order to render visible, and readable, the beliefs and values being critiqued. It seems clear that throughout his writing career Bowie's sympathies lie with those who are exploited and oppressed. Indeed, in relation to *"Heroes,"* the album he made subsequent to the Hitler comments in 1977, Bowie claims its raw material was drawn from watching migrants in Berlin. He tried "to capture" the experience of

> the Turks that live in the city. There's a track on the album called "Neuköln," and that's the area of Berlin where the Turks are shackled in bad conditions. They're very much an isolated community. It's very sad. … And that kind of reality obviously contributed to the mood on both *Low* and *"Heroes"* … You arrive at a sense of compassion. The title track of *"Heroes"* is about facing that kind of reality and standing up to it.
>
> (Jones, "Goodbye to Ziggy")

Such comments demonstrate that providing a voice for those in distress seems a more accurate reflection of Bowie's politics than a legacy of brownnosing with

authoritarianism. Given that "to be insulted by these fascists it's so degrading" ("It's No Game I & II"), Bowie's oeuvre is an attempt to kick back against those pricks.

Turning to Beckett, much of his politics can be surmised from his response to the observation that human distress is a dominant theme in his creative vision:

> Yes, [my texts] deal with distress. Some people object to this in my writing. At a party an English intellectual—so-called—asked me why I write always about distress. As if it were perverse to do so! … I left the party as soon as possible and got into a taxi. On the glass partition between me and the driver were three signs: one asked for help for the blind, another help for orphans, and the third for relief for the war refugees. One does not have to look for distress. It is screaming at you even in the taxis of London.
>
> (Driver 244–5)

In conceiving of bare, denuded men and women, what Agamben refers to as "Homo Sacer" (originally the "accursed" outsider unprotected by Roman law), Beckett succeeds in undertaking a critique of capital society, unmasking the biopolitical strategies structured to rapaciously exploit such figures. In *Waiting for Godot*, for example, it is established early on that Estragon takes regular beatings as a consequence of his vagabond state, and as soon as Pozzo and Lucky enter the scene, the audience are immersed in the politics of property-based power and the meager means the dispossessed have to defend themselves. Likewise, the squabbling of the isolated characters in *Endgame* reflects the travails of lives forced to play themselves out against the backdrop of environmental catastrophe they had no hand in shaping; a similar scenario to Bowie's song "Five Years" where the characters are victims of an ecological collapse brought about by the machinations of institutional power. In such ways, both Beckett and Bowie represent the most vulnerable and alienated within society. With this in mind, when D'Amado proposes that Bowie is

> a puppeteer and provocateur who seems to have no overt commitment to any ideology beside the brave libertarianism of the radical aesthete, ethically committed only to a freedom of play, expression and gender
>
> (121)

this seems an inadequate way to describe what Bowie does (just as the term "Theatre of the Absurd" is now recognized as a delimitation or distortion of what is a much more politicized intent in Beckett). Conversely, Bowie and Beckett's work is aware that capitalism generates the very inequalities it claims to remediate, and that the latter operates by excluding or including communities based on their legitimacy within the capital hegemony. Beckett's cast of vagabonds and tramps, operating on the margins of an affluent society which rigorously others them, is testament to his awareness of this state of affairs (even if his work predates the contemporary model of necro-capitalism). Similarly, Bowie's rent boys, trans chanteuses, blind junkies, and Palestinian aliens

bespeak the world of the subaltern condemned to the margins of corporate efficiency and its necessarily normative sociality.

Returning to the question of methodology, it seems reasonable to argue that although Beckett and Bowie may not have been practicing Marxists, they did produce art that is a response to the historical and social trauma capitalism provokes and necessitates in order to proliferate. However, rather than following communism in some literal sense, they followed their own instincts. Essentially, Marxism is about changing thinking, and Bowie and Beckett, too, like most important counterculture artists, were intent on challenging the ingrained ideologies that supported the status quo. Themselves alienated from an increasingly neo-capitalist society, they generate characters, moods, and aesthetic strategies in response to and in opposition to this emerging context. One obvious objection to this claim is that both artists willingly partake in the capital enterprise and that as the producers of market commodities both are as implicated in capital exploitation as anybody else. Indeed, as well-rewarded artists financially, they may be more implicated than most. In this regard, this study will propose that only for a short period in his life, between 1983 and 1985, did David Bowie have an interest in his financial security and for Samuel Beckett such reassurance arrived as a complete accident, an unexpected windfall consequent on "A country road. A tree. Evening" (*Waiting for Godot* 1). From an alternative perspective, (chapter) III will address the commodity status of art and propose that both Beckett and Bowie offer a self-conscious and fetishized art that challenges commodity culture, consolidating the notion, après Oscar Wilde, that all art is quite useless. They practice a strategy of resisting incorporation by first becoming it, as commodification. This necessitates a self-conscious approach to creativity and performativity; a constant awareness that they *perform* their alienation. In other words, performance and alienation are both the subject matter of their art and present in the aesthetic choices that shape and structure their approach to their practice.

At the same time, and despite valiant attempts to produce a useless art, it is clearly the case that Beckett and Bowie's output is highly valued by their fans as an object of consumption. In fact, a strong case can be made that fans utilize Beckett and/or Bowie's art to resist the standardizing imperative of commodity capitalism. Given that commodities circulate in two simultaneous economies, the financial and the cultural, the latter need not be assessed in economic terms only. For example:

> people find on the market incentives and possibilities not simply for their own confinement but also for their own development and growth. Though turned inside out, alienated and working through exploitation at every turn, these incentives and possibilities promise more than any visible alternative.
>
> (Storey 261)

Furthermore, in capital culture the commodity has a double identity, as both use value and exchange value, and in the metrics that demarcate fan value, use value consistently eclipses exchange value. As Lovell proposes "there is no guarantee that the use value

of the cultural object for its purchaser will be compatible with its utility to capitalism as bourgeoise ideology" ("Cultural Production," 598). Storey concurs with this assessment, proposing that

> almost everything we buy helps reproduce the capitalist system economically, but everything we buy does not necessarily help secure us as 'subjects' of capitalist ideology ... capitalism produces commodities on the basis of their exchange value, whereas people tend to consume the commodities of capitalism on the basis of their use value.
>
> (264–5)

Perhaps Henry Rollins says it best: Bowie's music "saved my ass" ("When Rollins met Bowie," 2:04′). In other words, the use value that consumers attach to Bowie's music, or to Beckett's drama, need not coincide with either normative capital circulation or its exchange values. Rather, art can have resistant and subversive value for its consumers. Those who value it often do so precisely because it radically transformed their life and politics in ways not congruent with hegemonic capital identity. In this regard, if we locate the moment of social alienation within a dialectical pattern of personal development, then when a reader or listener recognizes their alienation in Bowie and Beckett's work, this moment is also the basis of their individuation. And this is an important moment because alienation is the expression of an individuality estranged from but in touch with the potentialities of species being, and so capable of communicating with fellow consumers and creating the grounds for collective action against economic exploitation.

It goes without saying that to champion an anti-capitalist Beckett and Bowie might be a misreading of their work. Many fans of either artist could reasonably object to such a relatively specific and narrow framing, pleading instead for an idea of artistic license wherein creative content is not co-opted or confined within delimiting interpretive narratives. Read against the possibility of such multiplicity, my framing here might be considered as a strategy towards effecting an interpretive closure. This is fair criticism. I do recognize that there are numerous Becketts and Bowies. Countless excellent academic monographs and essay collections on Beckett and painting, cinema, philosophy, technology, and religion attest to the richness of his work and its capacity to reveal different Becketts whose voracious interest in art and culture generate the notion of a man of great curiosity and complexity. At the same time, these studies employ interpretive frames that are occasionally Marxist or socialist but are most often discreetly orthodox and centrist, which, consequently, can be read as disinterested in if not indirectly supportive of the economic status quo. In response, the Beckett outlined here is a Beckett specifically contextualized by his implicitly politicized aesthetic practice. And this Beckett seems to me a genuine Beckett, and the concerns glossed from his work, his genuine concerns. One Bowie, beloved of a friend of mine, is the author of songs such as "Absolute Beginners" and "Kooks." She is also enamored of the Bowie who performs the hilarious cameo in the TV show *Extras* and who entertains chat show audiences the length and breadth of YouTube. It is a different

Bowie who is invoked here, and of all the Bowies on all the jukeboxes in all the world I believe the Bowie here has weight, and the manner in which he is presented in this study will go some way towards substantiating his presence as another Bowie, perhaps an important one, in the Bowie universe.

I am aware that proposing Marxism not only as an interpretive tool but also as a potentially transformative discourse flies in the face of the history of political economy and the totalitarian fate of communism. There can be nothing positive about the way in which Marxism was instrumentalized in the twentieth century to oppress and tyrannize millions of people. I claim, however, that those versions of communism are the distortion of key principles of Marx's socialist vison and, ultimately, that Stalin was to Marx as the Spanish Inquisition to Christianity. Indeed, if anything, the distortion of Marx's altruistic doctrine confirms the essential cruelty and dishonesty of humanity; the very thing Marx attempted to reform and transform in his writing. Additionally, when I say that Marxism is proposed here as a positive intervention, I am not presenting his thought as a vitalist force for good but rather as the last remaining discourse that might be mobilized to recontextualize where we are now and imbue our remaining time with some clear-eyed perspicacity. In keeping with Marx's dialectic materialism, I am proposing our times are characterized by a relentlessly negative ontology such that no one is free in a world so distorted, even those who sit on accumulated fortunes while the continents overheat and the seas fill with refugees. It is this sense of loss that Samuel Beckett and David Bowie chart even if their own going predates some of the terrible developments discussed here, offering, by way of their own expiration, evidence of the need for all of us to prepare for our collective demise. Suffice to say, they were able to read the portents that their own experience of institutionalized economic exploitation and greed presented to them, and in mirroring it, creatively, reflect it in a cracked looking-glass back at us.

As stated previously, the Marxism deployed here will be twofold. In this study I both re-evaluate Marx retrospectively while also employing post-Marxist developments in the discipline. There is a clear sense in which classical Marxism, or what we might call "retro-Marxism," evokes a certain yearning for a return to Marxism as a matter of nostalgia, but this is at the same time a yearning for a certain authenticity as a result of the degeneration induced by the economic and philosophic epochs that have succeeded it. In other words, as late capital sociality begins to collapse in upon itself, it might be an idea to reassess and reintroduce Marx as a judicious critic of the status quo. Moreover, Marxism's ability to decode present circumstances also allows us to see how and why Marxism itself has been silenced in the Western idiom; in truth, its marginalization is an expedient political necessity rather than simply a consequence of the doctrine's unfortunate political embodiments and cultural history.

In the contemporary moment, capitalist production has so completely embedded itself as the dominant mode and means of production that, arguably, every second of every life is now shaped and directed by its concerns. As Laclau and Mouffe note:

> Today it is not only as a seller of labour power that the individual is subordinated to capital, but also through his or her incorporation into a multitude of other

social relations: culture, free time, illness, education, sex and even death. There is practically no domain of individual or collective life which escapes capital relations.

(161)

Similarly, Žižek identifies how life itself has become imbricated in the contours of the capital order:

> ... the defining feature of post-modern capitalism is the direct commodification of our experience itself: what we are buying on the market are less and less products (material objects) that we want to own, and more and more 'life experiences'—experiences of sex, eating, communicating ... "we become the consumers of our own lives."
>
> (*Courage of Hopelessness* 21; embedded quote, Vandenberghe 293)

This anthropomorphizing of exchange value produces a context in which

> money represents the moment of identity of all commodities as commodities, as exchange values rather than particular use values ... [and so] it takes the place of human social relations: the human *individual*, abstracted in the form of labor power becomes – as money also is – one among other commodities, a part of a set of intersecting series of things and objects, persons and commodities ... universal equivalence rather than universal equality.
>
> (Lloyd, *The Transformation of Oral Space* 213)

Consequently, to frame today's class struggle as the antagonism between industrial laborers and their capitalist employers is to fail to appreciate capitalism's growth and reach. One of Marx's most famous observations—that "the mode of production of material life conditions the social, political and intellectual life process in general" (*Critique of Political Economy*)—proposes that our total understanding of being is shaped by our economic life, and this is pointedly the case under capitalism. Today, all life is expected to conform to the dictates of capital economy both in its work and leisure time. Even if one is not clocking in and out of a factory, the individual often feels nonetheless alienated from his or her own potentialities by the coordinates of a consumer capitalism that crushes the spirit of its incorporated subjects—subjects who have come to understand how capitalism's structural dictates dispossess and enslave others as part of its necropolitical operations. Retro-Marxism allows us to see this systemic social structure more clearly, but it also requires nuanced modifications to achieve more significant ideological unmasking. For that reason, recent and contemporary post-Marxists who have begun to reconceptualize aspects of Marxism that require an upgrade in order to speak more cogently to the current political, cultural, and social moment are also employed here. Through the framework such thinkers provide, I argue that Beckett and Bowie generate an aesthetics of suspension by means of which glimpses of an alternative political landscape emerge, a landscape

ordinarily rendered invisible as a result of being subsumed into a mode of production which ensures "all that is solid melts into air" (*The Communist Manifesto*). They achieve this artistic suspension from the position of a notionally alienated outsider, facilitating better understanding of the invisible parameters of established conservative society and its conventional modes of thinking. Tobin Siebers articulates Marxism's role in this unmasking as follows:

> ideology creates, by virtue of its exclusionary nature, social locations outside of itself and therefore capable of making epistemological claims about it ... oppressed social locations create identities and perspectives, embodiments and feelings, histories and experiences that stand outside of and offer valuable knowledge about the powerful ideologies that seem to enclose us.
>
> (279)

Jean-François Lyotard refers to the understanding gleaned from such marginal positions, and the perspectives they afford, as "critical knowledge" or "critical theory" (Lyotard 47). He proposes a distinction between two different models of the social that influence the use value of knowledge:

> there have been, at least over the last half-century, two basic representational models for society: either society forms a functional whole, or it is divided in two. An illustration of the first model is suggested by Talcott Parsons ... and his school, and of the second, by the Marxist current.
>
> (33)

Any knowledge that displays a "desire for a unitary and totalising truth lends itself to the unitary and totalising practice of the system's managers" whereas "critical theory, based on a principle of dualism and wary of syntheses and reconciliations, should be in a position to avoid this fate" (45). For Lyotard, "it is a choice between the homogeneity and the intrinsic duality of the social, between functional and critical knowledge" (47). Marxism is coextensive with this critical understanding of how the world works. Moreover, expression, creative or critical, emanating from this outside is necessarily the statement of an alienation, and the key feature identified in these pages that unites Beckett and Bowie, as expressed in story and in song, on stage and on the page, is that they suffer such alienation. They are, variously, alienated from society, from other people and, often, from themselves. Furthermore, their characters are alienated through economic exploitation, through emotional and/or physical abuse, through technology, and, ultimately, through social indifference.

Marx remains the key historical thinker of such alienation, establishing how the individual is engaged in a constant struggle between resistance to and absorption within capital society from where s/he is either incorporated as willing capital subject or alienated to its margins. Consequently, retro-Marxism presents itself as a relevant theoretical framework that helps frame what is politically, emotionally, and intellectually important about Beckett and Bowie's artistic and creative treatment of the

outsider. Moreover, their work calls to and comforts individuals who, estranged from the status quo, find in either artist the statement of their exclusion and the illumination of its terms. In so doing, Beckett and Bowie call into question the legitimacy of the inside as a geographic, institutional, and metaphoric entity, creating *at the same time* an alternative non-material time and space that interrogates this interior "reality" from the outside. This outside is represented, variously, as crumbling cityscapes in which the subaltern seek asylum, as oppressive psychiatric institutions, as the furthest reaches of outer space and even as the restrictive form of the self-reflexive work of art that entraps and dematerializes its characters and their ideals. In these spaces, and through the aesthetic proxemics Beckett and Bowie employ to navigate them, ideological illusions are perceived, demystified, and dismantled.

Chief among these illusions is that late capital economic identity is a positive thing. Unquestionably, capitalism has been a good thing, economically, for a minority of people, but it has also produced a crisis of spirit for the great majority, many of whom may also be economically secure but who are becoming increasingly unmoored by the privileging of economic life over the nurture required for a rewarding metaphysical existence. Objective reality may be formed in the Marxist base where the monied classes are in charge, but subjective life is lived and performed in the social practices of the superstructure, and here, irrespective of an individual's economic security, there is increasingly great misery and despair. Quite simply, the world is in a state of *agōn*, or conflict. Spiraling debt; an explosion of refugees who are largely treated abominably; the emergence of a pandemic which is the direct consequence of unsustainable living practices guaranteeing yet more pandemics to come; continued environmental degradation and accelerated global warming; increased militarization and war; lawless law enforcement in the United States, perpetuating and endorsing a polarizing racism; and an increasingly disconnected and disenfranchised youth culture turning ever more to self-harm and suicide do not attest to the merits of global *laissez-faire* economics. And although the application of retro-Marxism might seem quaint if not obsolete, it remains the best discourse for highlighting, articulating, and trying to resolve the material antagonisms that arise, in the first instance, as a result of economic disparity and that trigger and subsequently manifest themselves in a host of social, cultural, and ecological conflicts. Surveying the economic landscape of today,

> real wages have fallen at the same time that productivity has risen, thereby transferring unimaginable wealth to the richest in society. Estimates of how much money is stashed in offshore accounts vary between $12 and $32tn—enough wealth to wipe out almost all the social problems of poverty in one fell swoop were it to be confiscated, socially invested and redistributed.
>
> (Thompson, "Negative Dialectics")

In this regard, the global recession in 2008 was a watershed moment as it constituted the paradigm shift when socialism was co-opted and "rebranded" as uber-capitalism for the rich such that, consequently, and to paraphrase Fredric Jameson, it became "easier to imagine the end of the world than the appearance of a better one" (Thompson, "Negative Dialectics").

Together with an understanding of alienation and the dangers of elite capital accumulation, a recognition of conflict and its role in social antagonism is central to Marxism. Marx believed social antagonism a reflection of the unresolved conflicts that are generated and perpetuated by inequality. In the present moment, the proliferation of protests about economic policies in countries around the world are primary evidence in support of this position. As I write, there are economic policy protests and/or anti-corruption protests in Sri Lanka, Venezuela, Argentina, Afghanistan, Egypt, and Cyprus, among others. In the aftermath of an extended peaceful peoples' protest in Sudan, the country has been ravaged by military corruption. According to the Carnegie Endowment for International Peace, over 230 anti-government protests and 110 economic policy protests have taken place globally in recent years.[1] Again, at the time of writing, Europe, together with the United States, the epicenter of free market economics, is about to embark on a recession marked by extraordinary hikes in domestic energy bills and previously affordable costs of living. It appears that the center cannot hold. Moreover, Marxism accommodates the belief that the antagonisms that recur in Western society today, and which are embodied in conflicts revolving around class, race, and gender, are also in part a reflection of counter culture's attempt to resist incorporation into the dominant mode of capital production. And the type of contemporary post-Marxism that identifies these trends, represented by thinkers like Laclau and Žižek, have their roots in the philosophy of the mid-twentieth-century Marxists, Theodor Adorno and Walter Benjamin, whose ideas were shaped by World War II and its legacy.

Both Adorno and Benjamin were committed to framing cultural production as potentially transformative culture, with a particular emphasis on the value of art as an agent of cultural change. Both understood that capitalism has turned culture into an industry, and both devised different strategies to combat capitalism's desire to neuter creative culture and depoliticize any instances of radical intent. Recognizing that commodification devalues the object by subjecting it to the rules of capital exchange, in which its value becomes its exchange value, Adorno came to understand that most art in the culture industry is finally determined by its economic worth in the marketplace such that its revolutionary capacity is "flattened out" by its commodity status. There are few thinkers who could say "I told you so" with quite the same justified satisfaction as Adorno, surveying how culture industry phenomena such as *Pop Idol*, *Big Brother*, and *Love Island* have so successfully instrumentalized the very human characteristics and cultural practices of singing, desiring, and seeking to belong.

In contrast, Adorno believed that what he called "serious music" ("On Popular Music" 64) is created to challenge such standardization. He proposed that the antagonistic nature of serious art (for which we can read experimental art) is palpable within the structure of any given work. In *Aesthetic Theory*, he declares "the unsolved antagonisms of reality return in artworks as immanent problems of form" (7). Adapting his proposition that "aesthetic form is sedimented context" (9), this study proposes that through the persistence of antagonistic form, Bowie (despite the fact that Adorno would not have considered his music serious) and Beckett (whom Adorno thought very serious) generate artistic moments that cannot be incorporated. Such moments reveal the realities of a world now shaped in the image of a catastrophic economics

and provide a glimpse of something alien, something better. In a capitalist mode of production, most artworks, in the words of Herbert Marcuse, "are deprived of their antagonistic force, of the estrangement which was the very dimension of their truth" (63–4). Bowie and Beckett's work, however, escapes this charge through aesthetic maneuvers that reflect and consolidate conflict as the mark of their alienation and of their ongoing resistance to incorporation. As a result, they provide refuge for estranged people by going beyond the norm ceaselessly, imagining alien spaces generated beyond normative thinking and giving voice to alienated people with whom they populate such spaces. In doing so, they generate "an inkling of the terms in which our condition is to be thought again" (Beckett, "The Capital of the Ruins" 29). This is an intentional aesthetic arrived at by both in different ways but amounting to the same thing: reading and understanding a revolutionary art for a revolutionary time. And this idea of revolutionary time, owes a great deal to the imaginative powers of Walter Benjamin.

Benjamin was a historical materialist who, in contrast to Adorno, made no pessimistic predictions of future catastrophe but instead tried to read the present as the necessary consequence of the past, proposing in the process that the present must adopt a revolutionary or "messianic time" ("Theses on the Philosophy of History") in order to break with the tyrants of history. As consumption is linked to how the individual practices politics, Benjamin shifted the emphasis away from the domain of the artist's intention, and its relation therein to production, and onto the domain of interpretation, which prioritizes consumption as the determining mode of Marx's social model. In other words, Benjamin saw the revolutionary potential of society in the audience rather than in the artist. As we shall see in II, the aftermath of postmodernism in modern criticism marks a return to history and historicity as the proper scholarly foundation for interpretation, but it also marks an opening of aesthetic interpretation into new areas of possibility, cross-pollinating previously separate domains and allowing for playful yet serious contemporary critical turns. Consequently, the methodology in this study is faithful to historical scholarship while also validating creative post-Marxist interpretations that open onto a possible revolutionary plane, one where a temporal suspension is achieved aesthetically and generates artistic intensities that constitute a potential transformation in the now.

A theoretical proposition (or, arguably, projection) such as claiming in grandiose fashion that art constitutes a transformation, or a revolution, is known in informal academic brainstorming, and associated discussion, as "a reach." The phrase "this might be a reach" is intended to signal the excessive nature of an imminent theoretical claim and, for good or ill, it is tailormade for what this study is attempting to achieve. Furthermore, it seems ideally suited for comparative theoretical work on the two very different artists considered here. In "God is in the House: Beckett and Cave," David Pattie opens his comparison of Nick Cave and Samuel Beckett with a description of a frenetic Cave concert in which the singer finds himself reaching to hold the hand of a fan. Pattie contrasts this with the ritualized yet gentle holding of hands that the audience encounters in Beckett's "Nacht und Träume" and then employs this haptics as a metaphor. Even though Cave and Beckett grasp at transcendence in their work, Pattie believes they knowingly fail because "the sought for object or

goal cannot be *reached*" (272, my emphasis). This is clever and insightful criticism and links Beckett and Cave figuratively as poetic support for a rigorous objective analysis of their shared art of failure.[2] It reminded me that there are other haptics in Beckett that are less gentle than his teleplay and bespeak familial and gendered antagonisms. For example, the old man and child of "Worstward Ho" walk "hand in hand" (473), whereas the mother in "Company" shakes off her son's hand "and makes a cutting retort" (19) that the young boy has never forgotten, although he does not share it with readers (intertextual allusion suggests the retort is most likely "fuck off" as it is enunciated by a mother to a child in a similar tableau in the short story "The End," 74). Elsewhere

> elaborate sequences involving gestures with the hands resonate throughout Beckett's plays and films, from the close ups of Buster Keaton's hands in *Film*, the communal praying in "Come and Go" and Winnie's hands as she mimes an inaudible prayer, to the ritual gestures in "Nacht und Träume."
>
> (Paraskeva 15)

Bowie's work, too, involves recurrent haptics such as the injunction to "reach out over race and hold each other's hands" ("Black Tie White Noise") or the joyous plunge "into the river holding hands" from "Sweet Thing" or the holding of "mad hands" in "'Tis a Pity She's a Whore." Most memorably, Bowie's reputation as an artist of the alienated was consolidated in the refrain "give me your hands" in response to the declaration "cos you're wonderful" that closes the song "Rock 'n' Roll Suicide" and the album *The Rise and Fall of Ziggy Stardust and the Spiders from Mars*. In short, there is fertile material for the study of haptics as a framework to unite Beckett and Bowie, but in this study it is I who, in certain places, do the most reaching, particularly in conclusion. I hope you will indulge me in this regard. During the course of this study, the methodological focus on Marx's alienation and its effects, and on his notion of antagonism as the basis for the transformation of negative ontology in art and life, offer a robust objective scaffold in support of the final suggestion that we might all reach for the stars in an attempt to see humanity in a form beyond our current confines. In defense of this eccentric denouement, I would ask you to consider that post-Marxist cultural studies rests on two imperatives, which John Storey summarizes admirably:

> First, although the world exists in all of its enabling and constraining materiality outside culture, it is only in culture that the world *can be made to mean*. In other words, culture constructs the realities it appears only to describe. Second, different meanings can be ascribed to the same text [for] meaning making (i.e., the making of culture) is always a potential site of struggle and negotiation ... This is not a question of semantic difference – a simple question of interpreting the world differently – it is about relations of culture and power, about who can claim the power and authority to define social reality; to make the world (and the things in it) mean in a particular way.
>
> (88)

At present, hegemonic meaning-making is the purview of capital production, and this study intends to challenge that with the meaning-making of Bowie and Beckett and the worlds they call into being, concluding with a fanciful notion of reaching for the heavens the better to appreciate that the nitrogen in our DNA was once a small star (Sagan). Consequently, our understanding of the terms of what we call the human might need to be rethought, and, in doing so, we might even forestall our own self destruction.

On the road to this conclusion, II outlines the antagonisms generated by cultural investigation within the mode of capital discourse and production. It examines the tensions generated by high and low perceptions of art and cultural value in both the university and the world of popular culture, and how these notions are structured around the ideas of popular and elite taste. It examines where audiences are positioned by their tastes and where either incorporation or resistance to capital culture begins. The chapter concludes by proposing that the antagonism underpinning the distinction between mass culture and elite culture, a distinction ostensibly reflecting naturally occurring hierarchies of taste, is in reality nothing more than the by-product of carefully constructed cultural divisions designed to maintain economic inequalities within the social. In our post postmodernist epoch, the chapter also argues for the necessity of a twin interpretive imperative: the need to recognize the role of history in production, and the need to be creative with aesthetic interpretation in the "business" of consumption.

III undertakes a comprehensive analysis of Marx's thoughts on alienation and how they might apply to Beckett and Bowie. It constitutes a historical excavation of Marx's central social idea and contextualizes it as a way of reading Beckett and Bowie's creative motivations and artistic choices. Further, it expands Marx's alienation to accommodate those estranged from architectures of power as a result of race, gender, and sexuality, while attempting to maintain the German's focus on the antagonisms that are produced by economics and subsequently projected onto alienated communities.

IV undertakes detailed analysis of both artists' interest in myriad forms of the creative arts. It aims to uncover shared or similar artistic influences which might then be read in their own work as evidence of their aesthetics of alienation. It concludes by proposing a shared aesthetic of intersubjective suspension that is at once a recognition of alienation and an attempt to heal this breach through a communal intersubjectivity.

V is an interzone that attempts to wed philosophy and aesthetics as a suitable interpretive context for the proposed intersubjective moments achieved by Beckett and Bowie. It is also an homage to another, proximate "bulletin."

VI addresses the somewhat vexed question of the queerness of both artists in the sense of a shared strangeness at the intersection of sexual diversity, gender fluidity, and eroticism. I say vexed because it is important to highlight Bowie's role in both sexual and gender liberation through his take on eroticized glam—an eroticism that Beckett's work does not broadly share. However, as this chapter suggests, in keeping with the post-Marxist framework of the study in general, such liberations should not

be considered ends in themselves but as steps on a wider and steeper climb towards a liberation from heteronormative modes of thinking which include the patriarchal and the imperial; modes of thinking that continue to drive the late capital moment even though it propels us toward calamity. In this regard, VI concludes by proposing that seeking liberation from "thinking straight" is the appropriate legacy for Bowie and Beckett's queerness.

VII then considers both artists' central preoccupation with an art of alienation and ruination, proposing that in driving the outsider out, beyond the city, new spaces are conceived not only on the margins of society but in the form of the work itself; spaces that function as a type of refuge from the voracious capital impulses that define the landscape of modernity. It also proposes that their shared examination of characters suffering psychologically in stifling biopolitical environments helps illustrate how "normal" is a type of social performance designed to ratify contemporary capital society as grounding and authentic. Further, it argues that an impulse towards ruination is present in the content but also in the form of their art and proposes that their crisis narratives foreshadow and predict the crises in which we find ourselves embroiled today.

VIII addresses how the obligation to respond to the magnitude of the thing called death requires real artistic courage and is something that both Beckett and Bowie carry off with such unparalleled aplomb that they are the high water mark of an artistic integrity harnessed to an obligation to express the incommensurable. The chapter proposes that they offer an aestheticized form of passage, countering the fear of finitude as it exists in civil society by inviting the audience to the site of their death, which becomes, at that moment, an intersubjective reflection on our communal demise through performed crisis narratives of social catastrophe. At the same time, Beckett and Bowie challenge these extant death narratives by suspending their own demise in space and time, facing down and deferring the oblivion of finitude in the crucible of a regenerating performativity.

IX argues that their regenerative performativity enacts an absolute rejection of the values of late capital society, moving beyond its tawdry economic terms to instantiate, in its place, an aesthetics of death that in challenging vitalism constitutes a potential new form of subjectivity.

Finally, X, in what is *the* reach, proposes that Beckett and Bowie refigure space itself, through death, both within and beyond the conventional framing of our shared universe. They illustrate how dying through art, through a mimesis that endures, is the most (post) human form of exit and—paradoxically—entrance of all. Moreover, it is an entrance so transformative of capital's negative ontology that, to quote Bowie, "the stars look very different today."

II

Inside ... Outside ... Counterculture

If, when you read the title of this book, you thought of Beckett with a lightning strike across his face think again. For those of you who only know Bowie as an image of electrified *Storm und Drag* or

> as a smiling, dancing, very clean and willing-looking member of the ageing rock establishment, it will be a surprise, even a shock [to discover] other Bowies, later and earlier ... finding what he's done with madness, drag, 1984, Berlin, Burroughs, space, and his vivid dreams and personal fear and fixations.
>
> (Morley, *The Age of Bowie* 432)

Similarly, those who think of Beckett as the godfather of absurd minimalism might be surprised to learn that he is among the most versatile and varied of literary and theatrical artists. Although there is clearly a signature Beckett style, his work nonetheless surprises for its diversity in media, length, mood, and intention. In other words, the instinct towards a populist reduction of the richness of both Beckett and Bowie does a disservice to both artists.

To my knowledge, no sustained comparison of the work of Samuel Beckett and David Bowie exists. The reason that no one has undertaken comparative analysis stems in part from the sense that the creative contributions of both artists have little in common, and that their respective contributions also reflect fundamental differences in the lives and lived experiences of the two people in question. Quite simply, there is no body of Beckett/Bowie research in the same way there are no Dostoevsky/Sinatra comparatives. The artists and artistic practices involved are considered so different in kind, that a serious comparative study would seem unprecedented. Allow me then to begin altering this perception by drawing attention to certain similarities in the lives and, more importantly, in the artistic practice of both artists.

A quick address of similarities in personality and lifestyle might dispel some initial doubts regarding a comparison of Beckett and Bowie's creative outputs. I mean by this that there is an implicit historical, cultural, and social context that generally frames Bowie as a rock-and-roll hedonist and Beckett as an ascetic literary hermit. It would probably be wiser to ignore this context altogether, but doing this, arguably, would allow an unexamined supposition to linger like a specter on the margins of this investigation when a couple of paragraphs will serve to quickly dispel the influence of

biographical hearsay. In this regard, where one might think Bowie lived as the rock-and-roll messiah, perpetually indulging in excesses of sex, and drugs, and rock and roll, in reality, early wild years characterized by these pursuits eventually gave way to a monastic lifestyle structured around daily song writing, rehearsing, and touring (Jones, "We'll Miss You"). Shortly before he met and married his second wife, he told a journalist

> I find it hard to live with anybody. I'm a very solitary person, actually kind of selfish that way. I like my own company. I like thinking on my own. I like writing on my own.
>
> (Loder 42)

Similarly, much of Beckett's life was spent alone, writing, translating, and devoting himself to his art. Having said that, when Beckett first moved to Paris in 1928, he was thrust straight into the Parisian avant-garde and the nocturnal bacchanalia with which the nineteen-twenties were associated. In other words, to imagine Beckett never imbibed or "let loose" in the manner more usually associated with rock and roll is to underestimate the writer's penchant for a good party. Indeed, before Paris, he was known to visit the brothels of Railway Street in Dublin (Knowlson, *Damned to Fame* 161), and when he settled in the French capital he spent long nights, often until the sun rose over Montparnasse, fraternizing with artists such as the sculptor Giacometti and painter and art collector Peggy Guggenheim, a woman with whom he also had a Bohemian relationship (Wilkinson; and Cronin 282–3). As alcohol was his preferred indulgence, it features prominently in tales of his youthful shenanigans. His friend and fellow writer James Joyce wrote a famous letter in 1929 that details how a traveling party, assembled to celebrate the twenty-fifth anniversary of Bloomsday and the French translation of *Ulysses*, had no choice, on the return leg from a libacious afternoon, but to abandon Beckett in a public toilet, he being blind drunk and incapacitated. James Knowlson, Beckett's official biographer, recalls that when he asked Beckett where he was in the group photograph of the lunch, Beckett replied "probably under the table" (*Damned to Fame* 119). Colm Tóibín has also catalogued some of the benders Beckett undertook with fellow Irish artists and drinkers, Pat Magee and Jack MacGowran, while (ostensibly) rehearsing in both London and Dublin ("Beckett's Irish Actors"). The Falstaff, a late-night drinking den in Montparnasse accessed by a special knock known only to the doorman and its customers, numbered Sartre and Beckett among its regular late-night patrons (Cronin 513). One could be forgiven for thinking such public houses exist only in the minds of the more romantic readers of the writers in question, but Beckett liked a good pub (one of his favorite movies was *On the Bowery*), as much as he appreciated a well-stocked Parisian café and he graced the door of very many such establishments before his race was run. Even in his later years, the occasional letter written from Beckett's writing retreat in northern France details how a "bucket of brandy" (*CLSBIII* 203) proved the only panacea when the desired creativity could not be channeled into words. What is perhaps the very last photograph of the man, taken in Le Tier Temps nursing home shortly before his death, features a bottle of Tullamore Dew prominently on the table in his room.

None of this is to suggest that Beckett's day-to-day life should be considered an example of the archly theatrical bacchanalia of rock-n-roll excess. He rode no motorcycles through hotel lobbies—although he did own and ride an AJS and a Douglas, the motorbikes *du jour* of the "roaring twenties," and he also totaled his car at least once (Knowlson, *Beckett Remembering* 26, 66). Specifically analogous to Bowie, Beckett did not go so far as to paint occult symbols on his living-room carpet while under the influence of hard drugs (Cinque et al. 293), but he was a theater man and was familiar with the eccentric nocturnal rituals and Dionysian excesses of some of its practitioners. In other words, he was not a shrinking violet leading only a quiet and conservative life, and this brief address of his capacity to "tear it up" is made only to challenge any unspoken assumption that Beckett and Bowie were diametrically opposite personality types: Beckett some quietist, silent monk and Bowie a raucous party queen. They both were and *were not* these people, as circumstances dictated, and circumstances very often dictated that they be the opposite to their public image, whether a bout of hedonism indicated a necessary disengagement from the tyranny of the empty page, or solitary retreat was required to fulfill the insistent obligation to create.

Arguing to establish a certain similarity or contiguity in Beckett and Bowie's general lifestyle must also take into account one significant domain of existence in which Bowie and Beckett are markedly similar, that of white privilege. It is plainly the case that both Beckett and Bowie benefited enormously from what is known as white privilege, a structural architecture of social and cultural advantage reflecting the hegemony of Anglo-Saxon whiteness. This hegemonic power paradigm has its roots in the upper echelons of American and European society, and, as a result of imperial expansion of military industrial and commercial dimensions, now extends into every corner of the world. At the same time, it is possible for a white person to recognize white privilege, to recognize the benefits of it to their existence, and, consequently, to seek to unmask it and reject it. Importantly, rejecting it does not mean one immediately ceases to benefit from it, nor does it constitute an absolute rejection (as white privilege must necessarily cohere as habitus), but it does at least introduce a distance as a result of which the conscientious objector is aware of how s/he embodies the distributions of power that the position confers. And such knowledge can arrive early or late.

Beckett, a clear example of white privilege, came from a wealthy family in affluent suburban Dublin, through which he drove a sports car and/or a sports motorbike to and from Ireland's premier, prestige university. He also taught at this same university, largely reserved for English colonial settlers and their assimilated descendants. His first attempt at a novel is about, in part, the narrator's desire to determine the relative physical attractiveness of a number of women known to him, and at its center is a lustful meditation on one of these women, the hostess of an elite suburban dinner party; a party the narrator will fail to attend, having consumed so much alcohol he collapses in the street. In terms of travel, Beckett benefited from the relative ease with which he could relocate to Paris from Ireland, live there, and return again to the French capital after evacuating during World War II. This freedom of movement was determined by a type of privilege afforded him as a result of his family's wealth, ethnicity, and social standing.

In the case of Beckett, however, hardship and misfortune rather distanced him from his privileges such that their cocooning nature became quite apparent to him. The first of such realizations arrived while living in London where he had first-hand experience of being the unwelcome outsider. Deeply unhappy about the need to follow and internalize the rules and protocols of Anglo-Irish life (the Irish habitus for which white privilege is shorthand), Beckett suffered a breakdown that required he travel to London and undergo psychoanalysis in an attempt to help him control his panic attacks. Once there he found that Londoners referred to him as "Pat" or "Mick" (Knowlson, *Damned to Fame* 187), demarcating him by his Irishness in a pejorative way. Consequently, isolated and lonely, he roamed the capital's streets, noting its architectural memorialization of England's imperial history while perpetually broke and while undergoing psychoanalysis at a time when such a scenario rendered him peculiar in the eyes of the moral majority. Under these conditions he passed days on end without speaking to anyone else, such that he "hated" his time in London (*Damned to Fame* 187). And Murphy, the fictional character he created at this juncture, is a man who flees from both poor and prestigious people, prostitutes and professors, rejecting the habitus to which he is supposed to aspire.

Significantly, while on the run from the Gestapo in Roussillon during World War II, Beckett learned the hardship and horror of war and this changed his attitude completely. From 1945 onwards his work becomes a conscious deconstruction of authority and privilege, populated by comic powermongers such as Pozzo and Hamm. These are figures Beckett lampoons to focus our intentions instead on characters such as Lucky and Clov who, destitute and shorn of any privilege that might be synonymous with their race and its economic power, elicit our compassion in our understanding of their plight. And Beckett's concern for the subaltern and the outsider is clearly evident in the interest he took in Rick Cluchey, previously a guest of American Corrections and subsequent interpreter of Beckett's work, and Jan Johnson, a Swedish director committed to staging Beckett's plays in prison. Indeed, Beckett's penchant for exchanging Morse code messages with the inmates of the Santé prison courtyard beneath his apartment window in Paris (sent by means of sunlight refractions from shaving mirrors) is not the behavior of a white privilege proponent practicing the fetishistic disavowal that would assume the city's prisons were there to protect him from its more disagreeable inhabitants.

Turning to David Bowie, it is indisputably the case that he too benefited from white privilege. His 1983 MTV interview with Mark Goodman, in which he turns the tables on the interviewer to ask important questions about the lack of diversity on MTV, implicitly demonstrates his ambivalence about being one of their favored prime rotation artists ("David Bowie Criticizes MTV"). As Bowie challenges the music channel regarding its exclusionist policies, he demonstrates his distance from self-identification with white privilege itself. And it is also important to note the degree to which Bowie *performed* white privilege rather than simply inhabit it. From the thin white duke to the imperial voyeur of *Let's Dance*, Bowie staged performances of the power associated with white privilege the better to expose its presence in a western cultural moment blind to its own architectures of domination. And his ironized performances also introduce the necessary distance in which tone and mood can

be read to divine Bowie's satiric intentions. Like Beckett, he cannot easily escape or relinquish the white privilege habitus, so his career must, necessarily, both engage and subvert its terms. As Cinque et al. note in their introduction to *Enchanting Bowie*, he "embodied particular versions of white masculinity that were on the one hand supportive of its idealized hegemony, and on the other, subverted its normative power" (171). In his excellent essay "The Whiteness of David Bowie," Sean Redmond analyzes three manifestations of Bowie as army major (in the movie *Merry Christmas Mr. Lawrence*), vampire (*The Hunger*), and the blond orchestrator of "Let's Dance." Redmond uses these representative examples to argue that throughout his career

> Bowie has constantly operated along a white continuum, self-consciously embodying it, granting it carnal and ideological power, while drawing attention to its death-like instinct, its anti-reproductive progeny, its implicit queerness.
>
> (173)

So the thin white duke, another performative example, embodies a fascist whiteness but as a figure that is simultaneously drained of its power by also embodying the very impulses—drugs and queerness—against which white fascism chooses to define itself in opposition. Wherever Bowie appears as the manifestation of a certain white privilege—the wealthy colonist in the video for "China Girl" for example—this pat representation is deconstructed within the symbolic artistic formation, such as in the lyrics of the song which reframe the same white colonist as a hopeless heroin addict.

Without question, Samuel Beckett and David Bowie both stood to privilege from race, but both resisted any uncomplicated enactment of same. Instead, both pursued an aesthetics of queerness that deconstructs the very episteme of privilege. Having said that, and as Walsh observes:

> Pride, the modern LGBTQ rights movement came out as a result of the Stonewall riots. Stonewall was not started by respectable, cisgender white people. The respectable, cisgender white people at Stonewall were the police. And in many ways that hasn't changed – white, wealthy or otherwise, influential gay men still control our movement. Not the butch, biracial lesbians, the bisexual community activists, the black & Latina trans sex workers, the political, working class queers, for example.
>
> ("Quest for Respectability")

Given their pedigree as customers of nocturnal, subcultural emporia like Becky Cooper's in Dublin and the Blue Cabaret in Paris, of Soho in London and the bars of Neukölln, Beckett and Bowie for all of their cis gender credentials would also have been at one with the denizens of Stonewall. This is not in any way to suggest that the very diverse peoples who revolted heroically at Stonewall were reliant on white saviors (they clearly were not) but simply to point out that in struggling against the straight at the level of representation, in order to reject the terms of heteronormative biopolitics, Beckett and Bowie in some important sense relinquished what has become known

as white privilege (or at least those aspects of white privilege that can be renounced). Essentially, to challenge heteronormativity is to reject a central foundation of white privilege. To put this another way; in order to fully enjoy white privilege, one must surely endorse it, or make excuses for it, as those embodiments of the straight patriarchy, Stephen Pinker and Jordan Peterson, are wont to do, demonstrating that whiteness is also a state of mind. Beckett and Bowie, on the other hand, reasoned and felt their way through this cultural deadlock and, in doing so, rejected its terms in favor of recognizing the legitimate claims of the perennial outsider. Ultimately, as we shall see, their work demonstrates that white privilege is the product—the consequence—of economic privilege, and that only when economy is equalized across race and gender will we see an end to the privileged habitus currently designated as white. In this regard, and in the end, although Beckett and Bowie did make money, that was never the object of their very revolutionary projects.

Given that Beckett and Bowie have so much in common in terms of how they practiced their art and what their aims were therein, it still does not seem that odd that they have never before been considered in tandem. If one accepts that Beckett and Bowie were like-minded artists both socially and creatively, the answer as to why there are no Beckett/Bowie comparative studies may well be that there is a suspicion of comparative analyses in which writers of intellectual weight are compared to pop stars (hence no Dostoevsky/Ol' Blue Eyes either). Quite simply, established interpretive convention suggests, in the main, that Bowie's pop music does not bear comparison with Beckett's dramatic universe; in short, why would one seek equivalence between the creator of a singular artistic vision hailed as the greatest in modern drama and someone feted for his capacity to pen a good tune? With this distinction in mind, and as a matter of course, this study is implicitly required to provide a justification for making the comparison between pop star David Bowie and Nobel prize winner Samuel Beckett. And in order to do that, one needs to outline the extant interpretive framework that makes a distinction between high culture and its popular equivalent in the first place.

Briefly, in terms of a standard definition, high culture is almost self-explanatory; it is the concert hall and art gallery, university and conservatory where take place lesson, lecture, and recital. The link between the intellectual and creative academies, the university and the institute, is firmly established. In the English tradition, high culture refers to fine art, classical music, Elizabethan theatrical traditions, Italian neo-realist cinema, opera, ballet, high literary modernism (which includes Beckett), and necessary appreciation of various ancient and modern architectural epochs, and so on. And this is only to touch the surface. The list is long and varied yet, crucially, gives the impression that it can be exhausted, a reflection of its ultimately select and reified nature. Whichever practices and/or practitioners are conjured by a culture to represent its high water mark, the chosen few are considered both a reflection of the culture's civilization and also embodiments of its civilizing force. In this regard, what is known as the Western Canon is a reflection of the West's idea of its own civilizing mythology and can clearly be seen to be a deeply ideological and therefore political practice. Matthew Arnold, one of the first formulators of English high culture, declared it to be "the best that has been said and thought in the world" (49). Despite being an Irishman, Beckett

can be fitted neatly (if not too well) into the echelons of this high culture. His work is serious (although frequently hilarious), is replete with countless Pre-Socratic and high literary allusions (although often easily accessible) and, above all, is engaged in a weighty existential and aesthetic project to understand the nature of being (an objective of many artists, be they pop singer, punk, or poet). Famously, in 1969, Beckett was cited by the committee that awarded him the Nobel Prize in Literature "for his writing, which—in new forms for the novel and drama—in the destitution of modern man acquires its elevation" (nobelprize.org). Weighty praise indeed, emphasizing, too, the capacity of Beckett's work to lift humanity above its shortcomings towards more transcendent destinations. Beckett's famous reticence in talking about his work also resonates as a type of unwillingness to discuss book sales, indicative of a certain noble detachment from the muck of the marketplace. This is an artist who felt that to explain the meaning behind his obscure literary representations was the equivalent of selling out the complexity of human experience, a position that can be framed as elitist and exclusionary but is really nothing of the sort.

Popular culture, which unlike 'literature' has not had the dubious privilege of being consolidated as a concept over centuries, seems then a more nebulous concept. John Storey has produced arguably the most useful definition of the term:

> A great deal of the difficulty [in defining popular culture] arises from the *absent other* which always haunts any definition we might use. It is never enough to speak of popular culture; we have always to acknowledge that with which it is being contrasted. And whichever of popular culture's others we employ—mass culture, high culture, working-class culture, folk culture etc.—it will carry into the definition of popular culture a specific theoretical and political inflection.
>
> (13)

For Storey, pop culture is a protean concept, offering a mirror or complementary term to a host of cultural formations that can then be returned to themselves as entities based on their difference, or similarity, to what constitutes the popular. Synthesizing Storey's others, accumulatively, popular culture can be understood as modern, accessible, disposable, and of the people for the people. On this basis, one might reasonably assert that David Bowie is pop culture. Although Howard Goodall, in "Lucky old Sun is in my Sky," has compared him to Bach, Mozart, and Beethoven, there was arguably nothing more popular in the popular culture of the time than *Top of the Pops*, the weekly TV event showcasing the contemporary sonic universe into which beamed an extra-terrestrial quasi-celestial David Bowie in 1972. Soon thereafter, he was to head west and reimagine himself as an American soul boy, quickly topping its charts, before materializing again as an all-singing all-dancing early nineteen-eighties yellow zoot suit phenomenon, then as a sound and vision nineties poster boy, before reemerging between 2013 and 2016 as the architect of two superior albums, a Broadway musical, and the subject of a major art exhibition. In short, Bowie made an indelible impression on certain listeners across three different generations of music fans. Music apart, his image is also rife throughout popular culture. As one of the most prominent faces

in the world, the androgynous pop star continues to float across the digital universe much like the sonic echoes of his first creation, Major Tom. The size of the "Pretty Bowie" page on Instagram is a testament to Bowie's visual appeal but it is important to point out that those who visit it may know nothing of "Oh You Pretty Things" or "Your Pretty Face is Going to Hell" or any other Bowie songs for that matter. Today, for many people, Bowie exists as a familiar image on the internet, no more no less, literally *the image* of pop culture personified, a state of affairs we will return to in due course.

One strategy that might be employed to quell any disturbance to the established cultural hierarchy between high art and pop, and also to fulfill the requirements of an academic treatment of Beckett and Bowie, would be to pull the latter up by his bootstraps to join the former in the esoteric, elite terrain of high culture. For all his spectral pervasiveness within the popular, his austere aesthetics, black humor, and classically allusive tendencies firmly locate Beckett steadfastly above Grub Street so that, in a very clear sense, David Bowie, ostensible pop icon, has to enter and ascend the ivory tower of artistic and intellectual sophistication in order to meet Beckett, or Beckett's interpreters, at least halfway. In attempting to have them commune in this ivory tower (Bowie rising perhaps by elevator to the thirteenth floor), one could choose to emphasize the singer's lifelong involvement in the theater and its traditions, generally considered a weightier intellectual pursuit than rock and roll. This would also allow for more direct comparison with Beckett the playwright and director. One could focus on Bowie's forays into theater, whether as actor playing John Merrick in *The Elephant Man* on Broadway in 1980, or as author for the stage, as in the dramatic musical *Lazarus* (2015), which Bowie saw mounted at the New York Theatre Workshop shortly before his death. Likewise, his TV work in a theatrical idiom, Bertolt Brecht's *Baal* (1982) for the BBC, film work like Nicholas Roeg's *The Man who Fell to Earth* (1976), his turn as Warhol in Schnabel's *Basquiat* (1996), and his cameo as Nicholas Tesla in *The Prestige* (2006) all afford him consideration as a practitioner within the serious, professional performative tradition.[1] Finally, in the televisual domain, his late music videos, echoing as they do the Beckettian universe (discussed in VIII), consolidate Bowie as a man embedded in the traditions of the dramatic. Of his career, Bowie himself said: "I feel like an actor on a stage, not a rock artist. I don't think that is much of a vocation, being a rock and roller" ("David Bowie in America").

Artistic credibility might also devolve to Bowie, sufficient to be compared to Beckett, as a result of his immersion in the art world as painter, critic, and collector. And given that Samuel Beckett also wore the latter two hats, further grounds for a comparison between them exist in the visual arts field. Similarly, Bowie's love of classical music (leaving aside for a moment his love of jazz, experimental music, and rock and pop), suggests that at least some of his aural interests might be akin to those of Beckett. In short, because both men admire the same, or similar artists in the painterly and music fields, and, as is becoming more evident, in other artistic fields too (these shared interests are explored in IV), these influences can function as a scaffold for considering both artists as embodiments of high culture rather than the conventional view of Bowie as a practitioner of pop and therefore of mass culture. Alternatively, and as opposed to teasing out a shared appreciation and involvement in the traditions of theater and other

art forms, one could propose that Beckett's artistic approach is a form of modernist assault on classical notions of tradition and aesthetics. In other words, that Beckett, from the nineteen-thirties onwards, was as committed to Robert Hughes's "shock of the new" philosophy as Bowie, who had been propelled into the limelight in the early nineteen-seventies as shockingly new. Thus, while Beckett was being evaluated as the most persistent and eloquent Absurdist on the block, Bowie was making a name for himself as the leading proponent of an eroticized glam that blew away the cobwebs of a failed hippie project which had naively imagined world peace could be achieved with a few guitars and a pocket of LSD. In other words, through arch experimentation born of a preoccupation to transform their respective art forms, both Beckett and Bowie are kindred modernists who share a similar desire to rip it up and start again. Such a credo is generally considered the apogee of elite modernist culture and could be applied equally to Bowie as to Beckett.

Quite apart from the intention behind their work or the effect that their work has on its audience, one could also make a case for both Beckett and Bowie having or embodying a certain form of integrity generally considered a mark of the serious artist who commits to his or her craft for art's sake rather than for financial gain. Given that profit is usually the first objective of a popular culture determined by sales, its quick, standardized commodity turnover business model often insists on a necessary disposability and an easy repeatability of product, characteristics at odds with a creative quest predicated on exploration, regardless of the destination. What is often referred to as independent or "indie" culture proposes that the innovative breakthroughs achieved by artists such as Bowie and Beckett, The Velvet Underground and James Joyce (from whom Beckett said he learned artistic integrity), The Clash and Mark Rothko, require a principled form of integrity which is then realized, aesthetically, through the literature, music, or art itself. For example, Harold Pinter said of Beckett that

> The farther he goes the more good it does me. I don't want philosophies, tracts, dogmas, creeds, and ways out, truths, answers, nothing from the bargain basement. He is the most courageous, remorseless writer going and the more he grinds my nose in the shit the more I am grateful to him. He's not fucking me about, he's not leading me up any garden path, he's not slipping me a wink, he's not flogging me a remedy or a path or a revelation or a basinful of breadcrumbs, he's not selling me anything I don't want to buy—he doesn't give a bollock whether I buy or not—he hasn't got his hand over his heart. Well, I'll buy his goods, hook, line and sinker, because he leaves no stone unturned and no maggot lonely. He brings forth a body of beauty. His work is beautiful.
>
> (131)

Pinter's praise is instructive in relation to why he considers Beckett an artist with integrity; clearly, the Irishman's subject matter is not designed to find favor in the court of majority public opinion. For this reason, Fintan O'Toole cites his "moral integrity and artistic authority" as conjoint characteristics of Beckett the author, each informing and reinforcing the quality of the other ("Game without End").

Similarly, and throughout the late nineteen-sixties, nineteen-seventies, and early nineteen-eighties, Bowie was considered the avant-garde popular musician *par excellence*. Seeking commercial success for a time in the mid-nineteen-eighties sullied the bib of this frontrunner of high-minded pop experimentation but he ascended once more from extra-terrestrial to celestial preeminence, and with refreshing vigor, in the last five years of his life, his late work redeeming his reputation from the poor choices he made when dancing in the streets with Mick Jagger seemed like a good idea. Considered from the perspective of artistic integrity, then, in contradistinction to the disposability requirements of much popular culture, both Beckett and Bowie can be considered artistic figures committed to achieving the creative expression of human integrity. From Beckett having an immediate post-war epiphany about the need for art to represent human suffering, to Bowie abandoning LA and its plastic celebrity lifestyle to fraternize with Turkish migrant workers in the bars near Berlin's Checkpoint Charlie, both artists' careers are characterized by the constant search for something more authentic, which they then attempt to represent creatively in art form. As we shall see, their shared artistic epiphany—that authentic experience is achieved through the self-conscious performance of alienation—is strikingly similar. Bowie's affinity with Beckett in this aesthetic objective is clear, suggesting that in the manner in which both have thought their way through a similar artistic deadlock, they are, ultimately, elite modernist artists.

However, elevating Bowie to the reified atmosphere of high culture is not the intention of this book. The goal is not to pluck a figure currently positioned comfortably in a popular culture framework and attempt to reposition his work within an elitist cultural environment and its educational wings, namely the university or, in classical parlance, the academy. And this brings us to the reason why a Beckett/Bowie comparison does not so far exist within academia. To wit, society organizes knowledge, and access to it, as a matter of taste and bearing and as a staple of social and cultural politics. In this regard, John Storey recognizes that "the consumption of culture is predisposed, consciously and deliberately, or not, to fulfil a social function of legitimating social differences" (6). In other words, Beckett and Bowie are made to mean in different ways as a matter of consolidating social differences which then create and maintain ideas related to class, rank, and privilege. Consider, for example, the way a painter like Rembrandt or a composer like Shostakovich or Samuel Beckett himself are made to function as emissaries, or signs, of a certain refined cultural taste and bearing which are associated with certain economically privileged social groups. Appreciation of such artists presupposes either being born into a certain stratum of society, like Beckett himself, or achieving or being granted access to the education opportunities necessary to join the same. In these situations, high culture appreciation functions as a mark of discreet social power and the process by which

> dominant classes seek to impose their own tastes as if these were in fact universal tastes [in which] patterns of consumption are used to secure social distinction, the making, marking, and maintaining of social difference … In this way, the

production and reproduction of cultural space helps produce and reproduce social space, social power and class difference.

(Storey 142)

Given that Samuel Beckett has already been seated at the table of high modernism, an attempt to elevate Bowie to the same smooth plains of sophistication is something that could be achieved, in part, by framing his value in the terms so far outlined in this chapter. This is politically problematic, however, given that the discourse of modernism, which celebrates Beckett's radical newness, reifies this modernizing tendency as a matter of art rather than as a significant political intervention. At the same time, to keep Bowie's relevance free of academic inquiry and confined within a conventional, conservative, and unexamined pop and rock idiom is to deliberately reduce his capacity, and that of popular culture in general, *to mean* substantial things and, further, inhibits its capacity to achieve significant forms of cultural and political change.

It was precisely in response to the need to champion popular culture beyond its ostensibly functional context, or, rather, to illuminate its inherent politics, that since the late nineteen-sixties, cultural studies, as an investigative academic discipline, has been involved in reframing the importance of pop culture as meaningful culture in general. As a result, cultural studies began to privilege the analysis of pop's commodities and the tastes, desires, and expectations of mass culture audiences in place of the creative cultural practices generally associated with the elite. Key figures in the genesis and consolidation of cultural studies include Raymond Williams and Stuart Hall and the Birmingham School in England, Theodor Adorno and Walter Benjamin of the Frankfurt School and, again in the UK, John Fiske and John Storey (reference to all of whom pepper this study). The salad days of a cultural studies that was engaged in the promotion of popular culture, in order to achieve parity with high culture, was the period broadly known as postmodernism that emerged into cultural studies in the nineteen-eighties and burned brightly for two decades before suffering significant damage intellectually in the early noughties (something addressed in more detail in X).[2] At its zenith, pomo was an exciting time for different disciplines within the university as traditional barriers between subjects became unstable and started to shift if not disappear. Postmodernism also sought to expand the study and relevance of pop as a democratic validation of myriad forms of commercial culture and, more importantly, as the reflection of the needs and desires of its audience. Thanks to Walter Benjamin, the study of fan culture, in particular, became a preoccupation, privileging the practice of consumption as an engaged political act in contrast to traditional literary interpretation, which was considered a far more cerebral and therefore solipsistic process. Humanities and social science departments expanded their syllabi as university discourse began to incorporate micronarratives of identity—gender, ethnicity, sexuality—with a healthy focus on individual political involvement, and, through these language games, students were awakened to their own agency, the results of which can be clearly seen today in the rise of engaged student protest.

Such courses and departments flourished throughout the eighties and nineties, but in doing so, and this is the nub of the issue, a central paradox emerged regarding the revolutionary change essential to Marxism as conceived by its founder. In its preoccupation with the molecular, its faith in micro and minority stories as part of its strategy to dismantle the ivory towers of higher education and replace them with more democratic institutions, post-Marxist postmodernism failed to take account of the need for molar transformation in the structural base. Using the Marxist analogy of base and superstructure, in which the base is determined by economics and the superstructure is built and molded around that economic foundation, Tony Bennett has argued:

> Acceptance of the contention that the flow of causal traffic within society is unequally structured, such that the economy, in a privileged way, influences political and ideological relationships in ways that are not true in reverse has usually been held to constitute a limit position for Marxism. Abandon this claim, it is argued, and Marxism ceases to be Marxism.
>
> (79)

The origins of postmodernism, oriented around the work of the Birmingham and Frankfurt Schools of thought, and around the writings of Walter Benjamin in particular, were practicing such an abandonment, attempting to change things through the cultural superstructure rather than the economic base. The implied thinking appeared to be that revolutionary transformation would take care of itself once the hierarchy of cultural values that privileged whiteness and classicism and elitism were dismantled. The problem was that the new privileging of previously marginalized identities, these imminent potentialities set to replace the old order, were being systematically subjected to the circle of capital. Having side-stepped the actual economic infrastructure of the social, the place where traditional Marxism would undertake its intervention, all the emerging and potentially antagonistic elements of postmodern culture—race, gender, and sexuality—were being coopted into a neoliberal allusion of cultural subversion that splendidly served and continues to serve the market.

In an attempt to counter this development, Jean Baudrillard made the audacious proposal that everything had somehow, almost imperceptibly, become simulacra. In offering a response to how the academic privileging of the popular was being quickly coopted into capital homogeneity, and in attempting to counter this draining absorption, Baudrillard proposed the radical notion that there was no value to begin with, in either the base or the superstructure. In short, in an attempt to undermine the values of bourgeois society, he undertook a grand attack on the very idea of value itself. Modernity, he argued, had left everyone alienated from value of any kind. His *Simulacra and Simulation* precipitated a new "post-modern turn" by proposing that the world is determined by the "precession of simulacra" (1) in which the image replaces the real so completely that it is no longer possible to speak of the world's *reality*. The result was that late and archly theoretical postmodernism, as opposed to the practical kind instituted by the Birmingham School in the UK and the New School in New York,

became characterized by the notion that all cultural production is a simulation without any real value. In effect, Baudrillard's world of simulacra was the inevitable endgame of postmodernism's celebration of popular culture as eminently reproducible and ultimately disposable.

As a result of an emerging hermeneutic crisis in which nothing could be ascribed value, traditional architectures of criticism reassumed their preeminence within the university and other sites of investigative practice by century's end. For example, in the first decade of the twenty-first century, critical readings of Beckett's experimental modernism, which were consonant with much postmodern theory, were superseded by a criticism somewhat more interested in textual and archival analysis and exposition. This was principally because the loss of faith in postmodern theory involved a corresponding de-emphasis on philosophy and on how it might render texts political. "The historical turn" (or "return") in literary criticism also somewhat subordinated Beckett's experimental aesthetics to genetic and historiographic concerns. Critical works by scholars such as Trezise and Hill and Elam gave way to a new wave of historical, biographical, and archival critical work.[3] Further, as technology developed and the internet provided hitherto unimaginable access to a wealth of research materials, artists could now be placed in very detailed and specialized historical and cultural contexts. And in Beckett's case, the arrival of four volumes of letters contributed significantly to a refocus of energies on historical biography. Correspondingly, an emphasis on genetic manuscript study emerged as another new and dominant critical paradigm. By 2010, Gontarski notes in *A Companion to Samuel Beckett* that in Beckett studies there is a "new pragmatism or a return to the archives to parallel the burst of theoretical work during the decades of the 1970s and 1980s" (3). In such a fashion, research consolidated its retreat from the postmodern and the latter's lack of emphasis on the importance of an author's contextual history. The "burst" of deconstructive theoretical work Gontarski mentions went into dormancy and a renewed emphasis on history reversed the flattening out of value that late postmodernism engendered.

At the same time, and as twenty-first-century serious art and popular culture categories were discreetly reasserted along historicist lines, these returning classifications were now significantly less stable. It became apparent that postmodernism had served to undermine taxonomic criteria that were less than robust. For example, the debate regarding whether a work was properly modernist or postmodernist, a distinction which was previously thought to be a consequence of historical progression, came to be perceived rather as a question of hermeneutic framing. To use Bowie as an example, in his study *Future Nostalgia*, Waldrep proposes that "over the years, Bowie has been called both a 'modernist' and a 'postmodernist.' The truth is probably somewhere in the middle in that he contains elements of both eras of cultural history" (41). Waldrep's reading attributes difference as reflecting the effect of the passage of time on the cultural artefacts Bowie produces. Lyotard, on the other hand, frames such perceived differences as ideological rather than spatio-temporal. His dictum "In order to be modern it is necessary first to be postmodern" (145) frames modernism as the first step in the delimitation of the potential meanings of the aporia that is all art in its nascent postmodern state. In other words, all meaning arises out of the

possibility of any number of ways of reading texts such that, for example, texts absorb the signification or suffer the limitation of being framed as modern or Victorian or comedy or tragedy and so on. In such a paradigm, theoretical framing can impose prefabricated contexts but, aware of such strategies of meaning-making, pomo could also liberate these texts into new and exciting hermeneutic dimensions. According to the dictates of postmodernism, the work does not contain meaning; rather, it is represented and framed as containing such meanings (and in this, postmodernism takes a position co-extensive with a post-Marxism that seeks to reveal the attribution of meaning as a matter of cultural and class difference).

In concert, and in an irony that would not be lost on Marx himself, the end of postmodernism reaffirmed history as a necessary interpretive prism. In fact, history is reasserted as an intractable interpretive imperative, and its demands have been re-emphasized as an ethical necessity since the so-called "historical turn" in criticism that occurred (or more accurately, recurred) in the early twenty-first century. Today this transition from the archly theoretical discourse of postmodernism, that shook some established interpretive methods to the core, to one more rooted in history and materiality has left a dual interpretive possibility in its wake. On the one hand, the reader must be aware that history necessarily embeds meaning in art as it does in material life, human production being its embodied manifestation. In other words, there is the necessity of being a witness to history and its contexts and an obligation to attempt to read such contexts in cultural production. At the same time, there is a requirement to study the degree to which meaning is often imposed critically, rather than emerging innately from the work, particularly through discourses that seek to delineate the shared aesthetic sophistication of movements and epochs that require a commensurate degree of audience expertise to appreciate them. Instead, there is now the possibility to think beyond contingent and conventional aesthetic interpretations that are in the service of establishing social difference, hierarchy, and class, and instead seek to appreciate how artists might interrogate these very expectations in their work. This study proceeds on the understanding that contemporary interpretive possibility is arguably most rewarding when it employs this dual hermeneutic; a hermeneutic in which one seeks to historicize while also offering historically complementary readings that seek to undo or move beyond more conventional and conservative academic framings designed to instate social difference.

Something of this interpretive duality, in which the attribution of aesthetic value has become increasingly unstable at the same time that history can be used to re-assert cultural context, is apparent in two recent collections of essays that position Beckett somewhere between the traditions of modernism and squarely within the landscape of popular culture. In the first of these, P. J. Murphy locates Beckett as a "highbrow" figure in what constitutes the popular culture field; highbrow signifying a quality superior to or elevated beyond lowbrow cultural interests. Murphy notes that "Beckett is the poster boy for popular culture depictions of the high culture artist figure" (171). In other words, Beckett *may* be an artist of elite cultural value within literary and academic circles, but he *is* certainly popular culture's idea of what constitutes that type of high culture icon. The Irishman thus represents a limit position that pop culture icons

cannot access—that of high culture icon—while also, in the process, consolidating what constitutes or defines popular culture's idea of acceptable high culture. Murphy draws attention to

> Beckett's iconic status as the 'great artist' who has refused to sell out his integrity and dedication to his art. Hence, adaptations of Beckett's image in popular culture serve an almost 'redemptive' or rehabilitative function.
>
> (170)

Published in 2016, *Beckett in Popular Culture* offers the Apple Corporation's "Think different" ad campaign, which used a monochrome image of Beckett in profile to sell its iMac, as an instance of cathecting the idea of a wise and imperious scrivener to the means of production Steve Jobs was attempting to market. Likewise, Murphy identifies the publicity campaign for the first New York production of *Godot* as one in which Beckett's serious and inscrutable qualities were accentuated in order to counteract the adverse effects of the promotional campaign for the play's American debut, in Miami, which had billed Beckett's humorous but bleak and minimal play as "the laugh sensation of two continents" (Schneider 183–6). Indeed, this is probably the earliest example of framing Beckett's redemptive function in the United States and it aptly demonstrates how he can be presented as both pop emissary and serious culture vulture.

In a similar vein, but more recently in the collection *Pop Beckett*, Hannah Simpson has analyzed Barry McGovern's performance as "the dying man" encountered by two of the regular *Game of Thrones* characters in the episode entitled "Mockingbird" (2014). Simpson believes the show's creators, D. B. Weiss and David Benioff (who met at graduate school in Trinity College Dublin where both studied Irish literature), employ the well-known Beckett actor and interpreter in a meta-reflexive gesture that allows Beckett's language and preoccupations with habit, entropy, and death to sit ironically, but nonetheless comfortably, within their fantasy milieu. Quite simply, and however briefly, the echo of Beckett elevates the sword-and-sorcery series onto a different plane of signification even as it opens his work up to a pop culture audience.

Precisely this same type of redemptive integrity is exploited in the more recent Warner Bros. *Ocean's 8* (2018) movie throughout which a Richard Avedon portrait of Beckett frequently frames the stage, and before which the characters, played by the A-list of Hollywood celebrity, discuss the importance of "having insurance against fraud" as part of the pseudo elaborate plot. Essentially, the film proposes that mobilizing a prominent Beckett signifier constitutes some type of gesture towards quality assurance. Suffice to say, the *Ocean's* franchise could not be further removed from Beckett's aesthetics of ruination. Similarly, the recent Netflix series *The Chair* (2021) set its action in the literature department of the fictional Pembroke University, where a professor with a Beckett bent is threatened with "cancellation" having delivered a parodic and ill-judged Nazi salute while encouraging his students to explore Beckett and Sartre's creative response to Hitler's National Socialist vision. Beckett appears in some manner in almost each of the six episodes, as the subject of a lecture or conversation, a portrait photo on a faculty desk or as a poster for a theatrical production; essentially, he

constitutes a floating signifier of level-headed artistic detachment in contrast to his fictional advocate's earnest but bumbling pedagogy.

Analysis of these film and TV cameos indicates that although in such instances pop culture is framing Beckett as high culture figure, he is, nonetheless, as artist and icon, influencing popular culture such that, to some degree, he *is* a popular culture artist as a result. In other words, although Beckett's work may not aim to *be* popular culture in the sense of having been conceived for a mass audience, he certainly *appears in* popular culture in a way that makes it harder to insist on some imagined separation between the two. When one considers that these types of fleeting pop dalliances with Beckett have been occurring now for decades, the notion of a separation between elite and popular becomes harder and harder to sustain. His genetic thumbprint is evident in comedy series such as *Seinfeld* (1989–1998), in which the eponymous character in "a show about nothing" has occasion to visit the Beckett Theatre, and in certain episodes of which the rhythms of the dialogue between Jerry Seinfeld and George Costanza clearly mimic those of Vladimir and Estragon in Beckett's *Waiting for Godot* (see, for example, the episode entitled "The Big Salad"); in the appearance of Beckett's ghost in *Sean's Show* (1992–1993) by the late, great Sean Hughes; in the Mayall/Edmondson two-hander *Bottom* (1991–1995); and in *Curb your Enthusiasm*, especially season 1 episode 8, in which Larry David is heard to cite, for comic effect, "can't go on, must go on" in a variation of the outpourings of the unnamable.[4] Beckett has also been invoked in popular entertainment shows such as *Quantum Leap* (1989–1993) featuring the time-traveling scientist Sam Beckett (in which the "parallel hybrid computer" is called "Ziggy"), and *Once a Thief* (1996–1998) with its detectives Murphy and Camier;[5] as mentioned, his crinkly visage has been used to encourage people to "think different" by Apple and it also prompted *GQ* magazine to include the Irishman in their "Icons of Cool: 50 Most Stylish Men" in October 2007 (incidentally, Bowie came fifth in the list, behind George Best, while Johnny Depp, at number 20, was sandwiched between Kerouac and Beckett);[6] the name "Beckett" has been chosen to identify the children of both Conan O'Brien and Stella McCartney (the latter also designing a fetching gray clutch and a range of handbags named after the playwright), and his words have influenced intertextual narrative explorations (that could be categorized as a type of mature fan fiction), such as Bill James's *Astride a Grave* (1995), Jo Baker's *A Country Road, A Tree* (2016), Michael Coffey's *Samuel Beckett is Closed* (2018), and Maylis Besserie's *Le Tiers Temps* (2020).

As a result of these insistent reformulations, or recyclings, of Beckett and his aesthetics, Stewart and Pattie in the introduction to *Pop Beckett* note a trajectory in which

> in the 1950s his work could be treated as the last word in willful modernist obscurity, and as such, as the antithesis of commercialised mass culture. By 2015, the tennis player Stan Wawrinka had a Beckett quote—the ubiquitous extract from *Worstward Ho*, 'Ever tried. Ever failed. No matter. Try again. Fail again. Fail better'—tattooed on his arm.

(19)

In this regard, *Pop Beckett* proposes that postmodernism also emerged as a result of and was coextensive with rapid technological change, presaging Beckett's increased visibility as a culture icon. The editors explain that TV made it "far more difficult to argue that culture was inherently hierarchical, or the expression of the unchanging soul of the nation, or of humanity as a whole" (16) and, certainly, as Beckett's work began to appear on TV it had the potential to reach a much wider audience than that of the theater. At the same time, however, it is pertinent to argue that the traditions of classical and experimental theater were being mobilized within TV culture as the sign of something more highbrow. Stewart and Pattie recognize that "by the end of the 1960s, the idea that popular culture could itself be a marker of value (albeit in a system that was constrained by capitalism) … was … beginning to gain credence" (18) but at the same time, British television was the site of a cultural struggle between the commercialism of the ITV network and the cultural brief of the BBC. In "'Do you really enjoy the modern play?': Beckett on Commercial Television," Jonathan Bignell argues that ITV's interest in mounting and recording a studio production of a Beckett play helps situate "Beckett's drama in the context of a time of dynamic and exciting instability in British culture, when the categories of the popular and the elite were being contested" (21). He argues that television and radio created a "pop Beckett" by making some of his work accessible to a diverse national public. However, when it came to consumption rather than access, the figures tell a different story. Bignell notes that "*Waiting for Godot*, the first of Beckett's theater plays adapted for television, was broadcast on BBC TV in 1961 but attracted only 5% of the UK population, compared to 22% who watched the commercial ITV channel that evening instead" (*Pop Beckett* 64). If we seek to update this viewing figure to something comparable in the early twenty-first century it is of note that 700,000 have watched the most popular recording of a *Godot* production on YouTube. In comparison, 61,000,000 people have watched Bowie's video for his final song "Lazarus" and, in a further expansion into the stats of pop culture penetration, 146,000,000 people have watched and listened to Pharrell being happy. Ned Beauman is spot on when he claims that the quote used by Wawrinka for his tattoo, and which appears as the title of a self-help book (Stephen Brown's *Fail Better: Stumbling to Success in Sales and Marketing*) and countless feel-good gifs and memes, is the real measure of Beckett's penetration into the pop culture world. He wryly observes, "none of Beckett's work is ever going to reach even one tenth as many people as this little crumb of 'Worstward Ho' taken out of context" ("Fail Worse").

This observation is key to a realistic framing of Beckett within culture in general. Although it is possible to argue that Beckett is a pop culture figure, it seems clear that his work is less amenable to popular culture status than an author like J. K. Rowling, for example. Beckett can appear as of and not of the popular insofar as his image resonates within the popular domain and signifies therein in different ways, but his work remains resolutely unpopular by the usual pop metrics. Alternatively, if one considers Beckett as an image with a certain popular culture cachet entirely divorced from a resolutely abstract and unread literature, it becomes increasingly obvious that this image of Beckett is nothing more than a chimera of the author, a kind of fragmented avatar of the obscure. For example, "Beckett" maintains both a Facebook

page and a Twitter account from which he tweets daily, but the limited, aphoristic contexts the platforms provide reduce the idea of Beckett to hopeless miserabilist, or worse, nothing more than a wrinkled mouthpiece for humorous sound bites. Moreover, on some platforms, Beckett essentially exists as distorted fragments of what were already fragments of his own work. In "Beckett and Memes: Online Aftertexts," Ken Alba superbly delineates how "the unified, mythical Beckett gives way to a series of idiosyncratic Becketts made up of whatever fragments of his work are picked up, copied, and passed around by a particular reader in the information ecology of the internet." He cites Ranjit Bhatnagar's "twitterbot @f____lb____tt____r," the random algorithm of which throws up daily recycled "Worstward Ho" gems such as

> Ever tried. Ever failed. No stagger.
> Try again. Fail again. Ail longer.
> By Samuel Beckott

and

> Lesser lied. Lesser bailed. No snapper.
> Lay defend. Bail again. Bail cheddar.
> By Samuell Beckett

Alba adduces that such randomized recyclings "disintegrate the illusion of the author as the single origin of their cultural impact" (173) and serve to repurpose the idea of Beckett as a randomized signifier that can produce endless, contextless sound bites, often coherent but more often than not, not.

Much the same can be said of Bowie. Today, he exists as a fragment in the popular rather than a central and well-known producer of consumed popular culture. In the world of accelerated consumption, his face is synecdoche for gay liberation, avant-garde artist and, finally, dead pop star. Certainly, in times past, Bowie was one of the preeminent popular culture figures for not one but three or possibly four different generations, but today, apart from a handful of well-known songs, Bowie's oeuvre is as little known to younger generations and as little regarded as Beckett's work. The reason for this is the same as that for Beckett: a hyper schizo-capital information overload that presents fragments, adaptions, recyclings, and fictions as erstwhile content. Paradoxically, whole immersive pictures are equally available, but the technological form does not encourage or foster such research. Instead of full and complete exposure to and submersion in the broad creative world of an artist, capital culture displaces and replaces these with meme, gif, and sound bite.

In this way, the postmodern paradigm is manifest in its most superficial and yet important form. A contemporary interpretation of the value of Beckett and Bowie must begin by reassembling the scattered fragments of a fractured simulacra and attempt to build on such unpromising foundations. One must first reincorporate history, while being careful not to frame the artists in question as emissaries of a constructed popular or elite cultural division, designed in either direction, to underpin orthodoxy. The

parameters both popular and elite culture propose as contexts serve to incorporate both Beckett and Bowie into their extant cultural discourses in ways that silence and elide what is most relevant about both, and what constitutes the important similarity between the work of the two, and the reason for writing this comparison, namely their countercultural and antagonistic function, or what can be referred to as their art of alienation. This art of alienation is qualitatively different to "the shock of the new" that characterizes counterculture in certain modernist discourses. Although Beckett and Bowie's work is engaged in an assault on convention artistically, assimilation to a discourse that privileges aesthetics over political intervention misses the mark. Instead, the critical requirement is nothing less than the articulation of a politics of their aesthetics reflecting unresolved antagonisms that yet must be addressed. To wit, what is similar in Bowie and Beckett beyond or before their commodification in/as culture, is their capacity to expose the degree to which we are alienated from our lives, our work, our sense of our value, and our fellow human beings. Moreover, their anatomy of alienation characterizes their art as valuable *valueless* culture, such that by their worlds' end, they leave behind an exhausted art that questions what it means to be human.

Redeploying history to contextualize both artists, Bowie is and remains known to an older audience as a gender liberator; as a historical figure whose image and music was a seminal influence in breaking down the heteronormative bind that structured much of twentieth-century sociality. Conversely, Beckett was awarded the Nobel prize for a literature so uncompromising that noted theater critic Kenneth Tynan referred to Beckett's theater as akin to a boot "stamping on the face of mankind" (Graver and Federman 166). As I hope to show, Beckett's ability to shake the literary establishment is congruent with what I think important about both artists, namely their subcultural or countercultural value, which was the wellspring from where Bowie's powerful androgynous gender intervention sprung and from whence Beckett's work shook both narrative and theater traditions with the idea of human ruination. They both rose to prominence and remain valued by their admirers because they lived and explored marginal and alienated culture, which is most often oriented around a direct challenge to the status quo, be it in relation to nation, religion, gender, professional life, or other forms of sociality; states of being which, in their conservative form, the dominant discourses examining high and pop culture are often designed to reinforce. It is to this neglected aspect of their work, side-lined thus far in order to address their elite and/or popular status as artists, that we now turn.

In keeping with the post-Marxist notion that culture constructs the realities it appears only to describe, the value of Beckett and Bowie is herewith reframed in terms of their strategies of subcultural subversion of the status quo. In Bowie's case, the first popular culture studies book, devoted to counterculture, contains a short but incisive academic treatment of his antagonistic social function. Dick Hebdige's *Subculture: The Meaning of Style* (1979) is a seminal illumination of the value of Bowie in destabilizing the norms that hitherto had separated bourgeois and working-class culture. Framing Bowie's influence as that of a cult leader, Hebdige proposed that we could now begin to understand "how the Bowie cult came to be articulated around questions of gender rather than class, and to confront those critics who related the legitimate concerns

of 'authentic' working class culture exclusively to the sphere of production" (88). In other words, until Bowie's creative intervention, the identity of the working class had been mobilized around a framework determined by labor. However, Bowie's eclectic and androgynous style, and the widespread nature of its adaptation across class determinants, brought certain factors to the forefront of class-identity—gender and sexuality, for example—that had previously been thought to be epiphenomenal to class concerns. Hebdige understood that "Bowie youth" were engaged in

> adapting images, styles and ideologies made available elsewhere on television and in films … in magazines and newspapers … in order to construct an alternative identity which communicated a perceived difference: an Otherness. They were, in short, challenging at a symbolic level the 'inevitability,' the 'naturalness' of class and gender stereotypes.
>
> (88–9)

Crucially, this challenge was more than just symbolic in effect because it set in train a new social context "by artfully confounding the images of men and women through which the passage from childhood to maturity was traditionally accomplished" (60). Bowie destabilized the ritualized passage that most often carried working-class young adults straight from school to the factory floor (by way of example, this book records the thoughts of many professional musicians who cite the first sighting of Bowie as the moment when they knew they wanted to be in a band). This transformative effect on identity is just one of the ways in which Bowie may be considered subcultural, and there are also others that still need to be fully articulated. Moreover, the importance of Britain's cultural history and Bowie's role in it cannot be understated here, testament to the irrepressible return of context and condition. In due course, this study will propose that these transformative moments arise out of a negative ontology alienated by capital and continually relevant in the current neoliberal environment that seeks to elide any trace of antagonism from the apparent surface of the bourgeois social, including contemporary debate about what constitutes the right towards self-determination for men, women, and trans-people.

Beckett, too, is an artist of the subcultural, albeit without the same seismic impact on orthodox culture as Bowie. Nevertheless, the Beckett creative signature has made a significant impression in artistic and philosophical circles and its primary resonance is in its rejection and disavowal of conventional teleologies proposing the benevolence of established social communities. His earliest characters, Belacqua and Murphy for example, are archetypal outsiders. Despite the fact that Belacqua has been born into wealthy aspirant Irish society, he chafes against its values and mores, longing to spend his days drinking in working-class pubs and frequenting brothels in the evening. Murphy flees from the company of his peers, mainly philosophers and prostitutes, first to a psychiatric institute and then to the refuge of his garret before being blown to kingdom come by its faulty gas connection. Watt, who follows in the world of Beckett's fiction, can barely be called a character at all and the places he is forced to inhabit seem determined to undo themselves in a narrative that confounds the expectations not

just of the realist narrative tradition but of narrative epistemologies in general. There afterwards, a series of tramps and vagabonds find themselves in worlds they do not understand and which seem oriented around their marginalization and expulsion. Moreover, despite their predicament, these characters do not seek repatriation within normative society but exist in a state of antagonistic opposition to established codes of social existence, preferring instead the liminal and abstract spaces in which they find themselves confounded. As Joseph Anderton explains:

> Though Beckett's creatures are refused human belonging in the biopolitical sense, they are not united with the natural world in the way that the animal is with the open ... the creature is estranged from the world through consciousness and alienated from socio-political value as a result of biopolitical order.
>
> (226)

This study addresses Beckett and Bowie's radical countercultural "creatures" within the domain of the biopolitical in VII. For now, one fundamental theoretical question remains to be broached in order to close this chapter and to reconcile its post-Marxist approach with the realities of the englobulating capital market that constitutes the mode of production of contemporary life.

In concluding this chapter, now that the distinction between high and low culture has been examined and dismissed as unstable, and the journey from postmodernism to the "historical turn" in criticism charted, and the relationship between both of these interpretive prisms established, a question remains. In claiming that post-Marxism represents the best critical optic to evaluate the legacy of Beckett and Bowie, to what degree can Beckett's writing and Bowie's music, as commodities within commodity culture, be considered any sort of alternative or antidote to the tyranny of capital commodity culture? To what degree, for example, does Bowie's countercultural influence on gender still hold any potency when gender inclusivity has so obviously become another opportunity for capitalism to strengthen its dominion as the dominant mode of production? Reflecting on the fate of postmodernism and on Marxism more directly, this study's attempt to frame these artists as revolutionary begs a fundamental question regarding the proposed autonomy of the subcultural artist in a culture and economy that greases the wheel of commerce regardless. In response to this dilemma, the following pair of brief observations are stated here and substantiated thereafter.

To begin with, both Beckett and Bowie were countercultural in their *intention*. As documented in I, the ambivalent response that Bowie received to the thin white duke character is proof of his willingness to challenge dominant modes of acceptable taste relating to historical conflict. Likewise, Beckett pursued a host of counterculture strategies depending on the culture he was countering. From representing Irish patriots as cowshit-poking maniacs to challenging Nazi national socialist Übermensch ideology with his own degenerate moribund characters, Beckett's intention and aesthetic was resolutely minoritarian. In fact, it is plainly the case that both Beckett and Bowie eschew representational mimesis that mirrors and so endorses the status quo. In contrast to a cast of normative characters, their work is populated with

outliers, a veritable pantheon of sub-Baudelairean or what Beckett called "margin people" (among whom he numbered himself), which includes delinquents, refugees, clowns, circus performers, artists, and losers (as will be addressed in VI & VII).[7] Such alienated figures problematize the exchange value of art forms more conventionally based on endorsing bourgeois fantasies of urban and suburban professional and familial subjectivities. Moreover, this intentionality is revolutionary. Beckett and Bowie have stood, variously, against the Nazis, racism, homophobia, aggressive patriotism, and religious fanaticism, and more. In short, they have ethical *credentials*, as will be borne out by the attention to their respective careers in subsequent chapters.

Secondly, they are aware that their work as commodity in the marketplace is engaged in a dialectic struggle between resistance to and inevitable incorporation within a capitalism that successfully absorbs and monetizes all forms of counterculture. Indeed, their work is, in part, an expression of this antagonism and is oriented around negotiating passage through it. In order to counter incorporation, for example, their work is framed, ironically, as a commodity fetish, adhering to a credo of "art for art's sake" as a knowing comment not on art's transcendent capacity but on its essentially ineffectual and therefore valueless, fetishized legacy. As the next chapter will make clear, they themselves have experienced degrees of alienation as both individuals and artists and from this wellspring of experience they alienate their own characters, often from their fellow humankind but also often from conventional coordinates of time and space and being. The result, paradoxically, is that they make artifice appear as something real, succeeding in politicizing aesthetics so that they represent what Rancière calls "a specific type of humanity" (24), and one which might yet make meaningful ethical intervention in the world.

In closing this chapter, I return briefly to the intro of *Pop Beckett* wherein Stewart and Pattie engage with the perennial question outlined here. They wonder if a Beckett t-shirt on sale in the Trinity College Dublin Gift Shop represents a kind of empty sign that might subsequently cheapen Beckett's literary legacy and undermine his creative contribution to the artistic critique of commodity culture itself. Seeking a compromise, they propose the gift shop t-shirt reveals

> the economy in which popular and academic Becketts circulate ... rather than a binary opposition, these two supposed poles exist in a continuum ... Beckett is merely one of a number of instances in which artistic creation is commoditized in the service of academic funding.
>
> (12)

In short, Beckett is here in service of the economy. Rather than imagining the university and commerce as mutually exclusive entities, Pattie and Stewart choose to recognize the degree to which both work in tandem, and, in this regard, both books on Beckett and pop culture make the same broad point. They propose that arguments about the specialized, or popular, or countercultural value of Beckett are largely specious given that his work exists as a commodity within a commodity

culture. In such a formulation, what seems at first glance countercultural is nothing more than the dominant culture offering up and then neutralizing critiques of its own operations. Stewart and Pattie mobilize Barthes in this regard, emphasizing the latter's theoretical insistence that "the avant-garde emerges from and will return to bourgeois, popular and commercial culture" (11). In other words, any pointed cultural critique of bourgeois life that middle-class Beckett might make will be silenced by repatriating him back into such a context, with his edges flattened out, in the shape of a t-shirt. But what if the t-shirt in TCD proudly displayed the phrase "Fuck Life" in tribute to Beckett's play "Rockaby?" Or, rather, is it not the case that the t-shirt in question does not feature the same phrase precisely because that would not serve the university's image of itself, nor the aims of the bourgeois economy it represents? Of course, bad language is only the tip of the iceberg when it comes to the types of behavior neoliberal society currently attempts to suppress. I am reminded of the narrator in "The End" enjoying the extension of his finger, to the knuckle, up his anus, or Clov's willingness to kill a child, or the Bowie songs that celebrate suicide, Satanism, and the sadism of school shootings, of characters that eat razors and fall wanking to the floor; all aspects of their work rarely discussed.[8] It is such statements of alienation that really characterize Beckett and Bowie, betraying the presence of a persistent antagonism that demands to be addressed, and, arguably, one that can only be dealt with adequately through a critique of capital economy. Consequently, we move now to analysis of Beckett and Bowie's careers and the history of the feeling that they spent those careers attempting to articulate: the feeling of alienation.

III

The Philosophy of Alienation

As it involves first a sundering then reintegration, the *Stanford Encyclopedia of Philosophy* "understands alienation as consisting in the problematic separation of a subject and object that properly belong together," while also acknowledging that "the basic idea of alienation picks out a range of social and psychological ills involving a self and other" (https://plato.stanford.edu/entries/alienation). Before turning to the social dimensions of alienation, let us first address the philosophic frame that incorporates the relation between subject and object as the principal parameter of definition. The subjective/objective binary is the founding dialectic of Western philosophy, constituting a distinction between the individual subject and the other, be it another individual or the totality of the objective world. Beckett, for instance, expresses his understanding of this type of philosophic sundering of subject and object in his essay, "Recent Irish Poetry," penned early in his career. In it, he states that "younger Irish poets evince awareness of the new thing that has happened ... namely the break down in the object" (*Disjecta* 70). He then chastises more established poets, whom he calls "antiquarians," who attribute this new development to the "breakdown of the subject" in the sense that the younger poets are at fault for failing to employ the conventions of classic poetry. Beckett proposes that the twin alienations apparent here, each from the values of the other, "comes to the same thing—rupture of the lines of communication" (70). Siding squarely with the generation of young poets, he desires to see a fresh poetry that "may state the space that intervenes between him and the world of objects" (70). In doing so, Beckett articulates the great alienation being experienced by younger poets in nineteen-thirties Ireland, a repressive and conservative culture looking to the mythological past to justify its essentialist Catholicism.

As this study progresses, it will propose that Beckett and Bowie's art helps people overcome their sense of separation, of alienation, from other people, through an art that is intersubjective and that finally finds a way to overcome the "rupture of the lines of communication" that Beckett felt so acutely in the Ireland of his youth. Both are aware that their preoccupation with alienation, indeed their own personal sense of estrangement from social norms, arises, at least in part, from the "social and psychological ills involving a self and other" that the *Stanford Encyclopedia* outlines. Both are subjectively and objectively alienated insofar as they feel that they are alienated, and they know this is a consequence of the psychological experience of social ills engendered by the cultural environments in which they grew up. It is because

Beckett and Bowie are aware of their alienation and the multiple causes of it, and its deleterious effects, that they have produced art of such power and with such resonance for likeminded and similarly alienated people.

Dana Gillespie, one of Bowie's early girlfriends, recalls details of the conservative home from which the young singer felt estranged. Reflecting on the lack of conversation apparent in the house and on his parents' placid investment in evening TV, Bowie confessed to her "I have to get out of here" (Dimery). Years later, reflecting on this sense of disconnection, he noted "in suburbia you are given the impression that nothing culturally belongs to you. That you are in this sort of wasteland" (Dimery). This sense of deprivation made him very comfortable exploring alienation in his music: "Thematically, I've always dealt with isolation in everything I've written. So, it's something that triggers me off and always makes me interested in a new project if it's anything to do with alienation and isolation" ("Afternoon Plus"). Similarly, Beckett recalls that he "didn't like living in Ireland, theocracy, censorship of books, that kind of thing. I preferred to live abroad" (Bair 269). His antagonistic Irish upbringing, in which his protestant upper middle-class milieu was disturbed by an emergent and violent Catholic nationalism, in conjunction with a personal diffidence that sought out solitude rather than community, left Beckett with a very clear sense of his distance from available identities, culminating in his becoming an artist, an occupation which further magnified his estrangement from conventional social life. Discussing the difficulty the visual artist encounters in bridging the space between canvas and reality, Nixon proposes that Beckett extends this "lack of relation between artist and the world to encompass the artist's alienation from his own self" ("Ruptures of the Physical" 76). For Beckett, the artist has difficulty, in the first instance, reconciling his own being. But whereas he may have felt this separation as a purely ontological dilemma, Joseph O'Neill proposes that, as a result of his career, Beckett "is profoundly alienated, not least because he inhabits a world of rejection slips, indefinite longings, extreme aesthetic sensitivity and (in the words of a friend) 'passionate nihilism'" ("I'll Go On"). As a consequence, both Beckett and Bowie have engaged with alienation as artistic subject matter and as condition to be examined—and, if possible, overcome.

Returning to the history of alienation as a concept, in order to crystallize its environmental context, it first appears in English in the fifteenth century in the Wycliffe Bible to indicate man's estrangement from God. Around this period, it also functions as a descriptor indicating the loss of property rights, conditions eventually to become central to Marx's use of the term, he proposing that "private property is ... the product, the result, the necessary consequence, of alienated labor" ("Estranged Labour").[1] Before Marx, the alienated individual was first framed by religious and legal contexts, being imbued with the psycho-social dimension of one alienated from, or by, civil society such as in Rousseau's *Discourse on the Origin and Foundations of Inequality*, published in 1755. For the French philosopher, man can only overcome alienation and free himself from the metaphoric manacles of society by merging his individuality with the community. By framing the solution to alienation as a necessary integration of the individual into the social whole, Rousseau must first position nature (and the freedom to follow one's natural impulses) and society (responsibility to the social contract) in dialectic relation, before setting them in opposition and,

finally proposing, as a resolution, that the individual has a duty to integrate into the collective. In the century that followed, resolving such opposites became the basis for Hegel's dialectical method in which the march of a teleological history—one bound to inevitable progress—would culminate in the victory of humankind's "Geist," or spirit (*Phenomenology of Spirit*, section 803). In this formulation, a person ceases to be alienated when s/he is united or reunited with her/himself (as subject) and so with the other members of society (the object with which and to which s/he must relate).

In 1844, from the center of the expanding British Empire, Marx proposed that there had emerged four related aspects of alienation that arise specifically from within the capitalist mode of production. Domiciled in London, he was well placed to articulate the multiple interrelated forms of estrangement from self and society that capitalism was beginning to generate. Although employing a Marxist analysis today undoubtedly involves a significant caveat insofar as Marx was addressing the idea of labor within an industrial model, in which the worker's job took place almost exclusively in the factory and/or other sites of mass-production, nonetheless, his original framing of alienation remains relevant to contemporary concerns. Clearly, the mode and means of production have changed in the digital age and many of his observations regarding industrial production are now antiquated and outdated. If, for Marx, "the hand mill gives you society with the feudal lord; the steam-mill society with the industrial capitalist" (*The Poverty of Philosophy*) how are we to employ the German philosopher to understand post-industrial capitalists like Bezos and Musk who wish to fly themselves to the moon? As we shall see, even if some of Marx's original terms require refining and redefinition, his emphasis on antagonism remains central.

For instance, at a time when there is an emerging antagonism regarding what constitutes "the working class," given that those with economic means now also struggle, there is also an ethical imperative to include as alienated those who have been historically estranged from the power bases of society by racism, misogyny, and gender discrimination. Further, Marx's initial working-class subject, alienated through class struggle, reappears in new guises today as both the estranged scapegoat of the contemporary social and as the most exploited laborer yet, the deterritorialized global person of color who constitutes a necropolitical chip in the current transnational casino capitalism death game. Before addressing this unsettling development, however, we turn retrospectively to Marx's treatment of alienation, where Beckett and Bowie are a sounding board for the hypothesis that there is still something to learn about alienation from close attention to Marx's foundational, political writings on the subject.

For Marx, to be a worker is to be alienated from yourself and from the fruits of your labor. This founding state of affairs then spills over into further estrangements that divide one from one's potential and from one's fellow humankind. Petrović sums up the four disruptions Marx identifies as constituting "self-alienation":

> not only the alienation of productive activity and the alienation of man's generic essence, but also the alienation of the results of production and the alienation of man from man, are in essence the alienation of man from himself, the alienation of man from his humanity.
>
> ("Marx's Theory of Alienation" 422)

In the first instance of alienation Marx addresses, workers are estranged from the objects they make as a result of the potentially endless production of identical and therefore increasingly valueless and finally alienating objects; in the process of producing these commodities, workers are also alienated as a result of selling themselves as labor, which constitutes Marx's second form of alienation; thirdly, workers alienated from self, having sold themselves for a wage, are also then alienated from the essential nature of their true species being, which is their conscious capacity to create objects and modify their environment in tune with the needs of their fellow peoples. Finally, and as a consequence of these three forms of alienation, which have led to their dehumanization through mechanical reproduction, laborers are alienated from the rest of their fellow humankind.

Of the first alienation, from the commodity the worker produces, Marx notes:

> so much does the appropriation of the object appear as estrangement that the more objects the worker produces the less he can possess and the more he falls under the sway of his product. [Ultimately], the worker is related to the product of labor as to an alien object [with the result] that the worker puts his life into the object; but now his life no longer belongs to him but to the object.
>
> ("Estranged Labour")

Individuals lose a part of themselves commensurate with the loss of any sense of possession of, or control over, the objects they make. Upon completion, the separation of commodities from their human producers means the object takes on a life that seems to preclude the former. Once made and released into general circulation these objects become alien to their makers, something exacerbated by the inherent reproducibility of such commodities. For Marx, such alienation from the commodities produced by labor is pursuant on the effect of mechanical reproduction. The sheer number of identical commodities the worker produces impacts the sense of originality and authenticity of each and every iteration such that the worker becomes alienated from the product now reified as fetish object. The market, creating the illusion of originary value in what are essentially mass-produced commodities, succeeds by fetishizing such commodities, creating the paradox that each has a value the workers can no longer imagine and thus alienating them from the fetish culture they help produce. Essentially, the commodity alienates workers *in* that culture because they are unable to identify with its mechanical reproducibility.

Obviously, in creating their own art rather than impersonal industrial commodities, Beckett and Bowie are not subject to the scale of industrial deracination Marx is suggesting (something extremely significant when it comes to assessing how both are not alienated from species being), but at the same time they do experience something of the de-subjectification which rips the work from the domain of the creator and repositions it as an object now engaged in an exchange ratio with its audience who, in tandem with the market, determine its exchange value. At the same time, an alternative and intriguing countercultural argument to the reification of the commodity is to propose that the artwork resists such fetishization because it is

simply and solely of and for itself already a fetish object. To claim art for art's sake as cultural object characterized by its transcendence above culture, and so definitional of high art itself, is to propose the artwork as more important than most other culture, or as the very definition of the value of high culture itself. Alternatively, Shelton Waldrep, in his study *Future Nostalgia*, proposes that Bowie is a dandy artist whose knowing performative style is akin to an artist like Baudelaire. Referring to Barthes on the semiotics of fashion, Waldrep argues that "the dandy was the master of the detail and turned his entire life into a detail. He was a perfect object" (52). Waldrep identifies Bowie as just such a dandy figure and, citing Agamben, suggests that Bowie, like Baudelaire before him, channels the spirit of Dandyism into his music such that it escapes from the tyranny of capital reification by embracing and realizing art as dandified object, as fetish. Agamben believes that as Baudelaire's poetic experimentation in *Les Fleurs du Mal* preceded Marx's treatment of the commodity fetish in time, the French poet generates art as fetish with an entirely different kind of cultural value to Marx's later model.

For Marx, on the other hand, the fetish character of a commodity arises when the relation between its use value and exchange value becomes entirely abstract. As the commodity became ubiquitous in post-industrialization, those designed for adornment, disposability, reproducibility, and a host of aesthetic purposes could not be defined by their use value in the same way as a tin opener or a pair of shoes. Further, design began to impact the link between use and exchange such that, to some degree, all commodities took on a fetish character. In this regard, a Philip Stark orange squeezer is a significantly greater financial investment than one purchased in the local supermarket despite their identical use value. Along such lines, Agamben reads Baudelaire as a visionary and the first to circumvent or short-circuit the relationship between use and value by focusing on the lack of purpose to art. Disassembling the relation in advance, Agamben argues Baudelaire's work demonstrates that the quality of a poem cannot constitute its use value nor can exchange value dictate the poetic qualities of art. Given the nature of *Les Fleurs du Mal* and its reception in Parisian art circles, Agamben suggests "the aura of frozen intangibility that from this moment began to surround the work of art is the equivalent of the fetishistic character that the exchange value impresses on the commodity" (*Stanzas* 42). In other words, art as always already fetishized paradoxically escapes the circle of capital fetishization. If, as Wilde proposes in his famous preface, "all art is quite useless" (*The Picture of Dorian Gray*), Baudelaire represents poetry as the most useless of the lot. In an economic context, art then is a product that escapes market rules because, as fetish, it is often produced for its own sake and so is oblivious to the structural demands of capitalism.[2] It should be noted that in order to arrest angst and alienation, commodity culture often reifies the commodity such that works of art can change hands for huge sums of money. Poetry, on the other hand, which accentuates existential emotional states as its basic mode of production, is not designed to triumph in capital markets and its associated financial exchange mechanisms. Understanding the subversive value of poetry in this regard, Baudelaire also knew, like Benjamin and Warhol to come, that art as fetish must also shock; that the work of art must be involved in the destruction

of the traditions that preceded it, and that in trying to make it new, it needs to strive to escape having its identity determined by its economic value.

This study proposes, in a similar fashion, that the primary value of Beckett and Bowie's art is in its countercultural impulse, which is nonetheless framed by a fetish quality generated in the intentional performance of inauthenticity. Whereas Bowie clearly performs aspects of the dandy as an homage to Baudelaire and Wilde and others,[3] at a more nuanced level both he and Beckett are mutual artists of a performative poetics—one that rejects complete identification with earnestness and authenticity and also the didactic impulse that privileges the explication of art along lines of interpretive mastery and genre classification. Instead, they often employ a self-conscious distance from such modes of production and consumption such that their work offers explicit critique. In this regard, both Beckett and Bowie produce fetish art not as the unconscious and unwitting result of market forces but in knowing and conscious opposition to them. It is a principal contention of this study that in playing on the distinction between what hegemonic society deems acceptable and unacceptable, normal and abnormal, true and false, both Bowie and Beckett make transparent the regimens of truth that determine notions like authenticity and legitimacy. In doing so, they ruthlessly expose the regimens' limitations by emphasizing the alternative claims of the abnormal, the queer, and, also, importantly, the merits of the inauthentic and the fake. In fact, Beckett and Bowie make inauthenticity a political cause *par excellence*, undermining, among many things, the capital injunction that seeks to make economic efficiency the bedrock of authentic identity. In this, their sub-cultural value as social critique is wedded to an aesthetics of a knowing fetishization which, paradoxically, arises from an earnest desire to produce an authentic artistic statement.

For example, playing with authenticity, such that the inauthentic can become a form of critique, is clearly manifest in both Beckett and Bowie's appreciation of a good hoax. Bowie, for instance, in conjunction with the artist William Boyd, imagined and invented a modern artist called Nat Tate (his name a combination of National Gallery and Tate Modern) who was ghosting the early twentieth century. Boyd and Bowie designed an illustrated biography of Tate's life, featuring reproductions of some of his more famous works and launched the career of this fictitious painter at an invite-only book launch party on April 1, 1988.[4] Boyd later stated plainly that the whole exercise was undertaken "to challenge notions of authenticity" (Pegg 698). Earlier in the century, Beckett, while a college lecturer in Dublin in 1930, together with his roommate, Georges Belmont (previously Georges Pelorson), also invented a fake artist and a corresponding art movement. Shortly after Beckett returned from two years as exchange "lecteur" at the École normale supérieure in Paris to take up a teaching post at his *alma mater*, Trinity College Dublin, he gave an address in French to the Modern Languages Society in the form of a spoof lecture on non-existent French poet "Jean du Chas" and "Le Concentrisme," the movement for which du Chas was the purported figurehead (see Pilling). And in those days, long before Google, only attendees with a comprehensive knowledge of the Parisian avant-garde could possibly deduce that Beckett's lecture was a hoax. Conversely, one wonders how many of the students

present joyously affirmed their knowledge of du Chas and his concentric circle, even offering informed commentary on the work of the French poet. Without doubt, it was for just such an opportunity to lampoon the self-regarding, self-ratifying elites of the Irish university system and New York art world that Beckett and Bowie undertook their respective hoaxes.

Moving beyond satire, however, there is something of the hoax that is deeper and more profound in relation to unmooring or destabilizing notions of essential identity. In Beckett and Bowie's work, the idea of adapting a "fake" character in order to make a telling point about how art can replicate life, or how life can be *as art*, is key to both artists. Indeed, in terms of characters, David "Bowie" is already a character conceived by David Jones from Brixton. Furthermore, the shock a Bowie fan experiences upon first hearing Anthony Newley is instructive regarding the idea of an "original" Bowie voice. What one believed to be the original Bowie voice turns out to be another adopted character, another performance of a singer Bowie tried on for size, early on (and, in part, retained throughout his shape-shifting career). In other words, instead of the idea of Bowie hiding out behind characters who afford him some privacy, it is arguably more useful to perceive Bowie as the sum total of the performances he enacts. As the man himself once said, "I'm really just my own corporation of characters. Don't expect to find the real me under all of this" (Crowe, "Ground Control"). In fact, as a consequence of being a "corporation" of characters, Bowie might be thought of as a profound disincorporation of conventional sociality.

If one undertakes a search for the real Bowie behind his characters, it more or less begins with examining Major Tom in his tin can and ends with Button Eyes on his death bed. In seeking a core subjectivity, one has to accommodate Ziggy and his spaceship to earth and take that Bentley with the thin white duke from Victoria Station to *The Cabinet of Dr. Caligari*; one must engage in battle cries and champagne with Aladdin Sane and take a limo with the Philly Soul Boy to the architecture of Hunger City where everyone gets flies in their milk. Be it donning a dress and filling our hearts with love today or maneuvering around a soiled carpet in a bungalow in the Hollywood Hills on a diet of milk and peppers, or hanging with transgender folk in the Turkish bars of Neukölln, diversity reigns. And from the moment one realizes that Major Tom may not be an astronaut but a junkie, that Nathan Adler may not be a detective but a psychopathic performance artist, and that Button Eyes is Tiresias, Gloucester, and Lady Lazarus all rolled into one, the audience is always engaged in getting to know the alien "other," the space creature whose irruptive explorations suggest, finally, that fiction, in its endless multiplicity rather than we in our "real," habitual singularity, has the shape of truth. This "alligator" "mama-papa," "space invader bitch" ("Moonage Daydream") constitutes a type of pure artistic difference, such that, as Ali and Wallace point out, "any attempt to search for profound truths about Bowie's identity contradicts the anti-essentialist variations of the many I's presented in his music" ("Out of this World" 264). In this way, Bowie's playing at identity produces a ceaseless becoming that undermines, or defers, easy assignations of being and the ontological and epistemological frameworks that conventional identity structures support. In terms of Marx's primary

alienation from commodity, Bowie *is* inauthenticity *as* commodity, and it is this that bridges the alienation felt by his audience and produces the intersubjective moment that defines the emotional and intellectual affect of his work. In terms of its reception, and as discussed earlier, his work enjoys a different use value wherein fans experience something akin to the simultaneous recognition and dissolution of their sense of alienation, finding a home in a crack in the sky.

Regarding Beckett, and the similar operations he undertakes on authentic voice, the narrator of *The Unnamable* announces:

> All these Murphys, Molloys and Malones do not fool me. They have made me waste my time, suffer for nothing, speak of them when, in order to stop speaking, I should have spoken of me and of me alone.
>
> (*The Unnamable* 19)

Thus, the unnamable intimates that the actual voice of Beckett himself might be imminent, made possible by shedding necessary but ultimately false, fictional avatars. But no sooner does the unnamable make this pronouncement than he adopts the persona of "Worm" (54) and then others, a series of "vice exister(s)" (31) standing in for the "me" who cannot be spoken. In Beckett's work, too, there is a sense in which the authentic gesture of being oneself, saying oneself, is impossible such that characters become disassociated from themselves. In this regard, the Beckett actor Lisa Dwan attests:

> In the world Beckett showed me, I have learned to give my imagination permission to dissolve the boundaries of my small self, where, on this stage, I go beyond the confines of identity that imprison me—it is here that I find this new narrative, this new tale of myself. We need to see that we are much greater and richer than our paltry ideas of identity can stretch to.
>
> ("There's an Irish Client")

Arguably, this disassociation reaches its apotheosis in "Texts for Nothing," the work that follows *The Unnamable*, the third part of which begins "Leave, I was going to say leave all that. What matter who's speaking. Someone said what matter who's speaking" ("Texts for Nothing" 109). These lines prompted Foucault, in his essay "What is an Author?" (1969) to propose that "in this indifference (as expressed by Beckett) appears one of the fundamental ethical principles of contemporary writing" (Foucault, open.edu). Through his "indifference" Beckett fails to assume the sovereignty of authorship. In contrast, Foucault implies that those who do assume such authority, in fiction and in life, do so by asserting an individuated subjectivity, and, in so doing, *assume* to embody the social and cultural authority that speaks the truth of the ratified sociality such subjectivities presuppose. When one claims the authority to say "I", one inhabits the knowledge but also the authority that defines neoliberal society. Thus, the absence of the actual presence of Beckett and Bowie from the meaning of their work has ethical and therefore political implications

regarding who assumes the authority to tell who what, and what are the consequences of listening, or refusing to do so?

Beckett's approach to the authenticity of performance in the theater is also equally defamiliarizing for a conventional audience. In an arena where engaged simulation is ordinarily privileged, where the audience are required to suspend their disbelief and imagine a theatrical performance as reality for the duration of the theatrical experience, Beckett instead often breaks the fourth wall or places an emphasis on repetitive performance such that the characters frequently sound more like actors engaged in performance rather than people wrestling with the dramas of life. His stage work is peppered with meta-theatrical moments in which characters draw attention to the explicit theatricality of what is taking place. For example, looking out over the audience in the early stages of *Waiting for Godot*, Estragon recognizes "that Bog" (7) much to the amusement of its inhabitants, the spectators. In *Endgame*, Clov, pointing a telescope at the audience, announces to Hamm that he sees "multitudes in transports of joy" before adding "that's what I call a magnifier" (*Endgame* 29). In the same play, Hamm, hoping his drama will never end, announces "me to play" (3) and like Pozzo in *Waiting for Godot* then demands of another character a theatrical review of his performance whilst *in situ*. Such moments emphasize the artificiality of what takes place on stage. In a manner similar to the estrangement techniques employed by Bertolt Brecht, which were his deliberate attempt to translate Marxism into aesthetics, Beckett's audiences are denied the opportunity to turn the theatrical commodity into a purely imagined fortification.

Similarly, in Bowie's work, in the song "Sweet Thing" (1974), for example, the narrator sings of "a set that is amazing it even smells like a street." The "girl with the mousey hair" in "Life on Mars?" (1972), another who is cast out, could write the script of the film that fails to move her, and, from the same album, Bowie surmises that when it comes to "Andy Warhol" and the "silver screen," he "can't tell them apart at all." Ironically, in his most "earnest" moment, the narrator of "Five Years" confides that "it was cold and it rained and I felt like an actor" and of his own career Bowie noted "I feel like an actor on a stage, not a rock artist" (Ferris, "David Bowie in America"). In this regard, Bowie's embodiment of a performance in which he privileges the theatrical by employing a knowing distance from authenticity is recorded (in both the sense of history and technology) in anecdotes of Bowie, in studio, repeatedly singing a word over and over again to achieve what he believes is the proper emotion of the moment. In other words, Bowie uses his voice, which seems profoundly charged with affect in any case, as a tool to engineer a carefully crafted sense of spontaneous feeling, as a means towards achieving an earnest verisimilitude that is nonetheless thoroughly self-conscious. Given this degree of conscious manipulation, there is a sense in which all of Bowie's voices might be considered fake and, in this way, to quote Critchley (who nails it): "Bowie's genius allows us to break the superficial link that seems to connect authenticity to truth" (*On Bowie* 41). In other words, performance can bring to "truth" a radical alteration of how we perceive it and, most importantly, how we feel it, such that a performed ritual can be one that moves us most. Furthermore, in this emergent, inauthentic truth, performative being replaces authentic being through repetition,

further mirroring the reproducibility of the capital commodity and the distance from authentic experience this labor relationship induces. In this way, Beckett and Bowie's art is both a response to and the creative expression of their social alienation which, paradoxically, forges powerful unities with their audience in whose enthusiastic reaction the use value of their work can be gauged.

Reveling in such inauthenticity, to counteract the enervating sense that authenticity is no longer possible in capital production, the audience is introduced to a liberating impulse. In this strategy, inauthenticity takes on the ring of a more powerful truth, one that speaks to those alienated from a world precisely because such people feel, at a profoundly self-conscious level, that they cannot achieve a sense of their own authenticity, their own value. In response to this fracture, Beckett and Bowie generate a paradox wherein performance and life overlap, such that what seems the incommensurable distance between mimetic representations of the world, and the reality of being in the world itself, are often traversed. For example, in their commitment to their art they challenge the idea that art and life are separate phenomena, and, in so doing, draw attention to the proscriptive nature of the extant division between true and false that conventional sociality entails and which relegates artistic practice to a subordinate role in capital society. But as artists driven by an obligation to express, such that producing their art *is* literally their life, this illusory division is obviated. In short, with Beckett and Bowie, making art about living dissolves borders such that life itself is self-consciously aestheticized. At the same time, and as we shall see in subsequent chapters of this study, such aesthetics are first crafted from the realities of being and suffering and from negative ontologies that require transformation.

Of immediate relevance regarding the workers' alienation from their own product is the sense in which Marx's framing of it is mirrored in the way in which both Beckett and Bowie often felt that they lost control of their work when it went out into the world. Certainly, they were constantly dissatisfied with work which, once completed, began to reflect the interest of the audience. In the early seventies, Bowie remarked "I was a strong idealist once, then when I saw all my efforts being mistranslated, I turned into an avid pessimist, a manic depressive" (Crowe, "Ground Control"). It seems that the albums released during his "Ziggy period" produced a scenario in which "he [had to] relate to the product of labor as to an alien object" (Marx, "Estranged Labour"). Yet, if this was a position that he occupied in the seventies it seems that by the nineties he had changed his mind, relinquishing any desire to control interpretation, accepting instead a benign alienation from the business of hermeneutics. Echoing Roland Barthes, he had come to understand that "the work is not complete until the audience comes in and completes it. The artist is really just a trigger."[5] Towards the end of his recording career, Bowie repeatedly alluded to this fact, claiming that the interpretations the audience generate are an integral and important aspect of the work. In exerting no sense of ownership or artistic entitlement over his product, often despite wildly divergent audience readings, he abandoned the desire to see himself objectified in the world, choosing instead that his audience use his music towards the same end. In this way, and despite the fact that Bowie put his life into the object of his music, "the life [of the music] no longer belongs to him but to the object" (Marx, "Estranged Labour").

Beckett, for his part, was loath to offer interpretive keys to his work from the moment it started to attract a curious audience. In a 1952 letter to Michel Poulac, who was seeking further enlightenment on the meaning of *Waiting for Godot*, Beckett wrote:

> I am no longer part of it, and never will be again. Estragon, Vladimir, Pozzo, Lucky, their time and their space, I have only been able to know a little about them by staying very far away from the need to understand. They owe you an explanation perhaps. Let them get on with it. Without me. They and I have settled our accounts.
> (*CLSBIII* 316)

Five years later, in 1957, Beckett wrote to Alan Schneider who, while directing *Endgame*, had received many requests, from both audience and actors, for further explication of the play's action. In response to Schneider's request for elucidation, the play's author responded: "If people want to have headaches among the overtones, let them. And provide their own aspirin. Hamm as stated, and Clov as stated, together as stated, nec tecum nec sine te" [neither with you nor without you] (*Disjecta* 109). Similar to Marx's idea that the laborer is alienated from the authenticity of the object of his/her labor once it enters the marketplace as product, Beckett and Bowie's relationship with their work likewise mirrors an absence of ownership of the intangible nature of the product. In their struggle to communicate an aesthetics of the inauthentic, and in their final willingness to relinquish explication as a form of control, Beckett and Bowie practice a resistance to commodity culture in the sense that they do not seek nor expect confirmation of their own legitimacy within it. They release the work to the world without rancor and so both suffer and combat the first stage of Marx's alienation.

Before moving on to Marx's second category of labor alienation, that of the laborer alienated through selling his/herself as labor, it is important to draw attention to those areas of this primary definition that are problematic, rather than complementary to a specifically Marxist framing of Beckett and Bowie. In this regard, we need only consider the laborer's reward, in contrast to both artists in question, to see a significant problem. If it is unethical that the Indian construction worker who builds a private hospital for his Arabian Peninsula hosts has no rights to visit the premises once it has been completed, then arguing Beckett and Bowie somehow give away their work when that relinquishing brings great financial reward is, at best, misleading and, at worst, foolish and glib. However, a privileged letting go is different to asking the working class to do the same insofar as it is a gesture of privilege's unwillingness to exercise its power, and perhaps the only appropriate response in relation to the antagonism that privilege generates, short of refusing any remuneration for the effort invested. More problematic, arguably, from a Marxist point of view, is the great disparity that exists between the working-class laborer and the two artists in question in relation to access to the means of production. For Beckett and Bowie, the means of production were first local, cooperative, and countercultural, their work primarily situated as resisting and so evading the worst excesses of commodity culture. For example, in France,

Beckett was first published by Les Éditions de Minuit (whose tiny company remains housed in what was once a brothel in the narrow backstreets off Boulevard Saint Germain). In America, he was published by the small independent Grove Press that "offered many readers their first introduction to the European dramatists of the Absurd, the French Surrealists, the San Francisco and New York 'Beat' poets, and the New York Abstract Expressionists" (Brower 60) and so helped fuel the American countercultural and sexual revolution of the sixties. However, despite these countercultural beginnings, both artists signed major distribution deals once their reputation was established. Bowie, for his part, began on MainMan but ended up a stablemate of Elvis Presley, on RCA, while, today, Beckett's work, and critical work on it, is distributed by major literary companies. Such accelerated distribution is shorthand for entering and sustaining the circulation of capital through commodity exchange at the corporate level. In defence of this market strategy, one can only propose that the antagonism it generates is proof positive of the persistence of an impulse of resistance in the content, form, and accessibility of Beckett and Bowie and like-minded artists who attempt to tackle these contradictions head on. As we shall see, both understand the concept of antagonism and engage with it as a context that impacts their characters and how those characters are represented (be it in musical, narrative, or theatrical forms of *agōn*).

Of the second form of alienation, in which Marx proposes that becoming labor is an alienating act, he writes:

> Till now we have been considering the estrangement, the alienation of the worker only in one of its aspects i.e. the worker's relationship to the products of his labor. But the estrangement is manifested not only in the result but in the act of production, within the producing activity itself.

In Marx's thinking, anyone receiving a working-class wage for energy and endeavor rendered is just so alienated. This is not the case, necessarily, for someone who receives payment in the form of exchange for providing specialized services. An architect who receives a large sum in exchange for delivering an architectural design for a new building is not necessarily alienated in the same manner as the man who is hired to install the building's first bricks and who receives a set wage for a task anyone else could do as well. Alienation occurs in the capitulation to a wage disassociated from the value of the object produced for said wage, and from a wage that takes no account of the dangers or risks involved in the earning of it. Returning to the artistic output of both Beckett and Bowie it would, again, be a distortion of the facts to claim that they are alienated as a result of selling their work for money as their earnings do reflect, to varying degrees, their creative input into their art. Certainly, at the height of what bureaucrats might refer to as their "creative capital"—those moments when the creative means of production are made readily available to them, those moments when publishers are ready to publish whatever Beckett submits, record labels happy to press and distribute Bowie's new music without hesitation, those important moments when both are free to compose and realize their creative vision without outside interference—it would be a

perversion of Marxism to argue that in the process of delivery they were alienated from themselves because they received financial reward.

At the same time, and for a long time in their careers, these moments of capital security were absent. Early on, when they did enter the labor market, both artists were forced to work jobs they did not like and both experienced alienation from the business end of their creativity in ways that left them feeling decentered and dissociated from their artistic output and so from themselves. For example, Beckett was so disillusioned by his experience of lecturing in French at Trinity College Dublin that he appeared to have a nervous breakdown while doing so, forcing his resignation after five months of lectures. A concomitant guilt at disappointing his family, who were proud of his teaching achievements, also compounded his sense of alienation at this time. Bowie, for his part, was disinterested in his job in an advertising agency before he decided to take the chance and become a full-time musician. He then bided his time in any number of bands, with whom he felt no real creative connection, before going solo and beginning to experience some commercial success that did not translate into financial success as a result of an extortionate performance contract that favored his then manager. Famously, he had to halve all of his pre-eighties' profits with Tony DeFries, creating such rancor between the pair that out of frustration both eventually took to mounting increasingly expensive stage shows to ensure that neither made any money (see Doggett 235). As a result, Bowie often struggled to make ends meet until the expansive success of *Let's Dance* in 1982. Similarly, until he found success in the early fifties, Beckett often subsisted on his wife's dressmaking earnings (*CLSBII* 72). In other words, although Beckett and Bowie only suffered the alienation pursuant on selling themselves as labor early in their lives, the experience helped them understand very well the frustrations of those for whom labor alienation is an economic inevitability.

Another aspect of labor alienation as a consequence of selling oneself as labor is an implied assumption that artists are somehow exempt from this alienating context because they enjoy what they produce. As understood by Marx, the alienation of sacrificial labor means the effort invested for the living wage brings no satisfaction to the worker. Alternatively, it is often thought that the artist, who is engaged in an act of creativity, is therefore not alienated from him or herself because the occupation brings them pleasure. However, the notion that the writer, or the musician, necessarily take pleasure in artistic production is problematic. Both Beckett and Bowie had a love/hate relationship with their art, which the latter attempted to rationalize by proposing "I don't think you have to love [music] to be able to produce something which is creative out of it ... I have the same relationship with paint. It's a struggle and we hate each other, but it doesn't have to mean you can't eventually get something onto a canvas that has a lot of spikiness to it" (Pegg 696). Likewise, Beckett often spoke of an antagonism with the fruit of his labors, the narrator of "First Love" echoing his author's sentiment when he says "[m]y ... writings are no sooner dry than they revolt me" (*The Expelled and Other Novellas* 65). Beckett's letters are littered with references to what he imagines is his failure to realize his imaginative thoughts in appropriate linguistic and/or theatrical terms. Various translations he has undertaken and staging of his plays with which he is involved as director are referred to as "impossible" (*CLSBII* 640) and "pointless,"

often producing "crisis" (*CLSBIII* 183) and, on more than one occasion, he refers to an emerging work as his "new moan" (*CLSBIII* 211). Further, and regarding his sense that language is not a suitable vehicle for expression, in one particular letter he confesses his desire to do a certain violence to it, to "bore one hole after another in it, until what lurks behind it—be it something or nothing—begins to seep through" (*Disjecta* 172). Such aggressive ambivalence seems a quite profound alienation from Beckett's chosen artistic medium. Relatedly, Bowie told Cameron Crowe in 1976 that *Young Americans* is "the first record I've actually liked since *Hunky Dory*" ("Ground Control" 32), dismissing all of the material in the interim as a personal disappointment. In these moments, both artists reveal a central antagonism at the heart of their occupation, which in some sense can be compared to the frustration of the alienated worker, if not necessarily aligned with the exploitation of capital as such.

Finally, in relation to the laborer alienated through the sale of labor itself, both Beckett and Bowie had direct experience of a certain helplessness induced by selling themselves short. Beckett was appalled, for example, that *Waiting for Godot* (1953) was advertised as "the laugh sensation of two continents" in advance of its American premiere at the Coconut Grove Playhouse in Miami in 1956 (see Schneider 183–6). Ripped from its genesis in a small avant-garde French theater and thrown into the Broadway bound circuit of large-scale American productions, his tragi-comedy bombed. Beckett knew full well that the expedient of profit over art had resulted in a production so oppressive its director believed the cast "attempted mass suicide" in the metaphoric sense, both on stage and in the wings. Conversely, frustrated by years of managerial exploitation from which he finally disentangled himself in 1980, Bowie thereafter employed Nile Rogers of Chic fame to "make hits," three of which Rogers delivered in 1982 ("Let's Dance," "China Girl," and "Modern Love"). Bowie then spent the rest of the decade lamenting the "bad creative decisions" he made throughout this period (Grow 87) as he found it difficult to find his way back into his hitherto countercultural creative vein after recording and touring to boost his bank balance rather than continuing to explore the possibilities of his artform. Like Marx's laborer, at the moment he sold his creativity, he lost more than he knew.

So, although not internally divided as individuals by the demands of labor, Beckett and Bowie's experiences of the market did influence the developing content of their work dialectically so that the question of the relationship between art and commodity fed into and influenced their approach to the content and nature of their evolving output. Additionally, if they were not alienated as workers, they experienced enough of such associated estrangement and saw enough of the direct exploitation of others to significantly influence the nature of their relation to their alienated fellow beings. As a result, their experience of alienation, reflective of the machinations of capital, is translated into their work as a persistent and antagonistic theme, finding a locus in the alienation of their characters and often in the form of the work itself. In short, both Beckett and Bowie feature characters who are alienated from family, nation, lovers, others, and, ultimately, from themselves. In a way that I hope will become increasingly apparent, both Samuel Beckett and David Bowie embody alien-ness as their own labor and, in so doing, create a space of refuge for readers and listeners alienated from their

societies. Moreover, in these imaginative spaces, and in keeping with Marx's vision, there exists the possibility that negative ontologies might be transformed.

The reason that neither Beckett nor Bowie are alienated from themselves through the activity of labor is because they are able to pursue their creativity in harmony with their species being, a human drive Marx imagined consonant with Darwin's theory of evolutionary adaptation and the disruption of which characterizes Marx's third type of alienation. For the German philosopher, non-alienated labor should be a holistic union of subject and object, laborer and object of labor, working like a mirror that reflects people's communal value back upon themselves in the world that they help create. Philosophically speaking, subject and object are unified and one's understanding and appreciation of one's being in such instances is intersubjective. Marx explains:

> in his work upon the objective world man really proves himself to be a species-being. This production is his active species-life. Through this production, nature appears as his work and his reality. The object of labor is, therefore, the objectification of man's species-life: for he duplicates himself not only, as in consciousness, intellectually, but also actively, in reality, and therefore he sees himself in a world that he has created.

On the other hand, "in tearing away from man the object of his production, therefore, estranged labor tears from him his species-life, his real objectivity as a member of the species." The exploited workers, forced to devote their labor exertions to the realization of some commodity that does not confirm their value to themselves, is obstructed in attaining the sense of self-fulfillment that one should have when one feels activity is in the service of improving and nurturing the lives of the species as evolutionary beings. Marx clearly specifies this dialectically engaged relationship between individuals and their environment when he states, "Man not only effects a change of form in the materials of nature, he also realizes his own purpose in those materials" (*Capital vol. 1* 284). This is what Marx means by objectification (in contradistinction to the negative sense in which a person's identity is reduced to and constituted in their sexuality).

In relation to this notion of positive objectification, Bowie and Beckett are fully integrated as explorers in pursuit of species being. Both are engaged in the examination of human nature, both in its natural state and in its engagement with the demands of its environment. As artists, they have found a way to fulfill the obligation their nature demands by creating and generating a variety of representations, verbal, musical, and visual, of human species being. Both have also spoken about the obligation that such an urge to create engenders. Beckett has addressed the obligation the artist faces to express the fact that "there is nothing to express … no desire to express, together with the obligation to express" (*Disjecta* 112), while Bowie has identified his "bloody-minded desire to create something that wasn't there before" (Morley, *The Age of Bowie* 135). Both understand the conflict inherent in realizing art during the age of capital production. Crucially, therefore, Beckett and Bowie's creations *are alienated from species being*, as Marx defined it, in that the philosopher's notion appears as an earnest but idealized version of human potential. In short, the species being that Beckett and

Bowie represent is neither self-realized nor fulfilled, but rather is ravaged and ruined by the effects of capitalism. Theirs is a paradoxically enlightened but disillusioned self-conscious creativity, an idea of human potential that while natural, is also shaped by its position within and treatment through culture. Where Marx entertains the notion of an ideal unity between individual, collective, and environment that capitalism impedes, Beckett and Bowie present narratives of that very sundering, demonstrating how potential unity is thwarted and inhibited by social ills consequent on a species in thrall to and framed by economics in the invasive and pervasive mode of capital production that became dominant in the twentieth century.

A letter by Beckett provides an instance of the depth of feeling associated with creating such alienated figures when, in 1946, he felt compelled to write to Simone de Beauvoir to insist that the journal, of which she was the editor, had made the error of publishing one of his stories incomplete. "It is quite impossible for me to evade the duty I feel towards a creature of mine" (*CLSBII* 41) he told her, because "there exists a wretchedness which must be defended to the very end, in one's work and outside it" (42). Beckett's fidelity to his subject here, and his desire to represent the suffering of a fellow being, stands in stark contrast to Marx's idealism, and yet, in keeping with Marxism's objectives, represents a necessary stage in the demystification of capital production in which the reader is presented with an image of how life is in the dominant mode of production. Likewise, Bowie's "Quicksand" presents a character struggling to define rather than simply realize his potential. Pegg notes that Bowie's voice is "bewildered, disempowered and intimidated by politics and religion" (218) as he asks if he should "herald loud the death of Man?" (Bowie, "Quicksand"). Fearing that he may be engulfed by mental health problems, while confessing to a lack of resilience to fight the same, the voice understands his fears as a consequence of the failure of meta-narratives, particularly religion, or what he refers to as "bullshit faith," to offer an alternative to despair. This leads to a choice between suicide by poison or admitting to and taking comfort in the failure of mankind to amount to anything. References to Nietzsche and Buddha are also embedded in what is essentially a statement of the failure of an idealized species being that might offer a redemptive context for humankind.

Beckett and Bowie characters such as these, estranged from their fellow species, mirror the concerns of many listeners and readers who are alienated from the idea of species being themselves. In another enlightening paradox, Beckett and Bowie's retreat from species being as communal objectification nonetheless forges an alternative identification with alienated audiences. In contrast to the idea of a species being inexorably improving its nature through a dialectic relationship with its ceaselessly evolving environment (Space Commander Elon Musk comes rather comically to mind), the species being these artists present is debilitated, on the cusp of ruination, and facing into an inevitable finitude. And this estranged subjectivity is in keeping with those capitalism produces in its generation of a species being distorted by economics. Just as Beckett and Bowie relinquish the idea of sovereign control over the meaning of their texts, so, too, they reject the impulse to realize an idealized species being and attempt instead to represent a species undone.

To contextualize this destituent feeling as a reflection of their own experiences, James Knowlson records Beckett's shock at seeing the people liberated from Europe's concentration camps into the French countryside: "At the end of the war, it was terrible! The forces just opened up the extermination camps as they came through. They had nothing to eat, those of them who were left alive" (*Beckett Remembering* 86). It is clear from the trajectory of Beckett's work that his World War II experience changed him, with his art becoming at this juncture more cruel in keeping with an increased cynicism regarding the failed potential of human species being. Bowie, to give but one example, identified his disappointment both with South African apartheid and Australian settler treatment of the indigenous population when he noted in Sydney, in 1982, that "as much as I love this country, it's probably one of the most racially intolerant in the world, well in line with South Africa. I mean, in the north, there's unbelievable intolerance. The Aborigines can't even buy their drinks in the same bars" (Loder). The video for "Let's Dance," featuring indigenous people in a watering hole normally reserved for white patrons (and thought of at the time as an MTV visual postcard), was an act of cultural disassembly on Bowie's part. Indeed, the compassion evident for a panoply of diverse but flawed characters in a whole host of his songs speaks to the idea of a species being distorted by a brutal environment, be its inhabitants privileged racists or marginalized victims.

Finally, regarding Marx's fourth form, man's alienation from his fellow man, he states that "an immediate consequence of the fact that man is estranged from the product of his labor, from his life activity, from his species-being, is the estrangement of man from man." In short, as a result of the three types of alienation previously outlined, the alienated individual finds other people a collective to which s/he cannot relate. Effectively, s/he finds that both the middle and professional classes and her/his fellow workers are, in various ways, all involved in "the activity of alienation," an activity defined by "loss of the object to an alien power, to an alien person." Regarding Beckett and Bowie's experience of complete social alienation, parallels might be found in the degree to which they were forced to withdraw from social life. If in 1972 Bowie had invented alien Ziggy as a character to creatively express his sense of alienation, by the time he released "Fame" in 1975, a song that clearly articulates the great strain and isolation of his success, he had become, to all intents and purposes, an *alien person*. He developed a serious drug problem while hiding out in Los Angeles, which led to him fearing for his health and sanity. Further, and subsequent to the *Let's Dance* years, Bowie also had to accept that his public life was to be largely determined by an audience's idea of who he was, perhaps the ultimate alienation of the individual from the communal possibilities of collective life. In not dissimilar circumstances, Beckett found himself deeply ambivalent about receiving the Nobel Prize for literature in 1969, aware that if he refused it the academy would still bestow it regardless, as they had for Sartre in 1964 (see *CLSBIV* 187–91). In the weeks leading up to the award, his wife, Suzanne, called it a "catastrophe" (Knowlson, *Damned to Fame* 570). With public life thereafter impossible, Beckett withdrew to Tunisia, where he was largely unrecognized, and then to a remote farmhouse in Ussy where he would attempt to write. Bowie, on the other hand, had no such escape, being an icon almost globally recognized.

In such ways, Beckett and Bowie know something of the feeling of alienation from their fellow humankind and yet as artists in touch with their species being, albeit destituent, they also avoid the worst excess of a disconnect as both artists and as people. At the same time, we have seen how both have experienced alienation of various types as they grew up in testing environments. Beckett, for example, was flung into the maelstrom of World War II, while Bowie emerged into the austerity caused by the same conflict and both of them understood the atrocity that had taken place during it. We have also seen how alienation experienced in the first throes of standard employment was very quickly absorbed and clearly remembered and mobilized in their work. We have seen how both have struggled with the materials of their art so that their practice became defined by a constant antagonism and how both have experienced alienation as a result of audiences misunderstanding their work and/or publishers and producers misrepresenting or flying fast and loose with the framing of their material. Finally, we have touched upon the experience of alienation that fame inflicted on both, an estrangement in which other people are incapable of relating in any way other than to the image of fame, to the alien alter-ego neither artist recognizes as himself. In such contexts, Bowie has spoken about the retreat that, as alienated person, he makes from other people:

> I think if he is in isolation, instead of receiving the whole world as his home he tends to create a micro-world inside himself. And it's that peculiar part about the human mind that fascinates me, about the small universes that can be created inside the mind.
>
> ("Afternoon Plus")

Beckett, likewise, understood his creativity as invested in the creation of imaginative and yet impoverished worlds. He told Michael Haerdter that

> it's no longer possible to know everything, the tie between the self and things no longer exists … one must make a world of one's own in order to satisfy one's need to know, to understand, one's need for order.
>
> (*Beckett in the Theatre* 231)

For example, in *Murphy*, Beckett's first published novel, the eponymous character seeks to retreat to the "dark … will-lessness" of his mind (*Murphy* 72) as a way of escaping the demands of his society. This mirrors the manner in which Ziggy also retreats to his room in "Rock 'n' Roll Suicide." In these reclusive reactions Beckett and Bowie's characters do not aspire to identification with species being as a collective but rather record the retreat into alienated worlds. From here, as alienated beings they try to connect with alienated audiences in representing a destitute species being and locating it within their implied understanding of that which is false in capital consciousness.

In concluding a review of Marx's four forms of alienation, it is important to emphasize their increasing relevance today wherein the technics of an original Western, industrialist paradigm have been systematically transposed and extended

onto the global capital working subject who is thoroughly alienated in Marx's principal ways. From the sweat shops of East Asia to the technology factories of China to the African and Asian workers building World Cup stadia in the Arabian desert, alienation from commodity, self, species being, and fellow man is depressingly pervasive. Add to this the ever-growing waves of refugees escaping war, famine, and extreme climate change and it is easy to see the effects of the increasingly global mode of production that Marx attempted to critique in its British and central-European infancy. Moreover, these modern subjects of capital are the supply line of contemporary "necro-capitalism," a new political economy formation in which alienation from the value of life itself is the key ideological gambit. Coined by Achille Mbembe, the term "necropolitics" describes "the generalized instrumentalization of human existence and the material destruction of human bodies and populations" (Mbembe 14). Essentially, it is the expression and result of the rise of a global capitalism, the structure of which necessarily claims victims at the directly inverse pole of the exchange. As Clough asserts, necropolitics "permits the healthy life of some populations to necessitate the death of others marked as nature's degenerate or unhealthy ones" ("The Affective Turn" 18). It is, basically, the politics of managing expendable death. Tyner summarizes ably:

> Those individuals who are deemed non-productive or redundant, based on an economic bio-arithmetic, are disproportionately vulnerable to … premature death … it is a supercharged utilitarian ethic whereby the lives of essential workers are sacrificed for politics, profit and pleasure … The failure of not saving lives is not a tragic failure of capitalism but a critical feature of capitalism that expends lives in its perpetual expansion … capitalism itself infects the body politics and leaves behind the alienated society addicted to mindless consumption, indifferent to the suffering and premature death of others, and intolerant of demands to affect change.
>
> (5)

Not just in the Global South, this process and its accompanying state of mind was front and center in the Global North during the first COVID-19 pandemic wave. Frontline medical workers were expected to risk their lives to try and help others despite the lack of protective equipment, which was unavailable as a result of a slow and strategically ignorant governmental response. Furthermore, during lockdown, delivery riders and other service industry workers were expected to travel with and provide food to customers despite the risk of infection and contracting a serious and potentially fatal illness. This collateralization of certain workers as a consequence of the circumstance of the mode of production illustrates how necropolitics, or necrocapital, operates by creating and utilizing disposable humanity even within the ostensibly developed world.

In a related fashion, Tyner has written extensively about both the increased prevalence of truncated life and premature death in the USA. The former "includes obvious situations, such as homicide by firearms, but it includes also the harm brought about by intransigent governments that refuse to enact gun control measures." Likewise, premature death can "result from a lack of affordable health care and it includes those

deaths resultant from lax occupational safety regulations" (38). One hugely significant instantiation of both truncated life and premature death is the disproportionate number of African Americans shot dead and/or fatally injured by police weapons and/or policing containment tactics in the United States. Consequently, as a result of the Black Lives Matter movement, there is now greater awareness of what has been an ever-present but institutionally silenced form of "intersectional alienation"; in other words, forms of alienation produced as a result of discrimination and necropolitical strategies of suppression practiced against people of color and often against people of diverse genders and sexualities. As a result, it might seem that Marx's systematic estrangement, founded on class exploitation and struggle, has been superseded by a more sociologically centered concept identifying feelings of difference and marginality that exist regardless of class, such as the experience of many LGBTQ+ people and people with disabilities. In reality, however, it simply means that what constitutes class, similarly with regard to what constitutes alienation, needs to be recalibrated and reimagined for the contemporary moment of late and increasingly invasive capital encroachment.

Class as a signifier is always mutable and has existed and been utilized as both a way to determine where individuals can be placed within economic systems and, more insidiously, to propose an inescapable and overarching social system—one that reflects a society's economic structure which requires people to think of themselves in limited and limiting ways in keeping with the necessary hierarchies of capital production. In this regard, Storey proposes that "class exists objectively in the base as an economic relationship and subjectively in the superstructure as a form of consciousness and lived practice" (139). In other words, although people who have to work for a living may exist as a fact, they have to see themselves as belonging to a formation of working people in order for that determination to function effectively. Conversely, when people see themselves as working class but with a revolutionary consciousness, they become a threat to the viability of the labor status quo. So, when Storey also argues that class "is not a thing, it is always a historical relationship of unity and difference" (141), he means that the manner in which working-class people are framed, and the degree to which they accept this, can determine the visibility of class struggle and its efficacy as a tool of resistance.

For example, Marx's initial classification of the working class is associated with the industrial revolution and its aftermath. Today, our post-industrial, digital society has made class less visible and, in the USA in particular, neoliberalism has successfully framed white working-class identity as both racist and sexist. By proposing that "working-class" identity, so called, demarcates an exclusively white and mythic entity, this extraordinary sleight of hand has also precluded women and people of color from identifying with and partaking in working-class identity, framing their struggles as a matter of identity politics rather than as struggles precipitated by historic reiterations of economic inequality. This strategy of removing class markers is also designed to remove the antagonism that defines class, with the result that in the West, post-industrial class hierarchies have lost some of their clear contours as hard labor has given way to less obvious forms of subservient work with the word "laborer" replaced by "employee" and so on. At the same time, as noted, the COVID-19 pandemic has clearly demonstrated

the exploitative treatment of frontline workers, indicating the degree to which their myriad forms of labor placed them at risk in a fashion similar to the necro-capitalism which already affects many millions of workers in the developing world. In other words, although the thousands of doctors and nurses and pizza delivery people may be thought of as stratified along different class lines, in reality COVID has illuminated the hierarchy in which the upper class are those who have a service base upon whom they can count for protected life, which includes professions such as doctors who were previously thought of as both frontline workers and privileged people. Where capitalism once protected the privileged, many can now see how their lives mirror the lives of those exploited for profit in the more traditional and obvious class hierarchies.

In proposing that Beckett and Bowie are affected by exploitative capital economy, this study is attempting to significantly expand beyond Marx's idea of the laborer as sole alienated subject and, by association, what might constitute the proletariat and the alienated in twenty-first-century society. As a consequence of living and working in a capitalist society, Beckett and Bowie—despite enjoying economic privilege that also translates into white privilege in many contexts—nonetheless suffered alienation and choose to represent it as a key theme in their work. Further, their work constitutes an attempt to expose and resist injustice. In this regard, they are countercultural and their lives are committed to an art that critiques the shortcomings of a brutalizing society. Alternatively, there are millions of people fully *incorporated* into capitalism, satisfied with its commodity culture and pleased to be favored in its systems of profit making and distribution. It is against such thinking that Beckett and Bowie have conceived their art of alienation, and against incorporation into such hegemonic framing that they imagined their particular aesthetics of resistance.

By way of concluding this chapter, consider how Beckett and Bowie's most famous creations are the embodiment of an art of alienation that speaks eloquently and directly to a myriad of alienated peoples and positions. Simultaneously, these characters also attempt to open the minds of the incorporated to the terms of an alienation that they may not yet experience subjectively, despite the increasingly troubling view from the bridge. In Beckett's *Waiting for Godot*, it is clear that Vladimir and Estragon—who wait by a tree, day after day, for an unfailingly absent Godot—are alienated as a result of becoming labor and also alienated from the fruits of their labor. Although it is not clear what commodities their labor might produce, given that we are not in an industrial landscape (although it is implied that they may be situated in the apocalyptic aftermath of such a mode of production), their impoverishment indicates that no previous employment has sufficiently sustained them, particularly Vladimir's stint as a poet. There is the suggestion that both have served as seasonal workers in the past, perhaps in the "Mâcon country" (*Waiting for Godot* 52) but this arguably idyllic memory has been supplanted by a change in fortunes. Now they are prepared to sell themselves to Godot in return for lodgings and food, the very definition of Marxist alienation as a result of exchanging the body as labor. Further, species being is represented, in part, as a selfish horizon, embodied by the figure of Pozzo, who is cruel and punitive and represents no desirable measure of human potential. And yet, while at first defined by his property and his commodities (watch, pipe and tobacco,

picnic basket, etc.) and his propensity for aggressive cruelty, he returns in the second act an impoverished version of himself, blind and now dependent on his vassal, Lucky, for direction. In this context, teleological species being appears as a chimera. Man "wastes and pines" (*Waiting for Godot* 34) because any idea of true potential seems an illusion in a universe where the being of the collective species is never considered beyond its capacity to be exploited or to exploit.

Importantly, Beckett's chosen mise-en-scène contributes significantly to this sense of contraction and limitation. The action takes place on an almost bare stage, in a theatrically denuded environment, which underwrites the corresponding mimetic sense of entropy. In this regard, Beckett has produced a deterritorialized space in which it is difficult for his characters to locate and or organize conventional behavioral coordinates. Space and time seem obviated of their traditional meaning. Vladimir and Estragon are unsure of the day or the week and if they have previously been in the space where they find themselves now. Unable to tell where they are or when they are, this deliberate stripping away makes it difficult to apply the ordinary teleology that species being presupposes. Interesting in this regard that Beckett once told Martin Esslin:

> I want to come down to the bedrock of the essentials, the archetypal. And that is exactly what the clown/tramp [in *Waiting for Godot*] is. The clown is not the allegorical figure but is a man who hasn't got any possessions … if you take away all the unimportant accidentals, you come to a human figure that is completely real but at the same time not encumbered by any sort of accidentals.
>
> (*Beckett Remembering* 48–9)

Seeking to identify a more pervasive type of alienation, Beckett equates the stripping out of commodities, a commodity deterritorialization, with a type of unmasking that suggests a movement towards truth. Perhaps to be subtracted to this degree is to be placed outside of the dominant mode of production that dominates social and cultural life? Alternatively, it may be that from such indeterminate space and time Beckett and Bowie are speaking of and to the stunted human development that capital production has wrought. Herein, practical indicators of inequality abound. Without access to the commodity luxuries of Pozzo, Estragon is reduced to stealing Lucky's food. Lucky himself is the image of isolation, of an inhabitant in an alien world that is still our world but in which the codes of epistemological security that govern late capitalism are no longer utterable, leaving him to babble incoherent fragments of knowledge seemingly "ti-ed" (*Waiting for Godot* 13) to ruination.

At the same time, there is a pronounced self-reflexive dimension to the play. The audience is left in no doubt that, on two separate occasions, the characters address the play's artificiality directly, and, throughout the course of the drama, Vladimir and Estragon also seem to have an awareness of themselves as engaged in a theatrical repetition, the distance between actor and characters blurred, if not thoroughly transgressed. Both admit that bouts of dialogue help pass the time as though the staged action is marking its own duration with welcome markers of its slow going. In this regard, the play exhibits a fetish quality in its clearly ironic admission of its inauthenticity, its certain awareness that

this is art rather than life, and therefore quite useless at remediating the vicissitudes of the latter. As a result of suffering the existential estrangement the terms of the play mobilize, Vladimir and Estragon are thoroughly alienated from everybody they meet, absolute outsiders from capital proxemics yet, crucially, experiencing radical alienation as a result.

Major Tom, the central character in "Space Oddity," is the first significant articulation of the recurring alienated figure who, in a multitude of guises, populates Bowie's work. In a literal reading of the lyrics of "Space Oddity," Major Tom functions as an astronaut fulfilling his duty as a space pioneer for a notional national space program. So far, so straight forward. And yet this conventional reading of the song is also supplemented by deliberate metaphorical resonances which suggest substantially different readings. In "Keeping Space Fantastic: The Transformative Journey of Major Tom," Michael Lupro proposes that the titular astronaut enacts a singular rejection of the military-industrial complex and, in doing so, opens up a different interpretive space. Lupro's alternative reading of the song "replaces the interpretation of Major Tom as a helpless victim of a technological mishap with a vision of him as an active participant in altering the conditions of his labour" (18). He is so alienated from the business of being an astronaut by the reality of what such an accolade involves that he takes measures to change it. In "Space Oddity" we find Major Tom discommoded by his ascent into the heavens, which has succeeded only in making him feel alienated and ineffectual. He floats in his "tin can" and remarks that the earth is distant and indeed disinterested in his galactic explorations. That "the planet earth is blue" is both the recognition of its visual appearance from space and a way for Tom to project his own disillusionment onto the object that has hitherto served as his home. Moreover, this disappointment with the isolation of deep space, and its capacity to make him feel irrelevant, is also an estrangement from his own sense of value, an estrangement from himself. In just such ways his alienation corresponds to those proposed by Marx in relation to the worker's alienation from self and from fellow humankind.

Furthermore, reduced to being a poster boy for the space race, such that his expertise as an astronaut becomes a type of ideological commodity, Major Tom is alienated from the commercial image that both "ground control" and his earthbound audience begin to generate, fast becoming a version of himself over which he has no control. Floating in space without any clear idea of what comes next, he is also alienated from species being in the sense that although achieving deep space travel is an impressive measure of our capacity for evolutionary development, the nature of space nevertheless calls into question the relevance of the exercise. Seeing the earth as a small, depressed ball indistinguishable from other planets in the solar system has the effect of calling the importance of the species itself into question. Despite the fact that exploring space to enhance human potential is his designated duty, when Major Tom announces his inability to cheer a blue earth, he signals his understanding of his space mission as incapable of assuaging human unhappiness. As Marx's species being is a measure of our ability to modify our environment to our benefit, Bowie's galactic satire then questions the very logic of space travel itself. If penetrating the final frontier means floating in zero gravity and having to wear a space suit to survive, then how does it benefit the human species or reveal any hidden capacity for its improvement?

These are questions that "Space Oddity" poses obliquely but insistently. "Strung out in heavens high," Major Tom is fatally alienated from the other members of his species. This spatial distance from humanity produces such existential angst that it appears he cuts ties with humankind altogether, stepping out into space as a form of ritual suicide, and so escaping from both the space race and the public's desire to reimagine his identity as a hero. Major Tom alludes to the fact that his spacecraft knows the route to his ultimate destination just before he falls out of contact. The suggestion is that he has abandoned his duty, choosing intergalactic oblivion instead. In this interpretation, Major Tom may well be Bowie's first rock 'n' roll suicide even as he sets in train the star-in-space trope that he will mine throughout his career. Supporting such a reading is the fact that at the precise moment when Tom "goes out" to fulfill his institutional duty, Ground Control tells him that "the papers want to know whose shirts you wear." But it turns out celebrity endorsement is irrelevant to a man who then goes "far out" into a self-negation beyond capital commodification. At the same time, however, it is only possible to say Major Tom "appears" to float out of life because, at the level of exposition, there is no clear statement of his fate. Indeed, just as Tom relinquishes his authority as a space officer, Bowie relinquishes any responsibility he might have towards greater explication about the fate of the Major until the character makes a return to Bowie's fictional universe in a very different guise, one framed by an emerging theme of ruination.

In "Space Oddity," outer space also functions in a similar capacity to the deterritorialization that characterizes the landscape of *Waiting for Godot*. Both are terrains of marginality, the world of Godot implying a recent catastrophe while the framing of outer space hints at the ruination of the planet itself. Ultimately, both "Space Oddity" and *Waiting for Godot* are asking us to read them as metaphor and this constitutes an important strategy in Beckett and Bowie's art of alienation, and key to how they fetishize alienation thematically. The deterritorialized metaphor in *Godot* creates the possibility of readings and interpretations regarding the persistence of nation, gender, sexuality, religion, and more. Each of these contexts resonates in the deterritorialized landscape, simultaneously and paradoxically opening up possible alternative readings. For example, Beckett's alien Irishness is present as something potentially intractable, as though it were inscribed in the rural landscape. Similarly, the idea of a world without reproductive generation is brought keenly into focus by the absence of female characters, as is the alternative succor of queer love and the fate, too, of an ecologically debased planet.

Similarly, Major Tom's journey beyond the conventional coordinates of earthbound domesticity also implies other new adventures. Given that his business shirt would be tied, in the nineteen-sixties and seventies, to semiotic notions of corporate heteronormativity, when he informs us that he loves his wife before stepping through the door to another world, Tom prefigures Bowie's own sexual experimentation. The astronaut's actions challenge the established frontiers of capital decorum. There is also the implication that Tom's act of rebellion rejects prosaic protein pills in favor of other, more exploratory drugs. This experimentation is represented in the extended chord structures of the song's lead guitar, at two key

junctures of the song, which suggest, simultaneously, a movement out into space and a spaced-out movement into the mind, further consolidating Tom's outsider status. Space proves to be an ideal frontier metaphor "to boldy go" where conventional pop culture had yet to follow; military and commodity culture losing its nascent hero to a metaphoric multiplicity involving social rebellion, drug consumption, homosexuality, and suicide. When he leaves his craft, Major Tom (r)ejects commercial corporate and celebrity culture, heteronormativity in its various forms and, importantly, the biopolitical imperative that values life as absolutely sacred. Chapman believes

> the manifestations of alienation evident in [Bowie's] work have fallen within a variety of categories including generational, psychological, technological, physical, and alienation based on gender.
>
> (27)

"Space Oddity" represents that career trajectory and these associated themes in resonant miniature.

The nature of the aesthetic effects touched upon here will be considered in greater depth in the following chapter. For now, these examples indicate the way in which both Beckett and Bowie represent a radically deterritorialized alienation from the coordinates of social and cultural convention. Although they enjoy certain privileges with regard to an intimate connection with the fruits of their labor (the art objects they make are not alien to them), nonetheless Beckett and Bowie perform an art of alienation, reveling in a sense of artifice that, paradoxically, opens onto the truth of alienation itself. In doing so, they speak to audiences who, experiencing alienation of their own, recognize an art that mirrors their sense of social estrangement. As this chapter has tried to outline both the history of Marx's alienation and Beckett and Bowie's artistic response to it, it has maintained a certain fidelity to the demands of an ethically focused historical analysis. Now, having established *why* Beckett and Bowie felt alienated historically, we turn to *how* they succeed in devising aesthetic strategies to express their being *as* alienation in both song and story.

IV

The Aesthetics of Alienation

If the previous chapter attempted to outline Beckett and Bowie's lived experiences of alienation, this one casts an eye over their interest in artistic representations of same. Studying their mutual appreciation of literature, painting, cinema, and music devoted to the expression of alienation arguably helps articulate their individual vision of estrangement. This chapter also attempts another outline; one which documents a similarity in their approach to aesthetic representation consequent on their exposure to the artists mentioned here. Moving from consideration of Beckett and Bowie's literary influences to those generated by their interest in painting and cinema to those sounds that inspired them, the chapter concludes with an emphasis on their attitude to rhythm in physical and sonic form, underscoring the manner in which both achieve an intersubjective aesthetic that opens onto the concerns of the other.

In the domain of painting, Beckett frames the modernist challenge to realist convention, both established and emerging, as something alien. His preference is for the "atomistic", art that is resolutely "deanthropomorphic" (*CLSBI* 223) (meaning that the artist renders the world strange and inhuman rather than as an organic, natural extension of ourselves), and he considers Cézanne a key practitioner of such a figurative deconstruction. Beckett describes Cézanne's landscape as "something by definition unapproachably *alien*, an unintelligible arrangement of atoms" (223). Taken by this approach, he attempts to translate this atomized alienation into the spaces of his own fiction, prompting David Addyman to argue that "[f]or Beckett, all places, even that which Bachelard considers the most intimate—the home—are alien" (141). As is more well known, Bowie, too, in adapting first Major Tom as astronaut and then Ziggy Stardust as alien persona, explored outer space as a sonic phenomenon that ushered in a universe of glamorous otherness, throwing into grim relief the post-war world Bowie was also satirizing and seeking to escape. Indeed, he made such great strides in distancing himself from conventional reality that many people believed the young man from Brixton might really be an alien from a world beyond the hetero, the homely, and the human. Moreover, both Beckett and Bowie rendered alien and distant a conventional society rooted in realist conceptions of space and time. Beckett, for his part, generated such an abstracted proxemics in his work, such a radical deterritorialization of person, place, and time, that in a letter

to Hans Naumann in 1954 he seems either incapable or unwilling to ground his own physical and temporal whereabouts:

> If you have other questions to ask, questions to which there are precise answers, I am at your disposal. But as for saying who I am, where I come from and what I am doing, all that is quite beyond me.
>
> (CLSBII 465)

Recalling their unwillingness to control the reception of their work (as discussed in III), here Beckett demonstrates a further disinclination towards explication. In this he seems to echo Bowie who responded to a request for further exposition of his lyrics with the rejoinder "You know, what I do is not terribly intellectual. I'm a pop singer for Christ's sake" (Bilmes, "Bowie on God"). Likewise, Beckett was often quick to downplay the intellectual impulse in his work. In an interview with Gabriel d'Aubarède, he proposes: "I'm no intellectual. All I am is feeling" (Graver and Federman 240).[1]

For the Irishman, art does not pertain to an explanatory impulse. Rather, his work addresses experience in a way that is neither organizational nor teleological; it is not determined by either identifying causes or providing final explanations. Indicating that in point of fact he is quite familiar with the intellectual work of philosophers, he explains to Tom Driver:

> One cannot speak anymore of being, one must speak only of the mess. When Heidegger and Sartre speak of a contrast between being and existence, they may be right, I don't know, but their language is too philosophical for me. I am not a philosopher. One can only speak of what is in front of him, and that now is simply the mess.
>
> (Graver and Federman 242)

And Bowie also recognizes the mess that eludes philosophic explanation. In the liner notes of *The Buddha of Suburbia*, he asserts "My own personal ambition is to create a music form that captures a mixture of sadness and grandeur on the one hand, expectancy and the organization of chaos on the other" (Bowie, *Buddha*). Likewise, he dismisses education and/or philosophy as substitutes for artistic exploration: "to me, it's the avenue of insanity to presume that if you keep studying you'll find the answers" (Bowie, "Pushing Ahead of the Dame").[2] The similarity of Bowie's observation here to Beckett's comment below, made to Michael Haerdter on the subject of the enlightenment project, is apposite:

> The eighteenth century has been called the century of reason, le siècle de la raison. I've never understood that. They're all mad, ils sont tous fous, ils déraisonent! They give reason a responsibility which it simply can't bear, it's too weak.
>
> (Beckett in the Theatre 231)

For both Beckett and Bowie, then, there is something crazy ("insane," "tous fous") in an art that proposes to explain the universe, the mess. Alternatively, both are interested

in the "organization of chaos." Beckett, too, believes that "the task of the artist now" is "to find a form that accommodates the mess" (Driver 243). Essentially, whereas many artists aim to explicate, enlighten, and ennoble through the transmission of knowledge and capacity, Beckett and Bowie reject this route, which is testament to their unwillingness to enforce a teleology that serves the capital status quo. Instead, they seek, in form, a way to express their sense of incapacity in a world oriented around the efficient performativity of commodity exchange for financial reward.

One method both artists occasionally employ to express their inability to communicate within capital production is to frame language as ostensibly failed or failing communication. As language is a tool that delineates the norms of the social, and as social norms are the subject of their artistic critique, both artists often eschew language, instead placing their faith in the silent aesthetics of painting and its capacity to communicate something important about being in a non-verbal idiom. Despite the fact that both men wrote daily until the day they died, both also often indulged in strategic bouts of skepticism towards the communicative possibilities of the word, and at various points in their careers both cast aspersions over language's signifying capacity. Beckett, in a 1937 letter to editor and bookseller Axel Kaun, expresses the desire "[t]o bore one hole after another in [language], until what lurks behind it—be it something or nothing—begins to seep through" (*CLSBI* 51). Expressing a similar distrust of the linguistic, Bowie in his "German period" of the late nineteen-seventies chose to forsake lyrics for instrumental mood music, exploring in particular the silences between sounds. Similarly, silence has always been operative as a motif in Beckett's work, various characters expressing a desire for silence that can be equated with the end and the very absence of being. In his late work, his previous preoccupation with silence translates into shorter page and stage representations that literally and figuratively present extended silence as a way to express an embodied suffering beyond words.

Another challenge to the idea of language as a tool that ratifies the sovereignty of the human subject are the occasions in which both Beckett and Bowie remove authorial intention from the center of making meaning. Beckett's "Lessness" is an exercise in which he

> wrote each of ... sixty sentences on a separate piece of paper, mixed them all in a container, and then drew them out in random order twice. The resulting sequence is the order of the hundred twenty sentences.
>
> (Brienza and Brater 246)

As a result of this randomizing, the first paragraph appears as follows in the printed record:

> Ruins true refuge long last towards which so many false time out of mind. All sides endlessness earth sky as one no sound no stir. Grey face two pale blue little body heart beating only up right. Blacked out fallen open four walls over backwards true refuge issueless.
>
> (*CSP* 197)

This method, and variations thereof, is referred to as "the cut-up technique" and was popularized by William Burroughs and Brion Gysin in the late nineteen-fifties as a foil to what they perceived as society's linguistic colonization of the mind. Burrough's biographer, Barry Miles, identifies a major theme in his subject's work as

> the fight against control systems: establishment values embedded in everyday language, thought and action; control exercised by the state, by religion, by the authoritarian family, by school and by notions of patriotism, honor, class, sexual orientation, conformity and loyalty. For Burroughs the main vehicle for control was the word. Words carry with them a set of assumptions and a system of values that, in his opinion, were often inimical to the individual's best interests.
> (*Call me Burroughs* 23)

Such "control systems," or what Michel Foucault and Gilles Deleuze call "dispositif" and/or "apparatus," require that relation between word and world appear natural and essential. Cut ups are offered as a resistance to essentialist discourses on the basis that they illuminate the contingent and provisional nature of discourses in general. Like Burroughs, Michel Foucault identifies control systems as

> consisting of discourses, institutions, architectural forms, regulatory decisions, laws, administrative measures, scientific statements, philosophical, moral and philanthropic propositions—in short, the said as much as the unsaid.
> (*Power/Knowledge* 194–228)

Crucially, those who sustain such apparatus often do not understand its effects. Rather than instrumentalize exploitative discourses, people must often exist within their structure. In response to this orthodox unconsciousness, Bowie and Beckett, after Burroughs, employ the cut-up technique as a way of escaping these discourses and the narrower confines intentional semantics might privilege. At the same time, they preserved grammar and syntax to afford the reader the possibility of a comprehensible interpretation, albeit separate from direct authorial intention. For Bowie, in particular, the juxtaposed lines of the cut up facilitate the production of strange but strong images, while also capturing something of the fragmentary nature of experience. Alex Sharpe proposes that Bowie enjoyed the technique because "he understood that in the fragments we recognize the patterns and rhythms of our experience. We sense something real and are undone" (63). The same could be said for audiences when they first experience Lucky's monologue in *Waiting for Godot*. Although his "think" defies rational interpretation it bespeaks something of the mess that both Beckett and Bowie identify beyond rational discourses and yet which lurks behind and within such discourses as their emergent other:

> Given the existence as uttered forth in the public works of Puncher and Wattmann of a personal God quaquaquaqua with white beard quaquaquaqua outside time

without extension who from the heights of divine apathia divine athambia divine aphasia loves us dearly with some exceptions for reasons unknown but time will tell.

(*Waiting for Godot* 34)

In Lucky's fragmentary and frantic diatribe, the disorder wrecked by capitalism can be heard as the disintegration of instrumental rationality, disassembled from the formerly coherent narratives of philosophy, sociology, and art.

At the same time, Beckett and Bowie's rejection of authorial intention—while yet trusting language to generate meaning—indicates, as it does with Burroughs, that although their interrogation of language may be deliberate and pointed, they are aware the word overcomes any perceived incapacity to communicate. In Beckett's *Watt*, for example, the eponymous character encounters what the reader assumes to be a pot in the kitchen of the house where he is staying. Yet word and world will not coincide to Watt's satisfaction:

it resembled a pot, it was almost a pot, but it was not a pot of which one could say, Pot, pot, and be comforted. It was in vain that it answered, with unexceptionable adequacy, all the purposes, and performed all the offices, of a pot, it was not a pot.

(*Watt* 29)

Watt can repeat the word "pot" as often as he likes but insofar as the word and object become insensible it remains "pot" and only "pot" that facilitates the statement of linguistic dissolution. In other words, it is the contingency of "pot" that allows the sense of its undoing, but it is also the semantic elasticity of the word "pot" once stated that forestalls its exhaustion as primary signifier. Aware of this supple yet intractable capacity of words to communicate their sense, Beckett and Bowie's use of the cut-up technique and other experiments (such as in the passage from *Watt* above) can also be understood as grudging endorsements of the word's capacity to generate meaning despite deliberate attempts to undermine it. Certainly, one should not equate Beckett and Bowie's occasional claim that linguistic meaning is inadequate for the purposes of human communication with a desire on their behalf to directly impede conventional semantic understanding at every turn. Rather, silence and the cut-up technique are occasional artistic strategies they employ in conjunction with many other approaches to writing that exploit the affective powers of language intentionally. In point of fact, while Bowie sought to achieve the "organization of chaos" through art and Beckett believed that the task of the artist is "[t]o find a form that accommodates the mess," (Graver and Federman 219) Beckett arguably speaks for both artists when he tells Charles Juliet

You can't even talk about truth. That is part of the general distress. Paradoxically, it's through form that the artist can find a kind of solution – by giving form to what has none. It is perhaps only at that level that there may be *an underlying affirmation*.

(*Conversations with Samuel Beckett* 66–7)

Both Beckett and Bowie see *art* as *the form* that offers the possibility of an affirmative politics in response to the general lie of a world alienated and alienating. And beyond their shared, intermittent assaults on semantic sense, they both embark upon many other linguistic experiments with artistic form in pursuit of this "underlying affirmation." Moreover, this task is something they undertake as an obligation. For Beckett, the predicament of the artist is the fact that

> there is nothing to express, nothing with which to express, nothing from which to express, no power to express, no desire to express, together with the obligation to express.
>
> (*Disjecta* 112)

Singing from similar sheet music in the catalogue essay for his first solo art show "New Afro/Pagan and Work," Bowie notes:

> In neither music nor art have I a real style, craft or technique. I just plummet through, on either a wave of euphoria or mind-splintering dejection. This can often all be held together by a bloody-minded determination to create something that was not there before.
>
> (Morley, *The Age of Bowie* 135)

And this obligation towards expressing something, albeit the impossibility of guaranteed meaningful expression, is really the crux of the issue. Both seek to make a new kind of statement in a deterritorialized space characterized by ruination but with an emphasis on artistic structure as potentially redemptive. They both have fidelity to art as craft with an emphasis on the form—on the "how" it is done—mirroring how experience needs to be shaped in art in order to adequately represent the feeling and sense of alienation. For these reasons their art involves experiments with the word, with time and space and our place within it, the better to highlight the alienation that we embody when our aesthetic capacity, along with our material existence, is systematically proscribed.

Turning to consideration of their interest in a communicative literature that presupposes broad forms of communal semantic agreement shared by author and reader, and one in which readers assume authorial intention as a guiding presence rather than a hindrance, in 2013 Bowie made public 100 books that he believed to be representative of his interests as a reader.[3] Regarding Beckett's extant reading history, Mark Nixon and Dirk van Hulle have catalogued his private book collection in their monograph *Samuel Beckett's Library* (2013). This collection reflects Beckett's reading habits from the nineteen-thirties, when Beckett himself was in his thirties, onwards. The first thing of note is that there are no works by Beckett in Bowie's list (just as, to my knowledge, Beckett possessed no Bowie music). We know for sure that Bowie was familiar with *Waiting for Godot* (1952) and *Happy Days* (1960), evidence for which will appear in due course, and there is reason to suspect that he was also familiar with *Endgame* (1957), "Krapp's Last Tape" (1957), and late dramaticules such as "That Time"

and "Ghost Trio" (1976). However, direct comparison between the books in Beckett's Parisian apartment and Bowie's list yields only one shared work: Dante's *Divine Comedy* (1308–1321 approx.). Certainly, a convincing argument can be made for the influence of Dante's vision on the work of both. In Bowie's work, echoes of Dante can be heard in "Width of a Circle" (1970) where the narrator seeking true knowledge encounters monstrous humanity on a journey there and back again. Most notably, and to be discussed in greater detail in VIII, Dante is present both analogically and allegorically in "The Next Day," "Blackstar," and "Lazarus," Bowie's parting contributions to the visual arts and music.

In Anne Atik's book, *How It Was* (2005), she states pointedly that Dante was Samuel Beckett's "mentor" (79) and that the latter knew, by heart, passages of *The Divine Comedy* such as "Sì che chiaro/per essa scenda della mente il fiume" [through it clear the stream of memory may flow] (qtd. in Atik 80; orig. Alighieri, "Purgatorio" XXXIII, 89–90). Certainly, Dante's work clearly flows through that of Beckett from start to finish.[4] From the title of one of his first short stories ("Dante and the Lobster") to the title of his first piece of significant literary criticism ("Dante… Bruno. Vico. Joyce"), Dante's work serves as a gloss and guide to Beckett's creative world, the Italian's dark and comic vision never far from the surface of Beckett's poetry, drama, and prose. Direct references to Dante pepper Beckett's theater. The animator in "Rough for Radio II" asks the stenographer "Have you read the Purgatory, Miss, of the divine Florentine?" to which she replies "Alas no, sir. I have merely flipped through the Inferno" (*CSPSB* 118). In "All that Fall," the Rooneys walk "Like Dante's damned, with their faces arsy-versy," (*CSPSB* 31) indicating one forward and the other backwards, in an allusion to the damned of the "Inferno" (XX.22–4) who are condemned to walk eternally in Hell, their faces turned towards an escape their bodies can never allow. Allusions, too, abound, especially in Beckett's poetry and short prose. His early poem "Malacoda," written on the occasion of his father's death, utilizes the name of a Dantean demon to mark both the undertaker and the unfortunate fart he releases while removing Bill Beckett's body from the family home. In "Texts for Nothing 6" the narrator recalls "I was, I was, they say in Purgatory, in Hell too, admirable singulars, admirable assurance. Plunged in ice up to the nostrils, the eyelids caked with frozen tears, to fight all your battles o'er again" (*CSP* 124–5), and utilizing a similar image in *Ill Seen Ill Said*, the narrator is resigned that "the eye will return to the scene of its betrayals. On centennial leave from where tears freeze" (*GCW* 458). Both of these moments deliberately echo the damned of the Inferno, frozen in ice ("Inferno" XXXII 46–8), whose crystalized tears are a metaphor for the irrelevance of penitence when one has been abandoned by God.

More than this, however, these references, and many others like them in Beckett's writing, indicate the degree to which Dante is both mood and map of the Beckett universe; a ruined world echoing the cosmology that Dante generated and which became a template for modern conceptions of Hell, Heaven, and a purgatorial earth betwixt. In this regard, Beckett's work can be purgatorial and/or infernal. Early stories such as "A Case in a Thousand" and *Murphy* emphasize the purgatorial quality of extended waiting. Just as the intertextual reference to Dante's Belacqua figures Dublin

as a purgatory by association, in *Murphy*, his first novel, Beckett works meticulously to generate the intertextual sense that London, where the action is set, is equally punishing. In what is referred to as his "Whoroscope Notebook" (kept at the time of writing *Murphy*) and although he makes a note to self to keep the Dante parallels low key rather than obtrusive, nonetheless he wishes to create a "Purgatorial atmosphere sustained throughout" his first major fiction (qtd. in Ackerley and Gontarski 94). In the purgatory that is the capital of the imperial British Empire, the Irish Murphy is a pronounced outsider, reflecting the London experiences of the Irish Beckett whose letters from this period record speaking to no one for days on end (*CLSBI* 111). *Endgame* and later dramas appear often to be set in the inferno of Hell itself. Keir Elam proposes that of "the seven dramaticules published after *Not I*, six share its dominant infernal dramaturgic and iconongraphic modes" ("Catastrophe" being the odd one out, Elam "Dead Heads" 155). Furthermore, the tripartite structure of the very late prose piece "Stirrings Still" reflects hell, purgatory, and a version of heaven from which the narrator wants to escape. Rather than live eternity in any of these three spaces, he wishes for all to end, a plea that reflects the degree to which Dante's creative vision is one wherein the subterranean is a much more interesting and inviting proposition than the celestial. Dante's imaginative underworld, with its own abstract elaborate geometry, is at once entirely different to material human space and yet—since it is populated with countless outsiders, those denied paradise and forced to live in chthonic space, including those without sin yet born too early into purgatory—it also frames the human in recognizable spatial metaphors as alien creature, banished, lost, and alone.

The estranged world that Dante evokes, a miserable place shot through with occasional humor and hope, is reflected in the geography of the worlds of Beckett and Bowie. In a moment that touches both, the appendix of *Watt* includes the fragment "qual ella sia, parole non ci appulcro" [what that is like, no words can embellish] from "Inferno" (VII. 60), which describes Virgil's exhausted inability to properly articulate his disgust at the behavior of corrupt cardinals. "The Next Day" features a Bowie character who appears as a medieval figure and who articulates the crimes of "purple headed priests," excoriating them for their sado-masochistic rituals of punitive and predatory self-loathing. And in the video for "Blackstar," Bowie, again performing the role of a prophet seer, looks to the night sky in a manner redolent of Dante at the conclusion of the "Purgatorio" who, having climbed out of Hell, is "puro e disposto a salire a le stelle" (XXXII.145) [pure and ready to ascend onto the stars] (Alighieri *Divine Comedy*). As we know, Bowie himself took flight from life shortly after completing the video in question that frames him as Dante ascending, book in hand, towards a notional Paradiso. At the same time, the video also contains a vision of an earth-bound triple crucifixion, and, to complete its allusion to Dante, an underworld with shivering inhabitants where a delighted Bowie dances in the subterranean darkness "at the centre of it all," like Lucifer in the ninth circle of Hell. As in Beckett's "Stirrings Still" here is another version of Dante's triune universe in miniature: a glimpse of and suggestion of Heaven, the sufferings of the material world, and a vision of Hades. Likewise, the video for Bowie's "Lazarus", which follows "Blackstar", echoes the possibility of a transcendence that is skewered by a bed-ridden Lazarus as a broken man reaching

for a Heaven he will never inhabit. In just such complementary and contrasting ways, both Beckett and Bowie employ Dante Alighieri's *Divine Comedy* throughout their work and, as we shall see, together with Shakespeare, the divine Florentine frames the mood and manner of both artists' late engagement with finitude. *The Divine Comedy* might be the only book both owned and yet it is also certainly *the* book best suited to illuminate the final movements of two creative artists who chart a descent into the inferno that is the very opposite of Dante's final ascension into Heaven. As we shall see, both knew hellish times require a hellish response.

The isolation endured by characters in Dante is replicated in Beckett and Bowie's modern literary tastes. Regarding one of the most preeminent modernists of his generation, we know Beckett and Bowie read T. S. Eliot's *The Wasteland* (1922); the modernist poem of alienation *par excellence* is on Bowie's list and a significant literary marker for both.[5] Eliot's poem, constructed out of a tissue of classical citations which suggest the reader may find a spiritual home in knowledge and appreciation of history and culture, fails finally to amount to a redemptive myth of regeneration. Rather, the poem's narrative arrives at the site of the holy grail to find the tabernacle empty, implying the same, finally, is true of a modern culture becoming increasingly mechanistic and instrumentalized. Eliot's strategy of lamenting the disintegration of aesthetic culture, in a style that reduces the history of that culture to half remembered fragments, is echoed in the manner in which Beckett uses literary and historical references to consolidate an increasing aesthetic impoverishment rather than endorse a nostalgic yearning for wholeness and originality. As we shall see, Bowie, too, often returns to previous artistic and aesthetic cultural moments, be they literary or musical references, and recycles them as fragments and citations, most notably on *1.Outside* where experimental sound is accompanied by the echo of a distant and wistful classical piano. His aim is the same as that of Eliot and Beckett; to use our inability to recapture the past as commentary on a modernity shorn of its authentic and organic relationship to its own history. For Eliot's "The Hollow Men"

> The eyes are not there
> There are no eyes here
> In this valley of dying stars

and this stellar blindness/insight metaphor may well have played a role in the conception of the "Blackstar" character, Button Eyes, and in the dead star motif that governs Bowie's artistic departure.

The motif of ruins and the associated metaphoric resonance of ruination, central to "The Wasteland" and "The Hollow Men," is also key to the work of Beckett and Bowie. A part of their intention is to frame ruination as an affront to bourgeois sensibilities, so they generate imaginative spaces in which architectural ruins constitute the backdrop against which the ruins of material history and artistic practice stand out in splinter and fragment, signs of the disintegration of the redemptive possibilities of previous traditions of epistemological legitimation. At the same time, this disintegrating

art succeeds in creating moments of what we might call, after Walter Benjamin, "revolutionary time." Benjamin proposes that at those moments when historic ruination emphasizes collapse, "jetztzeit" [Now time] ("Theses on the Philosophy of History") emerges as an alternative. As such, revolutionary time provides a glimpse of the need for real action, and it is generated through the proxemics of an art committed to exposing and challenging social alienation (something considered by way of conclusion in X).

Despite the fact that Beckett's library houses only one (albeit *uber*) work that Bowie also recommends to the general reader, the pair share a reading habitus of alienation spanning the centuries, and continents, from medieval Italy to post-war Europe. As discussed earlier in the chapter and by way of concluding analysis of their literary interests, Beckett and Bowie both have an occasional impulse towards undoing the word, devesting it of intentionality through using the cut-up technique and so on. Beckett once framed his occasional forays into both free-floating signification and intermittent opacity by asking "is literature alone to remain behind in the old lazy ways that have been so long ago abandoned by music and painting?" (*CLSBI* 518). Clearly, then, painting played a significant role in Beckett's thinking about language and about new approaches to classical and essentialist classifications of literature. And in their aesthetic engagement with the terms of meaning itself, in their desire to occasionally render language opaque, their mutual interest in painting and the canvases on which visual artists make and mark outside(r) spaces is pivotal to this aesthetic. As this chapter began with Beckett and Bowie's shared rejection of enlightenment rationality, it seems fitting now to move on to consideration of their relationship with painting and visual culture, including their mutual appreciation of cinema. All are instances of their love of visual art forms that contribute to their rejection of an aesthetics of knowledge and control.

Vision

If, for Beckett and Bowie, articulating alienation as a theme was something principally learned from literature, and in Bowie's case also from song lyric, then alienation as aesthetic form was something they gleaned from the formal experimentation of many arts, and, most notably, painting, an avenue not principally associated with either artist, but one deeply cherished by both of them. David Lloyd explains:

> A passion for painting motivated Beckett's repeated visits to Dublin's National Gallery as a student, when he lived around the corner in the attic of his father's offices, and his regular trips to the galleries as a young man in London. It structured his extended stay in Germany in the 1930s, where he visited not only galleries, museums and churches in order to view medieval and baroque religious art, but also the cellars of institutions where art banned by the Nazi regime was stored.
>
> (*Beckett's Thing* 2)

As a result of Beckett's life-long passion for painting, and of ceaseless self-exposure to art, Lloyd suggests:

> Beckett's theatre, for stage and for film and television … is not merely like painting, or based on paintings, but is its own form of visual art … It is a striking fact about Beckett's dramatic work in any medium that one can arrest the action at almost any point and be rewarded with a tableau that is a virtual painting—a 'still' from any of the works appears as a calculated 'still life' to borrow one of his favourite word-plays.
>
> (*Beckett's Thing* 1, 7)

Astute criticism from Lloyd, and, in addition to "still life," the French equivalent "têtes-mortes" offers a rich register for Beckett's staged paintings. Rather than a joyous still life such as *A Basket of Roses* by Henri Fantin-Latour, which graces the cover of New Order's *Power, Corruption and Lies*, Beckett's stage images are redolent of the Doré engravings of Dante's Inferno: Dark, chthonic outsider imagery featuring literal dead heads that also signify other forms of death, both spiritual and intellectual.[6] They are images intended to arrest the audience as a consequence of their power to frame the embodied being of estrangement. In this, they represent a type of aesthetic suspension in which time and space seem temporarily interrupted and the image presented occupies its own proxemic coordinates. Similarly, any still life image taken from the videos for Bowie's "Life on Mars?" or "'Heroes,'" or "Ashes to Ashes" generate a similar capacity to surprise the viewer with an image that defamiliarizes not only the expectations of a pop video but also gender and culture and species being.

Regarding the influence of the visual on his writing, Bowie observed:

> I see the whole of what I do in terms of painting. I've always thought they were very close. A lot of the songs I have written are for me paintings in words. A lot of the more embellished pieces, the ones really loaded with sound, where there are lots of things to listen to on repeated play, came from the idea of building up layers of paint so that you see something new each time.
>
> (Pegg 8)

Here he equates his approach to music, as layered and requiring multiple listens, to how the viewer must encounter non-representational painting. Bowie is clearly talking of figure as emerging from abstraction, in terms of a painting having depth that must first be explored before viewers can begin to absorb and assimilate what they see.

Jack Yeats is a painter noted for his use of thick impasto to achieve the same effect Bowie seeks in song, and his visual aesthetic is important to both Beckett and Bowie.[7] Although not such an avid art collector as Bowie, Beckett was still determined to possess the work of Jack Yeats, owning two of his paintings in his lifetime, and "spending days talking to the painter and walking with him in the

Dublin countryside" when Beckett still resided in Ireland (*Beckett Remembering* 60). Reading against the conventional critical assessment of Jack Yeats, Beckett compared him to Cézanne, imagining his work as de-anthropomorphic:

> The way he puts down a man's head & a woman's head side by side, or face to face, is terrifying, two irreducible singlenesses & the impassable immensity between …
> A kind of petrified insight into one's ultimate hard irreducible inorganic singleness.
>
> (*CLSBI* 536)

Lloyd surmises that "it is probably impossible to tell to which Yeats paintings Beckett is referring" (*Beckett's Thing* 33) in this passage but the description does suggest an uncanny similarity to *Sleep Sound* (1955), the Yeats painting Bowie owned. In it we encounter what appears to be a man and a woman reclining in a way that emphasizes more their mineral relation with the earth rather than any relationality with each other. They look indeed like a "petrified insight" of "irreducible … singleness" (*CLSBI* 536). For his part, and in contrast to Beckett, Bowie referred to Yeats as a "gentle artist" but one whose "symbols for love and death are strong" (Carr). Bowie had also been told, and told Eamon Carr in turn, that *Sleep Sound* might have been an influence on the iconography of *Waiting for Godot*:

> I have a painting of [Yeats] of two bums lying on a hillside, sleeping. The apocryphal story is that it was one of the paintings which influenced Samuel Beckett when he was writing *Waiting for Godot*, which I'd love to believe.
>
> (Carr, "A Genius")

Although interesting that Bowie thought of the figures in his painting as two bums, thus opening up the possibility that the Yeats's work did indeed inspire Beckett's famous play, the date of composition supports neither this hypothesis nor the idea that Beckett might have been referring to *Sleep Sound* when he spoke of Yeats's "petrified" style in 1937. The fact of the matter is that Yeats painted *Sleep Sound* in 1955, six years after Beckett composed *Waiting for Godot*.[8] At the same time, however, Beckett's interest in Yeats's "irreducible singlenesses" in his letter above, which was written in 1937, clearly indicates a Jack Yeats influence on Beckett, and David Lloyd, among others, has done a superb job of identifying the many ways in which Jack Yeats's work may have helped frame the look and feel of Beckett's writing and stage work. So, although the Yeats painting Bowie owned could not have been an influence on the mise-en-scène of Beckett's most famous play, this is not to suggest Yeats was not an influence on Beckett. Quite the opposite. Jack Yeats's work had been on Beckett's mind for decades at that juncture. Indeed, the manner in which *Sleep Sound* might reiterate something of the inorganic singleness Beckett admired in Yeats could have influenced the pebbled complexion of his characters in *Play*, which Beckett wrote in 1962, for example. Moreover, something extremely relevant regarding both Beckett and Bowie's appreciation of Jack Yeats lies precisely in his deployment of "love and death symbols" in his work. Bowie and Beckett do likewise in their own final moments (of

which more towards the conclusion of this study) and in doing so, in Bowie's words, "keep [us] focused on questions of humanity" (*Collector* Vol. I 13).

Another painter known to both Beckett and Bowie, whose work also has a pronounced aesthetic dealing with love, death, and, especially, decay, is Erich Heckel. The German had an important influence on their visual imaginary, which was also shaped by Robert Wiene's *The Cabinet of Dr. Caligari* (1920), a movie inspired by Heckel's style. Wiene's instantiation of ruination is part nightmare and part sci-fi parable. The influence of the movie on Bowie is a given because he said so directly, informing Michael Kimmelman in a *New York Times* article that he also has "a thing for Murnau and Fritz Lang" and other German Expressionist cinema ("Bowie's Favourite Artists"). In Beckett's case, the influence is indirect but nonetheless deducible. In *Samuel Beckett and Cinema* (2017), Anthony Paraskeva places in context a reference by Beckett to Werner Krauss, the principal actor in Wiene's 1919 masterpiece. After seeing the actor in rehearsals for one of his plays, Beckett writes: "Krauss is a great actor. The best I have seen. I had only seen him in films before" (qtd. Paraskeva 6). Paraskeva deduces that if Beckett had only previously seen Krauss on film then presumably he had seen *The Cabinet of Dr. Caligari* before he traveled to Germany in 1936. We can add further credence to this because, on his travels in Hamburg, Beckett also mentions seeing "German Expressionist film screw stairs" in a letter penned on November 4, 1936 (Paraskeva 6). These would most likely be the type of screw stairs utilized in the asymmetrical architectural designs that represent the exteriorized psycho-scapes of Wiene's film (Paraskeva also persuasively reads a passage from *Murphy* as an intertextual wink to the crazed courtyard which bookends *The Cabinet of Dr. Caligari*).

We know from his letters that Beckett had the opportunity to meet Heckel when traveling on an extended trip to Germany (see *CLSBI* 387, 427) but a meeting never took place largely as a result of Beckett's traveling from city to city to see art (and partially because of his pronounced youthful diffidence). Although Beckett claimed not to like the Heckel frescoes he encountered (see *CLSBI* 477), the aesthetic of the *Die Brücke group* (of which Heckel was a member) seems nonetheless to have had an influence on him. In this regard, Paul Sheehan notes of Beckett's German art trip that "he immersed himself in … numerous works by German expressionist artists: Emil Nolde, Erich Heckel, Ernst Kirchner, Karl Schmidt-Rottluff [and] Otto Dix" and that

> their compulsive fascination with the depredations of metropolitan life … leaves a lasting impression on the thirty-year-old Beckett. The residuum of the German expressionist outlook is as discernible in *Murphy*, and its characterization of the prostitute Celia just as surely as it is in the television dramas of the 1960s and 1970s and the late, spectral plays, *That Time* and *Footfalls*.
>
> (*Beckett in Context* 141)

Certainly, extant photos of the set of the various film recordings of "Eh Joe" (1965) look like a series of Heckel woodcuts, as does any properly staged production of *Endgame*. Alissa Darsa notes of German Expressionism that "the films of this era

are, in their own way, a revealing look at a society at a particular moment in history, expressing the disillusionment, distrust, and isolation experienced by many people living in Germany at the time" ("Introduction to German Expressionist Films"). Indubitably, Beckett's work is characterized by tropes of isolation and disillusionment, reflecting something of the *Die Brücke* vision and, certainly (as Sheehan points out) the *têtes-mortes* of the late drama and the monochrome symmetries of "What Where" and "That Time" evoke both the recognizable aesthetic in question and a sense of isolation and alienation.

Similar to Beckett's art excursion to Germany, a disillusioned Bowie fled LA to Berlin in 1977, and, once there, came directly into contact with the work of *Die Brücke*. Identifying with the stark aesthetic he decided to use Wiene's lighting designs for the *Isolar* tour in 1976 because he too was coming from a position of distrust; distrust of the music business, of how fame prohibits forging intimate human relationships, and the distrust engendered by "the fear," a feeling induced by habitual drug use, leaving the mind isolated and paranoid. Moreover, utilizing Heckel's monochrome mood (as mobilized by Wiene) so extensively in 1977, when color television had entered most households, meant that once again Bowie was cleaving from the popular to champion that which had been discarded. As he noted on the subject of being avant-garde:

> the most interesting thing for an artist is to pick through the debris of a culture, to look at what's been forgotten.
>
> (*Collector* Vol. I 159)

In keeping with preserving echoes of the forgotten, the singer appears on the cover of "*Heroes*" (1977) in a photograph that replicates Heckel's 1917 woodcut portrait of fellow artist Ernst Kirchner. Similarly, Heckel's painting (as opposed to woodcut) *Roquairol* (1917) inspires the cover for Iggy Pop's *The Idiot* (1977) and again Iggy mimics Heckel's self-portrait of 1917 for the cover of his album *Lust for Life* (1977).[9] At the same time, Egon Schiele's work is also clearly a visual reference for both Bowie and Iggy Pop during this period. Both Schiele and *Die Brücke*, as Sheehan notes, seem also to have been a fitting aesthetic for the type of urban alienation Beckett was trying to achieve in *Murphy* (1936), his "London novel," and then later in his dramaticules, as they emphasize the type of cultural dislocation for which Heckel and company became figureheads. In just such ways, both Beckett and Bowie were able to use the art of a previously fragmented cultural moment to help them express their own fragmented states; separated in time but "bridged" in their shared visual poetics.

Arguably the most important aspect of Beckett and Bowie's immersion in the visual arts is their sense that they capture something of the reality of being beyond what words can achieve. In this regard, Bowie remarked:

> art was, seriously, the only thing I'd ever wanted to own. It has always been for me a stable nourishment.
>
> (*Collector* Vol. I 11)

It turns out he owned quite a bit. The 2016 auction of his private collection at Sotheby's reveals a substantial array of favored artists across multiple styles and epochs. One of the most impressive pieces (a claim supported by its price tag) was Frank Auerbach's *Head of Gerda Boehm* (1967), which sold for 3,789,000 pounds sterling, beyond an initial estimate of 300,000 pounds.[10] Describing his fluid relationship with the painting, Bowie notes how it both reflects and often bridges his own sense of alienation:

> the same work can change me in different ways, depending on what I'm going through. For instance, someone I like very much indeed is Frank Auerbach. I think there are some mornings that if we hit each other a certain way—myself and a portrait by Auerbach—the work can magnify the kind of depression I'm going through. It will give spiritual weight to my angst. Some mornings I'll look at it and go: 'Oh, God, yeah! I know!' But that same painting, on a different day, can produce in me an incredible feeling of the triumph of trying to express myself as an artist.
>
> (Kimmelman)

It is interesting when comparing Bowie's meditation on his *têtes-mortes* with those of Beckett that, arguably, the archetypal image that most haunted the Irish playwright is the head. Consider "Eh Joe," "What Where" (1983), and the disembodied mouth of "Not I" (1972). The face, whole or fragmented, dominates these plays. In "That Time" (1975) the character C—who is himself a face floating above the blackened stage— recalls a face emerging from a black canvas in the National Portrait Gallery London; a verbal imminence not dissimilar to the manner in which Auerbach visually manifests the *Head of Gerda Boehm*. Moreover, Bowie sees in Auerbach's painting a reflection of his own being. For Beckett, this very capacity of abstract painting denotes it as the medium for a proper expression of being. Lawrence Harvey, summarizing an interview with Beckett as a young poet, observes:

> He doesn't think that the theatre is the best medium to do what he is attempting. There are too many conventions (i.e. forms) that must be accepted and that restrict. He thinks that painting being does not lead to doctrine and form.
>
> (Knowlson, *Beckett Remembering* 135)

It would appear that for Beckett, a visual aesthetic can invoke spaces beyond expectation in which "painting being" becomes possible. In short, writing should seek to escape convention in its desire to be alien. Believing that "[a]rt has nothing to do with clarity, does not dabble in the clear and does not make clear" ("Intercessions by Denis Devlin," 94) he seeks to frame literature in a similar space. In other words, Beckett's interest is in inhabiting spaces that are *beyond* the conventions of the dominant culture, including its artistic conventions. Recalling Storey's definition of how hegemony is the operation by which "dominant classes seek to impose their own tastes as if these were in fact universal tastes," it achieves its aims when

patterns of consumption are used to secure social distinction, the making, marking, and maintaining of social difference ... In this way, the production and reproduction of cultural space helps produce and reproduce social space, social power and class difference.

(142)

When it comes to painting, Samuel Beckett and David Bowie are interested in more than the dominant mode of classical representative painting, seeking to privilege alternatives that challenge that hegemony aesthetically in painting form. For both, painting is a space where the motifs, tropes, and inarticulations of alienation and estrangement can find a home in precisely the manner in which the form can consolidate the content outside of realistic representation.

For example, Lois Overbeck and the editors of Beckett's collected letters note that Georges Duthuit, Beckett's friend and fellow art aficionado, was actively antagonistic towards Italian Renaissance painting: "hostility to the Western mimetic tradition was cardinal to Duthuit's aesthetic, hostility to Italian art in particular" (*CLSBII* 87). In his book on the Fauvist painters, Duthuit declares that

> classical painting remains flat ... We live in material extension, it has depth and the masterpiece has not and it is into the midst of the ideal that we are thrust ... shackled by space and bowed beneath the axe of time ... and that is why their work had become unbearable ... none of these personalities overthrew the barriers which space and time interpose between the minds of men.
>
> (reproduced in *CLSBII* 88, from *Les Fauves* xxvi–xxxvi, trans Overbeck et al.)

In the course of their correspondence on the subject, Beckett responded to Duthuit:

> I feel so clearly what you say about space and the Italians. I remember a picture in the Zwinger, a St Sebastian by Antonello da Messina ... Pure space by dint of mathematics, tiling, flagstones rather, black and white, with long, Mantegna-style foreshortenings, that would draw moans from you, and the victim of the stoning, displayed, displaying himself, to the admiration of the courtiers taking the Sunday air on their balconies, the whole thing invaded, eaten into by the human. In front of such a work, such a victory over the reality of disorder, over the pettiness of the heart and mind, it is hard not to go and hang yourself.
>
> (*CLSBII* 86)

Beckett, agreeing with Duthuit's ideas about painted space, identifies that the da Messina painting is not just shackled by a realist framing of space and time in terms of perspective and event, but also by its reproduction of classical architectural symmetries, illustrating its creator's desire to frame Sebastian's suffering within a recognizable neo-classical Italian architecture. This architecture itself is mobilized within the painting to figure the torture within a coordinated aesthetic symmetry, what Beckett alludes to as "mathematics." In short, the painting's approach to space and time frames it through

Italian architectural culture, endorsing it as the appropriate visual context for turning human cruelty into an aesthetically pleasing event. The implication of Beckett's wry denunciation is that the modern artist must liberate painting from conventional mimetic coordinates of space and time, which means liberation from naturalist and realist traditions. In this it will become possible to present "the reality of disorder" as a means to challenge, at base, the ideologies generated by any given society—in this case Italian neo-classical art, which Beckett argues is designed to translate suffering and pain into an aesthetic event.

These exchanges on painting help clarify something about Beckett's deployment of unidentified and even deterritorialized spaces in his work. For example, the solitary tree and unnamed road in *Godot* provide a backdrop that opens up the possible resonances of the tramps' futile wait, allowing the play to function as a frame for crises, including the Bosnian war, the hurricane in New Orleans, native South African dissatisfaction with rising rent prices, and, more recently, the spatially denuded world of COVID-enforced online theater.[11] In other words, the play's mise-en-scène functions well in the type of "material extension" Duthuit ascribes to a meaningful world precisely because it does not try to batten down the action's space and place. Moreover, material extension can also be a spatio-temporal deterritorialization; spaces that are not invaded by the human but rather that challenge such anthropomorphism. In Beckett's *Watt*, for example, an old Irish "Big House" is gradually transformed into an uncharted and liberated architectural proxemics the coordinates of which begin to challenge conventional ontological or epistemological securities. At one juncture, Watt considers the relationship between two elements in a painting he sees in his new home:

> A circle, obviously described by a compass, and broken at its lowest point, occupied the middle foreground, of this picture. Was it receding? Watt had that impression. In the eastern background appeared a point, or dot. The circumference was black. The point was blue, but blue! The rest was white. How the effect of perspective was obtained Watt did not know. But it was obtained. By what means the illusion of movement in space and, it almost seemed, in time was given, Watt could not say. But it was given. Watt wondered how long it would be before the point and the circle entered together upon the same plane.
>
> (*Watt* 128)

The possibility that the circle and point are mobile, a perspective generated by the contrast between their relatively small size compared to the white space of the canvas, opens up the painting's simple arrangement to the larger philosophic (and aesthetic) question of the relationship between objects within the painting and the nature of the viewing subject's role in the representation of the objects being viewed (Watt, for example, has the "impression" that circle and point are on the move). In short, Beckett's denuded painting is a platform for a meditation on the nature of aesthetic creation and contemplation, and on the role of the viewer in creating what s/he sees.

The French philosopher Jacques Rancière believes what he calls "the aesthetic regime of art" to be necessarily political (*The Politics of Aesthetics* 11). Given that

"the distribution of the sensible is the system of self-evident facts of sense perception" (9), aesthetic function serves to reinforce or open up such distribution. Additionally,

> the distribution of the sensible reveals who can have a share in what is common to the community based on what they do and on the time and space in which this activity is performed. Having a particular 'occupation' thereby determines the ability or inability to take charge of what is common to the community; it defines what is visible or not.
>
> (12–13)

Artists who develop aesthetics must understand that their activity is

> a delimitation of spaces and times, of the visible and invisible, of speech and noise, that simultaneously determines the place and the stakes of politics as a form of experience. Politics revolves around what is seen and what can be said about it, around who has the ability to see and the talent to speak, around *the properties of spaces and the possibilities of time.*
>
> (13)

In this way, Rancière understands "aesthetic acts as configurations of experience that create new modes of sense perception and induce novel forms of political subjectivity" (9). If space is political then the delimitation of it that characterizes conventional forms of expression within the dominant hegemony can be challenged by an aesthetic practice that seeks to open space up beyond delimitation itself. Thus, Beckett (and Bowie, too, as we shall see) deterritorializes space and introduces us to "novel forms of political subjectivity" as space becomes the frame for movement between the mundane and the extraordinary as conventional borders are transgressed.

While Bowie often uses outer space to suggest liberating experience, similar to the way that Duthuit frames the possibilities of canvas space, it can also function in his work as a metaphor for the alienated nature of many of Bowie's subaltern characters. Moreover, he utilizes the image of outer space as a way to generate spatial shifts within songs that correspond to emotion shifts in character and mood that open up possibilities of space and time. For example, "Life on Mars?" involves three different spatial shifts—from home to silver screen to outer space—all culminating in the mousey-haired girl's yearning for alien identification. Yet at the same time that it sets up Mars as liberating destination, the song displaces the girl within the song structure itself, replacing the disaffected youth with an adult version now working in the entertainment industry and bespeaking an agèd cynicism that the younger girl would reject. Furthermore, and simultaneously, at the moment the poetic voice of the song begins to compose the images of the song itself, the mousey-haired woman becomes coextensive with David Bowie as character and creator. In this moment, gender and alienated subjectivity are both condensed and displaced as a switch in subject positions invokes a creator/character gender-inclusive intersubjectivity through which alienation from species being is temporarily suspended in a moment of intensely inhabited being.

The song begins, famously, with the girl cast out of the house, and friendless, making her way to the local cinema and her familiar seat and habitual refuge. Disowned by parents for some unknown crime against home and hearth she finds herself simultaneously plugging in and dropping out from movie stereotypes she once loved but now finds hollow and unfulfilling.

Reeling off references to what might be a cowboy movie or a routine American detective film, and what sounds very like *2001: A Space Odyssey*, it is clear they do not move her as they did before. The catharsis these films generated previously has been worn out and she begins to recount a series of images that may or may not play out on the screen before her. Her dissatisfaction with the cinema explains the dual sense in which these images seem at once politically charged and yet no more than fragments of a depoliticized entertainment culture. The homonym Lenin/Lennon nicely fuses the idea of a politically aware pop with the dangers posed to politically engaged left-wing ideology by a "mickey-mouse" America (mickey mouse here in the sense of new, immature, and ill thought out); an America that has metamorphosized into a cash cow, its fate sealed by an increasingly pervasive and alienating capital ideology. The implication throughout this section is that now bored with the silver screen, the girl is also aware of it as a technology that shapes life rather than simply reflects it. Just as Bowie elsewhere suggests Andy Warhol and the silver screen cannot be told apart, the mousey girl knows the world of cinema has become a type of reality itself, but a fetish reality attempting to disguise the meaninglessness of habitual living that in actuality is characterized by the smokestacks of British industry and its proliferating, identical housing estates, indistinguishable one from the other. She is dimly aware that movie sequences involving sailors slugging it out in saloons are precursors to an expanding fetish entertainment industry—one that has materialized today in the shape of reality TV shows and pop culture competitions, shows in which "reality" is potential fame packaged as seductive illusion, mickey mouse to the core. Moreover, Britannia, mascot of imperial England, is increasingly a symbol of colonial appropriation rather than one of national patriotism. Against this background of lost innocence and increasing alienation, the final image of the section suggests a suicide note and the entrusting of favored possessions to a passive mother and husband-compliant wife. And then, at this bleakest of moments, the chorus returns as do the principal images of the song:

> Take a look at the lawman beating up the wrong guy
> Oh man, wonder if he'll ever know
> He's in the best-selling show
> Is there life on Mars?

In a pleasingly diverting (and self-reflexive) moment the girl wonders if lawman or wrong guy are aware that they are fictional characters in a movie, just as she wonders if humankind will ever discover the secrets of the outer universe, inhabited or otherwise. The most cursory reading of the song concludes here. Alienated from home, and from the cinema where once she was often temporarily but safely housed, her only hope of finding communion now is in deep space itself, far beyond an

alienated and alienating humanity. At the song's conclusion, space is the next frontier of possible self-identification. However, the enjambment that runs from "best-selling show" to "life on Mars" also suggests that either of the actors playing "lawman" or "wrong guy" also star in a movie called "Is there life on Mars?" In questioning actor/character awareness of other performances in other cinematic worlds, other spatio-temporal evocations, she suggests the possibility of porous identity between performer and character, between the lives of those ostensibly real and those thoroughly imagined. Immediately, this porous possibility between character and creator becomes embodied in Bowie as the song switches to the first-person voice. Simultaneously, we hear the adult girl write, in an intense present moment, the images of the song to which we have been listening; she and Bowie are suddenly indistinguishable. In a future life (that has now arrived) she is the author, or artist, of such stereotypical images designed to keep the Hollywood cash cow afloat, perhaps working in advertising or even script-writing. But she is also now Bowie, and he she. The passage between the fictional and the real, between a temporal suspension and a space somehow jointly inhabited by singer and character, opens up another world, in another type of life—a life that is at once hers as character and Bowie's as author, and, simultaneously, neither the sovereign terrain of either. Finally, in "Life on Mars?" both the mousey-haired girl and Bowie are alienated from the position of sovereign subjectivity in control of the song's narrative. Our collective ignorance of the right answer to the song's central question—is there life on Mars?—is a fitting conclusion for a piece of art demonstrating the movement of being, one that is finally liberated from epistemologies calibrated for knowing self-identity. As we cannot see who the song describes, the possibilities of time(s) and the proxemics of space(s) are blown open.

Beckett's novel *Molloy* follows a similar trajectory; before a character's story ends, the alienation of its narrator is completed through a similar act of displacement. Comparably, readers never really know where they are in relation to Molloy and any fixed spatio-temporal coordinates. The novel begins "I am in my mother's room" and then evokes spaces into which the character Molloy either travels physically, or which he imagines without moving from the confines of the matriarchal abode. One way or the other, the reader is obliged to accept these spaces as having a particular type of concrete reality, but Beckett makes such material identifications difficult if not impossible. Very early on, Molloy introduces a road which is hard to imagine given the lack of coordinates and adornment of any kind: "So I saw A and C going slowly towards each other, unconscious of what they were doing. It was on a road remarkably bare, I mean without hedges or ditches or any kind of edge" (*Molloy* 10). By introducing such surreal spatio-temporal arrangements, Beckett draws attention to his own particular form of abstracted proxemics. Proxemics, the study or theorization of space and how people use it, and of proximity, the space between, are usually constructed by writers in ways that correspond with human conceptions of the natural and concrete. Hamon in *Expositions* proposes that

writers start out from the building, the cadastre, the parcel, in other words, from a static system of distinctions (be these real houses, or the fictive abodes of memory) and then subsequently imagine the travels and adventures of the characters.

(Hamon 30)

In this way, readers acquire a sense of a distinct world which characters inhabit. Proxemics, then, are ways of bridging the space from fiction to materiality; they are literary architectures of experience generated through language as lived reality. Garin Dowd believes that Beckett produces a very different proxemics in "a writing which simultaneously ordains and constructs" ("The Proxemics of 'neither'" 112). In other words, Beckett instantiates and makes, and often unmakes, proxemic space simultaneously. For example, no sooner has Molloy insinuated the image of the bare road than it dissipates and he announces: "And once again I am, I will not say alone, no, that's not like me, but, how shall I say, I don't know, restored to myself, no, I never left myself, free, yes, I don't know what that means" (*Molloy* 14). Molloy, as narrator and principal character in his own story, generates imagined spaces and then dismantles them just as quickly, often drawing attention to this exercise in simultaneous creation and deconstruction. Towards the end of his narrative, lost and finding himself on the edge of a forest, Molloy is reduced to crawling around in circles. He can see a town in the distance; it may or may not be the one in which his mother resides, the place where his story ostensibly began, and most likely the place from where emerged the original pages of the story the reader now reads. Molloy is then assailed by a strange intrusion:

> I heard a murmur … And then sometimes there arose within me, confusedly, a kind of consciousness, which I express by saying, I said, etc., or, Don't do it Molloy, or, Is that your mother's name? said the sergeant … and I had no impression of any kind, but simply somewhere something had changed, so that I too had to change … in order for nothing to be changed.
>
> (89–90)

Moments of the narrative he has recounted return as fragments, and as though they are now being told, murmured to him, by somebody else. There appears to be another voice that intrudes into his orbit, into his narrative space. Then he hears a voice say "Don't fret Molloy, we're coming" (84) and he seems to accept his fate:

> Real spring weather. I longed to go back into the forest. Oh not a real longing. Molloy could stay, where he happened to be.
>
> (93)

In a manner similar to how the narrative voice in "Life on Mars?" seems to get switched out for another voice, an alternative teller, so too Molloy moves suddenly from telling to being told, consumed by an alternative voice that might be that of Beckett or another version of Molloy. In both "Life on Mars?" and *Molloy* the

narrators who document their alienation from society are finally alienated from themselves in the spaces in which they appear and from where their story is told. Through just such disassembling of subjectivity, Beckett and Bowie articulate the atomization of identity Beckett felt synonymous with abstract art, the dissolution of the subject co-extensive with a visual culture that could represent such comings and goings without it becoming a convention of the form itself. It is when this visual understanding is married to Beckett and Bowie's love of music that their aesthetics of alienation find an affirmative medium, a form that accommodates the restitution of being, and provides a refuge from alienation.

Sound

Both Beckett and Bowie dabbled freely in high and low musical genres. The publicity material for one of Bowie's earliest press-releases paints a picture of the musician immersed in his art:

> He loves to sit amidst a bank of column speakers listening to Stravinsky, usually "Ragtime for Eleven instruments." Vaughan Williams, Dvořák, Elgar and Holst. His extensive record collection includes lots of Glenn Miller, Stan Kenton, and Gary McFarland.
>
> (Decca 1969; quoted in Johnson, "David Bowie Is" 10)

Explaining this broad palette (and, in doing so, adding legitimacy to this study), Bowie elaborates further:

> I don't think there is one truth, one absolute. It's an idea that I have always felt instinctively but it was reinforced by the first thing I read on postmodernism, a book by George Steiner called *In Bluebeard's Castle* ... confirmed for me ... that I could like artists as disparate as Anthony Newley and Little Richard ... or that I can like Igor Stravinsky and The Incredible String Band, or The Velvet Underground and Gustav Mahler.
>
> (Pegg 5)

Beckett, too, had an interest in a wide variety of music, appreciating, on the one hand, compositions of the highest technical accomplishment, while, on the other, having a soft spot for music hall sing-along classics and the solemnity of Christian hymns, fragments of which resonate throughout *Waiting for Godot* and elsewhere in his work.[12] Beckett often worked at playing Chopin's Piano Sonata no. 3 (1844) on a Schimmel he owned in his writer's retreat in Ussy. Here, too, he would try to master Haydn. As wife Suzanne Dechevaux-Dumesnil was a pianist, we can take it that music was a regular topic of conversation between them and a source of shared recreational attentions. He was also very encouraging of his nephew Edward who studied music in Paris and is today a flautist of international standing. In terms of the direct inclusion of music in his work, an excerpt from "Death

and the Maiden" (String Quartet no.14 in D minor, 1844) by Schubert appears in the radio play "All that Fall" (1956), as do excerpts from the "Largo" of Beethoven's Piano Trio in D major (Opus 70, no. 1 'Ghost') in the tele-play "Ghost Trio" (1976).[13] And then there is "Words and Music" (1961). What is particularly interesting about this Beckett vignette is that it stages a faux battle between words and music, contrasting the delay required to make semantic sense out of words with the emotional immediacy one experiences while hearing music. It appears the immediacy of the latter wins out in the affections of the central character, arguably reflecting his author's preference too.

Comparing Beckett and Bowie in relation to music as activity and influence, the important issue is not so much to prove either's demonstrable interest in music, that being quite self-evident with Bowie, but rather to find a way to articulate something of how both artists present and imagine alienation in musical terms. In this regard, it is interesting to consider how Bowie embodies music. Critchley talks of Bowie's voice as having the characteristics of Heideggerian "Stimmung"; that is, a vocal capable of generating a mood that can be articulated philosophically, a mood that while seeming to have awareness of its own artifice, its own status as fetish, also rings true. Additionally, it is necessary to identify the various *characteristics* of Bowie's voice; that it sounds, variously, despairing, disillusioned, earnest and, conversely, often proud, aroused, and self-satisfied by its own range and emotional reach, depending on which characters Bowie invokes in song. Which raises the question of how best to articulate the relationship between a singer's voice and a notional fictional character? In this regard, Jenefer Robinson suggests of instrumental music that

> When we hear music as expressive of emotion, we hear or imagine an agent or persona in the music, the owner of the states expressed ... which may be a 'character' or the composer himself, or a persona of the composer.
>
> ("Expression Theories" 204)

Assuming, then, that both music and human voice can generate forms of persona, the latter imagined as an embodiment rather than an intangible emotive immediacy, then the embodied Bowie persona is a voice that often shivers and seems to weep—to break down and cry—insofar as such emotional states are qualities of the voice rather than literal manifestations of tears and other emotions. When Bowie sings "tremble like a flower" on "Let's Dance" the form of his voice reflects the vulnerability the image evokes while also provoking a sense of dread in the attentive listener. Similarly, the final refrain in the song of the same name, "Wild is the Wind," seems, rather implausibly, to capture something of nature's wildness in its articulation, the enunciation, emotion, and theme in perfect alignment. Always there appears to be something both performed and real in Bowie's voice, measured and yet immediate, artificial, and yet deeply felt.

At one and the same time, recognizing how Bowie absorbed the vocal characteristics of Anthony Newley, and other singers he admired, necessitates acknowledging Bowie's as always an alien voice, as the expression of a *shifting and rootless persona*. This is then exacerbated by the degree to which one of Bowie's principal and yet differential character performances is that of a wanderer, or traveler. The song "Be My Wife"

includes the observation "I've lived all over the world, I've left every place" and it is possible to see these lines as a direct reflection of Bowie himself, moving and writing in London, LA, Berlin, Switzerland, and a host of other places, before settling in New York from where, in his closing work, he reimagines himself sitting again in nineteen-seventies Berlin, further destabilizing efforts to place him in spatio-temporal locations co-extensive with the song-writing moment. Moreover, his instrumental music is also charged with traveler affect, various pieces borrowing from and representing the music of Eastern, Asian, and European culture, often on the same album (such as *"Heroes"* which encompasses "Secret Life of Arabia," "Moss Garden," and "Neuköln"). Indeed, the album *Lodger* is a work dedicated to the peripatetic lifestyle, featuring songs like "Move On," "Yassassin" and exhaustive reference to planes, trains, and automobiles. The Bowie persona established on this album is a propertyless, marginal figure at home nowhere and abroad everywhere. Consequently, if key to Bowie's appeal is the idea of a person, persona, or personae represented in and through his music and voice, it is most always a shifting, littoral being, occasionally exultant but most often trembling and shivering on its journey from station to station.

Turning to Beckett, then, in order to try and establish a point of comparison—and a way in which Beckett's work might also somehow reflect or complement Bowie's ceaselessly mobile, shifting, and mutable musical figure—thoughts expressed on music in his early writing prove fruitful. Proust, whom Beckett much admired, had the following to say about the experience of music:

> music seemed to me something truer than all known books. At moments I thought that this was due to the fact that what we feel about life not being felt in the form of ideas, its literary, that is to say intellectual expression describes it, explains it, analyses it, but does not recompose it as does music, in which the sounds seem to follow the very movements of our being.
>
> (*In Search of Lost Time* 381)

Correspondingly, Beckett is also earnest that a friend know he can incarnate the feeling of music in a manner similar to Proust's suggestion that we, as listeners, channel the medium's emotional capacity. While listening to Schubert's *Winterreise*, Beckett writes "I've been shivering through the grim journey again" (*CLSBIV* 395), clearly indicating that in the absence of a singer, he takes on an embodied role as a subject generated by the music and responding to it physically. The music, happening in time, finds its space in Beckett himself. Robinson notes that *Winterreise*

> is both an actual and a psychological journey but even this one song is a mini-drama in itself: the wanderer's emotions shift and change from the beginning to the end … From the first bars, the funereal D minor harmonies, the descending notes of the piano accompaniment, and the harsh dissonance of the penultimate harmony of the cadence tell us that we are in a dark cold world both physically and psychologically.
>
> (Robinson 207–8)

Robinson claims Schubert evokes the terrain of a psychological journey but also a journey through our emotions, the music somehow helping to embody the emotional shifts it prompts. He identifies

> in the first movement of the Piano Sonata D960 in B-flat [that] there is a harmonic 'outsider' embodied in the strange trill on G-flat which interrupts the cheerful ambulatory music that opens the piece. ... the music seems to dramatize a search for reintegration of this 'alien' element, as the music wanders into far distant keys ... in *which the wanderings are those of a persona* ...
>
> (Robinson 209)

Bowie's music, both verbal and acoustic, and Beckett's poetry, like his prose and drama both verbal and otherwise (words replaced eventually by limited physical gesture and silence), invoke a wandering persona in an emotional space that attempts to prompt a similar emotional journey in its audience. Arguably, the dominant mood of this persona is one of estrangement and alienation, if not in the first instance, then eventually as a result of undertaking the journey itself.[14] In this regard, Robinson's chosen vocabulary in relation to Schubert (owing much to Charles Fisk)—"alien element," "alienated wanderer," "distant keys" of musical immersion, a mood that is "trembling" (Robinson 209; Fisk 72, 62, 240)—could just as easily describe the milieu of Beckett's poetry and prose, from the estranged wanderer of "Sanies I" to the eponymous subjects of Watt, Murphy, and Molloy who are all characters on the most surreal of journeys. But these are journeys with associated psychic moods that are also conveyed, principally, in the content. In conjunction with these rather obvious contextual parallels, there remains the question of how Beckett's work might invoke the intersubjective moment of the shiver of recognition in its readers as a consequence of his approach to aural proxemics, and, in particular, harmonics, or the notion of two elements in aesthetically pleasing unison. How might Beckett communicate the alienated subjectivity of Bowie's instrumental pieces, for example, in the very sound of his own work? How might he capture something of the wandering and alienated persona Bowie represents in both verbal and acoustic ways?

Recalling Georges Duthuit's rejection of the temporality mobilized in classical Italian painting where "[a]ll is subordinate once again to the traditional conception of an absolute time" (*Fauvist Painters* 51), Beckett's correspondent proposes instead that the modern painter should take to abstraction with a vitality that challenges conventional spatio-temporal coordinates. In response and by way of contrast, Beckett proposes a conception of time more marked by entropy and collapse. He tells Duthuit:

> you oppose a quotidian, utilitarian time to a vital time, a time of guts, privileged effort, the true one ... apoplectic, bursting at the arteries like Cézanne, like van Gogh ... can there exist or not, a painting that is poor undisguisedly useless, incapable of any image whatever, a painting whose necessity does not seek to justify itself? ... Never again can I admit anything but the act without hope, calm in its damnedness.
>
> (*CLSBII* 166)

Here Beckett wants to express poverty not only in the content but in the space and time of the work's formal manifestation. At the same time, one of the chief reasons he values music so highly, in contrast to the written word, is its capacity to generate simultaneity, the simultaneity of effect as affect, musical score as shiver. In a letter he castigates a friend who "won't hear of possibility of word's inadequacy" despite

> the dissonance that has become principle and that the word cannot express, because literature can no more escape from chronologies to simultaneities … [than] the human voice can sing chords.
> ("German Diaries, March 26 1937," qtd. in Knowlson, *Damned to Fame* 258.)

For Beckett, music is obviously a context in which musicians can state an affective immediacy, something intense even though it may be based on structural repetition (such as chords), but it is also a sonic form that can be fused with a statement of impoverishment at the level of content; a fusion designed to induce a shiver on a journey towards damnedness. Furthermore, as a result of this complex relationship between rhythm and semantic meaning, Beckett can generate moments of spatio-temporal suspension which although despairing, nevertheless achieve something affirmative through the success of their formal execution.

In order to achieve such moments, to escape from chronologies to simultaneities that yet are the statement of a compromise, it is necessary for Beckett to accentuate the musical qualities of language, and such emphases abound in his work. Eoin O'Brien recalls Beckett telling him that for the autobiographical landscape of "Company" the author changed the actual place name from "Barrington's Tower" to the fictionalized "Foley's Folly" because the name "Barrington's Tower has no music in it" ("Zone of Stones"). The hilarious frog song in the novel *Watt* (1953) is typographically arranged as a score, and Roger Blin has said Beckett thought of *Endgame* "as a kind of musical score" (Oppenheim 308). Certainly, *Play* (1963) accentuates the differing rhythms of the characters' lines in a mode similar to musical counterpoint, and Enoch Brater suggests "'What is the Word' (1989) uses words in the manner of scales or keys in tonal music" (*The Drama in the Text* 167). Beckett would also be aware that the Irish refer to a song's music as an "air" because there is a belief that songs simply need to be recouped from the acoustic proxemics where they permanently reside. Similarly, he attempts to channel something of the sonic rhythms of language into his work as a shared context that the audience recognizes and to which it responds emotionally.

This is all by way of saying that although Bowie might be the principal musician in this comparison, Beckett too created music in his texts, and was not afraid to experiment therein, devising a literary soundscape to complement his dramatic and poetic vision. Many of his theatrical collaborators (Bryden 44, Ben-Zvi 48) have recalled him, during rehearsals, standing before actors in the pose of a conductor. Billie Whitelaw felt as though she was "modelling for a painter or working for a musician"

(*Who He?* 44), while Delphine Seyrig felt Beckett was akin to "an orchestra; he sets the tempo" (qtd. in Ben-Zvi 79). Anthony Uhlmann summarizes:

> Beckett often mentioned that he was attempting to achieve something akin to musical structure, and his use of repetition as a playwright, and the emphasis he put on this repetition as a director, are clear attempts to approximate a motif-oriented musical structure.
>
> (qtd. in Paraskeva, 110)

Essentially, all of these observations indicate that Beckett endeavored to communicate mood, thought, and feeling through the rhythm of his language such that the source of the shiver is the word made flesh. His dramatic prose, for example, attempts to generate conditions similar to those that Schubert's form employs when creating the persona of the wanderer, engaging recurring emphases and their repetition first in the service of reiteration as mood, and then introducing alternation as both confirmation of mood and incremental shift in tone.

By way of example, consider first the individual rhythms of each speech and then the thematic relationship between and positioning of the two monologues that most precisely characterize Vladmir and Clov in Beckett's most well-known dramas, *Waiting for Godot* and *Endgame*: Didi's speech on habit and Clov's "something" from the heart as requested by Hamm. Both are monologues "without hope, calm in [their] damnedness," statements of a sense of human failure and yet in their rhythm and tone they are both affecting and comforting. Both employ similar types of repetition as rhythm and both are placed in their respective plays, towards the end of each, representing the final summative statement of both characters' feelings. In this way, both echo each other contextually but also rhythmically within a meta-rhythm that sees each play as a reiteration of the other; or a remix, if you prefer. At a formal level, both employ micro and meta sonic repetitions whose semantic emphases, on despair leading quickly to resignation, shape the terms of the shiver that Beckett wishes to induce in a willing audience. For example, Vladimir noting Estragon has fallen asleep takes the opportunity to confide his growing unhappiness to the audience:

> Vladimir: Was I sleeping, while the others suffered?
> Am I sleeping now?
> Tomorrow, when I wake, or think I do, what shall I say of today?
> That with Estragon my friend, at this place, until the fall of night, I waited for Godot?
> [arranged differently here to the original text for rhythmic emphasis, see *Waiting for Godot* 81]

Beckett frames Vladimir's confession in simple blank verse with an emphasis on similar syllabic repetition across sentences. His first line involves two small clauses that mobilize first a four-syllable and then five-syllable structure. A rhythm is established

quickly through such structural repetitions which stand in contrast to the more frenetic and quick-fire exchanges that characterize dialogue with Estragon. Yet, at the same time, although the tramps' dialogue has been suspended, Didi's monologue invokes the audience, or reader, as his witness and silent interlocutor. Listening carefully, then, and feeling the rhythms of Vladimir's speech in concert with the painful insight he experiences, the audience understands that the reference to "sleeping" in the second line reemphasizes the stress on the word "sleeping" in the first line which in turn echoes the emphasis that falls on "suffering" in the second clause. And in just such a delicate patterned structure Beckett creates the rhythms of a speech that absorb the listener in its content and form, their involvement now a reflection of the persona the speech and associated drama generates. As a result, although the sense of anguish might be introduced by Vladimir, it is felt and shared by the reader, or audience, who have willingly taken on the semantic and sonic journey that Vladimir's words invoke. It is just such imbrication of theme and mood to which Smith refers when he claims that the "musical sound" of

> the discordant voice of the other calls me to a sharing of the world … to a going out beyond myself by offering my hand, my heart, even my whole bodily being to the other.
>
> (*The Experiencing of Musical Sound* 36)

The very fact of our responsiveness to the music of language is the proof of its capacity to alter the listener in the moment and experience of listening, taking us on a journey of empathy and recognition, what Benson calls the "intersubjective experience that requires a dialogical exchange and receptivity to the other" (585).

In a strange paradox it is also the case that the intensity generated by the carefully constructed rhythmic patterns of Beckett's micro and meta rhythms are both tempered and accentuated by their ritualized nature in performance. Vladimir seems to understand that the habit he describes is as much a consequence of the business of performance as it is a singular cry from the heart, as though the lines equally represent the actor's thoughts and those of the character. In this regard, Conor Carville claims that the possibility of complete method "absorption is not present, cannot be present in Beckett's theatre, because there is no character into which the actor can withdraw" (4). As a consequence of a certain lack of depth in Beckett's characters, a feeling they are devoid of interior life, the insecurities and frustrations of the actor are also expressed in the dialogue as if grafted onto the character. This fetishization of the dramatic, the inability to separate the authentic from the artificial, is at the core of both Beckett and Bowie's aesthetics and so produces moments of extraordinary intensity that seem both extraordinarily real and utterly performative. And, by dint of this paradoxical paroxysm, their work is moving and powerful. Further, the shared intensity of these moments, when the mimetic and the real seem indistinguishable, generates a radical temporal suspension that feels, paradoxically, collectively inhabited. When Didi says "I can't go on. What have I said?" before finally, and necessarily, being called back to

the dialogue with Estragon, it is as though time has stopped in a powerful moment of insight and despair shared among character, actor, and audience.

Turning to *Endgame*, Clov's monologue towards the conclusion of the action also echoes the theme, structure, and dramatic placing of Vladimir's speech:

> Clov: They said to me, That's friendship, yes, yes, no question, you've found it.
> They said to me, Here's the place, stop, raise your head and look at all that beauty.
> [arranged differently to the source text for rhythmic emphasis, see *Endgame*, 50–1]

Although Clov begins with less emphasis on syllabic rhythm, aiming instead for longer parallelisms, the essential structural echo with Vladimir is established in the counterpoint between Clov and the absent figures ("they") who shape the nature of his response, as did the spectral presence of the "others" shape that of Vladimir. While extending line length throughout, Clov nonetheless begins to echo the rhythmic repetitions of Didi's earlier incantation in the distinction he makes between the speaking self and those who are now the harbingers of suffering (rather than simply its victims):

> Clov: I say to myself—sometimes, Clov, you must learn to suffer better than that
> if you want them to weary of punishing you—one day.
> I say to myself—sometimes, Clov, you must be there better than that
> if you want them to let you go—one day.
>
> (*Endgame* 51)

Like Didi before him, Clov utilizes both sound and sense to open himself up as seeking persona to the empathy of the other. In this regard, Didi and Clov exist in harmony insofar as they exist as two pitches synthesized in the single object of empathetic identification with the other, utilizing shared rhythms in order to do so. If performed well, in either case, the audience is drawn intersubjectively to their plight through a shared shiver of recognition. And Clov's speech, too, in its most carefully delineated moment seems also to suspend temporality itself, to puncture "the veil of time" as Beckett called it in *Proust*, and, in so doing, to house the alienated character in a suitably aesthetic proxemics that is at one and the same time Clov earnestly saying farewell to Hamm and the actor playing the part who knows, self-consciously, that "something is taking its course" (*Endgame* 26).

If Schubert creates an aural proxemics as the given terrain of a musical piece that also invokes, at one and the same time, the psychological being of a striving character, Beckett finds himself embodying that persona as a consequence of listening to the composer's work. Willing to experience intersubjectivity through music such that, in the absence of an embodied voice, he recognizes the journeying character of the music itself and succumbs to its emotional hold on him, moved to shiver on the troubled emotional journey of an expressed, imaginary subject. In a similar fashioning, he attempts to generate a comparable aesthetic effect through a rhythmic patterning in his work designed to complement its textual semantics. Moreover, as

his career developed, an embodied materiality begins to stand in for verbal semantics and instead speak physically, if silently, in late works such as *Quad* and *Nacht und Träume*, the actors' physical presence determining the plays' structural rhythms.

These aesthetic moments that both frame and respond to alienation, are examples of Beckett and Bowie's *intersubjective proxemics*, forged between actor, character, and audience (or reader) variously. Both artists generate a space wherein the alienated reader, or listener, who is also individuated in estrangement, is made aware of the political dimensions of rhythm as s/he forges a bond with a persona in the art whose "presence" and "mood" mirrors the individual's own sense of alienation. As Crespi and Magani are aware, "rhythms are not simply imposed upon the subject, but are constitutive and productive of the subject; our bodies move in the ways that 'become' us" ("A Genealogy of Rhythm" 43). In such ways, Beckett and his preferred audience produce the intersubjective alienated subject who is at the same time housed in the semantic and aural proxemics that the work generates. This notional space, which is also embodied emotionally, results in intense moments of spatio-temporal simultaneity of the type Beckett described to Georges Duthuit; moments in which "music is the Idea itself … existing ideally outside the universe, apprehended … in Time only, and consequently untouched by the teleological hypothesis" (*Proust* 92). They are moments "the word [alone] cannot express, because [they have escaped] from chronologies to simultaneities," (Knowlson, *Damned to Fame* 258) at least temporarily, in order to state what Beckett calls in *Proust* "the suffering of being" (19) from which respite is generated in the form itself.

For his part, Bowie's "Time" is a stellar example of a potential epiphany that brings us face to face with mortality in a moment of intersubjectivity between artist, character, and audience. Like much of Beckett's work, Bowie's song generates a shared cathartic identification achieved through a moment of temporal suspension that nonetheless constitutes a sense of time as mutually inhabited by performer and listener. In so doing, the aesthetic salve the song generates reverberates in the musical form as a type of comfort. The song also mocks, rather superbly, the arbitrary distinction society insists upon between authenticity and theatrical performance, and it does this through the necessity of performative repetition, emphasizing itself as fetish with feeling, similar to the manner in which the actors playing Didi and Clov must settle their theatrical accounts. In the beginning of the song the troubled narrator characterizes time as a vaudeville villain

> Time, he's waiting in the wings
> He speaks of senseless things
> His script is you and me, boy

and he laments the manner in which time has claimed the life of a friend, Billy Dolls (presumably Billy Murcia of the New York Dolls who died from an overdose in 1972). The central address of the song to "you" calls the listener to the stage of the performance and invites him/her to embody the emotions being shared. Then, in a memorably self-conscious moment, the narrator exhorts "you" to evict time. At this juncture both vocal and instrumentation cease, and instead you listen as Bowie breathes alone in a moment redolent of Beckett's "Breath," his dramaticule

in which a stage strewn with rubbish is accompanied by the sound of a man taking what the audience presumes to be his last breath. The pause in "Time" serves to draw attention to the immediacy of the moment, of the "now" of breathing as an instance of unadorned being, and yet as the sound of exhalation is engulfed by the musicians resuming the melody, the audience is struck by the necessity of the resumption, by the impossibility of maintaining the suspension of time itself which clearly waits for no man, including Bowie. The listener briefly hears time paused and, at the same time, the impossibility of that pause as the narrator is engulfed by time and grief and self.

And then from out of the cacophony of self-doubt that follows the pause, recognizable Bowie tropes emerge. The brain is likened to a regurgitating drain choked by vanity and incestuous urges. In order to offset the psychological stress of this psychic struggle the narrator desires the stage, and the opportunity of performance. The song then slowly begins to fade out on the repeated observation/question that surely the time has arrived when we should all be "on." In its most crude and obvious intention this line references the desire to come up on drugs, to be "on" before going on stage. But more significantly to be "on" blurs the line between the real and the staged performance, suggesting it is time to be on stage. The narrator of "Time" privileges the latter but, more importantly, he insists that the need to perform is coextensive with the will to survive; the imperative is to perform at all costs. To be on stage is to be out of one's mind in the best possible way: free, living, dreaming and, paradoxically, pure. "True" life here is performance and, as with so many other songs across diverse characters, we understand Bowie's self-conscious artistic performances of many different lives as his life. Moreover, the suggestion is that all of *our* lives are equally self-conscious performances in search of something transcendent and unique. Most importantly of all, in the self-identification with performance that ends the song, the message is clear. In play, conventional reality is superseded and replaced by art life; a greater, more immediate form of life that, in repeated performance, becomes a creative affirmation and the negation of a life enslaved to capitalism.

In replicating constitutive alienation in a song like "Time" or in a play like *Waiting for Godot*, Beckett and Bowie produce a notable cathartic release for audiences who in identifying their alienated selves, achieve some insight into the condition of modernity. When Vladimir opines "Was I sleeping while the others suffered?" (*Waiting for Godot* 96) we all perceive, however briefly, the degree to which we shut out the trials and tribulations of others. If we place the play in a contemporary context, it also helps us see how a capital environment divorces us from a truly collective or communitarian society such that we are forced to exist in the paltry reality of often isolated, desperate lives. And the moment in which Vladimir's epiphany momentarily suspends time gives us the opportunity, in the form of a profound insight, to rethink our social orientation, as does Clov's departure and the plight of so many of Bowie's alienated characters.

Approaching the end of this chapter, it is worth recalling that it began with Beckett and Bowie's lack of faith in philosophy as a tool of explication and concludes, by contrast, with the proposition that their faith in aesthetics captures—in often singular, suspended moments—something authentic about alienation and estrangement. Furthermore, their aesthetic design that emphasizes the inauthentic and celebrates the ruptures and

repetition that puncture notions of continuous, stable identity exhibits something of the fetish character of the infinitely reproducible commodity as identified by Marx. In this their aesthetic strategies find an echo in Jacques Rancière who proposes that

> the aesthetic regime of the arts is the regime that strictly identifies art in the singular and frees it from any specific rule, from any hierarchy of the arts, subject matters, and genres. Yet it does so by destroying the mimetic barrier that distinguishes ways of doing and making affiliated with art from other ways of doing and making, a barrier that separated its rules from the order of social occupations. The aesthetic regime asserts the absolute singularity of art and, at the same time, destroys any pragmatic criterion for isolating this singularity. It simultaneously establishes the autonomy of art and the identity of its forms with the forms that life uses to shape itself. ... The aesthetic state is a pure instance of suspension, a moment when form is experienced for itself. Moreover, it is the moment of formation and education of a specific type of humanity.
>
> (Rancière 24)

Here Rancière offers philosophy and aesthetic theory mobilized in conjunction, while also emphasizing labor's role in challenging capitalism. Uncoupled from a purely economic frame, labor is reimagined as aesthetics. For Rancière the required synthesis is not between aesthetics and reality, not between an artist and a craftsman, but precisely a synthesis between a life that combines both of these modes of being, equal ways of doing and making in equal measure *with* aesthetic possibility itself. Further, this synthesis of labor and aesthetics produces a suspension that is also the possible formation of a new type of humanity. Moreover, this "specific type of humanity" is understood between producer and consumer and its education takes place both within and simultaneously through the process of liberating itself from alienation. The philosophic *and* aesthetic space generated between artist and audience is the space of the aesthetic shiver, representing an intersubjectivity that contests the isolated subject of alienation and bridges its estrangement in moments of shared empathy directed towards new ways of being.

Such a position that synthesizes philosophy, production, and aesthetic possibility is important because the proxemics of alienation and restitution are, necessarily, a dialectical activity. Historically, in philosophy, the principal epistemological dialectic of subject and object, self and other, presupposes a separation such that philosophic interventions that try to bridge this divide can also be framed, in some sense, as attempts to heal the breach of alienation. Since the enlightenment, the legacy of Descartes has perpetuated a duality in dialectical thinking that has ensured the subject–object relation remains the central antagonism in contemporary philosophy. Houghton traces how ostensibly oppositional relations have been consolidated historically and how they are generally associated with the "scientific revolution pursuant on industrial development." Still prevalent today, such "foundational ontological dualisms" recur in culture in different forms and are "accepted by many people as a given, [including] the supposedly 'natural' divides between subject-object,

body-spirit, human-nature, and self-other." He also notes that "such dualism extends into our conceptions of good-evil, sacred/profane, and civilized-heathen/barbarian" ("Blacklists"). In contrast to this epistemology, a theory of intersubjectivity proposes instead that individual subjects are in some sense mobile, and in suspending their disbelief and engaging with art they can be transported into the figure of another character, or person. In this way, they become that "other" of the work, temporarily, and experience as the other does, be it joy or fear, the laugh or the tear, be it the sensation of that character's radical difference to themselves or the shiver of recognition as to characters' similar, alienated experiences. From within this (albeit temporary) intersubjective perspective, the subject–object divide can be understood for what it is; not a natural separation, but a manufactured cultural division designed, like high and low cultural distinctions and those binaries mentioned above, to maintain the relations of power that determine the status quo. In response to such social divisions, Beckett and Bowie's revolutionary art demonstrates how the subject object/dialectic can be traversed and transgressed, their alienated characters providing a point of identification for an alienated audience and so opening up passage between the real and artifice, art and life, being and becoming. And they do this, in the first instance, through the recognition of a negative ontology, a lie at the heart of the matter. Just as Aristotle, at the very foundations of recorded philosophy, challenged Socrates and his notion of trans-temporal infinite ossified being (advocating instead for a new becoming co-extensive with scientific investigation), so Beckett and Bowie defy conventional sociality with a skeptical vision designed to identify and amplify the antagonisms generated within a shared consciousness shaped by capitalism.

V

Interzone

The point has been reached where an explanation of the importance of the dialectic structures being/becoming and positive/negative ontology must be attempted. This interzone, so called, is necessary since I have failed to accommodate such important material into other chapters and find that it needs to be addressed here before proceeding any further. Once attended to, no further interzones—or bulletins, for that matter—will be necessary. Indeed, once these affairs have been adequately explained we can move on to more immediately interesting things, like sex and death.

From the fledgling beginnings of philosophical investigation there has existed both a complementarity and a tension between the concepts of "Being" and "Becoming." Pre-Socratic philosophers such as Heraclitus and Democritus speculated about what constitutes the being *of* the world, both also imagining movement and/or change in substance as a becoming (for Heraclitus fire begetting, whilst for Democritus atoms were the agent of change). In what are referred to as his "Philosophy Notes," which he transcribed in the nineteen-thirties from a variety of philosophy textbooks, Beckett records that

> The flux of things is a ceaseless strife of opposites and this strife is the father of all things ... Becoming is unity of opposites.
>
> (qtd. in Feldman 71)

Here Beckett clearly delineates the dialectical relationship between being and becoming that subtends Pre-Socratic, Platonic, and Aristotelean philosophy, with a notable emphasis on the role played by "strife," or conflict. Moreover, it would appear Beckett was taken with the oppositional flux that is inherent in Platonic thought and also essential to the potentialities of "ousia," Aristotle's conceptualization of matter as something always changing. In this regard, Beckett's notes record:

> All that exists implies 4 principles: Matter, Idea, Force, Purpose. These 4 may be reduced to 2. Matter and Form ... Matter and form are not 2 & distinct ... they do not exclude, but presuppose one another ... Motion mediates between them. It inheres in both matter and form and belongs to each. **There is no reality but the reality of becoming.**
>
> (qtd. in Cordingley 102, my emphasis)

This privileging of becoming over being is evident in much of Beckett's work. It describes, for example, the most important realm of Murphy's mind:

> The third, the dark, was a flux of forms, a perpetual coming together and falling asunder of forms … [It] contained … neither elements nor states, nothing but forms becoming and crumbling into the fragments of a new becoming.
>
> (*Murphy* 72)

And if the description of Murphy's mind is a somewhat mordant critique of Eastern mysticism, it is no joke for either Molloy or Moran in their respective narratives when their personalities begin to give way and other subjectivities emerge and begin to *become*. Molloy recounts

> a murmur … and then something there arose within me, confusedly, a kind of consciousness … and I had no impression of any kind, but simply somewhere something had changed, so that I too had to change.
>
> (*Molloy* 89)

And Moran relates to himself the experience of

> a crumbling, a frenzied collapsing of all that has always protected me from all I was always condemned to be.
>
> (*Molloy* 149)

Being in Beckett is frequently subject to profound transformations, albeit changes that are alienating to the subject and often involve a coextensive disintegration of mind and body. Further, the psychic dissolutions suffered by these characters are quite evidently the result of some unresolved or newly emergent antagonism at the center of the subject. As such, becoming in Beckett is not a smooth or easy transition, but rather one fraught with strife and difficulty. This is borne out by what are known as his "Psychology Notes," which place an emphasis on Otto Rank's *The Trauma of Birth*. Transcribed around the same time as the bulk of his Philosophy Notes, these psychology text synopses indicate a note-taker fascinated by the travails of the conflicted individual psyche that seeks a resolution to its conscious and unconscious tensions.

Bowie's work, too, favors a radical shift in being towards a transformative becoming. A character in the Ziggy Stardust universe proclaims that he can make "a transformation as a rock and roll star" ("Star") in a way that serves as commentary on Bowie's entire career. The "wild mutations" the star aspires to in 1972, and which Bowie subsequently actualizes, are all examples of his commitment to "becoming" as a central principle of his artistic engagement. Importantly, the musician becoming the star in question does so in contrast to Tony who goes "to fight in Belfast," presumably as a British soldier, and Bevan who has political aspirations "to save the nation," echoing nineteen-fifties Labour deputy leader Nye Bevin and the idea of an original "new labour" the Welsh guru came to represent. The star of "Star," in contrast, will use rock

and roll as political platform, as did Bowie, championing artistic transformation in both character and musical structure as politically engaged acts of culture. Elsewhere, Bowie's impulse towards *being* diversifying and *becoming* is arguably best summed up in the song "Changes." In conjunction with an imperative to enjoy evolving, the repetition of the stuttered "ch-ch-ch-changes" is always different to itself, not allowing being to settle. Bowie's staggered chorus emphasizes the absence of self-identical presence in language, and, by extension, in being. Consequently, the line "I turned myself to face me" also suggests a multiplicity of selves replacing one centralized being. Additionally, the use of the ripple metaphor—"I watch the ripples change their size"— recalls the philosophical treatments of the self by Heraclitus and Cratylus, who came to the separate conclusions that you cannot put your foot in the same stream twice as both stream and self experience change (see Smith, *Philosophers Speak for Themselves* 13). In "Changes," all changes on the way to becoming other. Later, it seems that Bowie had begun to accept a degree of permanent, or semi-permanent being, coextensive with aging when he noted in 2002:

> I kind of miss that 'becoming' stage, as most times you really don't know what's around the corner. Now, of course, I've kind of knocked on the door and heard a muffled answer. Nevertheless, I still don't know what the voice is saying, or even what language it's in.
>
> <div align="right">("Rock's Heathen Speaks")</div>

No doubt when he heard the chimes of midnight clearly ring such that the muffled answer was more distinct, he understood there would be one last significant change that he had yet to negotiate, which he did bravely and with style. As in the Beckett universe, Bowie would have understood this involuntary change as unpleasant, and coming at great cost, but, as always, he engaged with it, embodying a being/character that he imagined becoming "other" and creating the possibility of an audience encounter with the big other of death, intersubjectively.

Reflecting that the "entire history of reasonable discourse within philosophy emerges as one long extended self-contradicting aporia" revolving around being and becoming (Cordingley 72), many philosophers (such as Heidegger, Nietzsche, and Deleuze) have challenged and continue to challenge any immutable iterations of ontological being (being in its most immediate sense), proposing instead the fluidity and possibility of epistemological becoming (i.e., believing that changes in our episteme—in our knowledge—will necessarily produce changes in our ontological sense of being). The contemporary philosopher, Bernard Stiegler, attributes the inevitable return of this aporia to the *ex nihilo* (Latin "out of nothing") origin of being that is necessarily a moment of non-being. In *Acting Out* he proposes that the urge to know our origin is libidinal. It is a *desire*. He argues that "the question of the origin is what constitutes the whole of human individuation, that is the whole of desire" (7). However, because we have no memory of our origin, be it individual or collective, our philosophy must be a "passer à l'acte"—an "acting out"—within the context of ignorance.

The term "acting out" is one borrowed from the discourse of psychoanalysis and presupposes denial as a structural condition of being. A patient acts out when the motivations for actions are repressed such that behavior lacks self-conscious awareness. In traditional psychoanalytic theory "working through" is preferable to acting out because the latter involves the subject reflecting on experiences and their relationship with both conscious and unconscious motivations. LaCapra articulates the distinction as follows:

> There are two very broad ways of coming to terms with transference, or with one's transferential implication in the object of study: acting-out; and working-through. Acting-out is related to repetition, and even the repetition-compulsion, the tendency to repeat something compulsively. This is very clear in the case of people who undergo a trauma. They have a tendency to relive the past, to exist in the present as if they were still fully in the past, with no distance from it.

Alternatively

> in the working-through, the person tries to gain critical distance on a problem, to be able to distinguish between past, present and future. For the victim, this means his ability to say to himself, "Yes, that happened to me back then. It was distressing, overwhelming, perhaps I can't entirely disengage myself from it, but I'm existing here and now, and this is different from back then." There may be other possibilities, but it's via the working-through that one acquires the possibility of being an ethical agent.
>
> ("Acting Out, Working Through")

For Stiegler, however preferable working-through might be as a way to negotiate experience, it requires a return to root cause and so mobilizes a temporality based on origin. Conversely, and without knowledge of both epistemic and ontological origin we can only philosophize both about origin and about the nature of being. Hence Stiegler places a premium on philosophizing that *becomes* through *acting* positively. He believes we must stress the "existential dimension of all philosophy, without which philosophy would lose all credit and sink into scholastic chatter" (3) and the figure to whom he turns is Socrates. For Stiegler, Socrates refuses to apologize for corrupting the youth of Athens, agrees to drink the poison, and, in so doing, individuates his will so that he "becomes the model of all philosophical existence" (3). He becomes this model because he carries philosophy, as an act of faith, to the death. This is the kernel of a philosophical politics. Stiegler argues:

> this passage to the act of philosophy as politics (this acting out), where philosophical performativity founds *saying* as *doing*, leads us also to Marx's words, according to which it is necessary to pursue the *interpretation* of *being* through its *transformation* – in *becoming*.
>
> (9)

Socrates, in founding philosophy, is "acting-out," privileging an ethical gesture (drinking the poison) in order to replace anxiety about human origin with a call to action.

Stiegler's plucky mobilization of Marx, undertaken in order to introduce his own philosophical intervention that proposes an *ex nihilo* politic, is nonetheless opportunistic. Fundamentally, Marx's transformative impulse is predicated on the eventual economic liberation of the proletariat through violent revolution. Impressed by Hegel's idea of the march of history towards the realization of a pure spirit, Marx adopted the former's dialectic method but chose to center it in the material world, avoiding idealized formulations available in language (true self, spirit of history, etc.) and favoring dialectical materialism, the material conditions of being that the world of work produces. In other words, Marx's approach to finding truth is to be found in the production of the street, in those who dig, in the digging, in the creation of gutters to facilitate the street's emergence, rather than in contemplation of the stars. For example, in his "Critique of Hegel's Philosophy of Right" (1843) he reproaches the impulse towards becoming, evident in Hegel's proposed dialectical synthesis of a thesis with its antithesis, by observing that "actual extremes cannot be mediated with each other precisely because they are actual extremes" choosing instead to "develop new principles for the world out of the world's own principles" (Letters from the Deutsch-Französische Jahrbücher, "Marx to Ruge," May 1843). Shortly thereafter, and with Engels, Marx diversifies his scholarly intentions to include "political economy [which] came into being as a natural result of the expansion of trade" and which "developed a system of licensed fraud, an entire science of enrichment" ("Outlines of Political Economy"). It is here in the marriage of philosophy and political economy, both of which exploit the working class in their own way, and while yet retaining much of Hegel's template, that Marx conceives his own singular philosophic intervention.

In this regard, both Hegel and Marx employ negative dialectics; that is, they identify contradiction within things and seek to resolve this contradiction in a new synthesis with the key difference, as Thompson notes, that

> the Marxist dialectic replaces the idealist Geist of a period working in mysterious ways with the concrete materialist class struggle as the engine of history, constantly present and constituting history as such.
>
> ("Negative Dialectics and the Frankfurt School")

In what is a crude Marxist-Hegelian dialectic iteration, employed here simply as an example, the contradiction generated by the world of labor—the worker is alienated by the need to sell herself as labor—is resolved in the overthrow of the labor market (antithesis) leading to the synthesis of a reorganized social formation in which alienation is overcome. In turn, this new society, or mode of production, will reveal its inner contradictions which will give rise to the need for a new synthesis and so a better social formulation, and so on, in keeping with the idealism of Hegel's march of history. For Marx, these gains will be achieved in the material reality of the societies in question which will then add authenticity to the metaphysical narratives these societies use to make sense of themselves, rather than the other way around.

Since the publication of Adorno's *Negative Dialectics* (1973), a key text in addressing the role of art in perpetuating political philosophy, there has been a tendency to presuppose that Marxism always identifies a negative element, a conflict or antagonism that needs to be overcome or sublated into an emerging and potentially transformed positive element. Proletariat oppression precipitating Marxist revolution and leading to social equality is the most obvious example here. Against this context, Stiegler's iteration *ex nihilo* lacks the dialectic materialism for which Marx is known, replacing material reality with an a priori ethical becoming out of the void; the void still representing a negative element but one that can be instantaneously transformed into a positive element, first through choice and then through action. Stiegler is here trying to resolve the baggage that Marx's revolutionary philosophy necessarily carries historically, but may not be required to inhabit indefinitely; namely, the question of whether or not contemporary revolutionary thinking can escape its origins in the negative. For example, despite being often necessarily pre-emptive and even self-defensive, revolution is a bloody business which can hardly be considered a positive development, socially or philosophically. As a consequence of this, Deleuze and Guattari, both anti-capital thinkers, take a different approach to Marx, one predicated primarily on positivity in which they construct a

> non-Hegelian, monistic, and vital-materialist account of the genesis of political subjectivity that foregrounds the relational, negotiation driven, and affirmative elements of this process ... of engendering empowering modes of becoming.
> (Braidotti 34)

Deleuze and Guattari's most obvious articulation of this positive becoming is *A Thousand Plateaus* (1980) in which they oppose the metaphysical tradition of self-identical being with their fluid ontology of becoming. A consequence of this framing is that becoming, rather than being, is the foundational plateau, or fulcrum, or platform, which, consequently, is always shifting, never fixed. Many things in the spectrum from humans to animals become new "assemblages" (19) such that the concept of becoming deterritorializes person, place, and thing (something Bowie achieved in becoming animal on the cover of *Diamond Dogs*). This strategy displaces the centrality of the human from philosophic discourse and, in reaching towards the posthuman and the non-anthropomorphic, foreshadows the reality of the Anthropocene and our collective emerging ecological and ethical responsibility to the planet itself.

Considering, then, the dual claims both of negative dialectics and affirmative vitalism as they pertain to explicating the work of Beckett and Bowie, there is clearly a deterritorializing impulse in their art which is at one with a post-Marxist critical desire to deconstruct established meaning and reveal how power is mobilized and maintained within ideology itself, notwithstanding whether this impulse arises from a negative or a positive circumstance. In this regard, Storey notes:

> dominant ways of making the world meaningful, produced by those with power to make their meanings circulate in the world, can generate the 'hegemonic

discourses' which may come to assume an authority over the ways in which we see, think [and] communicate.

(89)

In response to such "hegemonic discourses," Deleuze and Guattari and Stiegler offer alternative ways to frame the world, characterized by the positive energy of their difference as the instrumentalizing force of their intervention, but the danger is that their own discourses reflect something of the values of the hegemony they seek to contest. Arguably, to jettison a negative ontology, at base, is to remove the need for and necessity of changing those negative circumstances. From a Marxist perspective, the failure to instantiate such changes leads to the persistent presence of antagonisms that reflect the conflicts generated by late capitalism, producing the negative ontology that Marxism perceives as the core of the problem.

Turning now to how Beckett and Bowie engage with change and transformation in relation to sexual identity, it will quickly become apparent how central this vitalist versus negativist aporia is to a truly ethical sexuality, gendered or otherwise. Despite the fact that "queer" is in no sense a negative ontology, over time heteronormative historical and cultural practices have distorted it into an epistemic estrangement from where it remains framed, in large swathes of the world, as an alienated identity. At the time of writing, diverse sexualities and gender identities are being fully absorbed into late capitalism and although a vitalist transformation of queer's historical trauma might be welcome, its roots in a negative ontology might also serve as necessary precondition for the liberation of multiple others alienated from social, cultural, and economic opportunity. Tellingly, the work of Beckett and Bowie facilitates negotiation of the complicated nuances that exist in the relations between sexuality and capitalism, and between being and becoming, to which we turn now.

VI

Struggling Against the Straight

"There's nowt so Queer as Folk"
(Restoration drama *Alan's Wife*, written 1893)

The etymological outline of the word "alienation" in III identified the fifteenth century as a time when the idea was co-extensive with estrangement from God followed by the seventeenth century when it came to identify antagonism between individual liberty and communal responsibility. It is interesting to note that by the nineteenth century the "alienist" enforced the emerging control society with respect to gender, sexuality, and morals. Specifically, the alienist was a psychiatrist specializing in the legal ramifications of mental illness, determining the competence of those providing evidence in court and, in so doing, reinforcing the parameters where law evaluated both mental health and sexual desire as the mark of individual social acceptability. Towards the end of the nineteenth century, editor of the journal *The Alienist and Neurologist*, Dr. Charles H. Hughes proposed:

> Within the past few years, the neurologist and the alienist have become familiar with so many strange morbid perversions and reversions of the erotic sentiments and sexual passion that they must be considered and classified in their relation to society, to morals, and to law.
> ("Erotopathia" 531, qtd. in Rosario 15)

The alienist's part in rendering human psychology subject to the jurisdiction of the law no doubt played a significant role in establishing the century's social mores with regard to "sexual passion." As we shall see, questioning such embodied ideological formations is a key affinity in the work of Bowie and Beckett, who attempt to liberate "erotic sentiments and sexual passion" from discipline, and to reframe "strange morbid perversions" in different ways towards the same end: rupturing the established relations between morality, society, and law as they pertain to the discipling of sexuality and gender. If the nineteenth century began the business of constructing perversions, these two twentieth-century actors chose to liberate and celebrate many of them while also representing sexual eccentricities, frustrations, and distortions as the repressed other of approved sexual biopolitics.

Simon Critchley opens his little book *On Bowie* (2016) with the following recollection:

> It all began, as it did for many other ordinary English boys and girls [and Irish, Scottish, and Welsh], with Bowie's performance of 'Starman' on BBC's iconic *Top Of The Pops* on July 6th 1972 … my jaw dropped as I watched this orange haired creature in a catsuit limp-wristedly put his arm around Mick Ronson's shoulder … It was overwhelming. He seemed so sexual, so knowing, so sly and so strange. At once cocky and vulnerable. His face seemed full of sly understanding – a door to a world of unknown pleasures.

Gavin Friday, of experimental Irish collective The Virgin Prunes and subsequent interpreter of Kurt Weill (and other chanteurs), remembers the same moment with uncanny similarity:

> The epiphany for me was in July 1972 when Bowie appeared on BBC's *Top of the Pops*, an orange haired androgyne in smoky-grey eye shadow … an arm draped sweetly over Mick Ronson's shoulder … the look, the sound, the stance, the sheer strangeness of it all. The teasing sexuality, the wild exotica. From that July night onwards nothing would ever be the same again.
>
> (*David Bowie: Critical Perspectives* xi)

In another extraordinary synchronicity both Ian McCulloch and Robert Smith (singers with Echo and the Bunnymen and The Cure, respectively) remember the aftermath among their peers the following day. The Scouser recalls: "All my other mates at school would say, 'Did you see that bloke on *Top Of The Pops*? He's a right faggot, him!' And I remember thinking, 'You pillocks' … It made me feel cooler" (Brown, "Bowie Retrospective Announced"). Smith, for his part, recalls the "morning after" schoolyard split between those who thought Bowie was "a queer and those who suspected he was a genius" (Hodgkinson, "Timeless Tunesmith"). And Siouxsie Sioux of Siouxsie and the Banshees has quite a poignant recollection of the Starman orbiting:

> Bowie inspired people to use their own imagination, which was exactly what he was doing. When I first saw him performing Starman I was really ill and in a hospital TV room. It was like I was being woken up, like being let out of a chrysalis. Suddenly, I was allowed to just *become*.
>
> (Morley, *The Age of Bowie* 70)

"To become" is a key phrase in all of these recollections. Critchley notes of this seminal moment that for many people "Bowie was the being who permitted a powerful emotional connection and freed them *to become* some other kind of self, something freer, *more queer*, more honest, more open, and more exciting" (*On Bowie* 17). The implication is that "more queer" is a welcome release from the day-to-day queerlessness of society; that Bowie embodies a queerness which, being the expression

of a diverse form of sexuality, reveals the otherwise heterosexually-centered modes of socialization that are often held in place as discreet but nonetheless powerful forms of prohibition on difference, and particularly sexual difference. It is quite clearly the case that for Critchley and Siouxsie Sioux, and others experiencing a Bowie "epiphany," becoming in this instance transforms an a priori negative ontology into something positive. As we shall see, the notion of coming out, synonymous with gay identity, is a powerful form of becoming that also achieves the negation of negation in that the subject succeeds in the positive transformation of their own identity in the first instance which then presupposes the possibility of the transformation of the social. In this sense, queer identity is at one with the tenets of Hegelian Marxist dialectical philosophy and so consonant with Marxist revolution, something that is not currently evident in the contemporary LGBTQ + dalliance with late capitalism.

Before analyzing this relationship between queerness and liberation, and the manner in which Bowie mobilizes erotic desire towards this aim, it is first necessary to illustrate (because it is not so immediately obvious) Beckett's relationship with queerness. To this end, this chapter approaches the issue of Beckett, Bowie, and queer through three related themes: firstly, how a degree of queerness in both Beckett and Bowie is a challenge to the social status quo; secondly, how Beckett (to some degree) and Bowie (to an extraordinary degree) celebrate erotic expression as a form of liberation from the status quo; and, finally, how Bowie's celebration of the erotic is an important part of a wider struggle within liberal society to achieve ontological freedoms in which both Beckett and Bowie are invested. As though they were three songs, let's call the stages of this progressive argument, "Normal People?" "Queer Erotics," and "Struggling against the Straight." Although the Beckettian verses may seem unduly lengthy in their attempt to frame his relevance in this area, the Bowie choruses compensate by restating the starman's contribution as an emphatic harmonizer of liberated queerness portending other transformations to come.

Normal People?

In the first instance, the idea of people and things as queer is rather prevalent in a version of the English language inflected with Irishness, or what is known as "Hiberno-English," English as spoken and altered by Irishness. "Quare" in Irish English can often be used as an adjective to mean "very" as in "it's quare windy today" or mean "large" as in "this is one quare mess" or something can take a "very quare turn of events" meaning that something strange is happening. However, the quare of Hiberno-English takes on a disciplining function when applied to people rather than situations. In the late seventies, when school friends expressed their disdain at my twin enthusiasms for *Never Mind the Bollocks* and the soundtrack to *Saturday Night Fever*, they referred to this as "quare" in the sense of it being unusual, but also, because it was that kind of quare, it also suggested I was queer (i.e., homosexual). Similarly, its standard English counterpart, "queer," is used to describe the LGBTQ community in both a celebratory and pejorative fashion and has also been used, historically, to describe activity deemed

strange or unusual, in much the same fashion as the Irish "quare." Consequently, the word queer functions in "Queer Theory" to invert such dual significations, proposing a positive homology between queerness, sexuality, and affirmation. Having evolved as a response to conventional discourses that try to "other" and marginalize the quareness of queerness, queer theory continues to play a nuanced role in the battle to determine the prevailing language of identity politics.

Certainly, in a way not entirely dissimilar to Critchley's reaction to Bowie on *TOTP*, I was deeply taken by a series of photographs of Beckett by John Haynes in 1973. Strikingly handsome (for a significantly older man) and impossibly cool, wearing a beret and mirror shades, looking like a hawk in a way that suggested his intellect was as sharp as his profile, dressed in black, smoking Gitanes, this was an Irishman so dismissive of Irish Catholic foibles he had relocated to Paris to write in French, drink quality red wine, and discuss art and philosophy with the likes of Alberto Giacometti until the dawn rose over the cafes of Montparnasse. To me, Samuel Beckett was the epitome of cool. However, it was also an image of an Irishman tailor-made to prompt the observation among many Irish people I knew, both young and old, that as Beckett looked and acted in these ways he must be a bit, well, "quare" meaning both quare (weird) and queer (gay). And for sure, this exilic Irishman was plenty queer in terms of being "othered" by predominantly conservative Catholic Ireland. One suspects that a young David Bowie, utterly immersed in advocating a queerness that challenged the hegemony of the English normal, would have been impressed by Beckett's otherness, once noting about his own youth: "from a very early age I was always fascinated by those who transgressed the norm, who defied convention, whether in painting or in music or anything" (Morley, *The Age of Bowie* 131).

Given that much of Beckett's work is self-translated from French to English, he uses the more easily recognized "queer" in translation to indicate when his work means something is quare and occasionally intimates something, or someone, is queer. It appears throughout his prose to describe things that defamiliarize the normal, and as Beckett is intent on such defamiliarization it appears quite a lot. Molloy is aware of a "queer one" (3) who takes away the pages on which he writes his narrative. In *Malone Dies*, the title character resides in a place surrounded by "queer things" (184) and is visited by a man who knocks him athwart the head, subsequent to which "the light is queer ever since" (99). As the narrator of *The Unnamable* toys with renaming his central character he decides that he will "call him Mahood instead, I prefer that, I'm queer" (29). Keith Ridgway, a contemporary Irish author of the surreal and strange, has noted:

> It wouldn't be right to use the word gay in relation to any of Beckett's characters, but queer is certainly applicable. These were men who seemed inordinately strange to me, and yet, they were from the places where I found myself, they used the same kind of language, they felt for each other in ways that made sense to me.
> ("Knowing Me, Knowing You")

Ridgway proposes that while there are no obviously gay characters in Beckett's oeuvre, its general queerness facilitates a Queer Studies critical frame that analyzes "the

normalizing practices and institutions that privilege heterosexuality as fundamental in society and [which] discriminate against those outside this system of power" ("Queer Theory"). Viewed from this perspective, the suggestive play between Vladimir (who occasionally goes "all queer", *Waiting for Godot* 3) and Estragon, allied to the play's deterritorializing dissipation of all the conventional institutions of power in heteronormative society, makes *Waiting for Godot* a queer experience along the lines Ridgway delineates.[1] One could certainly debate the characters' homosexuality, repressed or otherwise, but it seems more profitable to focus on the queer turn the play takes as it moves towards its denouement. When Vladimir says "was I sleeping while the others suffered?" (*Waiting for Godot* 81), his epiphany signals what is effectively an awakening from a society steeped in a type of unconscious repetition designed to deaden all difference so that everyone must suffer in silence. And in desiring to escape from this dead society full of "dead voices" Vladimir desires something along the lines that Critchley felt when he first saw and heard Bowie; Didi wishes to open a door to "some other kind of self, more free, more queer, more honest, more open" (*On Bowie* 2).

In this light, Beckett's fictional universe and the literary strategies he employs to create it can be described as queer. They illustrate, by contrast, erstwhile normalizing mechanisms within the literary, and often defamiliarize the readers' expectations by presenting a strange world populated by queer characters who do not reflect conventional orthodoxy and experience. Allied to contextual queerness in plot and theme, there is also formal strangeness; a queerness at work in the very structure of the work. Think of Beckett's insistent structural repetitions, the dead ends, the missing and/or absent characters, and the plays in which the characters are interrogated ("Play") and even consumed by the very mechanics of the staging (*Happy Days*). A very quare theater indeed. David Bowie's metaphorical theater of characters, as we shall see, is similarly queer in the sense that the imaginative worlds he generates and the dramatis personae who populate them, challenge normative culture implicitly, but Bowie's world is also queer in the sense that it both produces and drives erotic desire. If Beckett's world is queer partially because it exhausts desire, Bowie's world is queer precisely because it thrives on the perpetuation of an unfettered sexual yearning.

Queer Erotics

While also emphasizing the operations Beckett's queer work undertakes on the conventional and the "normal," it is important to clarify that when Critchley says Ziggy allowed for a new becoming that is "more queer," he means a queerness charged with eroticism. Of the first time hearing "Suffragette City" (1972) Critchley notes that "Mick Ronson's guitar collided with my internal organs" (*On Bowie* 7), producing an unexpected and welcome erotic charge. Similarly, Beckett's work can be the occasion of a manifest queer eroticism. In the Q&A after I presented the preliminary ideas of this study in London in March 2017, a participant spoke eloquently and passionately about the first time she encountered *Not I* on the BBC and the specific and exquisite moment of sexual arousal that was engendered by watching the play. Similarly, in "The

Calmative" (1946) there is an extraordinary encounter in which the narrator recalls how he is persuaded to kiss the forehead of a passing stranger with "shining teeth":

> All of a sudden his hand came down on the back of my neck, his sinewy fingers closed and with a jerk and a twist he had me up against him. But instead of dispatching me he began to murmur words so sweet that I went limp and my head fell forward on his lap. Between the caressing voice and the fingers roweling my neck the contrast was striking ... And if you gave me a kiss he said finally.
>
> (*The Expelled and Other Novellas* 64)

Boxall notes of this moment that "the narrator's desire is not indifferent to the stranger's gender, and the stranger's masculinity cannot be feminized. Rather, it is the homoerotic nature of this encounter that opens onto the possibility of a new kind of homeland for the narrator" (114). Here, in contrast to Ridgway, Boxall identifies explicit homoerotic experience in Beckett's work and ties it to a sense of belonging he associates with the story's overwhelmed yet excited character. In the story, homosexual being creates a space for homosocial being, free from the proscriptions of heteronormative narrativity. In other words, queerness serves a double function where the character can be "something freer" from straight, social expectation and free, also, from traditional narrative expectations. This relinquishing of conventional narrative form is established in the opening line of "The Calmative" which begins with the admission "I don't know when I died" (*The Expelled and Other Novellas* 51); conditions which should obviate the possibility of a character subsequently enjoying erotic foreplay in the present tense. Indeed, given that this narrator is no longer physically embodied in any conventional sense, and yet narrates his experience as though he were alive in the present tense, something very quare is taking place.

Elsewhere in Beckett's work, and rather than homoeroticism representing the possibility of a new theoretical domicile, or a new way of living, sexual relations are presented as anything but erotic, anything but relational. Consider Molloy's failing memories of love with a "woman" called either Edith or Ruth (or perhaps neither):

> It was she made me acquainted with love. She went by the peaceful name of Ruth I think, but I can't say for certain. Perhaps the name was Edith? She had a hole between her legs, oh not the bunghole I had always imagined, but a slit, and in this I put, or rather she put, my so-called virile member, not without difficulty, and I toiled and moiled until I discharged or gave up trying or was begged by her to stop. A mug's game in my opinion and tiring on top of that, in the long run ... Perhaps after all she put me in her rectum. A matter of complete indifference to me, I needn't tell you. But is it true love, in the rectum? That's what bothers me sometimes. Have I never known true love, after all? She too was an eminently flat woman and she moved with short stiff steps, leaning on an ebony stick. Perhaps she too was a man, yet another of them. But in that case surely our testicles would have collided, while we writhed. Perhaps she held hers tight in her hand, on purpose to avoid it.
>
> (*Molloy* 56)

Molloy does not know if he has had vaginal or anal sex; in fact, he cannot remember if Ruth was a man or a woman, and he does not know because ultimately he does not care. In contrast to how "The Calmative" places emphasis on the homo nature of that encounter, here Molloy throws the notions of both sexual and gendered encounters into comic relief. But at the same time, the Edith/Ruth moment destabilizes heterosexual privilege by decrying the importance of gendered distinctions. As a consequence of Molloy being devoid of gendered desire, heterosexual normativity is no longer foregrounded as a governing logic. Annamarie Jagose notes:

> queer locates and exploits the incoherencies in those three terms which stabilise heterosexuality (sex, gender, and sexual desire). Demonstrating the impossibility of any 'natural' sexuality, [queer] calls into question even such apparently unproblematic terms as 'man' and 'woman'.
> ("Queer Theory")

Bowie's work undertakes a similar deconstruction of heteronormativity. For example, recalling Shakespeare's sonnets, often the invoked listener of Bowie's songs is male. "Time" features the opening refrain "time is waiting in the wings, it speaks of senseless things, it's trick is you and me, boy," the reference to tricks consolidating a moment of potential homo-sociality merged in the image of a non-gendered "whore" who "falls wanking to the floor." At the same time, it is often the case that although the singer is ostensibly male, the persona Bowie songs generate is not necessarily a man. In "Sweet Thing," for example, a male prostitute milieu is suggested in the first instance but only as a consequence of the singer's gender. The song opens from the point of view of a character familiar with sexual encounters in the nocturnal doorways of a ruined city, but at the same time the invocation to "boys" who "want it, to get it here" suggests that the song's prostitute need not necessarily be male, but possibly female, and possibly other. Here potential shifts in gender are akin to the ambiguous switch between the personae of Bowie and the girl with the mousey hair in "Life on Mars?" The prostitute persona confides to the client that

> on the street where you live
> I could not hold up my head
> For I put all I have in another bed

before inviting him or her to buy some drugs and join them in jumping into the river, the principal symbol of fluid change in both philosophy and poetry. Throughout the near ten-minute duration of the piece, heteronormative gender is neither invoked nor established and the "boy/boys" addressed throughout the song are never gathered into a cis narrative framework nor housed in a semiotics of heteronormativity. The cumulative effect is that the sexual encounter remains free of conventional gendered assignation coextensive with associated normative sexual roles. The "boy" may be cruising with man, woman, or other. This subversion of clear gender roles is rendered explicit in the video for "Boys Keep Swinging" in which Bowie appears as three different women, suggesting that the "swinging" in question can be mindless

phallic embodiment or the transgressive exploration of transgendered experience. In these instances, despite Bowie being male, heteronormative subjectivity is not reinforced by sonic or visual embodiment but rather it is challenged such that the intersubjective moments these songs generate are queer and can be potentially trans-formative. As Waldrep observes, the "target for [such] deconstruction was not Bowie's own identity but the assumed identity of rock itself as white, heterosexual, and male" (33). Moreover, and more presciently, Krevel proposes that

> the modes in which Bowie employed gender transgression on his path to superstardom in the early 1970s signal a broader ontological breach; one that in the subsequent decades has been invariably recognized as intrinsic to the formation of identity within the ontological framework of postmodernity.
>
> ("The Mask Behind the Man")

In other words, Bowie, among others, opened up an entire way of thinking about being that is considered co-extensive with postmodernism, the historical moment when gender identity was uncoupled from biological determination, and was understood, consequently, as largely performative in the sense of culturally coded and transmitted, consciously or otherwise. Philip Auslander believes Bowie's staging of these performances contributed significantly to a broader recognition of gender as a performance within culture:

> Bowie's presentation of his sexuality ... suggests sexuality ... as performative, not expressive. His performance of a gay or bisexual identity did not express some essential quality of ... person; ... rather, a performance of signs that are socially legible as constituting gay identity.
>
> (135)

Essentially, a socially estranged Bowie presented gay identity, in multiple ways, as further performances of his sense of alienation. In so doing, he contributed to a cultural turn that came to understand all identity, gay, straight, and otherwise, as performative, and also helped pave the way for a queer culture of pose, characterized today by RuPaul and others, in exaggerated and celebratory performances of camp and queer LGBTQ+ identity.[2] Bowie's manifestation of the art of alienation as an intersubjective moment realizes precisely Rancière's belief that out of such invention "new modes of sense perception and ... novel forms of political subjectivity are generated" (9), in these instances as sexual and diversely gendered subjectivities.

It is also the case that Bowie's performances of queerness are not contained within the proxemics of heteronormative spaces, such as home and bedroom, but in the doorways and redlight districts of dystopian cities, and its tawdry backstreets. In their complementary proxemics of urban social strife, Beckett and Bowie touch from a distance insofar as something of their sexual aesthetics do converge towards ruination, with the singular difference that Bowie's creative libido seems inspired among the architectural ruins while the degenerating environment seems to contribute further

to Beckett's characters' tendency towards expiration. For example, the horny central persona of "Sweet Thing," wandering the dilapidated street of the song's ruined urban space, is in marked contrast to the protagonist of *Film* who runs desperately through a similar landscape seeking his empty room and solitude, away from the prying eyes of society in general, communion with the latter the last thing he desires. Nevertheless, whether it is emphasizing repressed homoerotic currents in the social, as in "The Calmative," or proposing a world-weary indifference to social communion in general, as in *Film*, by representing just such alternatives, Beckett draws attention to the habitual presence and de facto persuasiveness of an implicit, orthodox, social heteronormativity designed to perpetuate the hetero, and, more importantly, *the generative*. By removing the possibility of reproduction from his imagined worlds, such as those of *Waiting for Godot* and *Endgame*, Beckett seems, at first, to be advocating an entropic form of decline to extinction, a ruined landscape soon to be rendered people-less. Paradoxically, however, these works serve to emphasize reproduction's role in national self-definition and economic development as they are encountered in more traditional narratives. Seán Kennedy notes that

> in discourses of national regeneration, human validity is indexed directly to sexual fertility and/or a capacity for productive labour: to production and reproduction. Disability, like perversion, is abjected in the process of national self-definition.
> (*Beckett Beyond the Normal* 8)

Beckett's worlds without women, or with women but without virile men (such as the world of *Happy Days*), draw attention to the manner in which generative subjectivities are privileged at the expense of the queer and associated negative perceptions of being such as the degenerative, the barren and/or the disinclined. His degenerate characters, lacking the appropriate drive towards social performativity, and realized in a form that approximates "penury," or what he called a "syntax of extreme weakness" (*CLSBIII* 211), all implicitly draw attention to their framing as pathologized creatures when housed and judged by normative social discourse.

It is in this way that sexuality is a central concern in Beckett's work, despite its rare appearances contextually. Aesthetic drive is, after all, a form of channeled libido and Beckett's aesthetics of failure, of impotence and decomposition, indeed his works' pervasive silence, all (paradoxically) articulate novel subjectivities that have relinquished the performative tyranny of desire and its associated imperative to build an efficient workforce. For example, "All Strange Away" narrates the presence of a man and woman; the former upon espying the "face," "breasts," "thighs," "cunt," "arse," and "hole" (*GCW* 351) of the latter mutters "imagine him kissing, caressing, licking, sucking, fucking and buggering all this stuff" but in the story "fancy [is] dead" and the "gaping eyes unaffected" by desire for coitus or alternative sexual activity. The very possibility of intimacy is imagined as a type of deathly embrace, hence the story's suggestion that imagination is dead.

This is, of course, in contrast to diverse forms of sexuality that champion the freedom of enjoying the physical, something that Bowie's work celebrates. Nevertheless,

beyond the specifics of gender and sexuality, the presence of queer and degenerative aesthetics in Beckett's work is a strategic undoing of the implicit conditions that ordinarily underpin and support both familial and national ideologies, dismantling the heteronormative desire that drives economic efficiency. By way of example, in "The End" the narrator's choice is not between sex and masturbation, in which the possibilities of reproduction are set in contrast to a non-productive onanism, but between the latter activity and scratching, with the result that pleasure and desire are uncoupled from the reproductive drive completely:

> Real scratching is superior to masturbation, in my opinion. One can masturbate up to the age of seventy, and even beyond, but in the end it becomes a mere habit. Whereas to scratch myself properly I would have needed a dozen hands. I itched all over, on the privates, in the bush up to the navel, under the arms, in the arse, and then patches of eczema and psoriasis that I could set raging merely by thinking of them. It was in the arse I had the most pleasure, I stuck in my forefinger up to the knuckle. Later, if I had to shit, the pain was atrocious. But I hardly shat any more.
> (*The Expelled and Other Novellas* 87)

In such moments, Beckett's work deconstructs the legitimacy of the sexual conditions which support political economy by proposing non-generative alternatives to the desire usually mobilized to initiate and engage in sexual activity. In unmasking the relationship between sex and capital, Beckett's work operates in a manner similar to the way in which Disabilities Studies makes visible the architectural privileging of able-bodied people within proxemic constructions that naturalize their privilege and exclude the disabled from inclusive participation.[3] Comparably, Beckett's aesthetics render heteronormative social infrastructure visible such that his type of libidinal queerness is important for shedding light on aspects of competitive libido-driven liberal society that are, LGBTQ+ celebrations notwithstanding, alienating towards queers.

Regarding such normative sociality, Leighanna Rose Walsh observes about the current rush to praise countries for legalizing gay marriage:

> although marriage is a declaration of love, in many ways it is also an expression of interpersonal stability, economic security and social respectability—attributes that many marginalized LGBT people do not have. So while love may have won for middle and upper class gays, many transgender people, queer people of color and queer homeless youths instead find themselves left behind by a community that has become increasingly defined by the interests of its white, cisgender, middle and upper class members.
> ("Quest for Respectability")

Here Walsh refigures gay marriage rights less as an inclusive liberation and more as the draining of subversive subaltern energy, a way of preparing queerness to fit the status quo in soporific fashion. In other words, at the point where identity is ultimately determined by efficient economic performativity, subaltern identity must necessarily

lose its specifically oppositional nature, becoming incorporated instead as a feature of discreet capital drive. Judith Butler agrees, noting that the desire to legalize same-sex marriage

> effectively strengthens marital status as a state-sanctioned condition for the exercise of certain types of rights and entitlements; it strengthens the hand of the state in the regulation of human sexual behavior; and it emboldens the distinction between legitimate and illegitimate forms of partnership and kinship. Moreover, it seeks to reprivatize sexuality.
>
> (176)

Moreover, she identifies the community that gay marriage advocates abandon:

> They break alliance with people who are on their own without sexual relationships, single mothers or single fathers, people who have undergone divorce, people who are in relationships that are not marital in kind or in status, other lesbian, gay and transgender people whose sexual relationships are multiple (which does not mean unsafe), whose lives are not monogamous, whose sexuality and desire do not have the conjugal home as their (primary) venue, whose lives are considered less real and less legitimate, who inhabit the more shadowy regions of social reality.
>
> (176)

Butler is proposing that the desire to be married is also a desire to be wedded to the state; the willing bride/groom also marries into state power in its various legal and juridical aspects. In doing so, the married contribute to the ongoing construction of a biopolitical "normal" that simultaneously stigmatizes those abnormal who suffer the sanctions of a displeased nation, such as divorced fathers, for example, who experience a disproportionate degree of exclusion from conventional family sociality often legally, and painfully. Moreover, this marriage of hetero and, increasingly, homo convenience also endorses the state as the appropriate arbiter of love and desire, something which, historically, has proven deeply problematic.

If we take the historic framing of homosexuality as a way of mapping this exclusionary/inclusionary social process, it is important to remember that it was included, as a pathology, in the *Diagnostic and Statistical Manual of Mental Disorders* (DSM) as recently as 1968. The DSM is the psychiatric industry bible of dysfunctions, disorders, and diseases of the psyche. In 1968 it proposed homosexuality was a mental illness at a time when conservative America, and its economic armature, was intolerant of what it perceived as a libertarian minority pastime. However, neoliberal capitalism has the capacity to reinvent and include when it espies the profit potential of the previously non-normative. Today, the parameters of social inclusivity open comfortably to begin normalizing even the most traditional of scapegoats, as we are currently seeing with the rise of pink capital. Beckett's work can then be understood, retroactively, as an intuitive and predictive resistance to the absorption of the queer, the outlier, and the marginalized into normalized and normalizing society and as a celebration of diverse subjectivities nonetheless becoming increasingly shorn of their oppositional drive.

Struggling Against the Straight

In contrast to the queerness, erotic or otherwise, that Beckett engenders in order to critique the false consciousness that holds a repressive society in place, the queer "becoming" Critchley speaks of in relation to Bowie is a liberating one: a becoming free. Transformative "becoming" finds appropriate expression in Gilles Deleuze and Felix Guattari's book *Kafka: Towards a Minor Literature* (1986) which celebrates emergence as an act of resistance. Dene October, in his excellent essay in *David Bowie: Critical Perspectives*, notes that for Deleuze, "the contracted world of being-man is the very '"assemblage of power"' (248) and becoming minor is a form of resistance to that patriarchal subject. Certainly, Ziggy in his androgynous resistance to "being-man" facilitated Bowie becoming famous on *Top of the Pops*. At the same time, Deleuze argues that "there is no becoming-majoritarian; majority is never becoming. All becoming is minoritarian" (October 247). In the *TOTP* "Starman" moment, and what followed, Bowie advances the LGBTQ+ cause by performing a sensual and homosocial persona, which gradually became both more visible and more acceptable in society generally. As a result, Tony Visconti suggests:

> [David] opened the world for people who hid in the shadows who thought they were different, too different to fit into society. Look at the way society is now. It's much more open and in a large way I think that's down to David's philosophy, his lyrics, his own lifestyle, his own example of how to be different and how to be courageous about being different.
>
> ("We all Thought he had more Time")

Bowie's sound engineer and collaborator proposes that his friend's legacy, in the first instance, is one of social transformation for gay, straight, and gender fluid people, and consequently for everyone else. Visconti is proposing that Bowie's daring public displays of homoerotic otherness created a new world in which, to begin with, the outsider was in. Yet for all the truth of Bowie's transformative longitudinal influence, it is nonetheless important to recognize two things at this juncture: Bowie alone is not a single, defining character and/or moment that produced this transformation, and the transformed society, that Visconti proposes might be "open" for the business of tailoring lifestyles for some, is not open to opportunity in a truly inclusive way. Further, both of these mystifications complement each other in that suggesting one individual can make such a seismic difference is deeply ideological because it implies liberal society just needs a little nudge to realize its liberatory project. In point of fact, the idea that one entertainment figure can change the world, that such an individual's steely conviction can transform the majority consensus, is capital ideology in a nutshell. In reality, the idea of singular passage into inclusivity is an illusion. Liberal society is not changed incrementally though solely democratic means. Instead, there is always an impending conflict that needs to be engaged and/or resisted. There is always, in a word: struggle.

For example, Bowie was inspired to his own sexual experimentation by the openness and welcome he received when he started to attend gay clubs in Soho in the late nineteen-sixties. Similarly, he inspired generations of others—such as Boy George and Marc Almond—to express diverse sexuality and style such that Bowie's *Top of the Pops* intervention plays a significant role in what *became* a struggle to transform public consciousness. But Soho and the symbolic world of *TOTP* were enclaves of refuge, and as Robert Smith and Ian McCulloch noted, Bowie's TV appearance produced conflict and tension in the schoolyard. And if Bowie's appearance drew up battle lines among the young, and very many gay people have similar tales to tell of schoolyard bullying and intimidation, this is to say nothing of the divisions in the adult world (discrimination at work, bullying, job termination, physical harassment, murder, etc.). Consequently, when it comes to gay rights, the historical struggle to achieve change should be privileged in all its dimensions. Indeed, marching and performing might be referred to as the twin strategies of "boot" and "camp." Although the liberating effect of performing "Starman" is undeniable, Bowie's "Starman" moment is one with the Stonewall riots and the countless LGBTQ+ marches that began to have an emancipatory effect on emerging gender history. In other words, the history of gay liberation is rough and tough and tumble in response to systematic attempts to suppress sexual diversity, so to imagine one man can bring about such change by appearing as a louche Martian on the television is to suggest society is too easily molded. The reality is that change is produced through engaging in conflict and seeking its resolution, and these antagonisms continue long after neoliberalism attempts to suggest that they have all been resolved. In this regard, it is worth considering that Stonewall happened at a time when American society nonetheless represented itself to itself as democratic and free, as a vision of a successful liberal society. And liberalism necessarily proceeds in this way. Part of its ideological mission is to disguise its own instrumentalized *modus operandi*. Michel Foucault describes the genesis of liberal society itself:

> the liberalism we can describe as the art of government formed in the eighteenth century, entails at its heart a productive/destructive relationship with freedom. Liberalism must produce freedom, but this very act entails the establishment of limitations, controls, forms of coercion, and obligations relying on threats etc.
> (*The Birth of Biopolitics* 64)

Seen from this perspective, queerness became acceptable not as a result of a benevolent society suddenly recognizing queer legitimacy, but as a result of gay and transgendered people marching through the streets of the West demanding equal rights, through gay-friendly volunteer organizations educating people to the difficulties experienced by gay men and women living in an unforgiving society, and through the various arts that promote the same message. Yet as these queer advocates made the control systems of liberal society apparent, the latter then recalibrated its "forms of coercion" in other directions. The result is that flamboyant fundraising events like the Pride parade celebrate diversity in a manner that echoes the carnivalesque appearance of Bowie's

"Starman," but the reality is that there are queers left behind. As successful liberal life is both financially and structurally oppressive—producing material violence against excluded subjects—its discreet operations are arguably the most insidious of all.[4] Consider, by way of example, Colin Walmsley's description of Pride 2015. It is worth quoting at length. On the evening of June 28 he noted that

> two very different celebrations took place to mark the most historic New York City Pride week in decades. The flashier of these celebrations was the iconic Dance on the Pier. As the Pride Parade came to a drizzly end, an exuberant crowd of young, gay and mostly white men made their way to Hudson River Park's Pier 26, where Ariana Grande headlined a big-budget outdoor mega-party ... Admission started at $80, but that didn't stop 10,000 enthusiastic fans from snatching up tickets to what organizers billed as one of the world's top-tier LGBT events. If any of those 10,000 attendees had taken a break from the dancing and glanced across the Hudson to the north, they may have seen the outline of the Christopher Street Piers, where a celebration of a very different kind was taking place. Here, a motley crowd of queer homeless youths—who definitely could not afford admission to Dance on the Pier—decided to throw an impromptu party of their own. With the bass from the Ariana Grande concert pulsing in the background, the youths—male, female, cisgender, transgender, gay, lesbian, bisexual, black and Latino—drank, smoked, sang, vogued and played cards under the dim light of the street lamps ... the extravagant Ariana Grande concert and its upscale audience could not have seemed more out of place among the piers that have served as a safe haven for the queer community's most marginalized—mostly queer homeless youth of color—for decades ... And this growing rift between mainstream and marginalized LGBT people makes me fear that our community won't have a common future.
>
> ("The Queers Left Behind")

Walmsley bemoans the fact that the possibility of complete inclusivity, the type of party where all outsiders are invited in, indeed the type of party that the Hudson piers once represented, has been replaced by a celebration dedicated to economic profit rather than pride. Walsh concurs: "In many cases worldwide, Pride and LGBTQ movements in general have become deeply commercialized, respectable, sanitized. Apolitical" ("Quest for Respectability").[5] And it is because Pride has become commercialized and gentrified, that it necessarily needs to appear apolitical for fear of being revealed as the expression of oppressive neoliberal capitalism. It is worth considering that the parade, in principle, constitutes or facilitates a potentially transformative political moment. The bigger it gets, the bigger its potentially revolutionary character. The problem is that this possibility is ameliorated by its commercialization which also serves the function of increasing the ideological mystification that ensures the perpetuation of the status quo. Mikhail Bakhtin has written what Terry Eagleton calls "the best political tract on carnival" (*Humour* 189), in which the former recognizes the subversive power of the

festival moment. In "Carnival and the Carnivalesque" Bakhtin proposes there is a great leveling in the carnival parade that has profound political value:

> Carnival is a pageant without footlights and without a division into performers and spectators. In carnival everyone is an active participant, everyone communes in the carnival act ... The laws, prohibitions, and restrictions that determine the structure and order of ordinary, that is noncarnival, life are suspended during carnival: what is suspended first is hierarchical structure and all the forms of terror, reverence, piety, and etiquette connected with it ... or any other form of inequality among people.
>
> (Bakhtin, qtd. in Storey 286)

In the carnival moment, hierarchies are turned upside down, revealing in the process the potential for overthrowing extant power structures. Bakhtin draws attention to the symbolic celebration and divestment of the carnival king, or jester, noting that the "primary carnivalistic act is the mock crowning and subsequent decrowning of the carnival king, a dualistic ambivalent ritual" which symbolizes "the joyful relativity of all structure and order, of all authority and all (hierarchical) position" (Storey 287). However, although the carnival moment of Pride (and other such official pageants) is ripe with revolutionary potential, it is necessarily instrumentalized by an ideological habitus oriented towards maintaining the status quo. Its ritual character, and attendant sensual pleasures, are framed as a temporary cathartic release that must not interfere with long-term corporate and institutional goals. John Storey summarizes this operation as follows:

> Certain rituals and customs have the effect of binding us to the social order. A social order which is marked by enormous inequalities of wealth, status and power. Using this definition, we could describe the seaside holiday, or the celebration of Christmas as examples of ideological practices. ... they offer pleasure and release from the usual demands of the social order but ... ultimately they return us to our places in the social order, refreshed and ready to tolerate our exploitation and oppression until the next official break comes along. In this sense, ideology works to produce the social conditions and social relations necessary for the economic conditions and economic relationships of capitalism to continue.
>
> (4)

In the case of Pride, for example, its capital relations are embedded as social relations provided by corporations and companies from Marriot Bonvoy Hotels (which offers LGBTQ+ tailored holidays) to Adidas and Nike ("Proud Pride Sponsors") whose products encode commodity acquisition as social identity. In order to do so effectively, they ameliorate the revolutionary potential of the Pride parade through an ideological mystification that replaces liberation with consumption. The result is that rather than the growth of Pride contributing to increased revolutionary capacity

(its size should make it a potential threat to social order), its disruptive political efficacy is carefully neutered by a dominant ideological paradigm—one that insists on the revolutionary character of joy and pleasure as purely symbolic and temporary, represented as a fleeting moment of liberation. This is further supplemented by ensuring the capital ethos is endorsed by Pride rather than challenged by the parade's carnival possibilities. Once the parade becomes an affirmation of neoliberalism's commodified values it no longer constitutes any transformative threat to the status quo. In this regard, Pride is framed as the collective embodiment of a (temporary) moment in which positive idealism as an affirmative, universal gesture can be offered as a solution to the world's woes, but rather than this moment offering the intersubjective possibility of a radical change, it returns the participant to work on Monday, with a nice new t-shirt.

In "Posthuman Affirmative Politics," Rosi Braidotti champions a "vital materialism [that] defies the oppositional character of dialectical thought and posits a pacifist ontology of mutual specification as the motor of process of individuation" (36). She believes that such vital materialism avoids "the antagonistic dimension as the defining core of politics" (3). Relinquishing these roots, and the need to address the negative ontology therein, vitalism instead posits, a priori, an affirmative universality from which the presence of the negative, or negativity, has been elided. In relation to Pride and other initiatives, the result of this amputation is that although queer may appear to be a vitalist force grappling with the ambivalent beast of capitalism, given that the principle of struggle has been silenced, it is capitalism that now enjoys the full benefit of its incorporative capacity as the vital force in the equation. And Slavoj Žižek, for one, believes this outcome to be inevitable. Despite the fact that

> postmodern politics definitely has the great merit that it 'repoliticises' a series of domains previously considered 'apolitical' or 'private': the fact remains ... that it does not in fact repoliticise capitalism because *the very notion and form of the political within which it operates is grounded in the 'depoliticisation' of the economy.*
> (*Contemporary Dialogues on the Left* 98)

In this formulation, sexual identity is mobilized in capital production to privilege identity politics at the expense of economic politics and therefore facilitates identity struggles becoming overdetermined by the sublimated antagonism generated as a consequence of economic inequality.

Thankfully, in the third decade of the twenty-first century, both the revolutionary potential of the carnival moment and the manner in which the hegemony tries to sanitize and neutralize this revolutionary possibility is being addressed by a number of LGBTQ+ organizations. This has resulted in serious questions being asked of Pride in both New York and London. Mirroring Adorno's belief that antagonism always returns as sedimented history, an alternative parade entitled "Queer Liberation March" took place in Manhattan on June 30, 2019, the day the New York borough was celebrating World Pride Day. It left from outside Stonewall at 9:30 a.m. and

proceeded to Central Park along the route of the first Pride march in 1970.[6] The organizers insisted on no floats and no police presence in a bid to draw attention to the commercialization of the main Pride parade which included floats sponsored by AT&T and Mastercard and innumerable politicians marching with their entourages through the day. Meanwhile, back in London in 2019, the campaign group "Lesbians and Gays Support the Migrants" (LGSM) which mounted the well-known "Queer Solidarity Smashes Borders" banner on Vauxhall Bridge on the occasion of Trump's inauguration in 2017, took out a series of bus shelter advertisements drawing attention to who had acquired the right to march in London Pride 2019. The LGSM advertisements noted that individuals could not register to participate in Pride, but Barclays Bank was provided a prominent float space in the parade, prompting renowned gay rights activist Peter Tatchell to observe that the festival "has become too bureaucratic and regimented" (Davies, "Pride in London"). In these ways, the annual Pride celebrations serve as a microcosm of the problems involved in normalizing queerness. Žižek caustically notes:

> One cannot get rid of the suspicion that the politically correct cultural Left is getting so fanatical in advocating 'progress' in fighting battles against newly discovered cultural and sexual 'apartheids' only in order to cover up its own full immersion in global capitalism. Their shared space is the space in which LGBT+ meets Tim Cook.
>
> (*Courage of Hopelessness* 254)[7]

To queer the pitch on gender and sexuality, what became known as glam, in many ways typified by Pride, is one manifestation of a responsive, resistant aesthetic but its efficacy to achieve transformative change in the very means of production of liberal society is compromised by its collusion with capitalism. Alternatively, there are other resistant impulses that can make a stand against economic exploitation, racism, misogyny, and further contemporary attempts by capitalism to instrumentalize the human subject. The various manifestations of vulnerable Bowie personae with knife-lacerated brain and fragile grasp on reality, and Beckett's complementary, collapsing, last-gasp tramps, draw attention to this instrumentalization and the effect it has on vulnerable beings in an unforgiving, rapacious society. In Bowie's case, an emphasis on the dark energy of emotional power when expressed, unfettered, as tortured desire serves to challenge a domesticated status quo. As a response to Foucault's claim that "liberalism must produce freedom, but this very act entails the establishment of limitations, controls, forms of coercion, and obligations relying on threats etc." (*The Birth of Biopolitics* 64), Bowie's work offers transgressive emotive states that challenge the nature of the freedom offered and, in contrast, illustrate the excesses that liberalism sees as threatening, and seeks to contain. Such forms of coercion, codified legally since the advent of the nineteenth-century alienist, now exist as de facto prohibitions on desire and difference; a difference which can be found among the queers who do not aspire to marriage and other heteronormative social codes. In the song "John—I'm only Dancing," for example, the narrative persona paints

a picture in which desire manipulates jealousy to signify emotional states of arousal and anger beyond heteronormative modes of acceptable sociality:

> Well, Annie's pretty neat
> She always eats her meat
> Joey's almost strong
> Bet your life he's putting us on

A character dances with a "she" to the chagrin of John, which is most likely a generic "John," a term denoting a prostitute's potential customer. Given that the Annie referred to in the opening line is characterized by oblique reference to her willingness to provide oral sex and the intimation that Joey might be a transman, the mise-en-scène evoked is most likely a brothel or nightclub characterized by sexual diversity. Herein the song's narrative persona, not necessarily conforming to conventional cis gendered attractions, tempts the John with a sexualized dance with another person, designed to prompt and provoke his jealousy. In this regard, couples dancing are historically recognized as engaging in a clothed form of sexual intercourse, although you wouldn't know this from the dance halls of Irish yesteryear. Crucially, once it has been provoked, the jealous impulse is not resolved; jealous desire, prompted by dancing as sensual pas de deux, and teased throughout the song, remains unrequited and the song fades with refrains that the narrating persona be further touched sexually by the dancing partner, and so on. The song concludes with the energy of its unrequited, brooding, impassioned, queer desire intact so that neither it, nor the narrator who teases this desire, are easily accommodated into conventional cis gendered frameworks or heterosocial spaces. Moreover, and redolent of Beckett's non-generative proxemic spaces, the indeterminate nature of "she" with whom the prostitute dances represents a challenge to neoliberal architectures of gendered inclusivity, proposing a type of sexual freedom invested with the queer energy that might threaten established heteronormative architectures. Another example of how Bowie provokes an unrequited desire that challenges such hetero codes is the longing the narrative persona suffers for the "Queen Bitch" referred to in the song of the same name. "She," too, transgresses cis containment in another highly charged sexual environment:

> She's an old-time ambassador
> Of sweet talking, night walking games
> Oh and she's known in the darkest clubs
> For pushing ahead of the dames

The object of the narrator's affections is both a "she" and someone distinct from "dames," suggesting a transwoman who is also a well-established trans prostitute of some repute and sexual expertise. The song's persona watches from a room above the street as the queen bitch arranges a trick with a passing cruiser; again, the term cruiser suggests a gay customer and so reinforces the street walker's potential identity as that of a transwoman. Indeed, in a trifecta of gendered diversity, the narrator's claim that she

could turn out a more attractive outfit than the old-fashioned hippie ensemble worn by the queen bitch, frames her, also, as most likely a woman or a transwoman. Either way, this narrator endures a potentially destructive conflictual jealousy that cannot be "wedded" to a vitalist heteronormative biopolitics, remaining resolutely single and desirous of a promiscuous sexual fulfillment that the song endlessly defers. In this way, these subaltern characters illuminate the often invisible discipline and control strategies that marginalize such characters and their potentially disruptive desires within hetero-sociality. In Bowie's world "beyond," he gives trans identity a voice, often a disenfranchised voice sustained, principally, by the pleasure it derives from exploring its desires. In this way, queer kicks back against coercion and threat with its own anarchic and life-affirming libido. For this reason, the "Jean Genie" who "lives on his back" "and "ate all your razors," is perhaps a more "incisive" mascot for the need to recognize the struggle for greater gender diversity than a quasi-Martian deity singing a hook it stole from "Somewhere over the Rainbow." Having said that, it is as a result of emerging as an alien creature that Bowie could safely express transgressive desires such that they were associated in the popular imagination with alien life in the first instance. The intersubjective identifications the songs then forge began the long process of strengthening his influence as an emissary of diverse sexual cultures, a position strengthened by the appearance of many other advocates of both boot and camp.

Even if less erotically charged, Beckett's outsiders also give frequent expression to queer desires radically at odds with the hetero-normative hegemony that constitutes the status quo. In a strategic operation similar to Bowie, Beckett draws attention to the manner in which society determines certain behaviors as normal and others as marginal and/or perverse. And he often does this with great humor and Rabelaisian flair. His first (and for a long time unpublished) novel introduces the central character, one Belacqua, in a state of sexual excitement with "his mouth ajar, and his nostrils dilated," pedaling his bicycle furiously at the prospect of a galloping cart horse defecating until "like a perturbation of feathers the tail arches for a gush of mard. Ah" (*Dream* 1). Despite the comic framing designed to skewer eroticism, the sexual fetishization of the horse is nonetheless resolutely non-generative. Paul Stewart reads the expulsion motions of the horse in a Freudian manner, or as Beckett's parody of a Freudian reading in which the feces represent a child, but it amounts to the same thing, "fear or horror at reproductive sexuality" ("A Rump Sexuality" 257). This fear reaches its apotheosis in *Endgame* and "All that Fall" in both of which there is a clear suggestion that a child might be killed to thwart its future reproductive potential. *How It Is* represents another non-generative universe in which a series of men crawling in the mud assault each other in the anus with tin openers in perhaps one of Beckett's "quarest" worlds. In each of these instances, queer desires—infanticide, sadomasochism—unmask the reproductive necessity that underpins and reproduces the normal through a salient contrast with Beckett's beastly and childless caricatures.

There are also other Beckettian challenges to the heteronormative world outside of non-generative contexts. The opening line of the story "Enough"—"All that goes before forget"—is quickly followed by details that make it impossible to comply with such an

injunction. It features what appears to be a shambling aged couple who, the narrator tells us early on, were first united when the narrator "cannot have been more than six" (*GCW* 366). Quickly following this, it is rendered deliberately unclear at what age the narrator acquiesced to fellatio—"when he told me to lick his penis I hastened to do so"—(366) with the result that normative social codes are challenged in a disturbing manner. By the conclusion of the story, the narrator, now clearly aged, but never clearly framed as a woman, acknowledges gratefully the continued presence of the other— "Enough my old breasts feel his old hands" (370)—such that an emphasis on the female body and the passage of time allows for the deferral, in time, of the initial sexual contact until an appropriate age. Yet this conclusion is only partially reassuring. The other, the man, if indeed we can call him that, seems always to have been significantly older than the s/he who narrates at every stage of their relationship, and s/he is also unduly concerned with addressing his needs at the expense of her own, telling the reader "When he didn't desire anything, neither did I" (365) suggesting complete identification with the sexual initiator at the expense of an individuated subjectivity.

That the reader has ethical doubts which remain throughout the story is a deliberate provocation by Beckett as a means of challenging, in the first instance, the recording of testimony and, in the second, the chrononormativity that governs conventional sociality. In the first instance, narrative as a guarantor of meaning is always already compromised by its mode of construction. In "Enough" the narrator is dictating "her" story to one who writes with a pen and who can be heard at this activity somewhere behind her as s/he narrates. It becomes apparent that her transcribed words (we must presume they are transcribed given that the narrative we read is the exposition of her story) may or may not be a complete record of her recollections. S/he describes a scenario such that "when the pen stops I go on. Sometimes it refuses. When it refuses I go on. Too much silence is too much. Or it's my voice too weak at times" (365). The reader can therefore deduce that elements of her story may be missing as a result of her nervous tendency to talk too much or as a consequence of a faintness of voice. The transcriber could miss key details for either reason or simply fail to record what "it" feels is abject or obscene. In this way, Beckett's story questions the legitimacy of narrative to adequately convey human experience within it, emphasizing the gaps and absences that impede a full understanding of experience, producing alienated experience, from where the narrating character seems to emerge. Nic Barilar proposes that

> the logic of late capitalism choreographs the normative sequence of life's events from unruly childhood to disciplined adulthood through education, marriage, property acquisition, parenthood: the very cycle that secures the reproduction of family and/as nation.
>
> (108)

In contrast, "Queer Studies has advanced theories of time as an oppressive force" (108) and the narrative temporality of a story like "Enough" proposes to utilize heteronormative time narratively but fails, and, in doing so, opens up queer time

to function both as its contrast and commentator. Thus, queerness serves a double function in which character can be "something freer" from straight, social expectation, such as in Bowie's songs, but also free from traditional narrative containment if not from heteronormative expectations. Beckett's quare work illuminates how the one is reliant on the other as structural necessity.

Beckett's work can also be understood as suggestive of the experience and aftereffects of sexual trauma. For example, arguably the contextual and structural absences of the short piece "As the Story was Told" suggest the presence of the concentration camps of World War II, and, with its temporary huts and tents, it also seems to describe the mise-en-scène of post-war refugee experience. At the same time the story also implies a traumatic sexual experience. The short narrative begins:

> As the story was told me I never went near the place during sessions. I asked what place and a tent was described at length, a small tent the colour of its surroundings. Wearying of this description I asked what sessions and these in turn were described, their object, duration, frequency and harrowing nature.
>
> ("As the Story was Told" 103)

In the first instance, the narrator, through asking questions, engages someone in a dialogue that he then narrates to the reader. He recalls asking:

> where I was while all this was going forward. In a hut, was the answer, a small hut in a grove some two hundred yards away, a distance even the loudest cry could not carry, but must die on the way.
>
> (104)

The piece is triangulated in the sense that the narrator who narrates what he is told by his interlocutor thus narrates the second-hand story of an old man who dies, perhaps through torture—"[a]s the story was told me the man succumbed in the end to his ill treatment"—and who might have been pardoned if the narrator only knew what to say—"I did not know what the poor man was required to say, in order to be pardoned" (107). Unfortunately, the interlocutor does not enlighten the narrator in this regard, so both the character and reader remain in the dark. Likewise, the relationship between the tents and huts and a summer house are never established. In fact, the basic coordinates required to make sense of what is taking place are entirely absent.

Biographically, it is quite reasonable to assume that the tableaux of "As the Story was Told" reflects, in some imaginative way, Beckett's experience at the temporary Irish Hospital in Saint-Lô for which he worked as a porter in late 1946. In "The Capital of the Ruins," he informs the reader that the "hospital of the Irish Red Cross in Saint-Lô ... consist[s] of some prefabricated wooden huts" (17–18). One interpretation, then, of this story of tents and huts in a camp, where there is the implication of torture complicated by a diegesis within a diegesis which makes it impossible to ascertain who is speaking, is to suggest that it represents a shifting subjectivity that might be a way of representing refugee experience, be it in the concentration camps or in the temporary

hospital in Saint-Lô. At the same time, the old man may be the narrator as if narrated by another, or by himself, but at a remove, with the result that elisions generate an opacity that obscures singular, self-identical memory. Beckett states in "The Capital of the Ruins" that "Saint-Lô was bombed out of existence in one night" (25), so where we might reasonably expect engagement with refugees in his fictionalized account of the town, instead we encounter a text steeped in deliberate ontological confusion in which the narrator seems to be, in some sense, an alienated refugee from himself. As Beckett does not tie suffering directly to specific material causes, to specific refugee experience, this structural absence contributes to a sense of dread throughout the story. Such dread might also be read into the narrator's comparison between the hut in which he finds himself and a scene of potential childhood trauma:

> It reminded me strongly of a summer-house in which as a child I used to sit quite still for hours on end, on the window-seat, the whole year round. It had the same five log walls, the same coloured glass, the same diminutiveness, being not more than ten feet across and so low of ceiling that the average man could not have held himself erect in it, though of course there was no such difficulty for the child.
> ("The Capital of the Ruins" 7)

Beckett, such a scrupulous wordsmith, would be fully cognizant of the play on "erect" that takes place in this story of unidentified but palpable trauma. At the same time, the possibility of separate suffering in three different locations—the tents, huts, and summerhouse—makes identification of a specific sexual trauma more difficult. In psychoanalytic terms, Beckett's strategy here is to condense rather than displace the sense of a catastrophe. Whereas displacement operates by way of substituting one thing for another such that, in psychoanalytic terms, a trauma can be displaced along a signifying chain designed to obscure it or render it unconscious, in condensation, the trauma, although disguised through its conflation with other related signifiers, retains its antagonistic tension driving the symbolic formation of the dream/story. As Séan Kennedy notes, condensation "shows Beckett thinking through many things at once. Where historical materialism sees confusion, psychoanalysis sees the condensed eloquence of the symptom" ("Biopolitics of Famine" 65). Arguably, in "As the Story was Told," Beckett condenses the traumatic consequences of historic patriarchal formations that foreshadow the fall of the Catholic church in Ireland, figuring "the child" in the story as the victim of the institution's twisted desires. The effects of this abuse are at one with the cries heard near the huts and the harrowing torture and confessions being recounted in the tents that may be akin to individual and collective traumatic war memories. The implication is that just as in the temporary refuges of the casualties during war, the gardens of suburbia, too, can house the site of traumatic suffering. Moreover, the narrative that frames both does not distinguish between the degree of suffering or the traumatic aftermath of different types of psychological ruination.

The subaltern characters outlined in these stories are obliged to exist at the margins of society from where their spectral presence guarantees the "normality" of the mainstream. They exist ostensibly in stark contrast to the "healthy nature" of

society in its habitual form, a form that embraces and utilizes heteronormative social codes as controlling imperatives. Articulating such characters, and, in so doing, representing their experiences, introduces erstwhile stigmatized states into the social. These wounded subjectivities undermine established social practices, often revealing these orthodoxies as repressive mechanisms designed to silence the unspeakable, and, in this, they are redolent of Oedipus and his fate as the archetypal scapegoat of social expectation. Crucially, however, both Beckett and Bowie do not seek to repatriate these figures into extant society, as contemporary gender-inclusive initiatives are designed to do in the biopolitics of the status quo. Rather, in identifying these outsiders, Beckett and Bowie frame them as alienated figures beyond conventional sociality. This, in turn, produces the possibility of multiple subject positions for members of their audience. Some will identify with the alienated characters and, in doing so, will experience an intersubjective moment of identification and succor. Others may be prompted to admit to the alien in themselves, perhaps for the first time, be it in terms of recognizing their own desires, or accepting new understanding of their own sexual and social experience. Either way, it is a desired effect of Beckett and Bowie's alien art, as it engages with questions about gender and sexuality, for the audience to see themselves in these outsiders, to some degree, and, in the intersubjective encounter with these characters, to create the possibility of novel forms of being, a "specific type of humanity" (Rancière 24) oriented towards communitarian empathy and social change. Quite simply, Beckett and Bowie represent the outsider so their audience can have the opportunity to see and feel themselves *as* outsiders, in this moment drawing attention to their alien core. However, and unfortunately, the thing that most mitigates against the honesty of this recognition is the very thing that neoliberal society generates in order to protect itself: fear.

Today the average neoliberal subject is "eminently governable" (Foucault, *The Birth of Biopolitics* 270) because s/he is aware of the relatively privileged position s/he occupies within the social (i.e., not on the economic bread line). Additionally, these subjects have also internalized the disciplinary nature of the surveillance culture of the late twentieth century. The result is that with ever increasing numbers of *homo sacer*, everyone, including the subject making an average income, lives in fear; fear of having no job, no means, no property such that living becomes synonymous with a fear of failure, living with the persisting anxiety of human vulnerability and weakness. These fears and anxieties are further consolidated through fear for the environment, fear of being caught up and caught out in a surveillance society, fear (stoked by propaganda) of the migrating other, fear of being consumed such that walls and apartheid re-emerge, and all this is suffered silently, desperately. The result: an unavoidable feeling of complicity in these machinations that serves to corrode the individual spirit rendering people outsiders in a world in which they may even be financially comfortable.

The work of Beckett and Bowie stands in marked contrast to these operations. They write and perform in such ways that their legacy can be said to be a critique of late capital modernity. In imagining "configurations of experience that create new modes of sense perception" resulting in "novel forms of political subjectivity" (Rancière 9) they make possible the dissolution of borders between the self and other, between inside and

outside, offering all a frank recognition of our essential outsider-ness, which they render coextensive with a necessary recognition of our collective strangeness. Žižek observes of the modern moment of Western indulgence that once the previously forbidden fruits of desire—drugs, sex, alcohol, and so on—become the subject matter of protective legislation for the privileged, we have "a society in which personal libertarianism and hedonism co-exist with (and are sustained by) a complex web of regulatory state mechanisms. Far from disappearing, the state is strengthened" (*Courage of Hopelessness* 41). Yet under the guise of imagining itself free, not only does neoliberalism ignore the claims to inclusivity of those on the margins, as in the ongoing refugee crisis, it produces the very same crisis as the inevitable collateral damage of its economic project without the vast majority of participants recognizing this contradiction. In Europe, at present, the threat to European identity is projected onto external others such as ISIS and refugees, and, in the USA, onto China and Russia, illegal aliens and, internally, onto "black attitude" and Islamic extremism. These projections are the contemporary manifestation of previous fears that were projected onto gay culture, and hippie culture, and sexually permissive culture, and communists, and native Americans, and so on. But as the wagons continue to circle, and the circle itself shrinks, more and more liberal subjects understand their position at the heart of the control machine. When one strips away the strawman threats to liberal society, in reality, the liberal is *afraid of itself*, and this is the negative ontology that must be transformed if things are to change. Žižek ably sums up the structural logic of the tripartite Hegelian dialectic synthesis that can be employed by the liberal subject to effect such change, and, in particular, he clarifies the tenor of its primary element:

> Hegel does not actually start with negation, he starts with an apparent positivity which, upon closer inspection, immediately reveals itself to be its own negation ... positive 'bourgeois' freedom and equality reveal themselves (in their actualization) as their opposites, as their own negation. This is not yet negation proper, negation as a movement of meditation – the movement proper begins when the original form (which 'is' its own negation) is negated or replaced by a higher form; and the 'negation of negation' occurs when we realise that this higher form which negated the first effectively maintains the starting point, in other words, truly actualizes it, confers on it some positive content: the immediate assertion of freedom and equality really is its opposite, it's self-destruction; it is only when it is negated or elevated to a higher level (in the socially just organization of the economy) that freedom and equality become *actual*.
>
> (*Less than Nothing* 294)

In other words, bourgeois freedoms, although appearing at first as a liberation, are in reality a trap because bourgeois consciousness must first be transformed before a truly free society is possible. In this regard, and again in the Hegelian Marxist sense,

> the shift from negation to the negation of the negation is thus a shift from the objective to the subjective dimension: in direct negation, the subject observes a change in the object (its disintegration, its passage into its opposite) while in the

negation of negation, the subject includes itself in the process, taking into account how the process it is observing affects its own position.

(299)

Just as Molloy's subject being is negated in his conclusion, and Moran feels himself consumed from within by some strange new version of himself, and as Vladimir opens up to the suffering of others in his principal epiphany, and as Major Tom rejects his military candidacy and the mousey-haired girl comes to understand that she has grown into a disillusioned version of her former self, these characters negate their nominal selves by first recognizing the conflict within.

As part of their aesthetic strategy, antagonisms which are often cosmetically camouflaged by normative patterns of behavior within the social are emphasized and magnified by Beckett and Bowie. When it comes to unmasking the types of ideological false consciousness which shackle us to either established or immanent normative sociality, they have few peers. Their outsiders are finally and resolutely *beyond* the traps of neoliberal inclusivity and yet, paradoxically, instantly recognizable as within us, one and all, in the manner in which we all perform life, and in the manner in which we are all profoundly queer. The tramp and the (LGBTQ+) prostitute, archetypes Beckett or Bowie employ, function as cyphers for the human race in late capital modernity, individuals often living in fear as symbols of disempowerment translatable from the postwar nineteen-fifties and the premiere of *Waiting for Godot* to the cold war nineteen-seventies of Bowie's *"Heroes,"* to the existential spirit war of the third decade of the twenty-first century. Such characters provide the template for the type of epiphany Žižek believes is necessary for the next step to proper social inclusivity:

the point is … to recognize the stranger in ourselves … Communitarianism is not enough: a recognition that we are all, each in our own way, weird lunatics provides the only hope for a tolerable co-existence of different ways of life.

(*Courage of Hopelessness* 176)

He elaborates:

Today's liberal Left and populist Right are both caught in the politics of fear: fear of the immigrants, of feminists etc. or the fear of fundamentalist populists. The first thing to do here is to accomplish the move from fear to *Angst*: fear is the fear of an external object that is perceived as posing a threat to our identity, while anxiety emerges when we become aware that there is something wrong with our identity itself, with what we want to protect from the feared external threat.

(281)

And it is in this regard that the process of coming out is at one with Hegelian-Marxist dialectics and its commitment to the transformation of negative ontology. In considering innumerable testimonies of people who have come out as gay or bisexual or gender diverse, the trajectory almost always follows a similar path. The person feels at first that

there is something wrong with the world outside the subject; a world structured precisely not to recognize the legitimacy of the subject's true identity. This in turn contributes to the subject feeling negatively about themselves, adopting, or internalizing, if you will, the negative ontology that is the desired projection upon it of the world beyond the subject. However, this negativity is a form or false consciousness that the subject comes to understand as a consequence of the negative framing by the other, and as a consequence of a loss of agency and power such that the overwhelming recognition, and impulse, *becomes* to take control and transform the negative ontology into a positive by coming out; so doing achieves "the negation of negation", during which transformative moments "the subject includes itself in the process" (Žižek, *Less than Nothing* 299). In this, LGBTQ+ identity and Beckett and Bowie's aesthetic politics are as one. All offer, in the first instance, a disassembling queer impulse that constitutes a threat to an economic status quo in which capital drive utilizes divested sexual identity to enforce orthodoxy.[8] In challenging this orthodoxy, the queer subject undertakes a transformation that encompasses both self and other; and within this dual negation, in which a negative becomes positive, exists the potential transformation of the world itself.

Returning, by way of conclusion, to Visconti's quote, people who hide "in the shadows" ("We all Thought he had more Time") are all outsiders now who feel "queer" because conventional society excludes them from the possibility of a better, more equal society. And these shadows are so extensive that they now constitute a version of Plato's cave encompassing millions who know deep down that the play of these dark images is really illusion. In other words, those who are excluded from a say in the vision of a better society are queered by that society, and sexuality notwithstanding, to be queer now is to desire to challenge the norm, to transgress it, and to transform it. And this process should not begin and conclude with only a singular transformation leading to an accommodation of one's own sense of privileged identity. It is clear from their work that, in very similar ways, Beckett and Bowie's queerness involves ongoing conflict because it facilitates the fight within the social for voice and agency. This is apt because the freedom to express one's sexuality remains a challenge for many peoples in many places around the world in environments where exercising your voice is problematic. The tragic fate of Egyptian national, Sarah Hegazi, is a testament to this difficulty, and to the need for the neoliberal West to be less accommodating of international political allies who persecute minorities. Indeed, in 2011 when Hillary Clinton announced that "gay rights are human rights" at International Human Rights Day in Geneva she endorsed Western homosexuality in inverse proportion to which she brought unwelcome attention to bear on gay communities in less broad-minded territories. As Robbie Corey-Boulet observes in *Love Falls on Us: A Story of American Ideas and African LGBT Lives*, whereas Europe welcomed her comments, "the speech may have had unintended negative consequences for L.G.B.T.Q. communities that have created spaces for themselves 'underground, and out of sight'" (13) in Africa and elsewhere.

And, of course, it is not just for gender and sexuality that one can be outcast and persecuted. The ongoing refugee crisis indicates quite clearly how unwelcoming the West is to the new outsider in need, and it is equally important to remember that

precisely where one is supposed to be free to live equitably, in all the resonances of that phrase, is often where the struggle is fierce and unforgiving, psychologically. Watching helplessly as geopolitical catastrophe unfolds can make any insider feel as an outsider. It is in this shared terrain, metaphorically "underground and out of sight," that Bowie and Beckett's outsiders can be found, resolutely *Outside* like the album title suggests, because they reject the hegemonic power of the commodified status quo and refuse to submit to the ideological mystification that proposes majoritarian pleasures are the answer. However, fear also thrives here, which is why a Hegelian Marxist epistemological and ontological intervention is required. Žižek advises that

> the most elementary figure of dialectical reversal resides in transposing an epistemological obstacle into the thing itself, as its ontological failure; what appears to us as our inability to know the thing, indicates a crack in the thing itself.
> (*Less than Nothing* 17)

Or, as Leonard Cohen phrases it in "Anthem": "there is a crack in everything, that's how the light gets in."

WE are that cracked actor.

VII

Alienation & Ruination

In *The Courage of Hopelessness* (2017), Žižek proposes that the cupola, which constitutes the protected space separating the privileged from the poor in the film *Elysium* (2013), is a fitting metaphor for the inequities of the current capital moment in which wealth and opportunity disparities dominate on a global scale. Alain Badiou, in *The True Life* (2017), notes that "10% of the world population own 86% of the available capital; 1% own 46% of that capital. And 50% of the world population own exactly nothing, 0%" (31). The 1% who own 46% of capital and 9% who own another 40% constitute a privileged minority. By way of example, the social lockdown measures associated with COVID-19, as they were practiced in India during the pandemic, highlighted the poor's lack of access to food in a clear indication of the plight of the 50%. The remaining 40% of the global population share 14% of capital. Badiou splits this percentile between those who resent their limited share and those with a "ferocious desire to hold on to what they've got, in particular by the support they give, with racism and nationalism playing their parts, to the countless repressive barriers against the terrible 'threat' they perceive in the 50% who have nothing" (*The True Life* 31).

COVID-19 has further bifurcated Badiou's taxonomy. It has also prompted emerging, enlightened consciousness within the 9% who claim 40% of capital. For example, given that social distancing is relatively impossible in prisons, jails for undocumented immigrants, refugee camps, camps for migrant farmworkers, Native American reservations, and homeless shelters, there is now an alarming viral threat to the underprivileged body, globally (Griffiths, "Inequality and Austerity"). The architectures conceived to confine these populations were not designed to keep emergent viruses out. And as we learned from the initial wave of COVID, nursing homes bear the brunt of such disasters (Horgan Jones, "The Human Cost"). COVID-19 has clarified that the bodies under threat in all of these institutions, carceral or voluntary, are forgotten bodies. Similarly, what we might call "remote bodies" have been further consolidated during and after lockdown. A large proportion of those who constitute the 9% are increasingly isolated and disconnected from meaningful social engagement. The entire educational establishment was transferred to remote status in 2020, teaching online in largely affectless modalities, unable to access material libraries, research centers and laboratories, and a bifurcation in pedagogy has emerged since in which many universities and institutions encourage the perpetuation of digital teaching "modalities" in contrast to kinetic in-person engagement. Whereas remotes were originally professional, managerial, and technical workers—an estimated 35% of

the workforce—or people functioning from home for little pay in online and phone marketing jobs, now a yet undocumented percentage of the population have been rendered remote from previously centralized architectures of empowerment, and among them, most notably and regrettably, the emerging student body (Koetsier, "58% of American Knowledge Workers"). In a new reality determined by emerging viral attacks on the body, COVID-19 has rendered invisible bodies more visible while simultaneously erasing the presence, and soft power, of many of the ostensibly privileged. In short, more and more of the 9% in this late capital environment are banished to an indefinite remoteness, now occupying a similar proxemics to the forgotten bodies of the dispossessed. Such individuals, once incorporated into the false consciousness of capitalism, now have significant doubts about the latter's efficacy.

These developments are a consequence of political strategies that Naomi Klein calls "disaster capitalism," a phrase she coined to describe the states of shock that the capitalist hegemony is wont to exploit in suitably vulnerable populations in the resultant vacuum created by a natural or political disaster. With the people in a state of shock, their society is quickly and often irreversibly restructured to better serve free-market imperatives. Klein's detailed reframing of Pinochet's incursion into Chile as less a matter of foreign policy and more a reflection of the US desire to impose capital ideology in South America, together with her sophisticated and nuanced readings of a similar military incursion into Iraq and a global capital asset-stripping of post-Apartheid South Africa, are persuasive examples of how shock can be harnessed for economic profit (*The Shock Doctrine* 23–50, 197–205, 323–80). Similarly, her reading of Big Tech's recent gains in response to COVID-19 are a further example not only of how capitalism seeks to benefit from disaster but also how, in its voracious and schizophrenic approach to capital accumulation, it is a key contributor in exacerbating the very crisis it ostensibly attempts to remediate ("Screen New Deal" passim). Importantly, the contemporary shock doctrine paradigm instantiated by COVID-19 is organized and administered through contemporary biopolitical technics, and it is to this political domain that we now turn.

In his brief writings on the subject, Foucault offers the following loose definition of the biopolitical: "Where discipline is the technology deployed to make individuals behave, to be efficient and productive workers, biopolitics is deployed to manage population; for example, to ensure a healthy workforce" (*Society Must be Defended* 239). In short, "a normalizing society is the historical outcome of a technology of power centred on life'" (*The History of Sexuality* 144) in which discipline and technology become one. In the recent "Surveillance Capitalism," Zuboff modifies and updates Foucault's biopolitical ideas regarding population control, further reflecting a shift from a discipline society as imagined by Foucault to that of a control society as intimated by him and predicted by Deleuze. Foucault's panopticon presupposes the internalization of one all-seeing eye, like Big Brother, the presence of which guarantees subjection to the hegemony as a result of individual self-conscious self-regulation undertaken in fear of reprisal and discipline from the state. In contrast, Zuboff argues, the contemporary Western control society operates far more discreetly, ostensibly removing the cycloptic panoptic gaze as judgment (although the latter is more keenly operative in contemporary authoritarian

societies today) and replacing it with the notion of a free society so driven by data accumulation that the modern panopticon "radically distribute[s] opportunities for observation, interpretation, communication, influence, prediction, and ultimately modification of ... action" (Zuboff 82). Rosi Braidotti identifies this switch to what she terms "cognitive capitalism" and outlines how it is used to

> test and monitor the capacities of affective or bio-mediated bodies: DNA testing, brain fingerprinting neural imaging, body heat detection, and iris or hand recognition.
>
> (42)

In this new paradigm, both cognitive and surveillance capitalism are not forms of control that the populace necessarily fears and consequently adopts an internalized oppositional consciousness towards. On the contrary, and under the guise of a great liberalization, in the present moment people freely give up legitimate claims to privacy and to sole jurisdiction with regard to sharing personal experience. Today, everything that happens to us, or all that we do, is being absorbed, recorded, and assessed by data banks ostensibly owned by giant tech companies but also available to state institutions of power and to the power players in the market economy. This surveillance model is marketed as the easeful glue that consolidates liberal society and Ølgaard notes that it is operating "not just as a logic of accumulation adopted by private tech corporations but also as a logic of government increasingly adopted by (neo)liberal democracies" ("E-International Relations"). As a result, surveillance capital is a mode of production so pervasive that it is capable of transforming the consciousness that it molds in decisive new ways. For example, within existing democratic paradigms, this new mode of production harnesses hegemonic culture in order to have it appear as though it is a culture of convenience. Essential to this is the ostensible neutrality of the phrase "technological progress," designed to hide from view what is essentially a restructuring of power within society. Ølgaard understands this to be a transition from a discipline society to one of complete, tacit control:

> Unlike the gaze of the state, the institution or industrial production manager, there is essentially no escape from the gaze of digital capitalism since, as shown by both Klein and Zuboff, there are increasingly few places left where our behaviour is not observed.
>
> ("E-International Relations")

The argument is that surveillance capitalism is a new and, arguably, ideal mode of capital production which can achieve the complete negation of oppositional consciousness. As this new mode determines the very meaning of life itself as public, and as this new public persona is co-extensive with digital consciousness, surveillance capitalism begins the transformation of its contemporary mode into one which ameliorates and finally removes the notion of a reflective interiority that might represent an outside from which to judge it. In order to combat the presence of a viral antagonism, the

contemporary mode requires the examination of all aspects of biological life as we know it, in the process deprivileging or rendering obsolete interiorized forms of psychic life. In this way, the internalized subject, the first and most potent site of oppositional consciousness, can be elided generationally, replaced by a new ideological inculcation proposing a friction-free fully visible and completely secure digital universe. At present, one of the great concerns in this regard is the gradual removal of any sense of political agency among the privileged body politic who buy into the framing of modern life as convenience. This elision generates a palpable tension between those successfully incorporated within the capital project, that percentage of the 9% that fully endorse the emerging society of convenience, and those increasingly at odds with its encroaching *dispostif*, the latter more aware with each passing day of the reality of the necropolitical model the society of convenience requires. And it is at the site of this emerging tension that Beckett and Bowie's work signifies most meaningfully.

While they predate the marriage of the *biopolitical* and digital capitalism, Beckett and Bowie understood its underlying logic only too well. Although their work is a response to the historical and environmental conditions of their own experience, nevertheless its tenor and mood speaks to our current predicament in informed and insightful ways. Allied to their tendency towards moments of aesthetic suspension, in which time seems fully inhabited and intersubjective identification is made possible in imagined spatio-temporal proxemics, the imaginative spaces and places they generate are precisely an environment wherein an alienated audience's concerns are mirrored and engaged. Their work achieves this shiver of recognition by expressing "crisis narratives" which echo and reverberate within each other and speak directly to the predicament of late capitalism we are experiencing today. Essentially, their crisis narratives mirror Freud's conception of the return of the repressed in which unresolved psychic conflict inevitably reconstitutes itself in a troubled mind in search of its resolution. In mirroring something of this process and the contours of psychoanalysis as a practice, Beckett and Bowie provide the stage for both an acting out and then a working through, a performance of the deleterious effects of a society in thrall to political economy and the possibility of the latter's negation and transformation into something potentially positive. In each instance, the unresolved conflict with which Beckett and Bowie's characters grapple, the returning dialectic, the *agon*, is the by-product of a society distorted by money and the concomitant fear its scarcity generates. Consequently, by negating and transforming the collective false consciousness that is complicit in maintaining such a system, they generate the coordinates of a new space for the alienated: a people's republic of conscience.

The principal mode of Beckett and Bowie's crisis narratives reflects their shared concern with psychological suffering, and, more specifically, their impression that psychic disturbance is often a consequence of damaging environmental engagement (rather than a reflection of biological processes occurring independently of social embeddedness). In other words, they craft crisis narratives that are the expression of sociopolitical realities and therefore cannot be attributed to epiphenomenal activity in the material brain. Further, the personal struggles of their characters are folded into narratives that encompass broader environmental crises which, redolent of the

near obsolete phrase MAD or "mutually assured destruction," position the agent of catastrophe as humanity in its present treatment of nature (rather than the original iteration of MAD which referred to man-made oblivion as a result of a nuclear disaster). At the same time, their work might also be referred to as MAD if the latter were an acronym for "machines as death," a phrase that well describes a strain of technology paranoia in their work. This fear of the technological, common in their respective historical period and broadly shared across much of the population, is both expressed and alleviated by their treatment of aesthetic form, which, being embedded in these technologies, affords both the articulation of a brutalization of the human subject while also offering what Beckett calls "an underlying affirmation" (Juliet 67). Ironically, the redeeming value is an art engaged precisely in exploring the dialectic relation between the human and the inhuman. Fundamentally, in their work, crises in mental health produced by environmental and technological alienation are reflected in the psyche of their characters and expressed in the form of their songs and stories to reflect the capital mode of production as the cause of an inevitable damage. Adorno's notion of unresolved conflict as something that inevitably returns and is embedded and/or sedimented in the form of art itself, is reflected in Bowie and Beckett's articulation of the environment as facilitating the technological alienation of the subject ("I") first from nature and then from self. In short, Beckett and Bowie have produced lifelong catastrophe narratives as the expression of their crisis creativity, befitting their status as preeminent twentieth-century disaster artists.

As two crisis poems, if you will, consider the lyrics of Bowie's "Quicksand" (1971) and Beckett's "Saint-Lô" (1946).

> I'm tethered to the logic of Homo Sapien
> Can't take my eyes from the great salvation
> ...
> I'm sinking in the quicksand of my thought
> And I ain't got the power any more
>
> (*Hunky Dory*)

> Vire will wind in other shadows
> unborn through the bright ways tremble
> and the old mind ghost-forsaken
> sink into its havoc
>
> (*CPSB* 105)

In these comparable vignettes, both figure the loss of psychic equilibrium through the metaphor of sinking further into the recesses of the mind. At the time of writing their respective poems, Beckett finds himself in the immediate aftermath of World War II, serving in a post-war hospital for the wounded and traumatized. Bowie is expressing himself out of the more mundane but no less insidious suburban context of post-war Bromley surrounded by, as John O'Connell memorably puts it, "parents who were most likely clapped-out conformists drunk on war nostalgia" (19). In his lyrics,

Bowie clearly wrestles with the idea of faith and acknowledges the existential depths unlocked through his atheism. Having uncoupled himself from a dominant social ideology that seeks utilitarian homogeneity through the promotion of religious belief, he finds himself alienated and alone. Beckett, for his part, was so discommoded by stories emanating from Ireland about the negative treatment of Irish volunteers in war-torn Normandy that he wrote a public piece reprimanding neutral Ireland for promoting xenophobia against a devastated France (see "The Capital of the Ruins," passim).

In these ways, both artists are confronted by the deleterious effects of a biopolitics determining population as a collective body to be controlled, variously, through ideology and associated mythologies. And they use the means of production available to them, language in this instance, to resist the biopolitical imperative towards social cohesion. In bringing mental struggle to the page both also engage the ear, employing a musicality that offers harmonic comfort without suggesting psychological difficulties have been overcome. In Heidegger's "The Question concerning Technology" he contrasts "technē" with the corrective presence of "poiēsis" which enables authentic being to appear. "Technē" is a term, etymologically derived from the Greek word "τέχνη," meaning "art, skill, or craft" (3). Rather than being necessarily opposed to each other, technē and poiēsis are in a dialectical relationship in which technē emerges through poiēsis as a creative form of "revealing," or "Entbergen" (7), which involves "the disclosure of truth" (33). In this instance, both Beckett and Bowie employ the technology of language poetically to sustain a rhythmic refuge for being, yet, even here, where the rhythm is strong, both poems revolve around the resonances of sinking. There will be no transcendence here, no waving from on high; only drowning. Both pieces echo the negative ontology of Keats's desire for an "easeful death" ("Ode to a Nightingale"). Importantly, it is the presence of the personal psychological conflict, itself representative of a conflicted relationship with the social, that produces the need for the artistic intervention that cannot, finally, provide transcendence.

Although Beckett was a man of modernized sensibility, he was always in danger of sinking in the sea that was the deeply conservative Catholic Ireland of the nineteen-thirties. Unmoored in Dublin, he struggled to stay afloat. As he recounted to James and Elizabeth Knowlson, he found himself subject to fits of anxiety and panic:

> After my father's death I had trouble psychologically. The bad years were between when I had to crawl home [from Paris] in 1932 and after my father's death in 1933. I'll tell you how it was. I was walking up Dawson Street and I felt I couldn't go on. It was a strange experience I can't really describe. I found I couldn't go on moving.
> *(Beckett Remembering* 67)

Subsequent to the breakdown Beckett describes above, he traveled to London to begin psychoanalysis in 1933 (such exotic practices being illegal in Ireland at that time) during which a deep-seated antagonism with his mother, May Beckett, began to emerge as the focus. Beckett's mother objected to her son's artistic leanings and made

her displeasure known in a host of obvious and implicit disapprovals (see Knowlson, *Damned to Fame* 206–12, and Cronin 22–3). Reflecting on the experience years later, Beckett felt that the analysis, which uncovered repressed feelings of intrauterine claustrophobia, "helped him to control the panic" (*Beckett Remembering* 69) through a deeper understanding of his internalization of his mother's censure. In tandem with the subsequent sobering effect of life on the run from the Nazis during World War II, these events pointed him towards a creative epiphany that defines his mature work. Of the post-war period that begins with *Molloy*, written in French in 1947, and concludes with the staging of *Waiting for Godot* and the publication of *The Unnamable* in 1953, Beckett said: "I conceived *Molloy* and what followed the day I became aware of my own stupidity and I began to write the things I feel" (Graver and Federman 216). These things, arguably, were what he had previously thought needed to be suppressed, repressed even, in the conservative habitus of Ireland (such that he experienced the personal breakdown of the nineteen-thirties he describes above).

However, within the opening pages of *Molloy*, the post-war novel in which Beckett threw off inhibition, the reader encounters a vagabond without a care for decorum, a man who carries used toilet paper about his person and struggles, often comically, to keep overwhelming existential angst at bay. Moreover, it would appear that the expression of things he had "always struggled to keep under" ("Krapp's Last Tape," *CSPSB* 60)—to quote another of Beckett's characters—resulted in a certain emotional and intellectual liberation for the Irish author. Choosing to embrace "the dark" which provides access to "[artistic] vision at last" is a fictional epiphany experienced by the central character in "Krapp's Last Tape" (60), and it mirrors an actual epiphany experienced by Beckett wherein "a whole zone of being previously though incompatible with art" became, for him, its very substance (Graver and Federman 148).[1] In such ways, Beckett, from the beginning of his artistic career, sought to resolve internal conflicts by turning a certain psychic vulnerability into a strength.

If by the nineteen-sixties a sufficient modernization of English bourgeois pretensions had taken place such that Bowie could see (or feel) constraining conservative ideology for what it was, it still wielded a considerable hold over the developing young man. In relation to understanding his approach to a crisis of psychological wellbeing, in the "David Bowie is" exhibition in the Victoria and Albert Museum in London, in 2013, the contents of a narrative voice-over greeted visitors into the first room, a diorama of David Bowie's family home in Bromley. In tandem with black and white photos of his Mum, Dad, aunties, brother Terry (who was to commit suicide in 1984), and through the speakers of the stereo present in the recreation of Bowie's childhood, the adult singer recalled:

> One puts oneself through such psychological damage in trying to avoid the threat of insanity. You start to approach the very thing that you're scared of. It had tragically afflicted particularly my mother's side of the family. There seemed to be any number of people who had various mental problems. And varying states of sanity … and that was something I was terribly fearful of … I felt I was the lucky

one because I was an artist and it would never happen to me. As long as I could put these psychological excesses into my music, and into my work, I could always be throwing it off.

(Interview aired by BBC Radio 1, 1993, qtd. in Pegg 9)

Bowie identifies the discreet pressure that is applied socially when people deviate from conforming to implicit, normalized mental health expectations. In response, he believes he can use his music to express the psychologically prohibited and, in so doing, transgress the parameters of the discreet but palpable biopolitics designed to shame and shade the afflicted.

In *Upping your Ziggy*, Oliver James contends that psychological problems can generate a dysfunctional family dynamic which is then carried on generationally, and passed on by parents, grandparents, great grandparents, and so on. New generations of the family find themselves unconsciously involved in perpetual instances of what Freud calls "acting out" as they repeat the self-destructive patterns of behavior put in place by and learned from previous generations. Jacques Lacan, the noted psychoanalyst and author, employed his own concept mapping to describe such inheritance, terming the space of transmission "the symbolic," a notional realm that yet describes the web of material relations and psychological interactions learned from the previous generation and re-enacted largely unconsciously by the current generation. The presence of the symbolic explains why grandchildren can repeat everything from the small habits of older family members, sporting perpetually untied shoelaces and so forth, to the career choices of great grandparents whom the young descendants have never met (see Lacan's "Function and Field" 36–37, 49, 55–6).

The symbolic as mapped psychological terrain also revolves, or orbits around what Lacan refers to variously as the "objet petit a," or "point de capiton," which is generally a person or thing that absorbs and resonates with "jouissance," a term for excessive psychic energy, which may be invested in any activity from the sexual to the intellectual (see Lacan, *The Other Side of Psychoanalysis* 200–10). The individual's relation with this object can be beneficial to psychological wellbeing, but also often destructive. Employing such a Lacanian framework helps contextualize Oliver James's proposition that Bowie's Irish grandmother, Margaret Burns, wielded abusive, autocratic power over Bowie's own mother, Peggy Jones (née Burns) who, herself, repeated something of this dysfunctional psychological abuse towards her son, David, but particularly towards his brother, Terry Burns, whom she had conceived with a French sailor, Jack Rosemberg, before he shortly thereafter abandoned her. Compounding Terry's dilemma was the fact that much of his early development was overseen by Margaret, the grandmother, as Peggy was forced to seek work to support her child. As two of Peggy's sisters, Una and Nora, also suffered mental health problems and were both institutionalized for periods of time (see James 15–51), the Bowie (née Jones) family's mental health seemed to revolve, and spin out of control, around the dysfunctional symbolic central authority of Margaret, their *point de capiton*, who clearly had heteronormative expectations regarding the family unit, patriarchy, and generational reproduction.[2]

Bowie, for his part, was obviously very conscious of the psychological pressures being generated within the family. His intuitive sense that creativity might provide release appears to have been consolidated by his readings in Carl Jung, underscoring his instinctual awareness that art can help negotiate mental health pressures. Tanja Stark has written in some detail about Jungian Bowie references in her essay "Crashing out with Sylvian" in which she suggests Bowie "encapsulates Jung's idea of a Visionary Artist" (106). She focuses on the Swiss psychologist's belief that artists can reformulate the substance of their intangible dreams in productive ways, the expression of unconscious fears and desires going some way towards mediating them. Regarding dreams as a source of bountiful inspiration, Jung suggested that

> It is of great help ... to express their peculiar contents either in the form of writing or of drawing and painting. There are so many incomprehensible intuitions in such cases, phantasy fragments that rise from the unconscious, for which there is almost no suitable language. I let my patients find their own symbolic expressions, their "mythology."
>
> (216)[3]

And Bowie clearly concurred, noting that "according to Jung, to see cracks in the sky is not really quite on ... I thought I'd write my problems out" (Doggett 102). By adapting a Jungian approach, and with "a crack in the sky" duly referenced, Bowie began conceiving songs like "Oh You Pretty Things" in which insanity, expressed here as a maddening but endearing emotional response, is both produced by family antagonism but also alleviated somewhat by the jouissance generated through family bonds. In these creative strategies, the grandmothers, mothers, and brothers who were suffering varying degree of psychological distress, as a result of both biopolitical expectation and its domestic administration, are channeled by Bowie into song and verse in an attempt to confront the family strife and "be throwing it off."

The proposition that art can be a way of dealing positively with mental health issues is important as it keeps the dialectic relationship between brain and mind very much in focus while also privileging the social component in the tripartite psychiatric framing of the bio-psycho-social etiology of pathological conditions. One of Karl Marx's most important observations is the maxim that

> it is not the consciousness of men that determines their being, but, on the contrary, their social being that determines their consciousness.
> (Preface to *A Critique of Political Economy*)

As a principle of his philosophy, Marx presupposes that society shapes individual conscious being rather than any individual having an autonomous consciousness that shapes her/his thought independent of social and political experience. The philosophic corollary of this is, broadly, existentialism, and the psychiatric version can be framed as the difference between a biological etiology of mental processes as

opposed to one privileging the psychological influence of social experience. Marx's position is that thought itself is framed and structured by social experience. In related fashion, for Beckett and for Bowie, the state of a character's mental health, or mental illness, is not simply the result of a biological short circuit, or a neurological disorder, but is a psychic state that reflects conflicts embedded in society itself. Arguably, as a biopolitical strategy of control, mental health discourse often privileges biological and/or neurochemical markers of mental health issues which conveniently serve to elide the significance of the broken environment and replace it with a biological flaw within the individual. The discourse then works to further consolidate the uncoupling of the mental health condition from the individual's agency by stressing that the biological inevitability of the condition obviates any responsibility on the individual's part. This latter discourse operation takes place under the auspices of exculpating the sufferer from any personal responsibility for their condition and proposing they should not be shamed as a consequence. However, as Pat Bracken makes clear, "in psyche, which deals with such issues as individual struggles with meaning, emotion and social position, this neglect of agency imposes severe constraints" (364), most especially the elision of the capacity for the individual to manage and change their condition. The crux of the issue is that the entirely reasonable proposition society take a non-judgmental approach to the character of the sufferer also presupposes that the society itself is excused in the same way. In short, no judgment is made regarding the social and political environment in which the sufferer experiences the symptoms and related effects of their condition.

To challenge this framing is not to suggest mental illness is not a product of biological processes and/or neurological pathways—an impossible proposition given that these are the hardware and circuitry from which all thought emerges—but it is to question which is the principal trigger for an adverse psychological event, while further questioning the tacit assumption that neurobiological processes happen randomly and independently of the sociopolitical environment. For example, the contemporary biomedical mental health paradigm proposes that differences in brain architecture and plasticity, apparent in depression and other conditions, produce mental health issues. However, it also follows that the experiences people have *in* the environment—experiences of pain, of suffering, of loss—can also *produce* the plasticity differences that are often represented as random and exclusively neurobiological (and therefore bio-foundational rather than produced by antecedent environmental experiences). In fact, plasticity cuts new synapses both ways and the question of which is the principal actor—brain or environment—is irrelevant. Rather, a dialectical interaction of the plasticity of both, that privileges neither, requires that both are in focus as subjects of investigation and as agents of change. Biological determinism obscures this relationship. Determinists believe in an organism and environment insulated from one another, or unidirectionally affected despite vague claims that both domains affect outcomes. Invariably, when biomedicine suggests a 50/50 split between the effects of organism and environment this rarely accounts for the transformative intervention the biological can have on the environment, and significantly underplays the influence of the environment on the biologically predetermined. It is fruitful and rewarding instead,

to imagine an active mobile interpenetration of the organism with its environment. Humanity is testament to the fact that as a species we do not necessarily accept a given environment but actively seek to change what we inherit. Indeed, what exists of human nature must be simultaneously biological and socially constructed, and in a constant state of flux, as opposed to the evolutionary biologist maxim that our evolutionary development takes place at a glacial pace indistinguishable from that of lobsters.[4]

To translate this dialectic relationship between organism and environment back into a Marxist context is to first recognize Marx's belief that antagonism is generated as a result of the emergence of tensions within the social that demand to be addressed and resolved. Antagonism can be elided, to some degree, by ideological operations that seek to silence the cause of the discord, often sublimating the antagonistic element that nonetheless returns when its surplus energy is redoubled through its exclusion. As Macherey observes, "ideology exists precisely in order to efface all traces of contradiction" (130), but it rarely succeeds. For this reason, the environment plays the role of antagonistic element in contemporary mental health discourse. Regularly silenced by a biomedical industry in thrall to capital imperatives, it makes its aggressive return in pandemic situations like COVID to inevitably challenge its elision from the site of mental health etiology as the principal trigger for adverse developments.[5]

As a bulwark for increasingly pervasive bio-medical discourses, the *Diagnostic and Statistical Manual of Mental Disorders, Fifth Edition* (DSM V) represents a further civil society technic designed to pacify and neuter a largely privileged but anxious and uneasy population through a twin process of pathologization and concurrent medical prescription. Allen Frances, chairperson of the DSM-IV task force (and now a DSM skeptic, see Frances, *Saving Normal* passim), claims "there is no reason to believe that DSM-5 is safe or scientifically sound" ("One Manual Shouldn't Dictate") while advancing the view that mental illnesses are currently being overly diagnosed ostensibly for insurance requirements which conveniently serve profitable outcomes for big business. The current moment, for the deserving body, is becoming defined as one of psychopharmacological pacification in which the mind increasingly becomes the product of the brain and its circuitry, treatable not by dialogue and engagement with the other but by prescription medication and learned techniques for personal pacification that take no account of alternative responses to material contextual ills, such as protest and other actively engaged options.[6] The desired mode of production is therefore oriented to consolidate the belief that social and political context have no bearing on mental health. As a consequence, Pat Bracken observes, "today, psychiatry serves as a technology that helps to constitute radically different sets of power relationships in advanced liberal democracies" (365).

Returning to the work of Bowie, it is clearly the case that from "All the Madmen" (1970), that paean celebrating insanity (as the ultimate metaphor for difference), to the lightning strike on a "lad insane," to the character in "Scary Monsters and Super Creeps" (1980) who "wails" at traffic lights, has "a horror of rooms" and blue eyes "with nobody home," he presents and represents the outsider as degenerate and physically sick but also as mad. In this sense, the mad person is "the other" cast off by society but nonetheless produced by that society and is constitutive of its

marginalized underbelly. "Mental health problems," the current nomenclature for psychic struggle within the social, presupposes positive mental health as the norm from which problems are deviations to be regulated. The language used reduces, if not removes, a sense of struggle precipitated by the social environment. To be "insane," on the other hand, carries notable weight regarding the irregularity of the state of mind of the individual in question, and to be "driven insane"—or to drive your "Mamas and Papas insane" ("Oh You Pretty Things")—clearly privileges the influence of the social environment on the individuals affected. Recently, the word insane has become subject to prohibition on the grounds that it is pejorative and discriminates against people with mental illness, serving to compound their social isolation through stigmatization. A consequence for Bowie's legacy in relation to his "mad men" and women who are driven "insane" is that his work may be retroactively admonished for an insensitivity to the appropriate language of mental health, but it is worth considering instead that today the term "insane" carries some of the subversive charge previously held by the words "gay" and "queer." Just as Sinéad O'Connor was comfortable referring to herself as "a nut" (185), a person could use "insane" to describe themselves and, in so doing, self-identify with the continuous presence of the social struggle implied by the definition. The context here is similar to how African Americans and gay people self-identify, and so reclaim language used otherwise to demoralize them. In this case, in choosing to perpetuate use of the word insane, perhaps a speaker also articulates the history of its structurally embedded pain and alienation, and the possibility of its transformation. Echoing Fredric Jameson's imperative to "always historicise" (ix), claiming legitimacy for the word insanity requires mobilizing the record of the practices and prohibitions that its history reflects, including current attempts to elide it from the neoliberal lexicon and posing the important question about who might retain the right to use it. A mental health "problem," on the other hand, does not presuppose transformation. It is a "problem" to be solved by the architectures of the institutions that name it so. The individual problem will be remediated by pharmaceuticals, mindfulness, and CBT so that the economic infrastructure of the society producing these epidemic levels of "mental health problems" can proceed unchallenged in order to remain unchanged. And the best way to describe this state of affairs, the best way to bring language to bear with the full weight of its function, is to call the situation "insane."

"Scream like a Baby" (1980) is one of Bowie's most pointed framings of biomedical institutionalization as a disciplinary mechanism for social conformity. The song's persona tells us:

Well I wouldn't buy no merchandise
And I wouldn't go to war
And I mixed with other colors
But the nurse doesn't care

The "mental health problems" expressed in this song are the character's traumatized response to the demands of a world committed to big pharma, commercialism, wedded to war, intolerant of multiculturalism, and deeply homophobic. The character

suffers psychologically as a result of his desire to be excluded from it, and his condition is produced by the duress induced as a result of his alienation from what is clearly a dysfunctional sociality. Interestingly, Bowie manifests the conflict engendered by the society into the articulation of the word society itself, the narrator incapable of articulating it as a homogenous unity but forced to spit out "socie-soc-soci-society" in syllables that render the word recognizable only by the song's associated semantic context. Gergen's thoughts on alienation correspond to the estrangement Sam experiences in Bowie's song wherein "the loss of the natural condition of selfhood" must be attributable to environmental conflict:

> Because this loss cannot be originated within the self—i.e., there is no reason for the human agent in his/her natural state to become self-alienated—the source of the deterioration is typically traced to the environment (e.g., defective economic work conditions, urban life, consumerism, social influence).
>
> (117–18)

The alienated characters that populate the Beckett/Bowie landscape suffer as the result of a ubiquitous commodity culture that accelerates a growing despair in the mind. And such characters abound; Bowie's "DJ" (1979) who is unemployed, "incurably ill," and incapable of turning things around in his spiral of disassociation; Bowie himself caught in a "Fame" (1975) which puts you "where things are hollow" and where "it's not your brain" that is the problem but celebrity which "keeps you insane;" the character in Beckett's "Not I" so alienated from herself she cannot say "I" but can only recount the tale of a "she" who exists disassociated from some unspoken traumatic past; the Unnamable who feels a great unspoken panic, telling the reader that language "issues from me, it fills me, it clamours against my walls, it is not mine, I can't stop it, I can't prevent it, from tearing me, wracking me, assailing me" (23). In each instance, the anxiety expressed in these crisis narratives is in response to an impersonal, de-personalizing society that offers no relief, and it is against this society that the characters react.

In addition to this psychological deterioration, there is physical decay too. Cinque notes that Bowie's is "a body also haunted by imperfection, seemingly on the verge of breaking down, nearly always in the grip of addiction and mental illness" (171). In this it is a body similar to those of many Beckett characters whom their creator referred to as "falling to bits" (Graver and Federman 148). It is in framing body and mind in such ways that Beckett and Bowie are engaged in an aesthetics of ruination, the target of which are the parameters of conventional ideological presuppositions regarding sociality, health, and belonging within the capital mode of production. Their work, resolutely outside the false consciousness that dominates this mode, utilizes such estranged location to illuminate the conditions that produce their shared sense of otherness, dis-ease and alienation. Moreover, Beckett and Bowie's work also folds architectural dereliction into a complementary disintegration of mind and body; in other words, mental breakdown is produced by the dilapidation and degradations of the sociopolitical environment which wreaks havoc on the human body and the body politic.

For example, an aesthetics of ruination is internalized by Beckett as a young boy when Dublin was bombed by the British army during the Easter Rising in 1916, and critics have written comprehensively on Beckett's sense of the ruination of Anglo-Irish culture in the aftermath of Ireland's War of Independence (see Kennedy "In the Street I was Lost"). Similarly, his experiences during World War II, and particularly in the French town of Saint-Lô—which had been, in Beckett's words, "bombed out of existence in one night" ("Capital of the Ruins" 25)—prompted him to propose that the ruins of the town and the selfless attempts of the French Red Cross to repair the damage done to its people offered "an inkling of the terms in which our condition is to be thought again" ("Capital of the Ruins" 28). Later he captures something of this empathetic impulse in the novel *Molloy* whose central character, emerging from a deep reverie, momentarily perceives

> the thing in ruins. I don't know what it is, what it was, nor whether it is not less a question of ruins than the indestructible chaos of timeless things, if that is the right expression.
>
> (*Molloy* 34)

What might be "the right expression" of decay is central to all of Beckett's writing (including, in a pointedly self-reflexive moment, "what is the word," the title of his final work). Clearly discernible in Lucky's speech in *Waiting for Godot*—a speech which defies categorical explication—is the sense of a response to the ruination of enlightenment culture. To paraphrase Adorno, a sense in which such a speech is the only response after Auschwitz ("Cultural Criticism" 34). Seen in such a light, Lucky's references to the "labours left unfinished crowned by the Acacacacademy of Anthropopopometry of Essy-in-Possy of Testew and Cunard" (*Waiting for Godot* 53) are eloquent statements on the fate of reason when it produces an age of barbarism.

In terms of aesthetic strategy, Beckett clearly has a sense of how framing ruination allows for notes of entropy that can destabilize institutionalized forms of socialized being. For example, in a letter to Barbara Bray written in 1959 and while conceiving *How It Is*, he expresses his creative process thus:

> I'm struggling along with the new moan, trying to find the rhythm and syntax of extreme weakness, penury perhaps I should say.
>
> (*CLSBIII* 211)

To conceive of art as inscribing "weakness," or "penury," is to attempt to identify an implicit relation between the economic and the aesthetic and use the latter to transform the former's terms. Rather than aspire to an aesthetics that requires the economic comfort of contemplative leisure time, Beckett's approach is already impoverished, his aesthetics imagining a penurious world of defeat, pointedly at odds with the parameters of leisure art. Rather than equate beauty and truth (as Romantic poetry is wont to do), David Lloyd points out that

> The space of [Beckett's] work is, rather, the place made over and over again for the unfit in representation, for those that dwell only among the ruins. In the ruins of representation alone, where the nation meets its end, the anticipatory trace of a republic emerges as that thing that yet eludes representation.
>
> (*Beckett's Thing* 68)

Similar to Beckett, Bowie has represented the experience of ruination such that architectural, psychic, and spiritual disintegration are folded into each other. *Diamond Dogs* (1974) opens with a monologue called "Future Legend" invoking a dystopian proxemics where "in the death as the last few corpses lay rotting on the slimy thoroughfare, the shutters lifted an inch in temperance building, high on Poacher's Hill and red mutant eyes gazed down on Hunger City." The substance of the album, on songs like "We are the Dead" and "1984" (inspired by Orwell's dystopian surveillance parable) documents the existential angst generated by the disintegration of established social relations. "Sweet Thing" is the expression of Navaro-Yashin's belief that "subjectivities become affected by abjection such that they internalize the abject space" ("Affective Spaces," 11). The narrator enjoys "putting pain in a stranger" such that it is impossible to tell if s/he enjoys coitus or homicide in the back alleys of a city s/he believes to be a reflection of self, "a street with a deal [that's] got me, that's got you" in the sense of being present in that urban reality but also in the sense of the character having been overtaken, consumed, and obliterated by the decayed belonging the city confers on its inhabitants.

At the same time, David Lloyd observes that Beckett's strategies to accommodate "the unfit for representation" also presuppose an ethical artistry that seeks to mobilize ruination towards emancipatory ends. When Lloyd argues that "in the ruins of representation ... the anticipatory trace of a republic emerges" (*Beckett's Thing* 68) he is proposing that new ways of knowing appear and "become" new forms of public knowledge akin to the Roman *res publica*, a "public affair" that involves all of us. If Beckett and Bowie emphasize a psychic, physical, and architectural ruination it is as the limit point of ideology where false consciousness must cease and true understanding emerge. It is the negation of the negation of the living lie towards the possibility of a people's republic *becoming*.

Shifting the lens to the present, and contextualizing their representations of alienation and ruination in the contemporary moment, is to be struck by how eloquently Beckett and Bowie speak to our current political crises, namely environmental collapse and an explosion of refugee populations. For example, *The Rise and Fall of Ziggy Stardust and the Spiders from Mars*, released in 1972, emphasizes the struggle for gay and/or queer recognition that is taking place within a matrix of other painful struggles such as the Black Lives Matter movement, those involved in the battle to resist the medicalization of mental health in its various forms, and especially those such as Extinction Rebellion, committed to raising awareness of our imminent and shared environmental fate. By way of example, consider the lyrics of "Five Years," Bowie's dystopia on the verge of collapse, in which a newscaster has just announced what appears to be a final and irreversible moment of environmental catastrophe. The

echoes of the emergence of COVID are unmistakable. Faced with a disaster in which the stockpiling of commodities is quite useless, characters struggle to stay grounded, but in trying to do so, also create an opportunity for inter-racial empathy predicated on cooperation. A wounded soldier, designated as cannon fodder in another presumably unnecessary war, draws quiet attention to the corporate rewards which the military industrial complex generates, while a queer, repulsed by the twin technologies of civil society—police and priests—vomits in protest as institutionally ratified ideological professions attempt to determine his, her, or their existence as illegitimate. Finally, the narrator, reacting against a commodity culture where everything is on sale, casts himself, or herself, as a romantic outcast troubled by electric irons and TVs (in a deft ambiguity). S/he then expresses unconditional love for a racial, perhaps extraterrestrial, perhaps trans, perhaps disabled other:

> And I thought of Ma and I wanted to get back there
> Your face, your race, the way that you talk
> I kiss you, you're beautiful, I want you to walk

Yet unnerved by impending environmental collapse, s/he also pines for a prelapsarian return to the womb as s/he disappears over the horizon, inexorably moving towards the oblivion that appears to be planetary collapse. At the same time, the ambiguity that closes "Five Years," the desire that the loved one might "walk," suggesting infancy and/or decrepitude and/or disability simultaneously, and the implication that the loved one's "race" might differ to the human race (and perhaps even transcend it), gestures towards a different and potentially inclusive proxemics beyond the heteronormative model of conventional adult, ableist society, towards a place where those unfit for representation may find refuge. The narrator has articulated both love for and rejection of the configuration of a world to which s/he cannot be a part and although empathetic to its inhabitants, strikes out finally into exile, alone. Whether expelled or voluntary, s/he has gone beyond, and the implication is that the listener must strike out too, in a new direction and in an attempt to meet the other in the ruins beyond representation. As such, this space also exists as the imaginary and sonic world of the song in which characters, instruments, and audience are suspended together in a moment of intersubjective possibility, a moment of intensely inhabited time that might forestall catastrophe.

Similarly, the characters of Beckett's mature short fiction, written directly after World War II, are all more or less cast out, or exiled. In "The End" (1946) the narrator finds himself ejected from some form of sheltering institution, whereas the narrators of "First Love" (1946) and "The Expelled" (1946) are ejected from their homes. The narrator of "First Love" tells us "I found my room locked and my belongings in a heap before the door" (*The Expelled and Other Novellas* 12). Thus banished, he lives briefly with a prostitute before the story concludes with a desire, figured similarly to "Five Years," to return to an intrauterine state, which he then abandons in favor of fleeing his new domestic obligation altogether, presumably going further out into a world he has

neither embraced nor understood.[7] The narrator of "The End," who has been expelled from a shadowy institution and given a paltry sum of money on which to subsist, must use this to rent a small, unfurnished flat. Here he comes face to face with the same civil technologies that repulse the queer in "Five Years:"

> One day I had a visit from a policeman. He said I had to be watched, without explaining why. Suspicious that was it, he told me I was suspicious … A priest too, one day I had a visit from a priest … He gave me his name and explained where I could reach him.
>
> (*The Expelled and Other Novellas* 78)

Exploring the disciplining function of the polis and its clerical obverse, Dubreuil notes:

> We live in the era of techno-democratism. And the techo-political is largely supported by three previous modes of the political: the juridical, the theological and the military.
>
> (35)

In other words, the courts, god, and the military industrial complex, all once considered punitive, are now reframed as part of a democratic protection mechanism ostensibly taking an interest in maintaining social wellbeing in exchange for tacit acknowledgment of the consequences of transgressing mosaic and/or judicial law.

In the course of his slow dissolution, similar to the character in Bowie's "Five Years," the narrator of "The End" rejects the disciplining function of sociality, moving out further into a world that has discreetly rejected him. Casting off civility, he is reduced to begging in the street before setting out willingly on the road, making his way through a ruin-strewn landscape to the ocean where he steals a rowing boat that he then deliberately sinks so as to be one with oblivion. The parallels with the fate of so many in the refugee crisis, now ongoing since 2015, are starkly obvious. As Braidotti notes, "refugee and asylum seekers … are the perfect instantiation of the disposable humanity that … constitute the ultimate necro-political subject" (49). Furthermore, it is a vicious irony that many of the lives lost are the victims of a lethally dangerous global trafficking operation made lucrative by promises of access to what is an illusory Western utopia. In contrast, the conclusion of "The End" is the articulation of something akin to a willed suicide. Imagining himself at sea, the narrator appears to instigate his own death by deliberately sinking his rowboat. The first inkling that this is his intention is when, upon rising in the stern, "a great clanking is heard," of which he notes:

> That was the chain. One end was fastened to the bow and the other around my waist. I must have pierced a hole beforehand in the floor-boards, for there I was down on my knees prying out the plug with my knife.
>
> (*The Expelled and Other Novellas* 91)

As the water rises he records:

> The sea, the sky, the mountains and the islands closed in and crushed me in a mighty systole, then scattered to the uttermost confines of space. The memory came faint and cold of the story I might have told, a story in the likeness of my life, I mean without the courage to end or the strength to go on.
>
> (91)

The narrator effectively relinquishes all control, all power and agency over his own life in this catastrophic moment. Tellingly, in this crisis of uncanny capitulation he remembers not the story of his life but a story in "the likeness" of his life in which all fortitude is lost. But as his narrative continues beyond the moment of annihilation, most likely as a consequence of it being a vision rather than the narrating of an actual experience, the whole is suffused with a feeling of destituent power that lays no claim to redemption or resuscitation. Most poignantly, the reader is spared the ethical dilemma of a visceral representation of the experience of annihilation, carried beyond the atomization of the narrator by the persistence of the latter's voice. Beckett, rather than simply experimenting with a refugee metaphor, articulates the feeling of refugee subjectivity as an aesthetic suspension that calls the reader intersubjectively to an indirect approximation of refugee experience. There is no sense in which the moment of annihilation is to be considered an accurate representation of the experience of a life lost at sea, hence the self-conscious meta-narrative remove. Nonetheless, and as a consequence of this aesthetic strategy, something of the impoverished experience of the necropolitical subject is communicated authentically. In this instance, Beckett's narrator goes *beyond* the action in a deliberate attempt to create an alternative context in which an aesthetics constructed to emphasize the artistic, rather than the real, becomes an effective substitute for the real given that self-consciously alienated experience is increasingly recognized as "authentic" experience. Such figurative annihilation corresponds to Beckett's sense, articulated in 1937, that his only artistic hope lay in "turn[ing] dereliction ... into literature" (*CLSBII* 2/2/1937). In short, Beckett and Bowie go beyond in diverse ways, to the furthest proxemics of outer and literary space and to the most penurious and impoverished literary, economic, and spiritual contexts, but the result is always the same: to shine a light on restrictive sociality, and, in the case of "Five Years" and "The End," on the murderous operations of capitalism.

Returning now to the surveillance capitalism modes of production that currently define Western neoliberal societies, Naomi Klein documents an emerging post-COVID world designed to serve privilege while necessarily disguising the antagonistic element of its material actuality:

> This is a future in which, for the privileged, almost everything is home delivered, either virtually via streaming and cloud technology, or physically via driverless vehicle or drone, then screen 'shared' on a mediated platform. It's a future that employs far fewer teachers, doctors, and drivers. It accepts no cash or credit cards (under guise of virus control) and has skeletal mass transit and far less live art. It's

a future that claims to be run on 'artificial intelligence,' but is actually held together by tens of millions of anonymous workers tucked away in warehouses, data centers, content moderation mills, electronic sweatshops, lithium mines, industrial farms, meat-processing plants, and prisons, where they are left unprotected from disease and hyperexploitation.

("Screen New Deal")

In other words, although a global, digital revolution is taking place and is transforming privileged experience into a more hermetically sealed life, this is also an embodied event for millions of laborers who, in the process, are rendered almost thoroughly invisible. Thanks to critics like Klein, it is possible to see and understand the contours of the emerging biopolitics that neoliberal ideology strives so hard to disguise, and it is through identifying the fate of the bodies that are silently in the service of privileged bodies that a clear antagonism within the biopolitical can be discerned. Foucault defined biopolitics as the ability to "take life or let live" and to "make live and to let die" (*Society must be Defended 241*) and Kennedy understands such a biopolitical iteration of power as fundamental to capital growth: "where sovereign power wields the power to kill … and disciplinary power is directed at individual bodies, biopower entails the power 'to make live and let die' at the level of population" (Kennedy, "Biopolitics of Famine" 67). In other words, contemporary neoliberal biopolitics is increasingly shorthand for what Mbembe terms "necropolitics," or "the generalized instrumentalization of human existence and the material destruction of human bodies and populations" (14). All of the necropolitical endeavors Klein recognizes "make live and let die," in the same manner as the migrant labor industry in the Arabian Peninsula, and in the current treatment of migrants and refugees by the European countries where they set ashore. Biopolitics, in its current manifestation, now ratifies the assemblage and exploitation of disposable bodies, as we saw with front-line workers during the COVID emergency. In other words, necropolitical policy does not just affect those on neo-colonial borders but is written into the new economic order of the West itself. It is at the site of this tension between elision and emergence, between comfort and ruination, between the return of repressed conflict and the desire to deny it, between being and becoming that the fate of the 9% rests, and, by extension, the 40% who have nothing. The emphases in Beckett and Bowie's work on these dialectic relations is key to helping an alienated audience first find some source of asylum and then, ideally, from out of ruination take action in the service of an emergent possibility, the negation of negation its aspiration. For Beckett and Bowie, the negative ontology that first must be exposed and then transformed emerges out of their treatment of the dialectic relationship between technology and death, with an emphasis on death as a returning, intractable antagonism.

Today, digitality, in its multifarious forms, is instrumental in determining the coordinates of the necropolitical. As Braidotti notes, "death is central to political theory and practice, as exemplified by the new forms of surveillance, confinement and killing that are at work within a fast-expanding technological context" (50). To give but one example of how contemporary biopolitics introduces new "technological context" in order to manufacture new forms of destruction, Julian Henriques outlines how the

algorithm is both the driver of technological proliferation and the arbiter of new forms of dehumanizing death. He notes that

> capitalism's current financialised mode depends entirely on algorithmic calculation, as the basis of derivatives, high-speed trading and the new fintech sector, for example. Platform capitalism relies on algorithmic machine learning and AI, as does manufacturing. Expert systems for medical diagnosis and robot surgery are built from algorithmic machine learning. Political campaigning exploits the micro-targeting of social media messages, as we have learnt from the Cambridge Analytica scandal, not to mention the Snowden revelation of the most extensive government mass surveillance operations the world has ever seen.
>
> (242)

At the same time, the algorithm provides new forms of military rhythm to complement the marching bands and army exercises that characterize military identity. Henriques elaborates:

> The patterning that rhythm provides is currently being exploited as a tool to identify targets in the drone kill chain by making sense of the vast amounts of data currently available to military analysts.
>
> (257)

Essentially, "the task consists in distinguishing between 'normal' and 'abnormal' activity in a kind of militarized automated rhythm-analysis that takes increasingly automatized forms" (Chamayou 23). In response to the reading of data, drones launch "signature strikes" that are a reaction to patterns of behavior rather than recognized or confirmed human or material targets. Neal Curtis explains:

> What is targeted is not so much the individuals that Predator or Reaper drones assassinate as the determination of 'patterns of life' suggestive of hostile intent … [W]hen everyday habits and routines become signatures that trigger a strike … [t]he target is … the quotidian social patterns and minute divergences from those patterns that are suggestive of a terrorist threat.
>
> (523)

This is the very essence of the necropolitical. The human subject has been replaced by code. No longer a person but a "social pattern" to be read digitally, the universal application of such surveillance is now operational in both civil society (as the monitoring of urban population movement) and war. If the notion of "humanity" has already been removed from drone death strikes in the Afghan landscape, to quote Bowie, by way of Orwell, this development will hasten the inevitability that "We are the Dead" as a recognizable species, supplanted on the altar of this new digital efficiency by our encoding as data, which, consequently, is all the more easily deleted.

Translating such developments into Beckett and Bowie's treatment of technology is to illustrate how it plays a central role in the constitutive alienation their characters suffer. Their work can seamlessly incorporate how environmental crisis impacts mental health and how resultant anxieties are exacerbated by technology and by technological application that contributes to the initial crises. For this reason, both artists can be characterized as expressing a paranoia regarding the technological. This can seem quite eccentric today, but wariness of technological development is nothing new, nor is it necessarily antediluvian neo-Luddism. For example, Marshall McLuhan, the godfather of technology theory, famously argued that "every technological extension is also an amputation" (61). As artists, Beckett and Bowie's work incorporates and expresses the force of this contradiction. In contrast to the more widely held view that technological development increases human capacity and communication, their work seeks accommodation of the obverse: technology also alienates. Crucially, however, their position reflects how technology is deployed as a technic of the capital mode of production rather than the reflection of an inherent flaw in technology itself. The entry on Marx in the *Stanford Encyclopedia of Philosophy* sums up this distinction admirably:

> Marx's view about communism rests crucially on the judgement that it is the social relations of capitalist society, and not its material or technical arrangements, which are the cause of systematic forms of alienation. For instance, he holds that it is not the existence of science, technology, and industrialization, as such, which are at the root of the social and psychological ills of alienation, but rather how those factors tend to be organised and operated in a capitalist society; that is, a society based on a particular class division—in which producers can only access means of production by selling their labor power—and in which production, and much else, is driven by a remorseless search for profit. In volume one of *Capital*, Marx writes approvingly of workers who, through time and experience, had learnt 'to distinguish between machinery and its employment by capital, and to direct their attacks, not against the material instruments of production, but against the mode in which they are used.
>
> (https://plato.stanford.edu/entries/Marx 432)

A recognition of this reality, and the necessary distinction it accentuates, is now gaining increased purchase in our contemporary digital moment. Beckett and Bowie's work implicates the deployment of technology as part of the alienating habitus of the social; indeed, as part of the alienating substratum of late capital life itself. Essentially, they frame technology as accelerating our recognition of the artificiality at the core of the global capital economy. In this regard, David Lloyd proposes that Beckett's work

> marks an era when the subject has become the sum of its prosthetic functions in relation to the technologies through which it produces itself and dwells among its imaginary troubled relations to its part objects as an appendage of the machines.
>
> (*The Transformation of Oral Space* 143)

In "Play", for example, Beckett's characters, trapped in giant urns, appear to respond to the stage lights as though undergoing interrogation. Paraskeva observes that in "Play"

> the actors, drained of all life by the endlessness of their repetition, approach the condition of machines, offering unreflective instantaneous reactions, switching on and off for the device which observes them.
>
> (66)

In a sense they are reduced to data, divorced from metaphysical forms of meaning. Further,

> This mechanical repetition marks a departure from the earlier versions of repetition in Beckett, the self-conscious theatricality, the performance for the rehearsals for an audience in *Godot*, *Endgame* and *Happy Days*. It is repetition recorded for a machine.
>
> (66)

Here Paraskeva notes a shift from a gentler almost parodic engagement with repetition in earlier work—Vladimir and Estragon's "toilet humor," for example, where the bathroom is "end of corridor on the left" (*Waiting for Godot* 26)—to a more serious one in which discipline and control are instrumentalized through the very mechanics of theatrical practice itself. Moreover, if one is inclined to think of human identity as co-extensive with, rather than preceding technological immersion, then the coordinates of our being, our form and its content, are shaped by technologies that then determine the contours of our episteme. Just as Beckett occasionally framed language as a tool, or technology, and expressed his doubt that it could adequately articulate being, so too in order to demonstrate "his technological imagination in the theatre" (Paraskeva 3) Beckett presents his technological imagination *as* the theater.

The result, in a play like "What Where" (1983), emphasizes how repetition dictates the need for several characters to give "the works" (*CSPSB* 312) to other characters—in what Emily Morin reads as an allusive Beckettian gloss on the torture scandal that rocked France during the Algerian war (236)—so that a type of torture is repeated without any clear explanation as to why this might be considered necessary. Each voice is obliged to say "I switch on" before undertaking a daily ritual that incorporates a betrayal and a necessary cruelty. Finally, what Beckett produces is a type of immersive performative experience that is life, exhorted *on* by, and so distorted through, technology, which is itself the tool, or mode, of the alienating social habitus. Quite simply, "What Where" is servile repetition necessitated by technology and presented as torture. Alternatively, from the perspective of one tortured, O, the protagonist in *Film* (1965), strives to avoid the disciplining gaze of the camera, referred to as E (most likely E for exposure), as though he may be obliterated by such objectification. Paraskeva notes that in film form, by definition,

the camera enables the perceptive act while the spectator incorporates the camera as an extension of his or her body. This analogue between human and mechanical perception is also an embodied relation; the camera's vision simulates embodiment, it is a bodily style of being-in-the-world.

(52)

He argues that in *Film*, Beckett reproduces this necessary arrangement as an identity disjunction—an alienation—between physical embodiment and consciousness. Beckett's short film makes it explicit that there are two visions at work, the camera and the spectator, and that in being "ti-ed" (*Waiting for Godot* 13) to the camera's view, the viewer is necessarily disassembled, made contingent on the equipment that simulates a doubled eye while nevertheless privileging the technological. In this arrangement the viewer either unknowingly (for which read "unconsciously") or willingly concedes the power *to see* to the camera. In short, there is no escape from a mode of exposure that dictates what is to be seen and understood. In just such ways, as the individual who wishes to escape being seen and as the individual who cannot choose what to see, Beckett interrogates technology to illustrate its alienating habitus.

On the same theme, Simon Critchley proposes that Bowie

mobilizes personas as vehicles for a number of constant themes in his work, aging, grief, isolation, loss of love, horror at the world, and media induced psychosis.

("Bowie, A Tribute" 5:05')

Apart from the obvious fact that Critchley could just as easily be writing about Beckett's concerns, what is of interest here is that Bowie's articulations of media-prompted psychosis emphasize how advances in technology exacerbate his characters' existential anxiety. In Beckett and Bowie's respective fictions and stage craft (be it audiotape, videotape, photography, film, or other more modern media), the technology contributes to isolated minds losing their grip on reality. In Bowie's case this is wonderfully realized by Nicholas Roeg in the famous scene from *The Man Who Fell to Earth* (1976) in which Bowie, as the alien Thomas Newton, has a meltdown induced while trying to process information from a bank of TV screens projecting disjointed images, furiously. Precisely because he is an alien, Bowie's character feels the distortion and the alienating nature of the interrogative function of the screen more than his human counterparts. Indeed, this scene is often referred to as a watershed moment in cinema history; a glimpse at the future of media saturation and the uncoupling of reality and image, authenticity and simulation (see Compo 12-19).

Bowie's work was not always characterized by technology paranoia. Early in his career he was familiar with and taken by Marinetti's 1909 manifesto on Futurism in which the Italian set out to "affirm that the beauty of the world has been enriched by a new form of beauty: the beauty of speed" (51-2). As Paul Morley notes, "the Futurists decided that technology had brutally changed what it meant to be human, and an aggressive, enigmatic new kind of art was needed to reflect and explore this"

("Futurists and Me"). However, if in Bowie's career an initial enthusiasm for the machine world is reflected in his use of terms like "Love machine" and "Sun machine" ("Cygnet Committee" and "Memories of a Free Festival," respectively)—as much as anything to put some distance between himself and the hippie rejection of technology per se—by the opening strains of *Station to Station* (1976) it is clearly the case that he wishes to explore the degree to which machinery, in this instance the modern train, has begun the process of first conquering and then transforming the natural landscape to its own expansive industrial purposes. Further, the performative fascism of the thin white duke on Bowie's Isolar tour, appearing through the electrical break steam of an arriving train, functions as a deliberate, disquieting allusion. Marinetti had encouraged artists to "sing of ... smoke plumed serpents ... deep-chested locomotives whose wheels paw the tracks like the hooves of enormous steel horses bridled by tubing" (51) and Bowie responds in kind. But rather than anthropomorphize the train in a manner evocative of the natural animal, he has rather anthropomorphized it as a version of murderous humanity in a clear allusion to the vast network of train lines that facilitated the Nazis to populate concentration camps such as Auschwitz and Belsen. In this regard, both Beckett and Bowie frame technology as an element in an emerging dispostif, the genesis of which is to be found in the transport and trading of humanity as commodity to be instrumentalized, exploited, and destroyed in a manner similar to what is happening in contemporary necropolitics.

By way of concluding this chapter, it seems clear that Beckett and Bowie understand technological development as implicated in emergent human tragedy. Shane Weller notes:

> Beckett's work ... includes technology within a more general disintegration or running down ... [it] enacts the exhaustion of technology ... and results in no liberation from technology, any more than there is in his work the sense of a liberation through technology.
>
> (26)

The same can be said about Bowie's late engagement with technology in a manner, as we shall shortly see, that seems directly indebted to Beckett's work. Weller argues that Beckett's treatment of technology is designed "both to alienate and to reveal, or to reveal precisely by way of alienation" what is "an essential relation between technology and death" (23). He proposes that

> For ... Proust and Beckett ... a modern technological device reveals the catastrophe of death in advance. It makes death present before the fact. It destroys time, more precisely it destroys the lifetime, and drags us into the time of death.
>
> (23)

Ultimately, Beckett and Bowie are touching from the shortest distance when they both undertake an art that attempts to accommodate the fact of their own death. They do this in a way that undertakes the negation of the greatest negation, by generating a moment of intersubjective being with their audience, and by capturing

their own extinction within the soon to be obsolete technē and poiēsis of their chosen aesthetic formulation. In the latter maneuver they also achieve something of a liberation from the subjection otherwise inflicted through these technologies. Rather, their aesthetics of weakness, their alienated art and its residue, point the way towards new being beyond conventional representation; a new republic for the public conscience.

Their self-conscious engagement with, and preparation for, finitude also challenges the current biopolitical moment wherein sustaining and increasing population are important strategies for capital accumulation. For Foucault, biopolitics is "an explosion of numerous and diverse techniques for achieving the subjugations of bodies and the control of populations" (*The History of Sexuality* 140). Thus "where discipline is the technology deployed to make individuals behave, to be efficient and productive workers, biopolitics is deployed to manage population; for example, to ensure a healthy workforce" (*Society Must be Defended* 240). Strategically, biopolitics must be seen to "exert a positive influence on life, that endeavours to administer, optimize, and multiply it, subjecting it to precise controls and comprehensive regulations" (*The History of Sexuality* 137). On a micro level, for example, nation states must attempt to "increase their productive force through exercise, drill, and so on" (*Society Must be Defended* 252) but, on a macrolevel, biopolitical efficiency is best guaranteed through the valorization of life itself. One must be convinced that "to live" is the highest value, and this privileging of life, and living, is best achieved by reducing the presence, and so the significance, of death. In response to this contemporary biopolitic that defines neoliberal society, Beckett and Bowie engage with death in a way that is anathema to economic performativity. As they turn to face the strange of their own demise they open a dialogue with the uncanny of finitude that yet again challenges neoliberal govern-mentality and its ties to reason and capital production. And they do this at a time when death is increasingly figured as the *point de capiton* of late capitalism, becoming ever more prevalent not just in neo-colonial societies but on the front lines of the West, where previous architectures of privilege cannot repel a virus.

To conclude, in their work, Beckett and Bowie represent those who suffer psychologically as a consequence of exclusion from a social and economic environment they also reject; these mad outsiders, frustrated and psychologically damaged by capitalism, seek refuge somewhere beyond its terms. Towards the end of their lives, and work, Beckett and Bowie began to engage with their own finitude, imagining new spaces also beyond. When they first realized that they were about to become ethereal outsiders, they used their art, manipulating both the content (be it language and/or music), and the form (be it narrative and/or theater), to speak to the moment with such honesty and immediacy that the attentive viewer is exposed to a profound catharsis in realizing that it is the degree of artifice, the mimesis, that generates the "truly" authentic feeling. In producing art that emphasizes the performative as an actual mode of living, when they turn to address dying, they perform the same paradox such that a death performed well is a death that exposes the living death of habit, itself organized around the suppression of "the suffering of being" (Beckett, *Proust* 19). Quite simply, by bringing the drama of death into focus they reveal the paucity

of a life organized to avoid addressing it, and they critique the type of society that aids and abets this objective in order that its citizens might pursue capital pleasures. As always, they offer their alienated audience a space of authentic refuge. Further, and as we shall see, they succeed in this their final movement *outside* conventional sociality precisely because the work of alienation they create from beyond routine coordinates of space and time also creates a space for the articulation of something *beyond* death that is not yet a part of any conventional "after life" mythology. Beyond death, rather, is beyond both conventional reality and the symbolic of death, opening new doors across new thresholds of possibility, beyond conventional time and space, and, finally, in proper alien fashion, beyond the current figuring of what it means to be human.[8]

VIII

On

A coincidence will serve to introduce Beckett and Bowie's aesthetic approach to finitude, and—by focusing more closely on their technological paranoia in order to reframe it as a legitimate contemporary concern—will also help to further illustrate their relevance to our pandemic times. In 1977, Beckett traveled to West Berlin and stayed there from September 10–27, while directing Rick Cluchey at the Akademie der Künste in an English production of "Das letzte Band" ("Krapp's Last Tape"). At the same juncture, Bowie was also living in West Berlin, having just wrapped *"Heroes"* (released on October 14) on which he utilized the latest recording equipment at Berlin's Hansa Studios in an attempt to achieve a new sound that also harnessed the mood of the West German city. Effectively, he endeavored to traverse the studio walls and capture something of Berlin's ruined architecture and existential psychic mood through the technology available. In this way, Bowie and Brian Eno's willingness to experiment in the studio was more than simply recording in Berlin but an attempt to record Berlin itself in a synergy of technology and location.

Arguably, Bowie's most famous song, "'Heroes'" has neither lyrical verse/chorus nor verse/chorus middle eight musical structure. It is essentially a series of long mood-laden notes in minor alternation. The lengthy guitar signatures which guarantee this mood were achieved by first recording them and then utilizing play-back to repeat the recordings through the speakers and then to play the notes again live, over the top, extending the scope and range of each. Visconti remembers "[Robert] Fripp … would plug his guitar into the EMS synthi and Brian [Eno] would play around with it" (Buskin, "Heroes"). The guitar line is "Fripp standing in the right place with his volume up at the right level getting feedback" (Buskin, "Heroes") which was then recorded over the first track multiple times. Visconti had acquired the new pitch-shifting Eventide H910 Harmonizer which, he announced, "fucks with the fabric of time" since it could harmonize the pitch of the instruments in syncopation (Doggett 307). Now that the guitar could harmonize in different keys across different recorded takes of the song, the effect was singularly immersive. In terms of singing, Bowie used vocal gates which produce the sonic effect of a seeming distance in the voice despite the volume at which the vocal is delivered. As the furthest gate is triggered to record the most aggressive delivery, the impassioned vocal then gets absorbed into the character of the general mix rather than appear prominently above it, on the surface of the track, as in a conventional recording. Eno called the result "heroic and sad" likening it to the city itself (Troussé, "Eno on 'Heroes'"). Yet

again Bowie had surprised with a new sound and sense of direction, this time fusing the expression of his unmoored identity in Berlin with the developing technology of audio tape, a technology synonymous with the city in which he found himself.

According to Paul Morley, the German army had initially

> developed the use of audio tape recording to broadcast their propaganda across different time zones. After the war, the victorious Americans discovered the technology and it was introduced in America first of all on *The [Bing] Crosby Show*. It's at the very beginning of the kind of fluid time-shifting sound recording that Bowie, with Visconti, Fripp, Eno and co. had just been exploiting and extending. They had been doing this within 500 yards of the Berlin headquarters of the Nazis where the magical idea of tape as a way to supervise and rearrange time, and flexibly insert it into media, and to control the masses, first appeared.
>
> (*The Age of Bowie* 348)

So as Bowie is using tape, in the words of Gilles Deleuze on cinema, to "emancipate time," (*Cinema II* 39) painting sonic pictures of the deeply divided and alienated place Berlin had become (and, in so doing reflecting his own drug-addled and fractured sense of self), the coincidence is that Beckett, who had undertaken arguably the first major deconstruction of identity through audio tape in "Krapp's Last Tape" in 1959, is around the same time directing the very same play in another part of the divided city. Just as Bowie composes a largely instrumental album of sonic impressions as a way to represent the alienation he felt in Berlin, but also the unnerving inequality emerging among its cultures, Beckett's play, in which a man finds himself stratified across time and space and incapable of achieving or returning to organic wholeness, is being rehearsed across town. And Beckett's drama expresses similar things about the instability of all individuated identity in 1977 at a time when the mode of production was becoming increasingly determined by technology as the advanced wing of a new, all-seeing fully immersive capitalism. Moreover, the play also draws attention to the means of production, the tape-recording process, as a culprit in this debilitating sense of alienation. Similar to how "'Heroes,'" through the use of recording technology, achieves a sense of the individual at an alienated distance from self and home, Beckett had already conceived of this alienating effect through the figure of Krapp and his twin spools.

At the lyrical climax of "Krapp's Last Tape," the eponymous character, listening to a recording of himself, recalls a moment of happiness but also, in his ageing misanthropy, finds himself forced to acknowledge that the world has largely passed him by. Although the tape recorder extends him back through time, it reveals to him, simultaneously, that time "doth now his gift confound" (Shakespeare, Sonnet 60) as he struggles to identify with his former self. Rather than help restore him to a unified self-identity, the tape recordings to which he listens draw attention to the degree to which he has changed, to how he is no longer the Krapp on tape. He listens to versions of himself that once passed through but of whom no residua remain, save on tape. The exception is one moment in which the various Krapps cohere: his recollection of a romantic liaison

with a green-eyed girl in a small boat. The recitation of this emotive moment seems to forestall temporal diachrony, momentarily, in one of Beckett's significant aesthetic suspensions. Krapp feels as his former younger self felt; both versions appearing to exist as one, if only for a moment, through the technological intervention of the recording. This fleeting unity is then spooled away as quickly as it is arrived, with Krapp again at an impossible distance from himself listening to a younger fellow who feels creatively driven by a "fire in me now" (*CSPSB* 63) that is utterly at odds with the rather defeated looking man listening to him. Despite his attempts to find succor through immersion in a world of commodities—booze, bananas, prostitution, and the promise of a career as a proto-podcaster—such comforts offer no relief from his material and fetishized existence.

Through this powerful deconstruction of identity, "Krapp's Last Tape" draws attention to how people, in their day-to-day existence, hold themselves together by positioning themselves in space and time in a way that returns them to self-identity, whether it be through enacting daily habits, identifying their worth through commodity possession, or by believing in an integrated subjectivity produced, in large part, by the (very selective) deployment of memory. In the moment when Krapp remembers the encounter with the girl, and is returned to himself, it is through nostalgia (an emotional conduit that serves a unified sense of identity) but in a very clear sense he also hears himself "as he was" when he had something—true love—he does not enjoy now. Although he remembers the moment and is moved again by the experience, he is simultaneously distanced from the earlier version of himself and positioned, as are members of the audience, listening to *somebody else*. He is both himself and is not, is both the past and yet the past in the present changed. The technology, appearing at first to unite him, rather exposes the incommensurable gap between the versions of himself. Here "I" is very much "We" in Krapp's aural, ontological encounter(s). Similarly, when Beckett tells Georges Duthuit that "I shall never know clearly enough how far space and time are unutterable, and me caught up somewhere in there" (*CLSBII* 98), he reveals that a life in art has made him painfully aware of how identity is always a contingent construction, an attempt to unite versions of ourselves, temporarily, in a spatio-temporal "reality" before being swept away in the inevitable alienation produced by our positioning within a commodified culture and its increasingly technological universe.

"Krapp's Last Tape" has merited analysis here for three reasons. Firstly, it gives us a glimpse into the complexity of Beckett's thoughts on identity even in a play ostensibly so simple that one prominent Irish actor dismissed it "as a piece of Irish Protestant sentimentality" (Murray 119). Secondly, it is important to see how its themes are also explored sonically in Bowie's Berlin period, both artists opening up the possibilities of emerging technologies as ways of expressing something about being, and, particularly, the feeling of being alienated within a devolving sociality reliant on an increasingly technocratic capitalism. Thirdly, it appears to be the case that Bowie was influenced by Beckett's play when he began to say his own "goodbye." In 2013 and borrowing the architecture of alienation Beckett provides for Krapp, albeit replacing audio tape with video, Bowie explores memories of his experiences in the Berlin of some forty years

earlier. In short, the song "Where Are We Now?" released on Bowie's birthday in 2013, as both sound piece and video, seems a clear intertextual reference if not an homage to "Krapp's Last Tape."

As evidence in support of this speculation, consider this excerpt from a conversation held online on Bowie.net between Bowie, Ronan Keating (of all people), and a chap named Dara. At the time, Bowie was visiting Dublin, circa 1997, and soaking up the drum-and-bass scene in the Irish city's clubs. The transcript was uploaded to the now defunct Bowie.net on January 13, 1999.

> David: Being a Dublin boy, are you into Dublin writers? If so who are your favourites?
> Ronan: My favourites would be more outside Dublin, Sligo which was Yeats country. Kavanagh, and also Behan. Are you a fan?
> David: I suppose mine tend to be more Dublin oriented, Joyce, Beckett – major Beckett fan and Behan.
> ...
> Dara: David, have you ever attended a Beckett play in Dublin?
> David: Yes I have, at the Gate Theatre, also in New York and also in London. I know for sure I saw *Happy Days* in New York.
>
> (available at Bowie, "Bowie Wonder World")

Given that The Gate Beckett Festival, a two-week staging of all of Beckett's dramatic work, was first mounted in 1991 in Dublin and was then restaged in 1996 at the Lincoln Center, New York, and in 1999 at the Barbican Centre, London, it is reasonable to propose that Bowie encountered "Krapp's Last Tape" at some point before the release of "Where Are We Now?" on January 8, 2013, the eve of his 66th birthday. In fact, given that the *Beckett on Film* project, which features John Hurt as Krapp, is widely available on the web, and previously on DVD, it is most likely that Bowie (as a self-professed "major Beckett fan") was familiar with the play in question (especially given that both actors were also firm friends, the two having played the character of John Merrick in different adaptations of *The Elephant Man*). Certainly, the line "as long as there's fire" in "Where Are We Now?" seems to directly echo Krapp's line "not with the fire in me now," (*CSPSB* 63) the withering irony of Krapp's predicament notwithstanding. Conversely, Bowie's emphasis on the you and me—"as long as there's you, as long as there's me"—offers a moment more hopeful than Krapp's fleeting recollection of love.

Of equal importance, in the video for "Where Are We Now?" Bowie is suspended among old videos and possessions, rather than identified by them, in a manner similar to how Krapp is discombobulated by audio versions of himself. It features film footage of his life in Berlin in the late 1970s; a life in which the song's narrator tries to reposition himself, imagining that he is "sitting in Dschungel"—a Berlin nightclub long gone by 2013. At the same time, he also tries to take a train from Potsdamer Platz, which was only possible before or after reunification in 1989 and so impossible in the period in which Bowie and Iggy Pop lived in Berlin. So it is that Bowie's song, like Beckett's drama, presents characters whose coordinates are neither geographical nor physical but located in the mind and therefore shifting like memory, littoral and passing. Having

said that, some of the footage in the video has quite evidently been shot recently. In one sequence the word "Tacheles" appears as graffiti. This refers to an art squat in the Mitte district that was populated in 2012, and so indicates that the question that is the song's title spans at least three different moments in time. We assume some footage documents Bowie and Iggy Pop's lives in West Berlin in the late nineteen-seventies, not least some shots of their apartment at 155 Hauptstraße. Footage of many people crossing a bridge in conjunction with Bowie's in-song reference to the Bösebrücke in Berlin recalls the first border crossing of twenty thousand people on November 9, 1989, the day after the wall was dismantled. The song and video, therefore, reference the fall of the Berlin wall at the end of the nineteen-eighties and, in tracing time back to the recording of "*Heroes*" at the end of the seventies, use these moments as a framework within which to also reference the Tacheles commune—Künstlerinitative Tacheles—and the fact that, in 2013, it had only recently and unceremoniously been ejected and its building closed down and rezoned for demolition ("The Story of Tacheles"). Essentially, the song's title can be interpreted as a question regarding the fate of Berlin, and, by extension, global political economy in the early twenty-first century.

It is important to remember, in relation to the temporal contexts Bowie sets up in the video, that Berlin in 1977 was the material embodiment of the two competing economic philosophies that then vied for world domination. It was a city partly in ruins, ripped in half and enduring the material disintegration as a forgotten metropolis. This was a city in which Bowie wrote songs about the migrant workers living in its shadows as the great ideological battle between capitalism and socialism—the latter at the time represented by the rise of communism in the USSR and China—raged in the minds and on the streets of Europe and Asia. In 2016, in neoliberal Berlin, somewhere like Tacheles, an alternative art idea that defined the West Berlin of the nineteen-seventies but out of synch with the normative economics and biopolitics of the Berlin of late capitalism, is systematically closed down in an act of gentrification in keeping with the new economic realities. Such elisions can also be considered examples of the removal of antagonism and/or the routine silencing of potential conflict sites that might trouble a victorious and evolving pan-capitalism, the progress of the latter necessarily suppressing and removing viable, socialist alternatives. In this regard, the presence in the video of Siegessäule, "the Berlin angel," generates an echo of Walter Benjamin's "The Angel of History" in which the writer sees progress as the piling of debris behind the spirit of experience as it is propelled into an uncertain future. In this, Benjamin's angel is a metaphor for a world dragging with it the debris of the past, and, in doing so, revealing the ruination of capital progress. Benjamin describes his vision thus:

> A Klee painting named 'Angelus Novus' shows an angel looking as though he is about to move away from something he is fixedly contemplating. His eyes are staring, his mouth is open, his wings are spread. This is how one pictures the angel of history. His face is turned toward the past. Where we perceive a chain of events, he sees one single catastrophe which keeps piling wreckage and hurls it in front of his feet. The angel would like to stay, awaken the dead, and make whole what has been smashed. But a storm is blowing in from Paradise; it has got caught in

his wings with such a violence that the angel can no longer close them. The storm irresistibly propels him into the future to which his back is turned, while the pile of debris before him grows skyward. This storm is what we call progress.

("Theses on the Philosophy of History")

To contextualize Benjamin's angel in relation to Beckett, Bowie, and the present moment of "progress" it is worth pausing, and asking, "where are we now?" And the simple fact of the matter is that the storm envisioned by Benjamin is about to become the story of a hurricane.

VI devoted a significant amount of attention to how disaster capitalism has attempted to capitalize on the threat of our new viral epoch. Despite the prescience and moral weight attached to arguments denouncing the gains made by disaster capitalists in exploiting the presence of COVID-19, the grossly inconvenient and unwelcome truth is that COVID is simply the loudest viral shot across the bows of the Anthropocene in recent years—and the recurrence of these volleys should leave no one in any doubt that there is worse to come. This is also the painful reality for the disaster capitalist brigade whose efforts to milk pandemic politics for economic return see them face into the same fatal outcome as everybody else. From the major occurrences of avian flu in 1997 and the flurry of recurring outbreaks since, to the appearance of SARS in 2003 and Swine flu in 2009, to MERS in 2012 and to Zika two years later, the signs all point to the emergence of a major viral killer sooner rather than later. Quite simply, the current capital model, fine-tuned in the West and now expanding around the globe in the territories of China and Russia, and in the countries of West Africa, make contemporary global living unsustainable for everyone.

Historical evidence establishes a clear relationship between the early evolution of capitalism and the concomitant emergence of previous viral pandemics. Mike Davis believes that globalization, in its myriad forms, has proven responsible for the spread of plague events. The Black Death, for instance, "was the inadvertent consequence of the Mongol conquest of inner Eurasia, which allowed Chinese rodents to hitchhike along the trade routes from northern China to Central Europe and the Mediterranean" (17). Similarly, the flu of 1918 spread through newly established travel and trade routes but also achieved major penetration as a result of the mobilization of armies to fight the war across Europe. Davis laconically observes:

> Today's 'landscape of disaster' is eerily similar to 1665 and 1918: urban populations locked inside their apartments, the flight of rich to their country homes, the cancelation of public events and schools, desperate trips to the markets that often end with infection; society's reliance upon hero nurses, the lack of beds in hospitals and pest-houses, the mad search for masks, and the widespread suspicion that alien powers are at work (Jews, a passing comet, German saboteurs, the Chinese).
>
> (M. Davis 16)

Today's manifestation of the same production modes, in which multinational capital is responsible for the destruction of the world's forestry—replacing it with

the growth of factory farming to provide for unsustainable population explosion—is a recipe for similar disasters. This "development," in turn, produces conurbations of super slums wherein the world's biggest ever pandemic seems inevitable.[1] In this regard, the deforestation threat, present now for many decades, has suddenly taken on its most ominous context. Whether undertaken by multinationals or desperate subsistence farmers, it has gradually eliminated the barrier between human populations and the reclusive wild viruses endemic to birds, bats, and mammals. In tandem, huge industrial feed farms are potential sites for virus incubation in areas and territories where there is scant healthcare and increased susceptibility to disease through unsanitary conditions caused by overcrowding. In short, population increase, harnessed and instrumentalized by late capitalism, has produced a ticking time bomb. While in privileged society the elderly and those with underlying health conditions were the principal victims of the first wave of COVID, a future pandemic of a more virulent strain will result in fatalities produced by urban density, unsanitary conditions, and, finally, hunger. Similar to the "Irish Hunger," food shortages produced as a result of attempted life-preserving lockdowns for the privileged, in which resources are rendered inaccessible to the majority, will contribute to driving bacterial infections among the malnourished and produce concurrent health threats such as viral pneumonia. Inevitably, these disease burdens will then finally also consume even the financially secure. Estair Van Wagner recognizes that an emerging viral epoch

> has made it impossible to guarantee that the borderless enclave of the identical hotels, condos, office buildings, and convention centers that facilitate the mobility of the transnational elite is disease free. In the face of a possible avian influenza outbreak ... the presumption that our governance and health infrastructure have either the knowledge or power to control infectious diseases is no longer tenable and appears dangerously arrogant.
>
> (qtd. in M. Davis 47)

The emergence and continuing embeddedness of bird flu, or, more properly speaking, "H5N1," leads Davis to believe that it is the most likely contender to fill the role of viral killer. First appearing in Hong Kong in 1997 it has remained present outside of the human population and as

> a mutant influenza of nightmarish virulence—evolved and now entrenched in ecological niches recently created by global agro-capitalism—is searching for the new gene or two that will enable it to travel at pandemic velocity through a densely urbanized and mostly poor humanity. This is a destiny, moreover, that we have largely forced upon influenza. Human-induced environmental shocks—overseas tourism, wetland destruction, a corporate "Livestock Revolution," and Third World urbanization with the attendant growth of mega slums—are responsible for turning influenza's extraordinary Darwinian mutability into one of the most dangerous biological forces on our besieged planet.
>
> (M. Davis 51)

In other words, there is a global crisis narrative that is being written, and its plot and character conditions indicate a tragedy that will shock us all. And the work of Beckett and Bowie speaks to such a crisis precisely because both have always embraced a vision in which capital progress was wedded to the terms of its own disaster. From the character in "Panic in Detroit" who runs to the window to "look for a plane or two," foreshadowing 9/11, to that of "Drive in Saturday" who seeks knowledge from "the strange ones who live in the dome" in what is clearly the aftermath of an environmental catastrophe, to Beckett's "ruinstrewn land" through which the narrator takes "little panic steps" (*CSP* 233), their work documents unnamed but palpable instances of cultures in crisis. Further, both have utilized technology to articulate something of the destruction of modern forms of subjectivity coextensive with the dehumanization of late capitalism, as demonstrated in analysis of "Play," "Film," "Station to Station," "'Heroes,'" and "Krapp's Last Tape." The manner in which these works displace, or decenter, the human subject, alienating it from its own vitality, reflects how Beckett and Bowie eschew positivist narratives of self-realization and engage in alternative narratives of ruination and finitude. In this regard, Shane Weller proposes that

> technology's power to reveal appears to be a revelation not of life but of death: it discloses the ostensibly living as the already dead. This is what might be termed its ruthless proleptic power: the technological device anticipates the death that is to come … it destroys time; more precisely, it destroys the lifetime, and drags us into the time of death—the time of the so-called future perfect.
>
> (23)

This accurate reflection can be applied to the use of both tape deck technology in "Krapp's Last Tape" and the deployment of video in "Where Are We Now?" It also appears true about Bowie himself, who, in 2013, and like the angel of history, "would like to stay, awaken the dead, and make whole what has been smashed" (Benjamin, "Theses on the Philosophy of History"). However, his use of the Siegessäule monument qualifies this enthusiasm, intimating the presence of the angel of death. Nodding to Wim Wenders' *Wings of Desire*, and the opening scene in which two angels watch the city's citizens from Siegessäule's helmet, it is as though Bowie invites viewers to think for a moment about mortality. We catch a glimpse of him, aged and apprehensive, at the video's conclusion, wearing a t-shirt that says "Song of Norway" which indicates (for Bowie aficionados at any rate) that one addressee regarding the enquiry as to where we are now is Hermione Farthingale, an early love in Bowie's life who left him in the late 1960s to take a role in the musical named on Bowie's t-shirt. But despite, or indeed because of, the reference to love affairs long past, the song and video primarily seem to presage a lateness in the Bowie oeuvre, a distinct finitude. As the sound and vision come to a close, accentuating his anxiousness, Bowie seems to embody a melancholy interiority, a merging of the self with ruination. Not the ruination of the Berlin of the nineteen-seventies with which he previously identified, but arguably the modern Berlin suffering the

ruination of late capitalism and of himself suffering liver cancer and so reflecting a world facing up to its own dissolution. As he plaintively sings of "walking the dead" there is the palpable feeling that he has returned to say goodbye, that he is trying to orchestrate the time and space to do so in customary style and, crucially, that the dead he eulogizes are potentially multitudinous.

II

When, on Bowie's 66th birthday in 2013, the video for "Where Are We Now?" was dropped on YouTube, the internet lit up with analysis of the various symbols evident in it. Then on January 7, 2016—this time on the eve of his 69th birthday—Bowie released the video for the song "Lazarus," hot on the heels of "Blackstar," the flagship single from the album of the same name. Common to all three videos is the symbol of the skull, utilized as a *memento mori*, an object often incorporated within Renaissance painting that is intended to symbolize the proximity or presence of death. For example, "Where Are We Now?" opens with a glass skull atop a counter, and in "Lazarus" at 2:53′ a skull sits on the writing table as Bowie feverishly tries to compose his last words. Thirdly, in the song "Blackstar" a posthuman female of the species, complete with tail, uncovers from beneath an astronaut helmet a skull clearly redolent of Major Tom. Expressed in the recurring *memento mori* of a skull in each of Bowie's last three videos, death is near.[2]

The skull is a prominent *memento mori* in Shakespeare, and Shakespeare's drama also appears in late Beckett/Bowie as a sign of finitude. Indeed, the Bard is an important figure in the aesthetic landscape of both artists. Anne Atik recounts many evenings with Beckett in which their passion for Shakespeare is foregrounded, and particularly Beckett's appreciation of *King Lear* (*How It Was* 25). Shakespeare was also important to Bowie since Lindsay Kemp, actor, mime artist, and one of Bowie's mentors, reiterated to him the dramatic possibilities of both the tragedies and comedies. Kemp was intrigued by the Elizabethan frolics of namesake William Kempe who was the principal clown in "The Lord Chamberlain's Men," Shakespeare's Elizabethan acting troupe. Given that the modern Kemp performed as Puck in *A Midsummer Night's Dream* it is tempting to hear in "give me your hands"—the closing refrain of the song "Rock and Roll Suicide"—the invocation with which Puck (fairy and therefore extra-terrestrial) closes *A Midsummer Night's Dream*: "So good night unto you all. Give me your hands if we be friends, and Robin shall restore amends" (V, i, 15–16). Another obvious visual reference to Shakespeare in Bowie's work is the skull that accompanied performances of "Cracked Actor" (1974) on tour and which echoes Hamlet's rumination on mortality addressed to the skull of (another jester) Yorick. Jonathan Barnbrook, who conceived the sleeve of Bowie's penultimate album, had this to say about the iconography of *The Next Day*:

> *The Next Day* evokes numerous reference points, notably Macbeth's speech 'Tomorrow, and tomorrow and tomorrow', which deals with the relentless onward

push that any unnatural position of power requires. It also has the existential element of *Waiting for Godot* with waiting for *The Next Day*—these all seem to question the nature of existence so a monochrome palette seemed most appropriate to this feeling.

<div style="text-align: right">("Barnbrook Talks Bowie")</div>

Barnbrook identifies both Beckett and Shakespeare as influences on late Bowie work, supporting the suggestion that, in addition to the more obvious Tiresias, an image of Gloucester, the blinded scapegoat in *King Lear* (1608), might perhaps haunt both "Blackstar" and "Lazarus" (2016).

Allusions to Gloucester certainly figure throughout Beckett's work. The line "Suddenly enough and way for remembrance. Closed again to that end the vile jelly" ("Ill Seen Ill Said" 465) describes how having a sudden memory might close one's eyes involuntarily. This is an allusion to the last scene in Act III of *King Lear*, when Cornwall puts out Gloucester's eyes with the line "Out, vile jelly!" (III, vii, 2216), a phrase Atik claimed particularly impressed Beckett. Of Gloucester's presence in Beckett's work, Nixon and van Hulle note: "One of the ... passages in *King Lear* (the blind Gloucester led by his disguised son Edgar on the cliffs of Dover) recurs frequently in Beckett's works as an Ur-scene of someone who is on the verge of committing suicide and yet does not kill himself" (*Beckett's Library* 9). Just as in Bowie's "Blackstar" and "Lazarus," in which the singer appears to enact a version of the blinded Gloucester teetering on the brink of oblivion, Beckett, too, employs this archetypal Shakespearean character as the increasingly atomized raw materials of a narrating mind in crisis. A powerful line from *King Lear*—"The worst is not; So long as we can say 'This is the worst'" (IV, I, 2280)—is also echoed in the title and theme of one of Beckett's late meditations, "Worstward Ho" (1983), which employs the *memento mori* of a skull to meditate on a willed obliteration of the coordinates of the subject. In this parallel, and in the Bowie universe, the skull of Major Tom lies in the ruined landscape without. In the Beckett universe, the ruination is taking place within the skull itself; a space that is also a metaphor for the final ruination of history.

In Beckett's "Worstward Ho" the skull is the center of knowledge and of self. The piece begins by describing a man in a state of contemplation "head sunk on crippled hands" ("Worstward Ho" 472) and then the narrative, which appears to be the calculated stream of consciousness of this man, attempts a self-reflexive deterritorialization of his body, removing hands, head, feet, torso, and so on until eventually he, and reader, must contemplate only the skull, the "seat of all." At which point a certain paradox becomes apparent. Given the narrative's point of view, the one who attempts to reduce the mind to nothing more than skull must yet be the seat of the narrating mind. Quite simply, the mind that imagines nothing but the skull nonetheless persists in narrating/narration. The mind must then be present somewhere in the skull described. Just as Black Francis's mind must be some place in proximity to the question he poses, so too Beckett's narration must renew itself somewhere, and this despite its attempt at articulating the dissolution of its own consciousness:

> In the skull all save the skull gone. The stare. Alone in the dim void. Alone to be seen. Dimly seen. In the skull the skull alone to be seen. The staring eyes. Dimly seen. By the staring eyes. The others gone. Long sudden gone. Then sudden back. Unchanged. Say now unchanged. First one. Then two. Or first two. Then one. Or together. Then all again together. The bowed back. The plodding twain. The skull. The stare. All back in the skull together. Unchanged. Stare clamped to all. In the dim void.
>
> (477)

Even as the narrator instigates the slow dissolution of both the body and memory to arrive at the skull alone, the impending end, he of the staring eyes then begins a process of reconstitution as this skull is still the seat of his perceiving mind. In this, the narrative recalls Marx's famous maxim that "the mode of production of material life conditions the general process of social, political and intellectual life. It is not the consciousness of men that determines their existence, but their social existence that determines their consciousness" (Preface to *A Critique of Political Economy*). In "Worstward Ho" there is no "social existence" as such. We are encouraged to imagine that there is "a body. Where none." "A place. Where none." In this non-existent place there are "No bones. But say bones" and "No ground. But say ground" (471). In other words, the first injunction is to imagine a world shorn of the body so that there exists only a mind alienated from its own corporeal home. As a result of this psychological estrangement, the narrator attempts to imagine life in ever more deterritorialized ways. The two figures that appear in the reconstituting text as projections of the imagination of the narrator, "the old man and child" walking "hand in hand, "bit by bit," are redolent of Gloucester and Edgar as they make their way towards the cliffs of Dover so that the elder can attempt a suicide that the younger will cleverly foil.

> Bit by bit an old man and child. In the dim void bit by bit an old man and child. Any other would do as ill.
>
> Hand in hand with equal plod they go. In the free hands—no. Free empty hands. Backs turned both bowed with equal plod they go. The child hand raised to reach the holding hand. Hold the old holding hand. Hold and be held. Plod on and never recede. Slowly with never a pause plod on and never recede. Backs turned. Both bowed. Joined by held holding hands. Plod on as one. One shade. Another shade.
>
> (473)

If this couple are an allusion to Edgar and his father, then neither are reconstituted as avatars from the nourishing commodity of a Shakespearean tragedy. Instead, the narrator seeks to dismantle the figures, obliterate them, in the hope of stilling its own consciousness, to quell the only trace of social existence it evokes. And yet, despite the fact that the mind of the piece works tirelessly in this regard, the figures return, albeit in more disembodied ways, testament to the mind's persistent and perhaps

unconscious urge to imagine (which recalls both Beckett's "obligation to express" and Bowie describing his own work as "bloody-minded" in its attempts to make manifest "something that wasn't there before"):

> Long sudden gone. Then sudden back. Unchanged. Say now unchanged. First one. Then two. Or first two. Then one. Or together. Then all again together. The bowed back. The plodding twain. The skull. The stare. All back in the skull together. Unchanged. Stare clamped to all. In the dim void.
>
> (477)

Like Bowie suspended in an artist's studio at the conclusion of "Where Are We Now?" "Worstward Ho" suggests a slow dissolution and the gradual passing of time. However, this dissolution is also offset both by the necessity of perception, the ineluctable modality of the visible in the mind's eye, and by a certain fidelity to art, to finding the right words to express both this lingering dissolution and the possibility of its suspension. The consciousness that is present here is shaped by a desire both to create and to obliterate. Propelled by this conflict, it generates a powerful, visceral art. There is the implicit acknowledgment that as long as there is fire, which we can take to be a metaphor for imaginative creation, as long as there is desire on the artist's part to create, even an art that ushers in death, lives. And this paradoxical suspension somewhere between dissolution and perpetuation takes place in the mind of the reader in the act of reading such that the piece also proposes profound questions about the space of its restitution. Given that the narrative figures itself within a psychic space, within the mind perceiving the skull, the reader's mind then becomes the mind in which the text is processed. This mind is both "the one" and "the twain," narrator and reader, such that the text becomes the space of "the two" shortly after Gloucester and Edgar have been atomized beyond recognition. And the narrator even questions to whom the words belong in this intimate intersubjective communion:

> Whose words? Ask in vain. Or not in vain if say no knowing. No saying. No words for him whose words. Him? One. No words for one whose words. One? It. No words for it whose words. Better worse so.
>
> (475)

By indicating that the narrator is male but that the reader may be female, or other, the space of the narrative is degendered, deconstructed, but nonetheless resolutely occurring *between* author, language, and reader. In such ways, "Worstward Ho" is the intersubjective witnessing of a slow going in which the artist ostensibly attempts to bring things to an end through words:

> Whence no farther. Best worst no farther. Nohow less. Nohow worse. Nohow naught. Nohow on.
>
> Said nohow on.
>
> (485)

However, when the narrator says "nohow on," which is also a homonym for having the "know how" to go on, he invokes the reader, and the activity of reading, as an important way forward. Hence this final phrase suspends finitude between the impossibility of more ("I don't know how to go on"), and every likelihood of yet more ("I have the 'know how' to go on") as you, the reader, continue to read, and, hopefully, reread. In this creative space, in which conventional time has been suspended, Beckett has the know-how to go on but requires inhabiting the mind of his reader to achieve this state. Consequently, as long as there is life, there is text, and the reader's consciousness the host. Finally, Beckett's version of Marx's observation on consciousness positions social experience as that between self and other in intersubjective communion. In an imagined universe where consciousness appears to be an imperative it is also, necessarily, social. Shorn of commodities and other material coordinates, this imagined space nevertheless represents a profound sociality in its ability to marry self and other in aesthetic inclusion. In that, it represents form as the possibility of "an underlying affirmation" and so "a kind of solution" to "the general distress" of living (Juliet 66–7).

Something else that persists in this psychic space, shared between author and reader, is the image of the skull, the final irreducible trace of the body, and the refuge, if you will, where this fragile communication between word and world, between author and reader, is taking place in the act of reading. So, Beckett's use of the skull is partially a *memento mori* that presages finitude, but it is also, importantly, a site of the persistence of the creative impulse and, as an artistic symbol in his oeuvre, the sign of both an attempted and suspended conclusion. And Bowie achieves something similar in the manner in which the video for "Lazarus" employs the viewers' gaze as a way to suspend spatio-temporal diachrony, such that in a similar paradox, that which appears to be a "dead end" also aspires to be a perpetual becoming.

"Lazarus," as both song and video, released days before Bowie died, is loaded with allusions to historical and fictional characters. Bowie's Lazarus is the transgender seer Tiresias and, by implication, the blinded Oedipus who foreshadows also the blinded Gloucester, but principally, of course, he is Lazarus raised from the dead by Jesus. The actor Michael Sheen notes that when Bowie undertakes a comic mid-song, middle-aged shuffle he presents himself as "a vaudeville hoofer." At the same time, he also believes Bowie counterbalances this caricature by sporting "the stiff, quiffed gray hair of Beckett himself" (*Recorder* no. 1). The resulting juxtaposition is rather serio-comic. Just as Beckett's characters, lacking the strength or will to die, often laugh at their predicament, tragedy is not the genre in which Bowie chooses to leave the stage. In terms of specific literary allusions, the song namechecks Sylvia Plath's "Lady Lazarus" for whom "dying is an art, like everything else" (poetryfoundation.org). There is also an implied allusion to poet and activist Emma Lazarus who wrote the lines now inscribed on the Statue of Liberty, requesting that other countries

> Give me your tired, your poor,
> Your huddled masses yearning to breathe free,
> The wretched refuse of your teeming shore.

> Send these, the homeless, tempest-tossed to me,
> I lift my lamp beside the golden door!
>
> ("The New Colossus")

This pointed reference to a rich history of emigration foreshadows, as it simultaneously critiques, America's increasing anti-immigration policies. Considering Bowie himself was an immigrant to the USA, the identification of New York as a place of refuge is echoed in the lines "By the time I got to New York … I'd used up all my money" which might also allude to Nick Cave whose "Larry" in "Dig Lazarus Dig" ends up

> like so many of them do
> In the streets of New York City
> In a soup queue
> A dope fiend

who is then shunted from prison to psychiatric institution. Here Cave reiterates the biopolitics of exclusion faced by the impoverished immigrant who cannot succeed in the archetypal big city, which is ultimately weighted against him or her. It is notable that the main soup kitchen distribution area in NYC was the Bowery, a district adjacent to Bowie's Lafayette Street apartment. This is not to suggest that Bowie ever used its soup kitchens, but it is telling, nonetheless, that Bowie chose to live here rather than, say, the Upper West Side favored by the celebrity glitterati, or in West Hollywood, or other such star-studded territories.[3]

Performing the roles of all the Lazaruses that the song and video represent, Bowie is Bowie by multiplicity. Each Lazarus speaks something of him, from the East Village émigré to the agnostic, from the transgendered torch song savior to the contemporary champion of those excluded at the border. Playing multiple parts for multiple (often overlapping) audiences he is the performing Bowie, the playful Bowie, the salacious Bowie (looking both for Jesus's donkey as transport to Jerusalem while also desiring some piece of NYC ass in the great tradition of his cruiser characters), and the necessarily ironic and inauthentic Bowie who somehow manages to communicate something true. Furthermore, during this final curtain call we watch him struggle, comically, to commit his last words to paper. In this regard, and in an interview in 2002, Bowie mentioned that he had been thinking about what he believed to be Beckett's last words, in preparation for his own:

> Philip Larkin said, 'Well, I'm off to the inevitable', which I think is one of my favourite last words … Actually, Samuel Beckett's last words were my favourite. I wonder if these people prepare their last lines? … I need to write mine out and have them clutched in my hand in case I can't actually squeeze them out through my lips before I go. It's all about coming up with the right line.
>
> (Jones, "We'll miss you David Bowie")

There are two interesting things to note here. Firstly, Bowie mistakenly believed that Beckett's last words were "what a morning" when in fact these were the last words of

his father, Bill Beckett.⁴ Of greater significance is the fact that Bowie appears to stage the writing of his own last words in the video for "Lazarus." At 3:52', pen in hand, he transcribes the syllables that will stain the silence, as you would expect, playing it for laughs. Again, Bowie explicitly nods to Beckett as a key influence on the performance of his own artistic departure.

And yet talk of last words and final exit are a tad premature. Like Lazarus, Bowie too will rise from the dead in this video, or, more properly speaking, forestall death through a suspension produced by cinematic technology. In this he demonstrates how that which alienates also, in its own way, saves. Technology's capacity for repetition is exploited for the most poignant of truths, that simulated authenticity has staying power. In "Lazarus", the door the video frames in opening and closing seems to mark an internalized passage within the work, as it does in Beckett's "Stirrings Still" (on which more momentarily). Similarly, in his short poem "my way is in the sand flowing" Beckett hopes to overcome "long shifting thresholds" by living the natural movement of a door "that opens and shuts," even as the shape of the image itself suspends the impulse indefinitely (*CPSB* 118). Likewise, in "Lazarus," Bowie seems to live the space of a door that opens and shuts as he first appears out of a wardrobe into what can only be described as a dystopian carceral institution no doubt representative of the failed and so purgatorial environment of neoliberal modernity. This coffin metaphor, to which he returns at the song's conclusion, functions within the formal structure of the video through repetition, opening and closing indefinitely on repeat viewing.⁵ When Bowie sings "Look up here I'm in Heaven," floating above his bed, we watch in the knowledge that he is now dead as he speaks to us from the great beyond. Yet the invocation to look at him—to engage our gaze—also maintains his *presence*; in short, we see him live. And at the same time, like Hamm's expiration, we know we watch him put on the performance of his life, and death. As he has done throughout his professional life, he offers up another performance that nonetheless resonates with truth. Immortalized in the video itself, Bowie is a literal *ghost in the machine*, both captured and risen from the dead in perpetuity. In an extension of the desire to "be on" stage in the song "Time," conventional reality is suspended; here stage and staged life defer the impoverishments of so-called real life and yet inhabit this suspension powerfully in a meaningfully lived time. In just this way, the "Lazarus" video is replete with a beautiful revision of the power-knowledge regiment that proposes the truth and falsity of death. Bowie exists in the video suspended in a moment of time that both announces the finality of his death and yet subjects it to an indefinite deferral, on his terms, aesthetic terms, that continue to challenge conventional notions of space, time, and self. Further, he does so by manipulating video technology to his will. "For the record," as Bowie asks us to "look up here" he marks out the space of his permanent presence in our imagination. Quite majestically, as he retreats back into his upright coffin and the music fades to silence, his last recorded exit is best articulated by Bowie himself who in "Feel So Lonely You Could Die" (2014) tells us, when the time comes, that he will "leave without a sound, without an end."

When one considers the spatio-temporal gymnastics that Beckett achieves in his later work, and that may well have influenced Bowie to attempt the same, we get to

see both of them conduct, for a few glorious moments, their own time *and* space. However, if the work of both were to be frozen in time, for all time, that would defeat their radical political poetics. Rather than their art being preserved indefinitely, the reality is that the very possibilities their spatio-temporal aesthetics have engendered are threatened by the inevitable obsolescence of our already fading and flickering 4K screens which will soon be replaced by something more high definition and something purportedly more "real," to say nothing of the fate of books. In this impending obsolescence of the current technologies of stage, screen, and recording studio is the great lesson of their art of alienation regarding our future and future catastrophe: nothing lasts forever. Yes, Beckett and Bowie suspended time and so provide a glimpse of artistic triumph, but they return us to ourselves to remind us that the clock is ticking, and we need to rethink our realities, before we, too, are obsolete.

In "Reflections on Naomi Klein's Pandemic Shock Doctrine" Ølgaard, quoting Mbembe, proposes that

> necropolitics offers a framework in which to analyse how "contemporary forms of subjugation of life to the power of death" forces some bodies to remain in a permanent state between life and the possibility of death.
>
> (Mbembe, "Necropolitics," qtd. in Ølgaard)

Beckett and Bowie's late work seems to be a quite precise articulation of the hauntology to which Mbembe alludes, one in which the life and death of their characters is suspended in the form of their subjection to late capital modernity. This paradox is beautifully captured by Beckett when employing the technology that has sustained him all his artistic life: language. As though written from a pandemic future, Beckett's final prose piece, "Stirrings Still," begins:

> One night as he sat at his table head on hands he saw himself arise and go. One night or day. For when his own light went out he was not left in the dark. Light of a kind came then from the one high window.
>
> (*CSP* 259)

Perhaps the story is told after some sort of social lockdown as the narrator, who narrates his own immediate experience, tells of his attempt to rise and leave his sparse apartment. But his memory and sense of time and place seem fractured, as though he may be recovering from an illness that has taken a psychic toll. He imagines himself as "disappeared only to reappear later at another place. Then disappeared again only to reappear again later at another place again" (*CSP* 259–60). What is particularly interesting is that the narrator has no memory, or sense of having passed through a doorway in his passage from inner to outer space:

> It was therefore in the guise of a more or less reasonable being that he emerged at last he knew not how into the outer world and had not been there for more

than six or seven hours by the clock when he could not but begin to wonder if he was in his right mind

(262)

Finding himself out of his conventional mind, in a move that echoes characters like Mr. Endon in *Murphy*, but also now out of his mind in the sense of a psyche released from its ordinary coordinates, the narrator finds himself in a space redolent of Elysian fields:

> finally he was in a field which went some way if nothing else to explain his tread and then a little later as if to make up for this some way to increase his trouble. For he could recall no field of grass from even the very heart of which no limit of any kind was to be discovered … Nor on his looking more closely to make matters worse was this the short green grass he seemed to remember eaten down by flocks and herds but long and light grey in colour verging here and there on white.

(263)

In this field of infinite grass the narrator announces that it is time to end:

> No matter how no matter where. Time and grief and self so-called. Oh all to end.

(265)

And yet, like having the "nohow" to go "on," there remains, irreducibly, "stirrings still." Like Malone who feels he might "pant on to the Transfiguration" (*Malone Dies* 179), intention, language, communication persist here; they stir, even after all else has been ostensibly extinguished. At the moment of what appears to be a clarion cry to ending, there is the suspension of the end in a new non-space, a place to be interpreted which is yet "still" a mystery. Where are we now indeed? Are we finally outside of time and space and self? At the conclusion of "Stirrings Still" neither reader nor narrator knows how we got to where we are, or where we are. There is no clear way to measure the space and time generated by Beckett's imagination. We have clearly moved, but to where, and how might we measure the distance? The desire to end "time" and "self" is doomed as there is *still* movement, in another time, another space; a space with words, text, reader, and artistic life. More importantly, different truths seem required at the conclusion of "Stirrings Still." The remote hand wants "time and grief and self so-called. Oh all to end" (265) perhaps so that a new subjectivity can emerge, housed in a different temporality that has learned the lessons of isolation and can breathe again in a post-pandemic moment without contracting viral death; perhaps in the space of a new communal republic born out of the threat of alienation and ruination. And yet the voice also seems to will extinction, to finally be one with non-being, alienated at last from the promise of a reintegrated life of vitalist becoming. Echoing Beckett's desire for "a poetry which has been through the void and makes a new start in a new room-space" (Knowlson, *Damned to Fame* 569), the conclusion offers an intimation of a literature that has a sense of a more engaged future—one based on the painful realization of the absences endured through a world beholden to

capital imperatives, or it may reject that world entirely, expressing instead a desire for oblivion. In this, the conclusion of "Stirrings Still" reflects the dialectic choice available to the denizens of the world today. Beckett said "I think in new dimensions and basically am not very worried about whether I can be followed" (*Damned to Fame* 569). "Stirrings Still" represents just such a space *beyond*. At once it intimates the fourth dimensional capacity of the arts, wherein the desire to end is suspended in a language that allows something new to emerge, while also being the statement of a radical desire for finitude. Above all, it documents the slow going of Samuel Beckett, and represents options for the rest of us who are inevitably following *on*. How we choose to do that may *still* be our choice to make. We might consider, like Bowie's Lazarus, that we are suspended between life and death and that only fidelity to creativity, as the crucible for a reimagining, might save us from annihilation.

IX

Becoming Quantum

In *Mimesis* (1946), Erich Auerbach proposes a distinction regarding how Hebrews and Hellenes represent violence, which he believes to be discernible in the canonical texts of both traditions. The difference is essentially between Judaic and Homeric literary representations of death, the former engaged in a symbolic substitution and the latter rooted in the corporeality of the body and its annihilation. Auerbach identifies Homeric death as often gory and graphic, providing examples to support his claim, such as when Achilles splits Hector's ankles in order to tie the corpse to his transport:

> Piercing the tendons, ankle to heel behind both feet, he knotted straps of rawhide through them both, lashed them to his chariot, left the head to drag.
>
> (Homer, *Illiad* XXII.467–9)

For the Greeks, heroic death is glorious, but first and foremost, it is painful. Their motto might well have been "It's not done 'til it's dire." On the other hand, as Sander Gilman notes,

> Auerbach found the antithesis to this world of detail in *Genesis*. Here he presents a tale of death and dying which functions as a prototype for the Hebrew means of representing death as a symbolic rather than as a realistic moment in the text.
>
> (152)

Mimesis argues that just as the ram becomes a symbolic substitute for Isaac, such that Abraham does not then have to kill his son, so too Christ's rotting body is replaced by the divine body as an even greater metaphoric substitution. Whereas the Hellene tradition emphasizes the body and its suffering, as does the story of Christ's crucifixion as recorded in the gospels, Genesis, on the other hand, prefigures this suffering with the spirituality of the Holy Trinity. Despite the pain Christ experiences during the crucifixion, he is always moving, by metaphoric substitution, towards becoming a painless pleasure, that is at once man, god, and spirit.

Extending Auerbach's argument to modern literature, Kafka, for example, is quite Hellene in the manner in which K is butchered like an animal at the conclusion of *The Trial*. Likewise, Beckett's mature novels are a cornucopia of physical collapse. As Kennedy argues: "The body is a site of struggle in Beckett's work from the beginning, and almost always a source of suffering" ("(Dis)embodied Beckett Studies" 1). And

the handful of songs utilized here for evidence of Bowie's artistic value are notable for articulations of embodied experience (aching brains, clawing hands, violent wanking, etc.). However, Beckett and Bowie render their impending deaths, as encountered in their late texts and songs, in a manner that is non-material, ethereal, and essentially aestheticized. There is none of the emphasis on a painfully sensory embodiment that characterizes much of their other work. The artistic execution of these late pieces finally suspends physical decay, choosing instead, quite deliberately, a mode of aesthetic becoming. All of which speaks to the final part of Auerbach's argument wherein literary death is ultimately a symbolic experience for its readers. As Gilman notes: "death in fiction, even Little Nell's, is never final, because—and this is the truth that binds us all—the reader always lives, is always renewed" (159). In simple terms, fictional death creates, for its readers, the space for them to imagine themselves anew. At the same time, Beckett and Bowie's art, first of alienation and then of finitude, constitutes a kind of portent. Their estranged poetics, conceived and executed over many decades, strive for an affirmative motif of formal suspension that hints at *becoming* as an emergent possibility. At the same time, years of exploring alienation has consolidated a pessimism in their work such that long-term and perpetual renewal seems impossible. The great moments in their art suspend alienation momentarily, connecting with an audience that feels the same. Crucially, however, their career investment in alienation has also led to a focus on death, be it of the individual or in the form of extinction as a global threat. And it is attention to this collective threat that might well represent the possibility of humanity's salvation; a moment in which from "the ruins of representation … the anticipatory trace of a republic emerges" (Lloyd, *Beckett's Thing* 68) that might serve the public and save it from disaster.

The emphasis that Beckett and Bowie place on death in their late work is designed, quite specifically, to underline the inevitability of finitude and to accentuate the need for people to recognize its potential collective manifestation. The first step towards such a fatalist communal consciousness is to recognize the inevitability of individual mortality. For in our twenty-first-century reality, actual death is not so much to be honored or conceived of in artistic and/or philosophical terms, so much as to be denied altogether. Currently, for the comfortable, everything is something to enjoy as an "experience," but safely, such that any mortal connotations are removed. Žižek observes:

> the defining feature of 'post-modern' capitalism is the direct commodification of our experience itself: what we are buying on the market are less and less products (material objects) that we want to own, and more and more 'life experiences' – experiences of sex, eating, communicating … we become the consumers of our own lives. … I buy my bodily fitness by visiting fitness clubs; I buy my spiritual enlightenment by enrolling in courses on transcendental meditation; I buy the satisfactory experience of myself as ecologically aware by purchasing only organic fruit etc. Although these activities may have beneficial effects, their main importance is clearly ideological.
>
> (*Courage of Hopelessness* 21)

So our coffee is decaffeinated, and taken with sugar-free sweeteners. Our beer in the evening is non-alcoholic, and so on. All of these simulations of earthy pleasures are designed to postpone death, which is devoutly not to be wished. And more specifically, not to be talked about. Which leads directly to an urgent philosophical question: what is the value of addressing death in a culture that denies it, and even lives in fear of it? And what does this reticence in relation to mortality have to do with death's relation to economic performativity? Certainly, in pandemic times an unwillingness to countenance death seems naïve at best, and at worst, arguably, the unconscious expression of a death wish.

In attempting to answer such questions it is worth drawing attention to 2016 as the year of "art death" insofar as Bowie, Prince, Leonard Cohen, and others all died. What marked out Bowie and Cohen, as Johnny Cash before them, was a willingness to engage with the idea of dying and make art of it. Cash did this splendidly in the video for the NIN song and his own swansong "Hurt," while Cohen, too, on "So You Want It Darker" (2016) imagines a final conversation this side of the winding sheet between him and a notional creator. In a society entirely denying death—in which people "pass" rather than "die"—Beckett and Bowie's attention to death can be considered distasteful, unnecessary, and inappropriate. Indeed, in the current biopolitical environment they might even be accused of mobilizing potential suicidal behavior through exposure to death ideation. Likewise, too much reflecting on one's own mortality might interfere with early morning alarm calls and the imperatives of gainful employment. Alternatively, Bowie and Beckett offer considered, artistic meditation on individual death, namely their own. Their artistic gesture is made this side of the void to mediate the overwhelming reality of the void. As late capitalism gives shape and volition to what will most likely be an emergent viral epoch, their creative death-dealing is a vital artistic statement of the need for immediate and radical political intervention in what is surely a belated attempt to remedy a broken situation. For these very reasons the *art* of death practiced by Beckett and Bowie is a positive intervention in our contemporary death denying ontologies because it attempts to negate the false consciousness that denies death; restating therein a negative ontology *par excellence*. In proper Hegelian fashion, Beckett and Bowie instantiate the tripartite negation of death. In the first instance, they reveal the preexisting negative that is the collective and cultural false consciousness of a society denying death. Such is the illusory thesis to be transformed. This negative element is negated by presenting the antithesis that is the reality of death, their own, which, by embracing passage into the quantum universe beyond notions of eternal and religious afterlife, ushers in the synthesis of a transformed and transformative posthumanism.

In advancing her case for a posthuman affirmative politics, Rosi Braidotti rejects the type of oppositional consciousness pursuant on Marxism, preferring instead the notion of vitalism as a positive alternative to what she perceives as the negative ontology of oppositionality: "vital materialism defies the oppositional character of dialectical thought and posits a pacifist ontology of mutual specification as the motor process of individuation" (36). And of course the great "pacifist

ontology" in the modern arts is that of The Beatles and their claim that "All you need is love" (Lennon and McCartney). Likewise, Alex Sharpe mobilizes Alain Badiou's reading of love in order to frame Bowie as a lover. Interestingly, Badiou also reads the self and other in Beckett as the two that escape the solecism of the sovereign subject, such that throughout Beckett's work "the Two of love [are] the passage (passe) from the One of solipsism to the infinite multiplicity of the world" (*Badiou on Beckett* 31). Similarly, echoing Badiou's truth procedures that involve, respectively, love, politics, science, and art, Sharpe presents four essays that address difference, authenticity, the ethics of art, and the role of love, which she finally synthesizes in the idea of Bowie as an emissary of love. In this activity, Bowie is involved in a demystification—one significantly different to that of Marx, leading not to violent revolution but to a revolutionary love:

> Bowie enlarges our worlds. While our understanding of our world, our place in it, our life possibilities are inextricably tied up with ideology, its internalization, its affective concretization through/in us, Bowie breaks the spell … An ethics of love is implicit in such activity as demystification lays the ground for human flourishing, it enables freedom to take shape.
>
> (Sharpe 75–6)

Equally, in *The Alienated Subject*, James Tyner transforms Marx's first principle, revolution, into a metaphysical iteration in which the first ethical imperative is to the idea of care from whence will emerge an even more radical ethics of love: "an ethics of care centred on productive love provides a way forward, a path towards the emancipatory aspirations of a society that enables all to live meaningful, flourishing lives" (161). Such elements "provide the scaffolding for a radical ethics of love that transcends the market-oriented relations of capitalism and offers a path towards emancipation" (178). These notions of an unconditional love as affirmative, and transformative, find their apotheosis in Braidotti who believes that "affirmative ethics resist the habit of inscribing antagonistic relations in a logic of dialectical negativity" (53). All you need is to say "yes," like Molly Bloom, to the idea that love conquers all. Simon Critchley is closer to the reality when he argues that "within Bowie's negativity, beneath his apparent naysaying and gloom, one can hear a clear Yes, an absolute and unconditional affirmation of life in all of its chaotic complexity" (*On Bowie* 107). In this, Critchley identifies Bowie's urge towards the negative but he still proposes that "within" the work, and, presumably, the man, "affirmation" is present as something "unconditional." However, these appeals to love, as an unconditional affirmative, are a monist denial of Marxist dialectics which propose instead that the affirmative can only be realized in the abolition of capital production and the emancipation of the alienated and exploited subject. Embracing the notion of radical love, and its implicit imperative towards self-care, constitutes no threat to the capital habitus. Indeed, it is just such uncomplicated iterations of universal love that allows for universal market penetration. If love made The Beatles bigger than God it was a version of the amorous from which notions of crucifixion were subtracted. Which is why both Beckett and

Bowie take us in their art to the site of their own death. They seek to engage with this negation, this radical negative ontology of human finitude, and negate it aesthetically as the only statement they can make about humanity's failure to properly love itself and its planet.

This is why so many alienated subjectivities identify so strongly with Beckett and Bowie's art of alienation, and, having worked through the ideological proposition of love as the path to universal equality and endless regenerative vitalism, they recognize this position as the model of false consciousness and the ultimate negation of the reality of contemporary lived experience. Instead, they understand that our paths are locked into a necessary finitude—be it individual death or the death of the human race. Regardless, world's end as the result of a series of endlessly unresolved antagonisms generated and sustained by the zero-sum game of contemporary transnational exploitative capitalism. Those who are alienated in one or all of the four ways outlined by Marx find a mirror in the alien art of Beckett and Bowie and in their treatment of language and music, theater and technology, as activities integral to opening up an authentic perception of being. The artists in question help an audience work through their symptoms of alienation, be they depression, anger, dislocation, or despair, towards ideological emancipation *in the recognition of disaster*. Their audience also knows that in classic Marxist fashion the only viable, engaged response is revolution, but rather than capitulate to pro-active violence, an absurd and destructive strategy, and rather than cling to the notion of an affirmative and regenerative love that simply reiterates and reinforces the structural problem of capitalism, they seek solace in Beckett and Bowie's gesture of defiance and its foreshadowing of the end of society in its current form.

Beckett and Bowie, for their part, inhabit and celebrate this negative ontology as a space of failure, but their work also, always, points towards a becoming, even if it be an emergent antagonism from which the form of their work wrestles no more than "an underlying affirmation." Moreover, they are not finally promoting love as an affirmative ethic of human incorporation, but rather rejecting it for something much more problematic, the gesture of a recycled aesthetic that produces moments of intersubjective empathy, but which cannot, ultimately, forestall catastrophe. Finally, neither Beckett nor Bowie's work is an "unconditional affirmation of life in all of its chaotic complexity" (Critchley, *On Bowie* 107) but rather "poetry," in the words of Beckett, "which has been through the void and makes a new start in a new room-space" (Knowlson, *Damned to Fame* 569) at the end of the universe.

Braidotti, on the other hand, would most likely reject both Bowie and Beckett's aesthetic engagement with death. She recognizes:

> death is central to political theory and practice, as exemplified by the new forms of surveillance, confinement and killing that are at work within a fast-expanding technological context. Death is also, on the other hand, understated and underexamined as a term in critical theory; as a concept it tends to be stuck in a metaphysical block, while the repertoire of new ideas and political insights around Life and biopower proliferates.

(50)

In response to this teleological "block" she wishes to further "proliferate" a vitalist biopolitics that celebrates life as opposed to death, seeing necropolitics as the inevitable outcome of "political life qualified by death, as opposed to a political and legal philosophy which valorises our mortal condition and creates a politics of survival" (50). Rejecting, therefore, a taste for the negative in all of its forms, she states her positivist position clearly and confidently:

> My ethical stance is that there is no logical necessity to link political subjectivity to oppositional consciousness … political activism can be all the more effective if it disengages … from negativity and connects … instead to creative affirmation and the actualization of virtual potentials. Because these are by definition not contained in the present conditions, and cannot emerge from them, they have to be brought about or generated creatively by a qualitative leap of the collective praxis and of our ethical imagination.
>
> <div align="right">(53)</div>

Such a collective leap cannot be achieved through a preoccupation with death because the latter negates "the power of life itself," persuading her that, ultimately, "negative passions are black holes" (52). But what if Bowie, and to some degree Beckett too, primed the audience for one final spatio-temporal play, a creative leap of such magnitude that it is quantum rather than qualitative? What if their interest in a paradoxical art of finitude *and* renewal moves finally beyond the concerns of the human and its positive or negative contexts, such as life, death, and taxes, to engage with the posthuman as the final act of their art of alienation? And what if they arrive at this intervention precisely as a result of their attempts to harness negative ontologies and positively transform them as the very expression of their being, a being in which oppositional, alienated consciousness was born in response to capital living? In this creative moment the affirmation they seek through form is a negation of capital nihilism and necropolitics, but not a negation of death; rather they *engage* death in order to transform its terms. As suggested in the prologue, this idea constitutes a reach.

In attempting one last philosophical intervention, and in order to avoid an absurd wrangle over the relative merits of leaping and reaching, I invoke Nietzsche's observation that the truth is a "mobile army of metaphors, metonyms and anthropomorphisms" (42) and propose, by way of conclusion and in the words of the Starman, that we indulge in some "crazy cosmic jive."

X

Beyond and Becoming: The Men Who Fled from Earth

In 1996, "the Sokal Hoax" was the equivalent of an intellectual sting operation in which a New York University physics professor wrote a pseudo-deconstructive reading of science entitled "Transgressing the Boundaries: Towards a Transformative Hermeneutics of Quantum Gravity." It was published in the journal *Social Text*, one of the leading postmodern records of the moment. In the essay, he proposes that gravity is a social construct, and this hypothesis, rather than being presented as a mathematical formula, appears as a parody of the type of critical discourse, or critical language, postmodernism employed. Certain aspects are written in a jargon that one would have expected the editors to see straight through. Certainly, one would have also assumed that the external science reviewer the journal employed to peer review Sokal's essay would have called out the essay's cod physics immediately, had they sent it to a qualified scientist for critical review. Needless to say, the Sokal Hoax helped sound the death knell of postmodernism as a viable critical and/or philosophical position.[1]

The result is that since the Sokal Hoax it seems literature and quantum physics are uneasy bedfellows. Certainly, time spent in the literary archive studying manuscripts and looking backwards is not a conception of time likely to be contested by indignant scientists.

At the same time, this study has suggested that Beckett and Bowie generate aesthetic suspensions that challenge chrononormativity even as they create a space for intersubjective catharsis. It has been a contention that these spatio-temporal aesthetics are a type of radical political event precisely because they offer a different conception of time; one that is more amenable to immediate, transformative change. The history of philosophy outlined in this study has also been preoccupied with change, with the difference between being and becoming and with the spatio-temporal coordinates of such potential transformations. Lyotard's language games, for example, central to postmodernism, propose that a new move in the language games that determine a society could change that society as the new moves produce, by definition, suspensions of the extant rules of the game. Terry Eagleton satirizes Lyotard's language games as

> the guerrilla skirmishes of a 'parologism' which might from time to time induce ruptures, instabilities, paradoxes and microcatastrophic discontinuities into the terroristic techno-scientific system.
>
> ("Capitalism, Modernism" 134)

He also mocks the idea that language games "escape and confound history with the explosive force of the Now," instead framing Lyotard's

> paralogic as some barely possible, mind-boggling leap into free air which gives the slip to the nightmare of temporality and global narrative from which some of us are trying to awaken.
>
> (134)

Eagleton's acerbic and imaginative wit (wrapped around a kernel of Joycean allusion) is, nevertheless, a supercilious dismissal of Lyotard's philosophical intervention which is more properly a reevaluation of notional time, and an attempt to shift the perception of it, rather than alter the very modality of temporality itself. This study has proposed that both Beckett and Bowie generate aesthetic suspensions that approximate something of an alternative time with an emphasis on the now as a profoundly inhabited moment of temporality. This idea has currency in the work of many philosophers. For example, in Bakhtin's concept of the "chronotope"

> everything must be perceived as being within a single time, that is, in the synchrony of a single moment; one must see this entire world as simultaneous.
>
> (*The Dialogic Imagination* 157)

This notion of a temporal simultaneity is also invoked in the Jewish notion of "Messianic time." In "Theses on the Philosophy of History," Walter Benjamin suggests that revolutionary critics must reinvent the conventional perception of objective temporality in a manner similar to religious visions of the immediacy of time. He writes:

> A historical materialist cannot do without the notion of a present which is not a transition, but in which time stands still and has come to a stop. For this notion defines the present in which he himself is writing history ... The historical materialist leaves it to others to be drained by the whore called 'Once upon a time' ... He remains in control of his powers, man enough to blast open the continuum of history.
>
> ("Theses on the Philosophy of History")

Torn between historicism (the past as imagined) and historical materialism (the past as refigured by the present and vice versa), Benjamin proposes the creative historian can understand the past more accurately by being willing to suspend the mechanism of historicization, including its encroachment into the present moment. This creates a space to see and tell the secret histories that official history has suppressed. To do this, one has to be able to stop history and start again, but this approach comes with clear dangers. The historian is denying extant history, obviating present concerns structured around established history, and encouraging retroactive readings that take account of prolapsing temporalities. This rejection of current history rejects the status quo of the

present moment and the various injustices it ratifies, but, crucially, it also unmoors the present's epistemological constraints. Benjamin surmises:

> A historian who takes this as his point of departure stops telling the sequence of events like the beads of a rosary. Instead, he grasps the constellation which his own era has formed with a definite earlier one. Thus he establishes a conception of the present as the 'time of the now' which is shot through with chips of Messianic time.
>
> ("Theses on the Philosophy of History")

Benjamin understands messianic time as both religious and revolutionary. For Marx, on the other hand, all time is moving inexorably toward revolution if revolution is not actually taking place. In other words, the revolution will happen *in time*. Alternatively, here Benjamin proposes a different temporal paradigm in which all time is simultaneously present as Messianic time—the past, present, and future are imbricated in each other—but the present is a profound, transcendent moment of NOW, a revolution in the present.

More recently, Alain Badiou has proposed a philosophical intervention which he orients around the transformative nature of what he calls "the event" (and in this regard it is interesting to consider that the emergence of a black hole in space is known as an "event horizon"). Moreover, he has attempted to bridge the language gap between philosophy and the matheme by translating his philosophical precepts into set theory. Incorporating this algorithmic approach represents Badiou's gesture towards the role of science—as one of four truth procedures—in precipitating the event, which can be at once personal and/or collective. In an engaging dialogue with Žižek, Badiou asks

> What will philosophy tell us then? It will tell us that 'we must think the event'. We must think the exception. We must know what we have to say about what is not ordinary. We must think the transformation of life … And to do this against the continuity of life, against social conservatism.
>
> (*Philosophy in the Present* 11–12)

Badiou's event arises in response to truth and he believes Beckett's genius "tends towards such truth" (*Badiou on Beckett*, 41). There are sufficient quasi-mystical undertones to Badiou's event for Žižek to observe that religion is its "unavowed paradigm" (*The Ticklish Subject* 183) but, like Benjamin and Lyotard before him, Badiou's is a philosophical intervention that brings a critical intensity to the epistemology of the now. For Lyotard we must look out for an occurrence in the now that might disrupt social conservatism. For Badiou, the ethical act, carried out in an art oriented towards love of truth, a truth that can be ratified deductively, precipitates the event of political transformation, individual and/or collective. And this event arrives with the full force of the present moment. Therefore, now and by way of conclusion, this study would like to ask how art, like philosophy, might facilitate an immediate simultaneous

transformation of our ruined humanity in order to get *beyond* its current, rather narrow and self-interested concerns?

In defining posthuman affirmative politics, Braidotti proposes that the posthuman constitutes a departure from "a political and legal philosophy which valorizes our mortal condition and creates a politics of survival" (50). Accentuating Braidotti's faith in the affirmative, in *Philosophy in the Present*, Alain Badiou conceives of the inhuman (a synonym for the posthuman) in the following terms:

> we should understand 'inhuman' as something other than a negation ... 'Inhuman' must be understood as the affirmative conceptual element from within which one thinks the displacement of the human. And this *displacement of the human* always presupposes that one has accepted that the initial correlation is the link between the human and the inhuman, and not the perpetuation of the human as such.
>
> (Badiou and Žižek 82)

Badiou suggests that proponents of the inhuman must respect the semantic context that the word and idea of the "human" produces, and the traditions and experiences associated with it. At the same time, however, the inhuman to fulfill its destiny must be a transformation of the human. It both carries and transforms the human into the inhuman; it echoes and becomes.

In a fascinating discussion between William Burroughs and Bowie that took place in 1974, the former asks the latter to elaborate on the meaning behind the Ziggy mythology and the *fin de siècle* feel of the 1972 album:

> **Burroughs**: Where did this Ziggy idea come from, and this five-year idea? Of course, exhaustion of natural resources will not develop the end of the world. It will result in the collapse of civilization. And it will cut down the population by about three-quarters.
> **Bowie**: Exactly. This does not cause the end of the world for Ziggy. The end comes when the infinites arrive. They really are a black hole, but I've made them people because it would be very hard to explain a black hole onstage.
> (Burroughs, "Beat Godfather meets Glitter Mainman")

Bowie calls these star men "the infinites" and they are "black-hole jumpers." Apparently, "when the infinites arrive, they take bits of Ziggy to make themselves real because in their original state they are anti-matter and cannot exist in our world" ("Beat Godfather"). Interesting, then, that in "Blackstar" and the video that accompanies it, Bowie employs imagery that signals the death of Major Tom and a movement towards his quantum becoming as a black star. Utilizing again the *memento mori* of his late works, a jewel-encrusted skull from beneath the visor of an astronaut's helmet, Bowie as Major Tom completes a circle that has seen him play a spaceman, a junkie and finally, "by a commodious vicus" (Joyce, *Finnegans Wake* 1) yet again a spaceman,

until, in this final manifestation of being, he becomes a black star. The lyrics certainly position Bowie in the celestial realm:

> I'm a blackstar I'm way up, on money, I've got game
> I see right, so wide, so open-hearted pain
>
> ("Blackstar")

Whereas in "Ashes to Ashes" Major Tom was "strung out in heaven's high hitting an all-time low," in "Blackstar," in death, he's got game "way up," which of course is redolent of the line from "Lazarus" "Look up here I'm in Heaven." The design and iconography of the *Blackstar* album (★) clearly represents the characteristics of a black star in its sleeve art and accompanying booklet. Kardos summarizes the artwork admirably:

> The imagery that Jonathan Barnbrook devised for the ★ album package is suggestive of space travel, tapping into Bowie's already established stellar mythologies—the deep field Hubble photograph gazing out into a star field, the atomic star-sustaining proton-proton chain, the Pioneer plaques (designed by Carl Sagan and launched on spacecraft leaving the solar system in 1972) and the track names and sections of lyrics stylized as constellation maps. A black hole/gravitational singularity is [also] referenced in an image of interlacing geometric lines that bend in the centre, suggesting an unseen mass that alters space time, the heavy non-presence also suggested by the vinyl edition's star-shaped cutout on the front.
>
> (185)

According to the European Southern Observatory (ESO), the movement pattern that appears in the center of the ★ booklet (on the page dedicated to "Sue, or in a season of crime") traces the movement of a star that is influenced, gravitationally, by the presence of an event horizon, or black hole. In 2015 and again in 2020, ESO, an affiliate of NASA (America's National Aeronautics and Space Administration), released photographs indicating the movement of a star (known as S2) in close proximity to a black hole (known as Sagittarius A*). The photographs accentuate the shape of the star's dance with ultraviolet contours, a dance replicated on ★ in an embossed black font. The ESO believes that the Rosetta shape the star replicates confirms the legitimacy of Einstein's theory of relativity regarding the degree to which the presence of a black hole bends space (and therefore time).[2] Doubtlessly, the discovery of the star, and release of the 2015 photograph, contributed to the song "Dancing out in Space" from 2016's *The Next Day*, and it is particularly fitting that S2's dance reappears again in the artwork of ★.

Two successive headlines on the *Guardian* will serve to better contextualize Bowie's black star dalliance both before and after his death. On January 11 2016 the *Guardian* headlined "David Bowie dies of cancer at 69" (Davies and Helmore, "He Gave us Magic for a Lifetime"). "Black Star" is a slang term employed by medical professionals to describe the lesions that often accompany cancer, particularly breast cancer, so it is amusing to think that Bowie continued to queer gender even in death (at the superbly

symbolic age of 69). In this way, his black star symbolism is nonetheless redolent of very physical and material referents. The day after Bowie died, and without referencing him, the *Guardian* reported that "Scientists struggle to stay grounded after possible gravitational wave signals" (Sample, 12/1/2016). It remains an extraordinary coincidence that within hours of the Starman's exit, LIGO (Laser Interferometer Gravitational-Wave Observatory) detected gravitational activity. Most intriguingly, gravitational waves are produced when two dead stars collide, producing a black hole. Arguably (and no doubt with his tongue in his cheek), Bowie manifested as a Black Star "way up"; this object, which he signaled he was to become in the song of the same name, has collided with another black star in the universe, producing a black hole, and the possibility of the type of quantum spatio-temporal gymnastics that might allow for Bowie always having known—like the infinites he spoke of—that he was and would again become a time traveler. All of which of course is perfectly in keeping with the alien and outer space mythology that made him famous. From the narrator of the song "Star" on *The Rise and Fall of Ziggy Stardust and the Spiders from Mars*, who can "make a wild mutation as a rock and roll star," to "Blackstar" whose "spirit rose" "on the day he died", the symbol is ubiquitous in the Bowie oeuvre and always associated with change and transformation. Given that it takes the collision of two black stars to make a black hole, the question is quite straightforward: "If David Bowie's art is that of a singular black star, who or what might be framed as the other dying star required for a quantum collision?"[3]

From early in his writing career, it is evident that Samuel Beckett was a keen atomist. In his "Philosophy Notes" he records that for Democritus "consciousness of self implies a certain minimal activity of fire atoms" (qtd. in Cordingley 60). Chris Ackerley suggests that the delight Beckett takes in Democritus of Abdera "anticipated the radical paradigm shifts of twentieth century physics" ("Beckett and the Physical Continuum" 113) which were driven in large part by Einstein's Special Theory of Relativity. Likewise, Beckett's readings in Aristotle, and specifically Aristotle's *Physics*, doubtlessly had him ponder on the Greek's observation that "time seems most of all to be some sort of motion and some sort of change" (*Physics* IV.218b.5).

Certainly, Beckett's interest in space and motion, in how to imagine space and distance artistically, and in the possibilities of other spaces and parallel times, are key themes in his work. From the abstract manner of measuring a body's movement in a literary space (such as the dimensions of the figurative rotunda in "Imagination Dead Imagine") to the incommensurable spaces the universe proposes, and which remain beyond our ability to imagine, alternative measurements of space and time are ever present in Beckett's oeuvre. His final literary work—the poem "what is the word"—has a central refrain "afaint afar away over there" which attempts to articulate potentially infinite spatial distance by suggesting the speaking subject can move, imaginatively, towards infinity. Which is not to say Beckett had a working knowledge of the inner mechanics of quantum physics. Rather he approached, creatively, how movement in space and time was possible both at a macro and molecular level. For example, in *Watt* (1953), the picture in Erskine's room, of a circle and point that give the impression of moving one towards the other, strikes Watt as being a representation

of "boundless space, in endless time" to which the narrator adds "Watt knew nothing about physics" (272–3). In other words, the narrator intimates how, from the symbolic cadaster of an art canvas, a representation of the spatio-temporal universe might be constructed. These proxemics, moving from the painted canvas to the concrete world to the undiscovered universe beyond, are an act of imagination rather than of scientific exactitude.

Now, regarding an impulse in the opposite direction, and as a gesture towards deconstructing our understanding of the material world as mass, and so measurable (which is central to evidence-based representations of materiality), in 1934 Beckett praised Cézanne's work as an "unapproachably alien arrangement of atoms" (*CLSBI* 233). In his own work this preoccupation with the constituent elements of experience as something molecular, diffuse, and malleable is ever present. As Chris Ackerley perceptively notes, "the challenge was to incorporate into his writing, without becoming inchoate, something of this force" (114) of material deconstruction and diffusion. Certainly, Beckett succeeds in this aim in *Murphy* which is guided to its conclusion by "the guffaw of the Abderite" (154) whose ideas help shape the novel's atomistic denouement wherein we find the "body, mind and soul" of Murphy dispersed over the floor of a London pub (171). Likewise, Molloy feels, as identity fades, the "namelessness (nameless things, thingless names) of waves and particles" (*Molloy* 27). The reference to waves and particles is telling; throughout his career Beckett sets up his writing somewhere between the atom and the universe, between the molecular and the molar, intent often on charting the passage between both, representing a becoming that recognizes the transformation of being as one entity transmutes into the other.

This position is perfectly captured in one of the *Fizzles*, "For to end yet again," which foreshadows "Worstward Ho" with the ineluctable presence of that last outpost of thought, seat of all, the skull:

For to end yet again skull alone in a dark place pent bowed on a board to begin …
For to end yet again skull alone in the dark the void no neck no face just the box last place of all in the dark the void.

(*CSP* 243)

In this void, redolent of outer space, the narrator perceives a strange phenomenon:

There again in the end way amidst the verges a light in the grey two white dwarfs.

(244)

At first it appears they are actual figures:

Long at first mere whiteness from afar they toil step by step through the grey dust … Slowly it sweeps the dust so bowed the backs and long the arms compared with the legs and deep sunk the feet.

(244)

But even as he describes them they appear to transform:

> Dwarfs distant whiteness sprung from nowhere motionless afar in the grey air where dust alone possible.
>
> (245)

Now it appears the narrator describes a different type of being, a type of star known as a "white dwarf," and, in concluding, that he describes how the world looks from deep space:

> for in the end for to end yet again by degrees or as though switched on dark falls there again that certain dark that alone certain ashes can. Through it who knows yet another end beneath a cloudless sky same dark it earth and sky of a last end if ever there had to be another absolutely had to be.
>
> (246)

By the end of "For to end yet again" a white dwarf is both a diminutive creature struggling in the desert and the galactic white dwarf of nuclear capacity. Beckett's work allows for *both/and*. His prose transforms the white dwarf from human being to celestial being and back again *at the same time*, in the same words. In so doing he opens up conventional diachronic space and the conventional time relations which ordinarily must narrate a transformation from one thing into the other, one after the other. And in the narrative form too, the voice speaks from the desert and outer space, simultaneously, free from the tyranny of singularity. Here Beckett imitates the dialectical relationship central to quantum mechanics: the ongoing debate and scientific examination of light as wave and/or particle and the shifting nature of the relationship therein. The complexity of physics' conflictual theory of matter so far points to a certain epistemological and ontological incompleteness, the sense in which the project of our understanding of ourselves and the universe remains partial, inadequate, and possibly flawed. The work of Beckett and Bowie cited in this chapter draws attention to this incompleteness in the manner in which it invokes the paradoxes generated by Heisenberg's uncertainty principle, Bohr's notion of complementarity, and the manner in which the non-linearity of Eisenstein's general theory of relativity affects the curvature of space time. Such ideas now illuminate our understanding of the fourth dimensional possibilities of a black hole, something Bowie seemed to have unprecedented knowledge of in 1974. Moreover, Beckett and Bowie's expression of posthuman life in deep space as something akin to the matter of the galaxy exists at some remove from more conventional religious ideas of eternal life, in the process scuppering the relevance of the biopolitical codes implicitly validated by people's anxious desire to succeed to a vision of religious paradise. Alternatively, Beckett and Bowie's deep space poetics point to the necessity of establishing a sustainable life, for all, on earth, as a temporary halting site before the reality of cold infinity.

Such creative experiments illustrate how representational norms have never inhibited Beckett or Bowie from crossing imaginative thresholds. An aspect of pop

culture addressed in this study, the struggle between resistance to and incorporation within capital, led to the rather dispiriting observation that capital can always incorporate pop culture into its program because it never really disturbs the epistemological and therefore the economic base of society. Beckett and Bowie's work is different, however, as it succeeds in disturbing the very idea of the human. And even though our universe remains too young for a white dwarf to have yet *become* a black star, such temporal distension is no barrier for the Beckettian imagination, a place where space and time arguably mirror complex scientific thinking on the subject. Returning again to the narrative voice of "Worstward Ho," we find it, towards its conclusion, conjuring the presence of a black hole. Kardos notes:

> there is a subtle difference between black holes and black stars. A black hole is a star that has collapsed under its own weight to the point that not even light can escape the force of its own gravity. A black star refers to a gravitational object that's very similar to a black hole, but still contains matter ... and there are mysteries within it—theoretically—such as quantum energy, quarks and particles; creative potentials.
>
> (140)

With this distinction in mind, Beckett's narrator asks

> What were skull to go? As good as go. Into what then black hole?
>
> ("Worstward Ho" 484)

The narrator ponders if a black hole is the necessary outcome of an expired consciousness. But the voice is also aware that one could not know about the dissolution of consciousness without consciousness. "Worstward Ho" stages this paradox—that it is impossible to imagine a black hole and its activity without being consumed by one:

> Black Hole agape on all. Inletting all. Outletting all.
>
> (484)

"Worstward Ho" attempts to state the paradox of a black star approaching a black hole in deep space, beyond time and thought, in a space beyond the skull—becoming quantum in an act of dark imagination—beyond ideal love itself. The skull, the last threshold to unself, both outlets and inlets, remaining human while transforming beyond the human into the dark matter of the inexplicable. Persisting creatively at the very periphery of the human, in deep space imagining a dark star transformation, Beckett issues in the terms of becoming posthuman. Together with Bowie he has figured himself as another Black Star in the as yet uncharted quantum universe where both "conduct" meaning as a matter of human redefinition; a redefinition rendered necessary by the inevitable ruination of the human as we know it. In just such ways, Samuel Beckett and David Bowie coalesce, to quote Gilles Deleuze, in "not becoming-man" but, instead,

prompting a "revolutionary-becoming of people" [devenir-révolutionnaire des gens] (*Dialogue* 147) who understand, as Carl Sagan did, that we were all once stars.

To quote Beckett on transformed thinking, from out of "a time-honoured conception of humanity in ruins" both artists provide "an inkling of the terms in which our condition it to be thought again" ("The Capital of the Ruins" 28) because once gravitational waves have been discovered

> The questions multiply. Why is the visible universe made of matter, and not antimatter? And why is 96% of the universe invisible and undetectable, existing as dark matter, and even more mysterious dark energy? Why does it seem to be stable? Is this all there is, or are we one of a zillion universes? Why does it exist at all? This ultimate confirmation of Einstein's theory would be the end of one set of questions, but it would open up a whole new set of puzzles.
>
> (Radford, "Gravitational Waves")

Loving both of the aliens, the "ausländers," helps contextualize the emerging discourse of the posthuman where art and philosophy meet science on the terms in which our being might be reimagined, especially in moments of intersubjective simultaneity. Such moments forge intimate and communal identities between self and other that reframe our current embodied and intellectual understanding. Further, the imaginative paradox both artists present might also help science to see itself more clearly. "Back in the day," in *The Postmodern Condition*, Lyotard recognized that scientific knowledge would soon translate into the primary post-national power paradigm. He understood that the Enlightenment and the Industrial Revolution complemented each other, the latter providing the former with the material terms of its ideological project. The result: in the age of the modern laboratory, knowledge became a commodity and certain types of truth became the preserve of the wealthy. Lyotard characterizes the terms of modern science as

> No money, no proof—and that means no verification of statements and no truth. The games of scientific language become the games of the rich, in which whoever is wealthiest has the best chance of being right. An equation between wealth, efficiency and truth is thus established.
>
> (*The Postmodern Condition* 45)

In 2024, it is reasonable to argue that the privileging of scientific knowledge must now be challenged. Over fifty years of its increasing privatized wealth confirms the truth of our failed and further failing hopes of global equality. Furthermore, as neoliberalism becomes all pervasive, the role of the arts in challenging its precepts is diminished by an education system increasingly committed to economically competitive STEM subjects. And outside of the academy, the continued rise of commodity fetishism has replaced the arts as the basis for identity individuation, and, in particular, has diminished them as the locus for identifying and giving voice

to alienation. Increasingly, as the brand becomes the site of identity, a countercultural arts of resistance becomes less potent. Beckett and Bowie, however, give the lie to the false consciousness of progress, the first step towards the negation of our nihilism. In such circumstances perhaps the task now is to recognize that just as Beckett's work illuminates that of Bowie, and vice versa, so using art to measure science's objectives extends our knowledge in new directions and prompts an ever new *becoming* for philosophical thought in the twenty-first century. Such is the dialectic understanding that might yet avert the course of our impending catastrophe. So spake these angels of history.

Acknowledgments

I would like to thank Leah Babb-Rosenfeld, Rachel Moore, Anne Hunt, Benedict O' Hagan, Elizabeth Nichols and the staff at Bloomsbury for helping this book come to fruition, the Bloomsbury reviewers for taking the time and trouble to make it better, and Weill-Cornell for providing Education Leave opportunities that make a book-length study possible.

I'd like to thank all the Beckett scholars I've spent time with, and learned from, throughout the years; be it those affiliated with august institutions such as the Beckett International Foundation or those who populate Dublin's more interesting bars. Special shout out to the Irish Beckett crew, and Scott Hamilton (honorary member). Thanks, too, to the musicians who have influenced this book; those I've played with, or accompanied to gigs, or those with whom I've waxed too lyrical about rock 'n' roll into the small hours of many a morning.

I'd like to thank Jim Fleming and Garrett Phelan for companionship and creative advice on the rocky road; Linda Sharkey for her regenerative enthusiasm for sounds, and for keeping the home fires burning; and Suzi Mirghani for countless reasons, but for two in particular: for giving me your hand, and for being wonderful.

Notes

I

1 See https://carnegieendowment.org/publications/interactive/protest-tracker
2 As there are different Becketts and Bowies, there are also different Caves. Pattie is shrewd in observing that Cave generally seeks but does not achieve transcendence, but there are some glorious exceptions such as "Straight to You," "Into My Arms," and "Jubilee Street" to name but three. Different contexts, different Caves.

II

1 Here are links to some of Bowie's theatrical performances available on YouTube.
 www.youtube.com/watch?v=cPithDmHrd0.
 www.youtube.com/watch?v=fRxUNKBFm90.
2 It remains a matter of some debate as to whether postmodernism emerged as a deliberate theoretical strategy of the left, or, despite such art-socialist posturings, as simply the material expression of capital economics. A combination of Thatcherism and Reaganism, and their emphasis on the privatization and privileging of the free market within the sphere of corporate governance, can equally be posited as a key influence on pomo's heightened emphasis on consumption patterns and the breaking of tradition and boundaries. As Stuart Jeffries puts it "both post-modernism and neoliberalism were couched in terms of liberation—the former from the tyranny of functional style, the latter from the state. And yet, the new neoliberal orthodoxy of minimal state and personal responsibility substituted one tyranny for another—namely the tyranny of the market" (10–11). As suggested in this chapter, postmodernism was compromised in the same way.
3 See Keir Elam's *The Semiotics of Theatre and Drama* (1980), Thomas Trezise's *Beckett: Into the Breach* (1990) and Leslie Hill's *Beckett's Fiction: In Different Words* (1990).
4 Beckett's influence in and on comedy is extraordinary. Paraskeva notes that "the distinctiveness of *Godot* partly lies in its blending of theatrical and music hall techniques with the clowning, physical choreography [and] cross talk [of] Chaplin … Laurel and Hardy and the Marx Bros" (24). In turn, these archetypes, wedded to the surrealism of Vladimir, Estragon, Pozzo, and Lucky, have influenced comedy groups like Monty Python and The Comic Strip Presents, and comedians such as Sean Hughes, Stewart Lee, Bill Bailey, Michael Redmond, Dylan Moran, Steve Coogan, Steve Martin, Robin Williams, Nathan Lane, and John Goodman (the latter quartet having all performed in *Godot* on Broadway at some point).
5 In *Once a Thief*, a detective recounts the pursuit of a series of leads:

 Crohn: I talked to Knott, who talked to Hamm, who talked to Mr. and Mrs. Tough, who talked to Boss Croker. None of them knew, so I tried Estragon.
 (Murphy 82)

To the uninitiated these are all (some quite obscure) Beckett characters and/or places associated with the author's youth—"Boss Croker" being Richard Welstead Croker from Ballyva near Clonakilty who was taken by his parents as a child to New York during the famine and there became a figure associated with the "wild west" politics of Tammany Hall before returning to Dublin in 1905 and buying and living on "Croker's Acres," his eponymous farm which features in Beckett's prose and drama.

6. The text for Beckett's entry in *GQ*'s "The 50 Most Stylish Men of the Past 50 Years" reads:

> A timeless figure, both ancient and modern, traditional and (whether he liked it or not) hip, he favored black (which ignited his blue eyes) and wool or tweed coats that could have come from any number of centuries
>
> (*GQ* 368)

Murphy and Pawliuk note, dryly, "that Beckett's wife, Suzanne, actually chose and bought many of his clothes from flea markets in Paris is an incidental detail" (136). One wonders what *GQ* would make of Beckett's Molloy, dressed in the *Times Literary Supplement* while continuing to wear the remains of his disintegrating cravat around his shirtless neck. Or of the fact that the same character stitches extra pockets into his great coat so he can have a store of stones to suck while he counts his farts.

7. "Life even for margin people like me is increasingly difficult. Only the low rent makes it possible," wrote Beckett in a post-war letter in which he expressed concern that high rents would force Suzanne and him out of Paris (*CLSBII* 65).
8. Relatedly, something of the same erasure characterizes *The Chair*. In various episodes, Jay Duplass as Professor Bill Dobson wears first a Joy Division then a Velvet Underground t-shirt, but neither lead to the extra-diegetic appearance of, say, "Heroin" or "New Dawn Fades," on the series' soundtrack. Instead, the season ends with "Oxford Comma" by Vampire Weekend; a tune that sounds like the Ivy League set to music. Given such compromises, the t-shirts Dobson wears bearing the iconography of The Velvets and Joy Division function as empty signifiers to rival the poster of Joe Strummer on the walls of Peter Parker's bedroom in Andrew Garfield's turn as *The Amazing Spider Man*.™

III

1. All subsequent quotes from Marx are from "Estranged Labour," unless otherwise indicated.
2. There is a clear problem with this proposition when one considers the profits to be made from maximizing the fetish in reified art. Indeed, it is precisely its fetish quality that makes art valuable in capital markets, instanced by paintings selling at auction for hundreds of millions of dollars. At the same time, this fetishization is explicitly revealing of the very abstract and oppressive nature of capitalism rather than art. Baudelaire, like Wilde, would argue that the paintings themselves are quite worthless.
3. We know that Bowie read Wilde, the next chapter addressing this and other of Bowie's literary interests. Elsewhere, he admitted that the opening line of "Rock 'n' Roll Suicide" was pinched from Baudelaire and, arguably, the theme of "The Bewlay Brothers" echoes the concluding line of "Au Lecteur," the poem that opens *Les Fleurs du Mal*: "Hypocrite lecteur,—mon semblable,—mon frère!" [Hypocrite reader—my

twin—my brother!]. Iggy Pop also recounts a story in which Bowie encouraged him to sing a lyric the latter had conceived for the former Stooges front man: "I know what kind of man I am/I'm not Saint Francis of Assisi or Baudelaire's son." Pop demurred. For details of these borrowings see Mike Harvey, https://5years.com/rrs.htm and Chris O'Leary, https://bowiesongs.wordpress.com/2012/01/31/shades.

4 Back in the year 2000, the official Bowie website launched an online quiz that invited Bowie-net members to name the fictional artist that the singer invented together with William Boyd, in 1998, so instigating a hoax on the art world. The first correct response would win a copy of *Nat Tate*, the flagship fictional biography of their notional painter. I responded to the quiz and won the book. When it was delivered to Cyprus, where I was based, I thought including it in a course on postmodernism might be fruitful. I set about incorporating some passages from the book and reproductions of two of his paintings in a section of a course packet that compared forms of modern art. There was no suggestion that Tate's art was a hoax. Then, in the final exam I included a question that announced Tate's work as fake and asked the students to write about how the double hoax to which they had just been subjected illustrated that a postmodern period might actually be taking place. Although many students laughed at the revelation (whether through pleasure at the ruse, or through uncontrollable nervousness), two members of the class downed tools unless they got an extra hour to process this new development. Relatedly, and as if to keep the question of the value of postmodernism afloat, a drawing by "Nat Tate" sold for 7,250 pounds sterling in auction at Sotheby's in 2011.

5 Paul Du Noyer: "So you'd be very happy if I and another journalist had different ideas of what your songs were about?"

David Bowie: "Absolutely. As Roland Barthes said in the mid-sixties, that was the way interpretation would start to flow. It would begin with society and culture itself. The author becomes really a trigger" (Du Noyer, "ChangesFiftyBowie").

IV

1 The original French iteration of this quote—"Je ne suis pas un intellectuel. Je ne suis que sensibilité"—carries more precisely the sense that raw emotion is the opposite of refined sensibility. The French original (an interview with Gabriel d'Aubarède of 16 Feb. 1961) appeared in *Les nouvelles littéraires*, 16/2/61, 7 and is translated in Graver and Federman 217.

2 On the subject of Bowie's meditations on certainty, the song "Law (Earthlings on Fire)" (1997) references a quote attributed to Bertrand Russell—"what men really want is not knowledge, but certainty"—apparently from a radio interview Russell gave to the BBC magazine *The Listener* in 1964. I have not been able to trace the quote from "Law" to this source but found many Russell quotes in a similar vein. For example, in "Philosophy For Laymen" Russell observes that "the demand for certainty is one which is natural to man, but is nevertheless an intellectual vice" (*Unpopular Essays* 38) and in "Reflections on my Eightieth Birthday" he notes:

> I thought that certainty is more likely to be found in mathematics than elsewhere. But I discovered that many mathematical demonstrations, which my teachers expected me to accept, were full of fallacies.
>
> (*Portraits from Memory* 54)

"Law (Earthlings on Fire)" also includes the phrase "what a morning" which were the last words spoken by Samuel Beckett's father. Bowie mistakenly thought these were Beckett's last words (of which more in VIII).

3 For Bowie's 100 Books see Lauren Weiss, New York Public Library. https://www.nypl.org/blog/2016/01/11/david-bowies-top-100-books

4 Rather amusingly, Beckett reread the "Inferno" on a vacation to Tangiers (*CLSBIV* 406, n.1). One shouldn't be surprised by such holiday reading as it seems Caravaggio's *The Beheading of Saint John the Baptist* in Saint John's Co-Cathedral in Malta is Beckett's equivalent of a virtual holiday photo, he having made a point of visiting the painting, committing it to memory, and then describing it in detail to friends thereafter (*CLSBIV* 271, 332).

5 In fact, many references to the American poet and essayist—who underwent a naturalization process into Britishness and into the English literature tradition—pepper Beckett's early correspondence, notably his realization that the name T. S. Eliot is an anagram for "Toilets" (see *CLSBI* 421).

6 Recognizing the delicious resonances, Beckett named a collection of his short French work, *Têtes-mortes* (1967).

7 David Lloyd notes Jack Yeats's use of a "thick impasto" which produces "unstable oscillation between the emergence of the figure and the foregrounding of the medium that dissolves even as it reveals" (*Beckett's Thing* 28). Jack Yeats's work was very dear to Beckett.

8 The title *Sleep Sound* is taken from W. B. Yeats "Lullaby," the opening line of which is "Beloved, may your sleep be sound" (*Collected Poems of W. B. Yeats* 264). This suggests Jack Yeats envisioned the two figures in the painting as a couple in love, which does not discount the idea that they are precursors of Vladimir and Estragon.

9 Although entirely speculative, Heckel's *Junges Mädchen (Mädchenkopf)* (1913) seems to me a candidate to have influenced the cover of Bowie's *Lodger* (1979), thus making the album covers of the Berlin trilogy a Heckel homage triptych.

10 Heckel works owned by Bowie also appeared for sale at "Collector." The rather ordinary *Weisse Pferde* sold for 112,500 pounds, the quite queer *Geschwister* for 15,000 pounds and the alluring *Frau* sold for 11,250 pounds. All three far outstripped the means of this author. Nevertheless, the budgeted amount I set aside to purchase something in the auction secured a Memphis Design Group vase. It may be an awful mélange of blue and orange and pink, but once it was Bowie's vase and now it is mine.

11 On Susan Sontag's production of *Waiting for Godot* in Bosnia in 1993 see her essay "Godot Comes to Sarajevo." On Paul Chan's production in the Gentilly neighborhood of New Orleans in the immediate aftermath of Hurricane Katrina see "A Broken City. A Tree. Evening" by Holland Kotter. On South African discontent with rising rent prices reflected in positive response to staging of *Godot* see David Smyth "South African Township Happy," and on the New Group Online Stream Theatre production of COVID lockdown *Godot* see Michael Coffey's review in *The Beckett Circle*, Spring 2022.

12 Beckett did have the misfortune of having a copy of *The Unforgettable Fire* (1984) foisted upon him by Bono. A state of affairs arguably as troubling as finding oneself in Dante's inferno. See https://www.atu2.com/news/im-a-beckett-fan-says-rocker-bono.html

13 And yet despite these inclusions, Beckett was often irreverent about the work of the great composers. He dismisses some Beethoven—the Quartets for example—as a

waste of time (*CLSBI* 68), and Schumann's Fourth Symphony (D minor, Op. 120) as "less like a symphony than like an overture begun by Lehár, completed by Goering and revised by Johnny Doyle (if not his dog)" (*CLSBI* 182).

14 In this regard, the musical journey involves aural transitions that are the equivalent of mood shifts produced by the semantics of Proust's work which Beckett felt "represent the perilous zones in the life of the individual, dangerous, precarious, painful, mysterious and fertile, when for a moment the boredom of living is replaced by the suffering of being" (*Proust* 19).

VI

1 The meaning of the terms "heteronormative" and "homosocial" are often confused. Heteronormative is used to describe an ostensibly "normal" day-to-day reality that is in fact coded and shaped by heterosexual norms and expectations. Heteronormativity is at best tolerant of homosexuality and, at worst, deeply hostile to it. Against this discreet but powerful mode of heterosexual social organization, homosociality is imagined as a positive alternative, a social coding designed to embrace and celebrate homosexuality.

2 RuPaul was hugely influenced by Bowie's gender-bending and is a fan, in particular, of the mousey-haired girl "hooked to the silver screen." See Christine Estima, "Meeting David Bowie."

3 See Jim Ferris's crip poem "For the Betterment of Humanity" in which he underscores, line by line, how the neo-classical design of the Mary Baker Eddy Library in Boston impedes special needs access and, in so doing, discreetly equates aesthetic appreciation with ableist capacity (L. Davis, *The Disability Studies Reader* 550–1).

4 One example of the technics of neoliberal society is the current rate of incarceration in the United States. At the time of writing, the U.S. has the largest incarceration system in the world. It has one-fourth of the world's prisoner population despite having only 5% of its global population, such that one in every two Americans is related to someone who has done or is doing time (see Enns 13–18).

5 As an example of queer politics becoming normalized within a widening neoliberal status quo, an article by Donald Lynch that appeared in *The Sunday Independent* in 2019 calls Ellen DeGeneres to book for being a pal of George Bush. The reason is not because of the Bush-led invasion of Iraq but because of Bush's track record on gay rights. One would think that the forced invasion of a sovereign country might be alluded to as support for claims about the pair sharing right-wing attitudes, but Lynch frames DeGeneres's complicity crime as it being solely an affront to sexual inclusivity. For an alternative view on the necessity of a homophonous relationship between queer and the left see Tony Kushner's position as he outlines it in *Tony Kushner in Conversation* (Vorlicky 93–104).

6 This "Queer Liberation March" is also a gesture of recognition and remembrance. In contrast to current Pride celebrations, consider Andrew Solomon's recollection of the first gay rights march in NYC in 1970. Studying photos of the marchers in a parade he himself watched from the sidelines (afraid to participate like so many other gay men and women) he notes that

the people gathered in these photos reflect a time when it took tremendous courage to march. They were breaking the only tested model then available for queers (the word was still an insult at that time), which was secrecy. Look at these marchers, some with faces upturned with wonderment and discovery, some with arms raised to clap, some scowling and angry; some seeking militant visibility and some turning bashfully from the camera. Look at the number of people marching: A year after Stonewall, a great crowd accrued, reportedly as many as 5,000 people speaking the name of the love that dared not speak its name. They are mostly young and garbed for late spring weather rather than for show (there are no feathers). This was serious business.

("The First New York Pride March")

7 Against these global and grave contexts, the trans bathroom controversy can be understood as the contemporary manifestation of the neoliberal inclusivity masquerade. In a very welcome development, transgender rights are now being openly addressed. Indeed, establishing and instituting the legal rights of gay marriage paved the way for considering transgender bathrooms as another legal necessity. And yet in 2015 with transgender bathrooms becoming a prominent debate topic, discussion of it taking place on prime-time current affairs TV slots across the West, an international refugee crisis breaks out which places the bathroom debate in a different context; one reflective of a world with time and space to discuss such issues even as it shuts its border against the new wave of migrants. Furthermore, as the Mediterranean ocean began to fill with people fleeing both institutionalized oppression and radical climate change, fleeing both political instability and global warming, it should be noted that these conditions have been produced, in part, by the geopolitical policies of the very territories towards which their flimsy rafts navigate, and which, they will discover, are strategically structured to keep them out. Žižek writes,

> To get a fuller picture, one need only imagine a gigantic transparent cupola (similar to the one in *Zardoz* or *Elysium*) to keep the city safe from its polluted environs, plus transgender toilets to guarantee that all forms of segregation are left behind (in a city which is still itself a segregated area).
>
> (*Courage of Hopelessness* 8)

Quite simply, the violent struggles endured by the trans community will not be erased by the suggestion that bathroom space somehow solves the problem of discrimination. Trans people have been scapegoated, consigned to the margins of the heteronormative and often murdered. The desired effect is to render trans largely invisible; a marginal and impotent sign within patriarchal society. Advocating for separate bathrooms substitutes for discussion about this history and so displaces rather than amplifies the conflict underpinning the turbulence of trans experience. And it is the history of this conflict that must be addressed in order for the underlying economic context to emerge. Only when that context is apparent can the motivations for discrimination and prejudice be properly understood. Indeed, in the absence of such a context advocating for trans toilet facilities can appear as an indulgent luxury. Alternatively, perhaps instead of transgender bathrooms we need queer bathrooms, where all can recognize each other for the first time, pissing and shitting with alacrity and equanimity.

8 A theoretical and methodological problem is generated within gender studies when, in an attempt to establish a hybrid discourse, a critique proposes to switch its investigative tools between philosophy and psychoanalysis. Žižek identifies the issue thus:

> for philosophy the subject is not inherently sexualized, sexualization only occurs at the contingent, empirical level, whereas psychoanalysis raises sexualization into a kind of formal a priori condition for the very emergence of the subject.
> (*Less than Nothing* 745)

As "philosophy cannot think sexual difference in its philosophical (ontological) dimension," this must take place in the domain of the psychoanalytic where "sexual difference stands for the primordial antagonism" (745). The problem with this formulation is that, for Žižek, antagonism is to be found in everything as it is the reflection of our traumatic relationship with "the real," or the nature of experience beyond all ideological framing. For this reason, Žižek identifies a conflict with regard to ideological mystification and how it pertains to sexual identity. For him, trans identity is necessarily conflicted because it reflects the trauma of the relationship between the real and sexuality. In this study, however, the conflict surrounding gender is analyzed as a reflection of how capital mobilizes sexuality to its own ends, rather than there being any suggestion that there exists a conflict within gender itself. The framing here remains philosophical and invokes a collective LGBTQ+ consciousness, in this instance, simply to underscore its importance as a positive form of liberationist consciousness.

VII

1 Krapp recounts a fragmentary epiphany in which he realizes that a personal engagement with depression and darkness is the only way for him to fulfill his creative potential. Beckett said of Krapp's epiphany, "[a]ll the jetty and howling wind are imaginary [but] it happened to me, summer 1945, in my mother's little house, named New Place, across the road from Cooldrinagh." (Beckett in a letter to Richard Ellmann, January 27, 1986; qtd. in Knowlson's *Damned to Fame* 772 n. 55).
2 In 2017, Bowie's cousin, Kristina Amadeus, robustly dismissed the idea of a history of genetic schizophrenia in the extended family. Speaking to Bowie's biographer Dylan Jones, she offered credible environmental explanations for the women's troubled mental states, including the fact that her mother, Bowie's aunt Una, suffered a nervous breakdown after her husband deserted her (Jones, *David Bowie: The Oral History* 513–16).
3 A shared interest in Carl Jung is another instance in which Beckett and Bowie are touching from a distance. As Beckett underwent psychoanalysis in London, his analyst, Wilfred Ruprecht Bion, invited him to a lecture by Jung at the Tavistock in 1935. In "All that Fall," written in 1956, Beckett has a character recall attending a lecture by "one of these new mind doctors" ("All that Fall" 35), who spoke of a patient that "had never really been born" (36). This allusion incorporates a double reference, firstly, to Carl Jung and then to Lucia Joyce, James Joyce's daughter, who having been diagnosed a schizophrenic was treated by the Swiss who believed her to be her father's "femme inspiratrice." See Hutchins 679–80.

4 Lewontin et al. make a persuasive case for an end to biological determinism and the recognition of a more fluid dialectic relationship between humankind and its environment:

> For example, if we had eyes that were sensitive, like those of some insects, to ultraviolet wavelengths, or if, like some fish we had organs sensitive to electrical fields, the range of our interactions with each other and with other organisms would doubtlessly be very different. If we had wings, like birds, we would construct a very different world. In this sense, the environments that human organisms seek and those that they create are in accord with their nature ... [However, and at the same time, although] human chromosomes may not contain the genes that, in the development of the phenotype, are associated with ultraviolet vison, or sensitivity to electrical fields, or wings ... in our present society we can do all of these things ... see in the ultraviolet, detect electrical fields, fly by machine, by wind and even pedal power. It is clearly in human nature to so modify our environment that all of these activities come well within our range, and hence within the range of our genotype ... This is why about the only sensible thing to say about human nature is that it is 'in' that nature to construct its own history... [In this context,] biological determinist ideas are part of the attempt to preserve the inequalities of our society and to shape human nature in their own image. The exposure of the fallacies and political content of those ideas is part of the struggle to eliminate those inequalities and to transform our society. In that struggle we transform our own nature.
>
> (13–15)

5 By way of example, arguments involving either environment or biochemistry as the basis for depression are indicative of the necessary dialectical relationship that is invoked by the presence of depression as an experiential condition in the world. Pre-COVID, and for a significant period of time, depression was believed to be the result of low serotonin levels, or insufficient serotonin uptake, and therefore principally biochemical rather than the result of any significant or decisive environmental factors, such as unemployment, divorce, social despair, etc. Post-COVID, and at a time when psychiatry recognizes the negative effects of lockdown on general mental health, with higher rates of diagnosed clinical depression and suicide prevalent, studies questioning the serotonin hypothesis began to appear, most notably "The Serotonin Theory of Depression: A Systematic Umbrella Review of the Evidence" by Moncrieff et al. published in *Molecular Psychiatry* in July 2020. They conclude that patients should not be told depression is biochemical and should not be advised that anti-depressants treat a biochemical imbalance. These findings were presented at a time when one in six English adults and 2% of teenagers are on prescription medication to combat depression. More recently, the serotonin hypothesis has been reasserted in a study in *Biological Psychiatry* by Erritzoe et al. which purports to offer "clear evidence for dysfunctional serotonergic neurotransmission in depression" ("Brain Serotonin Release"). Regardless of what the biological reality might be, this debate clearly demonstrates that the claims of the environment as a significant cause of depression are not easily dismissed. Moreover, its intractable dialectical relationship with biology is again the subject of scrutiny at a time when our responsibility to make vital, life-saving interventions regarding our environmental reality can hardly be ignored.

6 For example, consider as a new biopolitical appropriation the recent claims in the journal *Nature Genetics* by Watson et al. that anorexia is genetically determined. Although there may be a genetic predisposition to anorexia, current thinking on the subject sees it as principally a psychological condition driven largely by social pressures that determine being thin as socially desirable. In identifying anorexia's genetic determinants, the science now begins the process of treating not the root of the problem—social expectations—but exclusively treating the biological "flaw" within the individual, no doubt with rapidly emerging Big Pharma solutions to be consumed by the patient. In contrast, one can reasonably argue that intellectual and economic efforts would be better invested in interrogating what shapes the values of a society that demands a size 0. Problematically, however, individual and collective critical self-scrutiny is of little benefit to capital equilibrium. Reflection is essentially a waste of time and money. Furthermore, in addition to this increasing de-emphasis on environmental factors, psychotherapy, which is suited to achieving self-insight with regard to our individual and collective social conditioning, is gradually being replaced by mindfulness, a practice that proposes to empty out the organ we usually use for critical thinking. For this reason mindfulness, in its pseudo-Buddhist approach to deep thought, might be more honestly recharacterized as "mindlessness" much to the chagrin of its practitioners. See Lewis's *The Biology of Desire* and Hari's *Lost Connections* for alternative views of the nature/nurture divide. These authors, like Lewontin et al., privilege the dialectic interaction of organism and environment as the primary shaper of behavior, and so argue for the agency of the individual as crucial in overcoming depression, addiction, anorexia, and other states that they believe to be psychological and reversable, rather than genetic and immutable.

7 Interestingly, in Beckett's "First Love" there is an echo of the indeterminate play with which Bowie closes "Five Years." Towards the conclusion of the story when the prostitute with whom he lives is now heavily pregnant, the narrator draws back the curtain "for a clear view of all her rotundities" (*The Expelled and other Novellas* 28) but looks beyond her belly to "the mountain, impassible, cavernous, secret, where from morning to night I'd hear nothing but the wind, the curlews, the clink like distant silver of the stone-cutter's hammers" (28–9). Then an immediate and strange shift in semantic association occurs when he states, "I'd come out in the daytime to the heather and gorse, all warmth and scent, and watch at night the distant city lights" (29). The narrator, by "com[ing] out," substitutes himself suddenly for the child yet to be born, disturbing the temporal terms of the story, and, by association, the idea of patriarchal lineage. Moreover, the conflation of womb and mountain, of organic interior with impenetrable stone, disturbs the physical and geographical boundaries that frame the action. Conventional space, temporality, and normative forms of embodiment are displaced as Beckett, like Bowie, articulates the disguised queerness lurking within conventional representation. A further example, associating the work of the two, is how the mother conjured in "Soul Love" whose "stone love … kneels before the grave [of] a brave son," echoes Vladimir's claim that women give birth "astride of a grave" (*Waiting for Godot* 81). In these metaphors of an entombed parturition, there is both a loss of the refuge of the mother, and perhaps a loss of regenerative mother earth—both narratives orienting themselves instead towards an alternative mineral being, foreshadowing where this study, in its conclusion, locates both Beckett and Bowie.

8 Both Beckett and Bowie employ the symbol of a door throughout their work. It functions as a trope of passage and continuity but also as a sign of enclosure and extinction. Doors, as thresholds, begin to appear frequently in Beckett's postwar work. In the concluding lines of *The Unnamable*, for example, the narrator announces "it's I now at the door, what door, What's a door doing here … I'll go on, you must say words, as long as there are any … you must go on, I can't go on, I'll go on" (132). Assuming he proceeds through the door, the narrator is silenced and the narrative concludes. For his part, in "My Death," mortality haunts all of Bowie's habitual experience until, in the end, a door emerges, prompting him to declare:

> But whatever lies behind the door
> There is nothing much to do
> Angel or devil, I don't care
> For in front of that door
> There is you.

Love appears to forestall the narrator having to cross a threshold coextensive with his extinction. In early Bowie, love conquers all, even mortality. To quote from "Rock and Roll with Me," "love is the door which lets me out." However, in "Lazarus," his last video work, the door is a more complex symbol of being which involves continuity but also places firm emphasis on impending absence and inevitable finitude.

VIII

1 The emergence of COVID has also been marked by questions regarding the role of research in its initial spread. Suspicions remain that "gain of function experiments" were carried out in Wuhan subsequent to the transportation of bat feces from the Yunnan province where three miners died many years previously, in 2012, from a similar viral strain. Gain of function experiments attempt to genetically engineer existing viruses in order to establish how mutations might work and predict potential immunity pathways. Although questions regarding such experimentation were initially rubbished in the media as conspiracy theories (largely due to Trump's racist agenda viz what he termed "Chinese flu"), a letter demanding a full investigation signed by 18 prominent MIT scientists and viral epidemiologists led to a White House inquiry. The published conclusions broadly support the possibility that the pandemic was initiated by the transportation of the COVID virus to a major populated city (Wuhan) from a remote site (Yunnan) where it was initially discovered—its remoteness arguably a testament to the bat's consideration of human welfare—and, once there, subject to gain of function research that lacked ecological, ethical, and adequate safety consciousness. See the declassified White House Report on the "Updated Assessment of COVID-19 Origins" undertaken by the Office of the Director of National Intelligence, available at https://www.dni.gov/files/ODNI/documents/assessments/Declassified-Assessment-on-COVID-19-Origins.pdf. For the MIT letter see Rowan Jackobsen, *The MIT Technology Review*, 13/6/21. And for details on the Yunnan Mine virus precedent see Ridley and Chan, *Viral: The Search for the Origin of COVID-19*.

2 In relation to the use of the skull as *memento mori*, Jacques Lacan provides a masterful reading of Holbein's painting *The Ambassadors* in *The Four Fundamental Concepts of Psychoanalysis* (the painting appearing on the cover of the 1973 edition). He points out that when one stands directly in front of the painting facing the two ambassadors (after whom the painting is named), the skull at its base is difficult to clearly perceive, obliquely slanted as it is. Lacan proposes that this centralized viewing position is representative of our conventional, collective ideological position that distorts the presence of death, the latter also known in Lacanian terms as the Real. However, when one adjusts one's perspective in order that the skull becomes clearly visible—by stepping to one side for example—one simultaneously distorts the primary ideological universe which ordinarily marginalizes death, as the presence of death itself becomes all too apparent. According to Lacan, this twostep ably represents our perception of death within the symbolic order (*Four Concepts* 88–9). The painting—full of symbols of ambition and success—"reflects our own nothingness, in the figure of the death's head" (92). This in turn mirrors the ideological paradigm in which we practice our false consciousness about life and death. In the standard, centralized view of the painting/life, death is there but unrecognizable for what it is. When we orient ourselves to see death and turn our gaze to the skull, the world from which we turn away becomes unfocused. For Lacan, this optical switch represents habitual life as ceasing to make integrated sense in the face of death (meditation on mortality renders life meaningless and so on). Similarly, when we turn away from having to face death, such that the skull becomes oblique again, it assumes the presence of the great repressed truth at the margins of our consciousness that we cannot properly accommodate in its terrifying incommensurability. According to Žižek, himself a Lacanian, we then simply deny death by practicing what he calls a "fetishistic disavowal" the logic of which plays out as follows:

> I know that I know but I don't want to know that I know, so I don't know. I know it but I refuse to fully assume the consequences of this knowledge, so I can continue acting as if I didn't know it.
>
> (*Violence* 42)

In contrast to this disavowal, when Bowie sings "the moment you know you know you know" in "Where Are We Now?" it seems to acknowledge an unshakeable understanding that time is now demanding not Billy Dolls but another friend of Davy Jones, variously known as Major Tom, Ziggy and/or David Bowie. In other words, rather than unconsciously expressing his denial, the song is a radical acknowledgment of his awareness of his own end.

3 Beckett loved Lionel Rogosin's *On the Bowery* (1956) and shortly after seeing it wrote to recommend it to a friend, stating he'd go again later in the evening if he could keep out of the pubs long enough (*CLSBIII* 374). Paraskeva notes of the film: "mainstream film critics did not appreciate the film's rejection of Hollywood production values, its use of non-professional actors, lack of narrative arc, and gritty cinematography of squalor and poverty. But the film found its ideal audience in Beckett" (57).

4 The song "Law (Earthlings on Fire)" (1997) contains the line "What a morning," which Bowie believed to be Beckett's last words (see Egan 376). In fact, these were the last words of Sam's father. See Knowlson's *Damned to Fame* (194–5) for details of Bill Beckett's death.

5 On this opening/closing metaphor, Beckett wrote a poignant letter about his ailing mother in which he locates the opening and closing of passageways from love to grief, and back again, as personal, *internal* movements of emotional turmoil:

> I keep watching my mother's eyes, never so blue, so stupefied, so heartrendering, eyes of an endless childhood, that of old age … I think these are the first eyes that I have seen. I have no wish to see any others, I have all I need for loving and weeping. I know now what is going to close, and open inside me, but without seeing anything, there is no more seeing.
>
> (*CLSBII* 92)

X

1 Looking back at the Sokal Hoax, retrospectively, what stands out now is that despite Sokal's desire to propose science as a liberatory discourse, one in contrast to what he perceives as the oppressive superstition of religion, a kind of techno-bureaucracy underpins his imperative that physics be considered anterior to politics, and this despite some of its regrettable and obvious political applications (Hiroshima and Nagasaki as a self-explanatory example). Similarly, his desire to assert the sovereignty of science such that it is not considered "another branch of cultural studies" (*Lingua Franca*) fails to take account of the fact, ironically, that his essay, as cultural text, is a fine, representative example of the postmodern moment. Although he sets out to ridicule the validity of claims that society was living a postmodern reality, his hoax suggests the same; editors, publishers, university departments, himself (as gamer) confirm the notion that pomo can be defined as playful engagement with pseudo-serious culture, and that, in undertaking the hoax, Sokal is squarely positioning science within a wider cultural studies discourse about inclusivity and legitimacy. Perhaps, despite his best efforts, he proved, ultimately, that no one person, or group of people, can control the zeitgeist, or bend the epoch to their will. In order to most effectively register his protest, Sokal was compelled to play the postmodern game.

2 On behalf of ESO, Brandon Specktor reports:

> After watching the star complete nearly two full orbits, the researchers concluded that the star does not have a fixed elliptical orbit as predicted by Isaac Newton's theory of gravity, but rather 'dances' around the black hole in a pattern that resembles a rosette drawn using a spirograph.
>
> ("Dancing Star")

Beckett, for his part, reported on the movement within Murphy's mind as follows:

> how much more pleasant was the sensation of being a missile without provenance or target, caught up in a tumult of non-Newtonian motion. So pleasant that pleasant was not the word.
>
> (*Murphy* 72)

3 Elvis Presley and David Bowie share a birth date. Elvis Aaron Presley was born on January 8, 1935 while David Robert Jones was born January 8, 1947. On August 8, 1960 Elvis recorded the song "Black Star" in which the dark star in question is a metaphor for death. In 2016, Bowie did the same. In another essay, at another time, one might figure this pair and Little Richard, another black star, as the Holy Trinity who forged a great Event Horizon in Rock and Roll.

Works Cited

Ackerley, Chris. "Samuel Beckett and the Physical Continuum." *Journal of Beckett Studies*, vol. 25, no. 1, 2016, pp. 110–31.
Ackerley, Chris and Stanley Gontarski. *The Faber Companion to Samuel Beckett*. Faber & Faber, 2004.
Addyman, David, "Different Spaces: Beckett, Deleuze, Bergson." *Deleuze and Beckett*, edited by S. E. Wilmer and A. Žukauskaitė, Routledge, 2015, pp. 137–51.
Adorno, Theodor. *Aesthetic Theory*, edited by G. Adorno and R. Tiedemann, translated by C. Lenhardt, Routledge and Kegan Paul, 1984.
Adorno, Theodor. "Cultural Criticism and Society." *Prisms*, MIT Press, pp. 17–34.
Adorno, Theodor. *Negative Dialectics*. Continuum, 1981.
Adorno, Theodor. "On Popular Music." *Cultural Theory and Popular Culture: A Reader*, edited by John Storey, Routledge, 2019, 197–209.
"Afternoon Plus," Mavis Nicholson speaks to Bowie about his music and acting career—first broadcast on Thames Television on 16/02/1979. https://www.youtube.com/watch?v=LwTFW4kfHl4&t=334s&ab_channel=ThamesTv
Agamben, Giorgio. *Homo Sacer: Sovereign Power and Bare Life*. Cambridge UP, 1995.
Agamben, Giorgio. *Stanzas: Word and Phantasm in Western Culture*. Translated by Ronald C. Martinez, University of Minneapolis Press, 1992.
Alan's Wife; a dramatic study in three scenes. First acted at the Independent Theatre in London by Lady Florence Eveleen Eleanore Bell and Elizabeth Robins. With an introduction by William Archer Bell. London, 1893. Collection Robarts, Toronto. Available at https://archive.org/stream/alanswifedramati00belluoft/alanswifedramati00belluoft_djvu.txt. Accessed January 2023.
Alba, Ken. "Beckett and Memes: Online Aftertexts." *Pop Beckett*, edited by P. Stewart and D. Pattie, pp. 157–82.
Ali, Baris and Heidi Wallace. "Out of this World: Ziggy Stardust and the Spatial Interplay of Lyrics, Vocals, and Performance." *David Bowie: Critical Perspectives*, edited by E. Devereux et al. pp. 263–79.
"Alienation," *Stanford Encyclopedia of Philosophy*, https://plato.stanford.edu/entries/alienation, accessed November 2022.
Alighieri, Dante. *The Divine Comedy* featuring the "Inferno," "Purgatorio" and "Paradiso". (orig. 1321). Columbia University library, cited here, employs the Petrocchi Edition, publ. 1966–1968). https://digitaldante.columbia.edu/dante/divine-comedy
American Psychiatric Association (Author), *Diagnostic and Statistical Manual of Mental Disorders* (5th Edition), American Psychiatric Publishing, 2013. See also second edition compiled by The Committee on Nomenclature and Statistics of the American Psychiatric Association and published by The American Psychiatric Association, Washington DC, 1968. Available at https://www.madinamerica.com/wp-content/uploads/2015/08/DSM-II.pdf. Accessed March 2022.
Anderton, Joseph. *Beckett's Creatures: Art of Failure after the Holocaust*. Bloomsbury, 2016.
Aristotle. *Physics*. Translated by Robin Waterfield, Oxford UP, 2008.

Arnold, Matthew. *Culture and Anarchy and Other Writings*, edited by Stefan Collini, Cambridge UP, 1993.
Atik, Anne. *How It Was: A Memoir of Samuel Beckett*. Counterpoint, 2005.
Auerbach, Erich. *Mimesis: The Representation of Reality in Western Literature*. Translated by Willard R. Trask, Princeton UP, 2013.
Auslander, Philip. *Performing Glam Rock: Gender and Theatricality in Popular Music*. University of Michigan Press, 2006.
Badiou, Alain. *Badiou on Beckett*. Edited and translated by Nina Power and Alberto Toscano, Clinamen Press, 2004.
Badiou, Alain. *The True Life*. Translated by Susan Spitzer, Polity Press, 2017.
Badiou, Alain and Slavoj Žižek. *Philosophy in the Present*, edited by Peter Engelmann. Translated by Peter Thomas and Alberto Toscano, Polity, 2009
Bair, Deirdre. *Samuel Beckett: A Life*. Vintage Lives, 1991.
Bakhtin, Mikhail. "Carnival and the Carnivalesque." *Cultural Theory and Popular Culture: A Reader*, edited by John Storey, Prentice Hall, 1998, pp. 283–91.
Bakhtin, Mikhail. *The Dialogic Imagination*. Translated by Caryl Emerson and Michael Holquist, University of Texas Press, 1981.
Barilar, Nic. "Beckett's Queer Time of Défaillance: Ritual and Resistance in *Happy Days*." *Beckett Beyond the Normal*, edited by S. Kennedy, 105–117.
Barnbrook, Jonathan. "Barnbrook Talks Bowie." quietus.com http://thequietus.com/articles/11062-david-bowie-the-next-day-jonathan-barnbrook-cover-artwork. Accessed 11 Jan. 2019.
Baudelaire, Charles. *Les Fleurs du mal* (1857). https://fleursdumal.org/1857-table-of-contents, accessed November 2022.
Baudrillard, Jean. "The Precession of Simulacra." *Simulacra and Simulation*, translated by Sheila Glaser, Michigan UP, 1982, pp. 1–42. Available at http://criticaltheoryindex.org/assets/baudrillard%2C-jean_the-precession-of-simulacra.pdf. Accessed 11 Jun. 2019.
Beauman, Ned. "Fail Worse." *The New Inquiry*. 9/2/2012. https://thenewinquiry.com/fail-worse/
Beckett, Samuel. "All that Fall." *Collected Shorter Plays of Samuel Beckett*, Faber and Faber, 1987, pp. 9–40.
Beckett, Samuel. *As The Story was Told*. John Calder, 1990.
Beckett, Samuel. "As the Story was Told." *As the Story was Told*. John Calder, 1990 pp. 103–107.
Beckett, Samuel. "The Calmative." *The Expelled and Other Novellas*, pp. 49–69.
Beckett, Samuel. "The Capital of the Ruins." *As The Story was Told*, pp. 17–29.
Beckett, Samuel. *The Collected Letters of Samuel Beckett*. Vols I–IV. Edited by Lois More Overbeck et al., Cambridge UP, 2009–2016. The four volumes appear in the main body of the study as the abbreviations *CLSBI, CLSBII, CLSBIII, CLSBIV*.
Beckett, Samuel. *The Collected Poems of Samuel Beckett*. Edited by Seán Lawlor and John Pilling, Faber and Faber, 2012. The volume appears in the main body of the study as *CPSB*.
Beckett, Samuel. *The Collected Shorter Plays of Samuel Beckett*. Faber and Faber, 1987. The volume appears in the main body of the study as *CSPSB*.
Beckett, Samuel. *The Collected Works of Samuel Beckett: The Grove Centenary Edition: Volume IV: Poems, Short Fiction. Criticism*. Edited by Paul Auster, Grove Press, 2006. The volume appears in the main body of the study as an abbreviation of Grove Collected Works (*GCW*).

Beckett, Samuel. "Company." *The Collected Works of Samuel Beckett: The Grove Centenary Edition: Volume IV*, 427–51.

Beckett, Samuel. *Disjecta: Miscellaneous Writings and a Dramatic Fragment*. Edited by R. Cohn, Grove Press, 1984.

Beckett, Samuel. *Dream of Fair to Middling Women*. Black Cat, 1992 (orig. written 1932).

Beckett, Samuel. "The End." *The Expelled and Other Novellas*, pp. 69–93.

Beckett, Samuel. *Endgame*. Faber and Faber, 1983.

Beckett, Samuel. "Enough." *The Collected Works of Samuel Beckett: The Grove Centenary Edition: Volume IV*, pp. 366–70.

Beckett, Samuel. *The Expelled and Other Novellas*. Penguin, 1977.

Beckett, Samuel. *Film*. Dir. Alan Schneider. 1965.

Beckett, Samuel. "First Love." *The Expelled and Other Novellas*, pp. 7–30.

Beckett, Samuel. "Footfalls." *Collected Shorter Plays of Samuel Beckett*, pp. 277–83.

Beckett, Samuel. *Happy Days*. Faber and Faber, 2012.

Beckett, Samuel. *How It Is*. John Calder, 1964.

Beckett, Samuel. "Ill Seen Ill Said." *Samuel Beckett: The Collected Works of Samuel Beckett: The Grove Centenary Edition: Volume IV*, pp. 451–70.

Beckett, Samuel. "Intercessions by Denis Devlin." *Disjecta*, edited by R. Cohn, pp. 91–4.

Beckett, Samuel. "Interview with Gabriel d'Aubarède." In *Samuel Beckett: The Critical Heritage*, edited by L. Graver and R. Federman, pp. 238–40.

Beckett, Samuel. "Krapp's Last Tape." *The Collected Shorter Plays of Samuel Beckett*, pp. 53–65.

Beckett, Samuel. "Lessness." *Samuel Beckett; The Complete Short Prose, 1929–1989*, pp. 197–201

Beckett, Samuel. "The Lost Ones." *Samuel Beckett, The Complete Shorter Prose, 1929–1989*, pp. 202–23.

Beckett, Samuel. "Malacoda." *The Collected Poems of Samuel Beckett*, edited by S. Lawlor and J. Pilling, 21.

Beckett, Samuel. *Malone Dies*. Faber and Faber, 2010.

Beckett, Samuel. *Molloy*. Faber and Faber, 2009.

Beckett, Samuel. *More Pricks than Kicks*. Calder & Boyars, 1973.

Beckett, Samuel. *Murphy*. Faber and Faber 2009.

Beckett, Samuel. "my way is in the sand flowing." *The Collected Poems of Samuel Beckett*, edited by S. Lawlor and J. Pilling, p. 118.

Beckett, Samuel. *Proust and Three Dialogues with Georges Duthuit*. John Calder, 1987.

Beckett, Samuel. "Recent Irish Poetry." *Disjecta*, 70–5.

Beckett, Samuel. "Saint-Lô." *The Collected Poems of Samuel Beckett*, edited by S. Lawlor and J. Pilling, 105.

Beckett, Samuel. *Samuel Beckett: The Complete Short Prose, 1929–1989*, edited S. E. Gontarski, Grove Press, 1995. The volume appears in the main body of the study as *CSP*.

Beckett, Samuel. "Stirrings Still." *Samuel Beckett: The Complete Short Prose, 1929–1989*, pp. 259–65.

Beckett, Samuel. *Têtes-mortes*. Editions de Minuit, 1969.

Beckett, Samuel. "Texts for Nothing." *Samuel Beckett: The Complete Short Prose, 1929–1989*, pp. 100–54.

Beckett, Samuel. "Three Dialogues with Georges Duthuit." *Disjecta*, edited by R. Cohn, pp. 138–45.

Beckett, Samuel. *The Unnamable*. Calder and Boyars, 1975.

Beckett, Samuel. *Waiting for Godot*. Grove Press, 1954.
Beckett, Samuel. *Watt*. Grove Press, 1959.
Beckett, Samuel. "what is the word." *The Collected Poems of Samuel Beckett*, edited by J. Pilling and S. Lawlor, pp. 228–9.
Beckett, Samuel. "What Where." *Collected Shorter Plays of Samuel Beckett*, pp. 305–11.
Beckett, Samuel. "Whoroscope." *The Collected Poems of Samuel Beckett*, 40–3.
Beckett, Samuel. "Worstward Ho." *The Collected Works of Samuel Beckett: The Grove Centenary Edition: Volume IV*, pp. 471–85.
Benjamin, Walter. "Theses on the Philosophy of History." *Illuminations: Essays and Reflections*, edited by Hannah Arendt and translated by Harry Zohn. Schocken Books, 1969, pp. 253–64. Available online with alternative translation at https://www.sfu.ca/~andrewf/CONCEPT2.html. Accessed 1 Apr. 2020.
Bennett, Tony. *Formalism and Marxism*. Methuen, 1979.
Benson, Bruce Ellis. "Phenomenology of Music." *The Routledge Companion to Philosophy and Music*, edited by T. Gracyk and A. Kania, pp. 581–91.
Ben-Zvi, Linda, editor. *Women in Beckett*, Chicago UP, 1990.
Bignell, Jonathan. "'Do you really enjoy the modern play?': Beckett on Commercial Television," *Pop Beckett*, edited by P. Stewart and D. Pattie, pp. 63–84.
Bilmes, Alex. "David Bowie on God." *GQ Australia*, 2016. https://www.gq.com.au/entertainment/music/david-bowie-on-god-greater-forces-and-what-lies-beyond/news-story/e6a6d57d040d9d95b8a2b78e453fc36a (reprint of interview originally appearing in British *GQ* 2002)
Blin, Roger. "Joan Stevens interviews Roger Blin." *Directing Beckett*, edited by Lois Oppenheim, University of Michigan Press, 1997, pp. 301–15.
Bowie, David. *Aladdin Sane*. RCA, 1973.
Bowie, David. "All the Madmen." *The Man Who Sold the World*, RCA, 1970.
Bowie, David. "Andy Warhol." *Hunky Dory*, RCA, 1971.
Bowie, David. "Ashes to Ashes." *Scary Monsters and Super Creeps*, RCS, 1980.
Bowie, David. "Blackstar." ★, ISO, 2016.
Bowie, David. "Black Tie White Noise." *Black Tie White Noise*, Arista, 1993.
Bowie, David. *The Buddha of Suburbia*, Arista, 1993.
Bowie, David. ★. ISO, Columbia Records and, Sony Music, 2016.
Bowie, David. "Bowie Criticizes MTV." Music Television (MTV), 11 Jan. 2016, https://www.youtube.com/watch?v=XZGiVzIr8Qg. Accessed 1 Apr. 2020.
Bowie, David. "Bowie in conversation with Ronan Keating." bowie.net, 30 Jan. 1999, http://www.bowiewonderworld.com/chats/dbchatronan0199.htm. Accessed 1 Apr. 2020.
Bowie, David. *Bowie on Bowie*. Edited by Sean Egan, Chicago Review Press, 2015.
Bowie, David. "Bowie's 42 Word Statement." rumpus.net, 4 Apr. 2013, http://therumpus.net/2013/04/swinging-modern-sounds-44-and-another-day/. Accessed 11 Jan. 2019.
Bowie, David. Bowie Wonder World, online resource. Bowiewonderworld.com. https://www.bowiewonderworld.com/chats/dbchatronan0199.htm
Bowie, David. "Changes." *Hunky Dory*, RCA, 1971.
Bowie, David. "Cygnet Committee." *Space Oddity*, Philips, 1969.
Bowie, David. *David Bowie, Collector*: Vols. I–III. Sotheby's, 2016.
Bowie, David. *David Bowie Is*. Catalogue for V&A Exhibition, 2015.
Bowie, David. "Diamond Dogs." *Diamond Dogs*, RCA, 1974.
Bowie, David. "DJ." *Lodger*, RCA, 1978.
Bowie, David. "Drive-in Saturday." *Aladdin Sane*, RCA, 1973.

Bowie, David. "Fame." *Young Americans*, RCA, 1975.
Bowie, David. "Five Years." *The Rise and Fall of Ziggy Stardust and the Spiders from Mars*, RCA, 1972.
Bowie, David. "Future Legend." *Diamond Dogs*. RCA, 1974.
Bowie, David. "Heroes." *"Heroes."* RCA, 1977.
Bowie, David. *Hunky Dory*. RCA, 1971.
Bowie, David. "Interview." *Pushing ahead of the Dame*. https://bowiesongs.wordpress.com/2013/07/02/law-earthlings-on-fire
Bowie, David. "It's No Game, Part One." *Scary Monsters and Super Creeps*, RCA, 1980.
Bowie, David. "It's No Game, Part Two." *Scary Monsters and Super Creeps*, RCA, 1980.
Bowie, David. "John, I'm only Dancing." RCA, 1972.
Bowie, David. "Lazarus." ★, ISO, 2016.
Bowie, David. "Life on Mars?" *Hunky Dory*, 1971.
Bowie, David. *Lodger*. RCA, 1978.
Bowie, David. "Moonage Daydream." *The Rise and Fall of Ziggy Stardust and the Spiders from Mars*. RCA, 1972.
Bowie, David. "Moss Garden." *"Heroes."* RCA 1977.
Bowie, David. "My Death." (Original "La Mort" by Jacques Brel, 1959, translated by Mort Shuman and Eric Blau). *Ziggy Stardust: The Motion Picture*. RCA, 1983.
Bowie, David. "Neuköln." *"Heroes."* RCA 1977.
Bowie, David. "The Next Day." *The Next Day*, ISO. 2013.
Bowie, David. "Oh, You Pretty Things." *Hunky Dory*, RCA, 1971.
Bowie, David. *1.Outside*. Arista, 1995.
Bowie, David. "Panic in Detroit." *Aladdin Sane*, RCA, 1973.
Bowie, David. "Quicksand." *Hunky Dory*, RCA, 1971.
Bowie, David. "Rock 'n' Roll Suicide." *The Rise and Fall of Ziggy Stardust and the Spiders from Mars*, RCA, 1972.
Bowie, David. "Rock's Heathen Speaks." Livewire Interview One on One, 2002. http://www.concertlivewire.com/interviews/bowie.htm. Accessed 9 June 2022.
Bowie, David. "Scary Monsters and Super Creeps." *Scary Monsters and Super Creeps*, RCA, 1980.
Bowie, David. "Scream like a Baby." *Scary Monsters and Super Creeps*, RCA, 1980.
Bowie, David. "Secret Life of Arabia." *"Heroes."* RCA, *1977.*
Bowie, David. "Soul Love." *The Rise and Fall of Ziggy Stardust and the Spiders from Mars*, RCA, 1972.
Bowie, David. "Space Oddity." *Space Oddity*, Philips, 1969.
Bowie, David. "Star." *The Rise and Fall of Ziggy Stardust and the Spiders from Mars*, RCA, 1972.
Bowie, David. "Station to Station." *Station to Station*, RCA. 1976.
Bowie, David. "Sweet Thing." *Diamond Dogs*, RCA, 1974.
Bowie, David. *The Rise and Fall of Ziggy Stardust and the Spiders from Mars*, RCA, 1972.
Bowie, David. "Time." *Aladdin Sane*. RCA, 1973.
Bowie, David. "Time will Crawl." *Never Let Me Down*. EMI, 1987.
Bowie, David. "'Tis a Pity She's a Whore," ★, 2016.
Bowie, David. "Valentine's Day." *The Next Day*, ISO, 2013.
Bowie, David. "We are the Dead." *Diamond Dogs*, RCA, 1974.
Bowie, David. "Where are We Now?" *The Next Day*, ISO, 2013.
Bowie, David. "The Width of a Circle." *The Man Who Sold the World*, Mercury, 1970.

Bowie, David. "Wild is the Wind." *Aladdin Sane*, RCA, 1973.
Bowie, David. "You Feel So Lonely You Could Die." *The Next Day*, ISO, 2013.
Bowie, David. *Young Americans*. RCA, 1975.
Boxall, Peter. "Samuel Beckett and Homoeroticism." *Palgrave Advances in Samuel Beckett Studies*, edited by Lois Oppenheim, Palgrave, 2004, pp. 110–32.
Boyd, William. *Nat Tate: A Life*. 21 Publishing, 2000.
Bracken, Pat and Philip Thomas. "Critical Psychiatry in Practice." *Advances in Psychiatric Treatment*, vol. 10, no. 5, 2004, pp. 361–70.
Braidotti, Rosi. "Posthuman Affirmative Politics." *Resisting Biopolitics: Philosophical, Political and Performative Strategies*, edited by S. E. Wilmer and A. Žukauskaitė. Routledge, 2016, pp. 30–57.
Brater, Enoch. *The Drama in the Text: Beckett's Late Fiction*. Oxford UP, 1994.
Brater, Enoch. "The *I* in Beckett's *Not I*." *Twentieth Century Literature*, vol. 20, no. 3, July 1974, 189–200.
Brienza, Susan and Enoch Brater. "Choice and Chance in Samuel Beckett's 'Lessness.'" *Journal of English Literary History*, vol. 43 (Summer), 244–58.
Brower, Steve and John Gall. "Grove Press and the Vanguard." *Print* magazine March/April 1994.
Brown, Mark. "David Bowie Retrospective at the V&A Announced." *Guardian* 4/9/2012. https://www.theguardian.com/music/2012/sep/04/david-bowie-retrospective
Bryden, Mary, editor. *Samuel Beckett and Music*. Clarendon Press, 1998.
Buckley, David. *Strange Fascination. David Bowie: The Definitive Story*. Virgin Books, 2001.
Burroughs, William. "Beat Godfather meets Glitter Mainman: William Burroughs interviews David Bowie." *Rolling Stone*, 28 Feb. 1974. https://www.rollingstone.com/music/music-news/beat-godfather-meets-glitter-mainman-william-burroughs-interviews-david-bowie-92508. Accessed 6 July 2019.
Buskin, Richard. "David Bowie's 'Heroes.'" Sound on Sound @ sound.com 2004, https://www.soundonsound.com/techniques/classic-tracks-david-bowie-heroes. Accessed 1 Apr. 2020.
Butler, Judith, Ernesto Laclau and Slavoj Žižek. *Contingency Hegemony, Universality: Contemporary Dialogues on the Left*. London: Verso, 2011.
Carr, Eamon. "A Genius who made us all Believe." *Irish Independent*, 12 Jan. 2016, https://www.independent.ie/entertainment/music/music-news/david-bowie-19472016-a-genius-who-made-us-all-believe-we-could-be-heroes-34355786.html. Accessed 11 Jan. 2019.
Carville, Conor. *Absorption and Theatricality: On Ghost Trio*. Cambridge UP, 2022.
Cave, Nick and The Bad Seeds. "Dig Lazarus Dig." *Dig Lazarus Dig*, Mute, 2008.
The Chair. Amanda Peet (author). Netflix, 2020.
Chamayou, Grégoire. *Theory of the Drone*, The New Press, 2015.
Chapman, Ian. "Ziggy's Urban Alienation: Assembling the Heroic Outsider." *Enchanting David Bowie*, edited by T. Cinque et al. 27–48.
Cinque, Toija, Christopher Moore and Sean Redmond, editors. *Enchanting David Bowie: Space/Time/Body/Memory*. Bloomsbury, 2016.
Clough, Patricia. "The Affective Turn: Political Economy, Biomedia and Bodies." *Theory, Culture & Society*, vol. 25, no. 1, 2008, pp. 1–23.
Coffey, Michael. "'New Group Online Stream Theatre production of Waiting for Godot," *The Beckett Circle*, Spring 2022.

Cohen, Leonard. "Anthem." *The Future*, Columbia, 1992

Cohn, Ruby, editor. *Disjecta: Miscellaneous Writings and a Dramatic Fragment*. Grove Press, 1984.

Compo, Susan. *Earthbound: David Bowie and The Man Who Fell to Earth*. Jawbone Press, 2017.

Cone, Edward. "Schubert's Promissory Note: An Exercise in Musical Hermeneutics." *Schubert: Critical and Analytical Studies*, edited by Walter Frisch. University of Nebraska Press, 1986, pp. 13–30.

Cordingley, Anthony. *How it is: Philosophy in Translation*. Edinburgh UP, 2018.

Corey-Boulet, Robbie. *Love Falls on Us: A Story of American Ideas and African LGBT Lives*. Zed Books, 2019.

Crespi, Paulo and Sunil Magani. "A Genealogy of Rhythm." *Rhythm and Critique*, 30–55.

Crespi, Paulo and Sunil Magani, editors. *Rhythm and Critique: Technics, Modalities, Practices*. Edinburgh UP, 2020.

Critchley, Simon. *On Bowie*. Serpent's Tail, 2016.

Critchley, Simon. "Bowie: A Tribute (Part 2)." Critchley speaks at The New School. https://www.youtube.com/watch?v=08ep7nQbAww.

Cronin, Anthony. *Samuel Beckett: The Last Modernist*. HarperCollins, 1997.

Crowe, Cameron. "David Bowie: Ground Control to Davy Jones." *Rolling Stone*, 12 Feb. 1976, https://www.rollingstone.com/music/features/ground-control-to-davy-jones-19760212. Accessed 1 Jun. 2019.

Cunard, Nancy. "Parallax." *Nancy Cunard: Selected Poems*, edited by Sandeep Parmar. Fyfield Books, 2016, pp. 97–117.

Curtis, Neal. "The Explication of the Social: Algorithms, Drones, and (Counter-) Terror." *Journal of Sociology*, vol. 52, no.3, 2016, pp. 522–36.

D'Amado, Amedeo. "Ain't there one Damn Flag that can Make me Break Down and Cry." *Enchanting David Bowie*, edited by T. Cinque et al., pp. 119–53.

Darsa, Alissa. "Art House: An Introduction to German Expressionist Films." *art net*, 26 Dec. 2013, https://news.artnet.com/market/art-house-an-introduction-to-german-expressionist-films-32845. Accessed 11 Jan. 2019.

d'Aubarède, Gabriel. "Interview avec Samuel Beckett." *Les nouvelles littéraires*, 16/2/61, 7, reprinted and translated by Christopher Waters in *The Critical Heritage*, edited by L. Graver and R. Federman, pp. 238–41.

David, Larry (author). "Beloved Aunt." *Curb Your Enthusiasm*, season 1 episode 8, HBO, 2000.

Davies, Caroline and Edward Helmore. "David Bowie dies of cancer at 69: 'He gave us magic for a lifetime.'" *Guardian*, 11 Jan. 2016, https://www.theguardian.com/music/2016/jan/11/david-bowie-dies-at-the-age-of-69. Accessed 29 Apr. 2020.

Davies, Caroline and Henry McDonald. "Pride in London: Organisers fend off Pinkwashing Claims." *Guardian*, 6 Jul. 2019, https://www.theguardian.com/world/2019/jul/06/pride-in-london-organisers-fend-off-pinkwashing-claims. Accessed 6 Jul. 2019.

Davis, Lennard, editor. *The Disability Studies Reader*. Taylor and Francis, 2013.

Davis, Mike. *The Monster Enters: COVID-19, Avian Flu, and The Plagues*. OR Books, 2020.

Deleuze, Gilles. *Cinema II: The Time Image*. Translated by Hugh Tomlinson and Robert Galeta, Athlone Press, 1989.

Deleuze, Gilles. "What is it to be from the Left? Dialogue with Claire Parnet." thefunambulist.net. https://thefunambulist.net/philosophy/deleuze-what-is-it-to-be-from-the-left. Accessed 11 Jun. 2019.

Deleuze, Gilles and Félix Guattari. *A Thousand Plateaus: Capitalism and Schizophrenia*. Translated by Brian Massumi, University of Minnesota Press, 1987.

Deleuze, Gilles and Félix Guattari. *Kafka: Towards a Minor Literature*. Translated by Dana Polan, University of Minnesota Press, 1986.

Devereux, Eoin and Aileen Dillane and Martin Power, editors. *David Bowie: Critical Perspectives*. Routledge, 2015.

Dimery, Robert. "'By the age of 14, he was already a cult figure': How David Bowie's Formative Years Shaped His Art," *GQ Magazine*, 5 February 2021. https://www.gq-magazine.co.uk/culture/article/david-bowie-childhood. Accessed November 2022.

Doggett, Peter. *The Man Who Sold the World: David Bowie and the 1970s*. Random House, 2011.

Dowd, Garin. "The Proxemics of 'neither'." *Samuel Beckett Today/Aujourd'hui*, 24, 2012, pp. 367–77.

Driver, Tom. "Beckett by the Madeleine." *Samuel Beckett: The Critical Heritage*, edited by L. Graver and R. Federman, pp. 241–8.

Dubreuil, Laurent. *The Refusal of Politics*. Translated by Cory Browning, Edinburgh UP, 2016.

Du Noyer, Paul. "ChangesFiftyBowie." *Q Magazine*, Apr. 1997, www.bowiewonderworld/press. Accessed 11 Jun. 2019.

Duthuit, Georges. *Les Fauves*. Éditions Des Trois Collines, 1949.

Duthuit, Georges. *The Fauvist Painters*. Translated by Ralph Manheim, Wittenborn Schultz, 1950.

Dwan, Lisa. "There's an Irish Client." *Irish Times*, 29 Feb. 2020, https://www.irishtimes.com/culture/books/there-s-an-irish-client-none-of-us-wants-to-handle-from-the-north-enter-gerry-adams-1.4183431. Accessed 1 Apr. 2020.

Eagleton, Terry. "Capitalism, Modernism and Postmodernism." *Against the Grain: Essays 1975–1985*, Verso, 1986, pp. 131–48.

Eagleton, Terry. *Humour*. Yale UP, 2019.

Egan, Sean, editor. *Bowie on Bowie: Interviews and Encounters with David Bowie*. Chicago Review Press, 2017.

Elam, Keir. *The Semiotics of Theatre and Drama*. Routledge, 1980.

Elam, Keir. "Dead Heads: Damnation Narration in the Dramaticules." *The Cambridge Companion to Beckett*, edited by John Pilling, Cambridge UP, 1994, pp. 145–66.

Eliot, Thomas Sterns. "The Hollow Men." (1925). https://allpoetry.com/the-hollow-men

Eliot, Thomas Sterns. "The Wasteland." (1922). https://www.poetryfoundation.org/poems/47311/the-waste-land

Elysium. Dir. Neil Blomkamp. Columbia Pictures, 2013.

Enns, Peter. *Incarceration Nation: How the United States became the most Punitive Democracy in the World*. Cambridge UP, 2016.

Erritzoe, David, Beata R. Godlewska, et al. "Brain Serotonin Release is Reduced in Patients with Depression: A [11c] Cimbi-36 Pet Study with a D-Amphetamine Challenge." *Biological Psychiatry*, October 2022. https://doi.org/10.1016/j.biopsych.2022.10.012.

Estima, Christine. "Meeting David Bowie," *NickySwift.com*. https://www.nickiswift.com/917095/why-meeting-david-bowie-had-such-an-impact-on-rupaul/. Accessed November 2022.

Feldman, Matthew. *Beckett's Books: A Cultural History of the Interwar Notes*. Continuum Literary Studies, 2006.

Ferris, Jim. "For the Betterment of Humanity," *The Disability Studies Reader*, edited by Lennard J. Davis. Taylor and Francis, 2013, pp. 550–1.

Ferris, Timothy. "David Bowie in America: The Iceman, having calculated, cometh." *Rolling Stone*, Nov. 9, 1972. Accessed at https://www.rollingstone.com/music/music-news/david-bowie-in-america-56227

"Fifty Most Stylish Men of the Past 50 Years." gq.com, 13 Sept. 2007, https://www.gq.com/gallery/cary-grant-paul-newman-andre-3000-george-clooney-slideshow. Accessed 1 Apr. 2020.

Fisk, Charles. *Returning Cycles: Contexts for the Interpretation of Schubert's Impromptus and Last Sonatas*. California Studies in 19th-Century Music Series. University of California Press, 2001.

Foucault, Michel. *The Birth of Biopolitics: Lectures at the Collège de France, 1978–1979*. Edited by Michel Senellart and translated by Graham Burchell, Palgrave Macmillan, 2008.

Foucault, Michel. *The History of Sexuality Vol. 1: The Will to Knowledge.* Translated by Robin Hurley, Random House, 1978.

Foucault, Michel. *Power/Knowledge: Selected Interviews and Other Writings*, edited by Colin Gordon. Vintage Books, 1980.

Foucault, Michel. *Society Must be Defended: Lectures at the Collège de France, 1975–1976*. Translated by David Macey, Picador, 2003.

Foucault, Michel. "What is an Author?" *Modernity and its Discontents*, edited by J. Marsh et al., Fordham University Press, 1969, pp. 299–314. Available at http://www.open.edu/openlearn/ocw/pluginfile.php/624849/mod_resource/content/1/a840_1_michel_foucault.pdf. Accessed 5 Jul. 2019.

Frances, Allen. "One Manual Shouldn't Dictate US Mental Health Research." *The New Scientist* 5/5/2013. https://www.newscientist.com/article/dn23490-one-manual-shouldnt-dictate-us-mental-health-research

Frances, Allen. *Saving Normal: An Insider's Revolt against Out-of-Control Psychiatric Diagnosis, DSM-5, Big Pharma, and the Medicalization of Ordinary Life*. William Morrow, 2014.

Gergen, K. J. "Postmodern Culture and the Revisioning of Alienation." *Alienation, Ethnicity and Postmodernism*, edited by Rudolf Geyer, Greenwood Press, pp. 117–25.

Gilman, Sander. "Representing Dead and Dying Bodies." *The Body in Literature*, edited by Ulrika Maude and David Hillman, Cambridge UP, 2015, pp. 149–62.

Gontarski, Stan, editor. *A Companion to Samuel Beckett*. John Wiley & Sons, 2010.

Goodall, Howard. "Bowie: Music, Lucky old Sun is in my Sky" in Geoff Marsh and Victoria Broackes, editors, *David Bowie Is London*, V&A Publishing, 2013, p. 165.

Gracyk, Theodore and Andrew Kania, editors. *The Routledge Companion to Philosophy and Music*. Routledge, 2014.

Graver, Lawrence and Raymond Federman, editors. *Samuel Beckett: The Critical Heritage*. Routledge, 2005.

Griffiths, David. "Inequality and Austerity: Our Weak Links in Countering COVID-19." Amnesty International, https://www.amnesty.org/en/latest/news/2020/05/inequality-and-austerityweak-links-in-counteringcovid19. Accessed 30 May 2020.

Grow, Kory. "Never Let Me Down." *Rolling Stone Special Editions: Bowie*, p. 87.

Haerdter, Michael. "Rehearsal Dairy for *Endgame*." *Beckett in the Theatre*, edited by Dougal McMillan and Martha Fehsenfeld, Riverrun Press, 1988, pp. 218–34.

Hamon, Phillippe. *Expositions: Literature and Architecture in Nineteenth Century France*. Translated by Katia Sainson-Frank and Lisa Maguire, University of California Press, 1992.

Hari, Johann. *Lost Connections: Uncovering the Real Causes of Depression*. Bloomsbury, 2018.

Harvey, Lawrence. *Samuel Beckett: Poet and Critic*. Princeton UP, 1970.

Hebdige, Dick. *Subculture: The Meaning of Style*. Routledge New Accents, 1979.

Hegel, Georg Wilhelm Friedrich. *The Phenomenology of Spirit*. Translated by A. V. Miller, Oxford UP, 1979 (orig. *Phänomenologie des Geistes*, 1807).

Heidegger, Martin. "The Question Concerning Technology," *The Question Concerning Technology and other Essays*. Translated by William Lovitt, Harper & Row, 1977, pp. 3–35.

Henriques, Julian, "Rhythm, Rhythmanalyis and Algorithm-Analysis," *Rhythm and Critique*, edited by P. Crespi and S. Magani, pp. 242–57.

Hill, Leslie. *Beckett's Fiction: In Different Words*. Cambridge UP, 1990.

Hodgkinson, Will. "Robert Smith: Timeless Tunesmith." *Guardian*, 30 May 2013, https://www.theguardian.com/music/2003/may/30/homeentertainment.features. Accessed 11 Jan. 2019.

Homer. *The Illiad*. Translated by Robert Fagles, Penguin, 1990.

Horgan-Jones, Jack. "The human cost of Covid-19: Ireland's care homes with the most deaths revealed." *The Irish Times*, May 28, 2020, https://www.irishtimes.com/news/ireland/irish-news/the-human-cost-of-covid-19-ireland-s-care-homes-with-the-most-deaths-revealed-1.4264170. Accessed 28 May 2020.

Houghton, Frank. "'Blacklists' and 'Whitelists': A salutary warning concerning the prevalence of racist language in discussions of predatory publishing," *Journal of the Medical Library Association*, vol. 106, no.4, 2018, pp. 527–30. https://doi.org/10.5195/jmla.2018.490

Hughes, Charles. "Erotopathia – Morbid Eroticism." *Alienist and Neurologist*, vol. 14, 1893, 531–78.

Hughes, Robert. *The Shock of the New: The Hundred-Year History of Modern Art, its Rise, its Dazzling Achievement, and its Fall*. Knopf, 1991.

Hutchins, Patricia. *James Joyce's World*. Methuen, 1957.

Jackobsen, Rowan. "Covid 19 Origin Story Questions." *The MIT Technology Review*, 13/6/21.

Jagose, Annamarie. "Queer Theory." *The Australian Humanities Review*, Dec. 1996, http://australianhumanitiesreview.org/archive/Issue-Dec-1996/jagose.html. Accessed 11 Jan. 2019.

James, Oliver. *Upping your Ziggy: How David Bowie Faced his Childhood Demons*. Routledge, 2018.

Jameson, Fredric. *The Political Unconscious*. Cornell UP, 1982.

Jeffries, Stuart. *Everything All the Time, Everywhere: How We Became Postmodern*. Verso, 2021.

Johnson, Kathryn. "David Bowie is." *David Bowie: Critical Perspectives*, edited by E. Devereux et al. pp. 10–21.

Jones, Allan. "Goodbye to Ziggy and All That." *Melody Maker*, 29 Oct. 1977, available at http://www.bowiegoldenyears.com/press/77-10-29-melody-maker.html. Accessed 1 Apr. 2020.

Jones, Dylan. *David Bowie: The Oral History*. Three River Press, 2017.

Jones, Dylan. "We'll miss you, David Bowie." GQ.com, Nov. 2002, https://www.gq-magazine.co.uk/article/david-bowie-ziggy-stardust-2002-heroes-interview-photos-1, accessed March 2019.

Joyce, James. *Finnegans Wake*. Random House, 2014.

Joyce, James. *Ulysses*. Penguin, 1983.

Juliet, Charles. *Conversations with Samuel Beckett and Bram Van Velde*. Translated by Tracey Cooke and Axel Nesme, Dalkey Archive Press, 2009.

Jung, Carl Gustav. *Liber Novus: The Red Book* (orig as notes 1914–1930). Edited by Sonu Shamdasani, Philemon Series and W.W. Norton & Co., 2009.

Kardos, Leah. *Blackstar Theory: The Last Works of David Bowie*. Bloomsbury Academic, 2021.

Kennedy, Séan, editor. *Beckett Beyond the Normal*. Edinburgh UP, 2020.

Kennedy, Séan. "Beckett, Evangelicalism and the Biopolitics of Famine." *Beckett Beyond the Normal*, pp. 62–79.

Kennedy, Séan. "'In the street I was lost': Cultural Dislocation in Beckett's 'The End.'" In *Beckett and Ireland*, edited by S. Kennedy, Cambridge UP, 2010, pp. 135–61.

Kennedy, Séan. "Introduction: (Dis)Embodied Beckett Studies?" *Journal of Beckett Studies*, vol. 27, no. 1, 2018, pp. 1–4.

Kimmelman, Michael. "David Bowie on his Favourite Artists." *The New York Times*, 14 Jun. 1999, https://www.nytimes.com/2016/01/15/arts/design/david-bowie-on-his-favorite-artists.html. Accessed 11 Jan. 2019.

Kiryushina, Galina, Einat Adar and Mark Nixon, editors. *Samuel Beckett and Technology*. Edinburgh UP, 2021.

Klein, Naomi. "Screen New Deal." *The Intercept* 8/6/2020. https://theintercept.com/2020/05/08/andrew-cuomo-eric-schmidt-coronavirus-tech-shock-doctrine/ 8/6/2020, accessed November 2022.

Klein, Naomi. *The Shock Doctrine: The Rise of Disaster Capitalism*. Picador, 2008.

Knowlson, James. *Damned to Fame: The Life of Samuel Beckett*. Bloomsbury, 1996.

Knowlson, James and Elizabeth, editors. *Beckett Remembering // Remembering Beckett: A Celebration*. Arcade Publishing, 2014.

Koetsier, John. "58% of American Knowledge Workers Are Now Working Remotely," Forbes, 20 March, https://www.forbes.com/sites/johnkoetsier/2020/03/20/58-of-american-knowledge-workers-are-now-working-remotely/#2edb54933303. Accessed 30 May 2020.

Kotter, Holland. "A Broken City. A Tree. Evening," *New York Times* 2/12/2007.

Krevel, Mojca. "The Mask Behind the Man: Gender Bending, Sexual Fluidity and the Fractal Subjectivity of David Bowie," https://www.researchgate.net/publication/344954040, accessed November 2022.

Lacan, Jacques. *The Four Fundamental Concepts of Psycho-Analysis*. Translated by Alan Sheridan, Penguin, 1979.

Lacan, Jacques. "The Function and Field of Speech and Language in Psychoanalysis." *Écrits*. Translated by Bruce Fink. W. W. Norton & Company, 2004, pp. 31–107.

Lacan, Jacques. *Seminar, Book XVII, The Other Side of Psychoanalysis*. Translated by Russell Grigg. W. W. Norton, 2007.

LaCapra, Dominick. "Acting Out and Working Through Trauma." Amos Goldberg interviews Professor Dominick LaCapra, 9 June 1998, https://www.yadvashem.org/odot_pdf/Microsoft%20Word%20-%203646.pdf. Accessed 1 Apr. 2020.

Laclau, Ernesto and Chantal Mouffe. *Hegemony and Social Strategy: Towards a Radical Democratic Politics*. Verso, 2001.
Lazarus, Emma. "The New Colossus." *Emma Lazarus: Selected Poems and Other Writings*, Broadview Press, 2002. Poem available at https://www.poetryfoundation.org/poems/49000/lady-lazarus. Accessed 11 September 2019.
Lennon, John and Paul McCartney. "All you Need is Love." *The Beatles*. Parlophone, Capitol, 1967.
Lewis, Marc. *The Biology of Desire: Why Addiction is not a Disease*. Public Affairs Books, 2015.
Lewontin, Richard, Steven Rose and Leon J. Kamin. *Not in our Genes: Biology, Ideology and Human Nature*. Pantheon Books, 1984.
Lloyd, David. *Beckett's Thing: Painting and Theatre*. Edinburgh UP, 2016.
Lloyd, David. *Irish Culture and Colonial Modernity 1800–2000: The Transformation of Oral Space*. Cambridge UP, 2011.
Loder, Kurt. "The Man who Owned the World." *Rolling Stone Special Editions: Bowie*, pp. 38–42.
Lovell, Terry. "Cultural Production." *Cultural Theory and Popular Culture: A Reader*, edited by John Storey, Pearson Education, 2009, pp. 509–15.
Lupro, Michael Mooradian. "Keeping Space Fantastic: The Transformative Journey of Major Tom." *Enchanting David Bowie* edited by T. Cinque et al., pp. 13–26.
Lyotard, Jean-Francois. *The Postmodern Condition: A Report on Knowledge*. Translated by Geoff Bennington and Brian Massumi, Manchester UP, 1983.
Lynch, Donald. "Why Ellen DeGeneres's Friendship with George W Shouldn't Bother Us." *Sunday Independent* 13 Oct. 2019, https://www.independent.ie/life/donal-lynch-why-ellen-degeneress-friendship-with-george-w-shouldnt-bother-us-38588681.html. Accessed 1 Apr. 2020.
Macherey, Pierre. *A Theory of Literary Production*. Routledge, 2006.
Marcuse, Herbert. *One Dimensional Man*. Sphere Books, 1968.
Marinetti, Filippo Tommaso. "Manifesto of Futurism," *Futurism: An Anthology*, edited by Lawrence Rainey, Christine Poggi, and Laura Wittman, Yale UP, 2009, pp. 51–2.
Marsh, Geoffrey. "100 Bowie Books." open book.ca, 26 Sept. 2103, http://openbook.ca/News/Special-Feature-How-to-Read-Like-Bowie-David-Bowie-s-Top-100-Books. Accessed 11 Jan. 2019.
Marx, Karl. *Capital Vol I: A Contribution to the Critique of Political Economy*. Translated by S. W. Ryazanskaya, Progress Publishers, Moscow, 1859. Available at marxists.org, https://www.marxists.org/archive/marx/works/1859/critique-pol-economy/, accessed 25 Dec. 2019.
Marx, Karl. *Capital Vol III*. Transcribed by Hinrich Kuhls, Dave Walters and Zodiac, https://www.marxists.org/archive/marx/works/download/pdf/Capital-Volume-III.pdf, accessed November 2022.
Marx, Karl with Friedrich Engels, *The Communist Manifesto* (1888), https://www.gutenberg.org/files/61/61-h/61-h.htm, accessed November 2022.
Marx, Karl. "Critique of Hegel's Philosophy of Right" (1843) https://www.marxists.org/archive/marx/works/1843/critique-hpr/. Accessed 12 November 2022.
Marx, Karl. "Estranged Labour." Economic and Philosophical Manuscripts of 1844. Translated by Martin Milligan, https://www.marxists.org/archive/marx/works/1844/manuscripts/labour.htm, accessed November 2022.

Marx, Karl. "Letters from the Deutsch-Französische Jahrbücher." Marx to Ruge, 1843, https://www.marxists.org/archive/marx/works/1843/letters/43_05.htm. Accessed 12 November 2022.
Marx, Karl. *The Poverty of Philosophy: Answer to the Philosophy of Poverty By M. Proudhon*, 1847. Translated by The Institute of Marxism, Leninism, https://www.marxists.org/archive/marx/works/download/pdf/Poverty-Philosophy.pdf, accessed November 2022.
Marx, Karl and Fredrich Engels. "Outlines of a Critique of Political Economy." 1843 https://www.marxists.org/archive/marx/works/1844/df-jahrbucher/outlines.htm, Accessed 13 November 2022
Mbembe, Achille, "Necropolitics." Translated by Libby Meintjes, *Public Culture*, vol. 15, no. 1, 2003, pp. 11–40.
McLuhan, Marshall. *Understanding Media: The Extensions of Man*. MIT Press, 1994.
McNaughton, James. *Samuel Beckett and the Politics of Aftermath*. Oxford UP, 2019.
Miles, Barry. *Call Me Burroughs: A Life*. Twelve, 2015.
Moncrieff, Joanna and Ruth E. Cooper et al. "The Serotonin Theory of Depression: A Systematic Umbrella Review of the Evidence." *Molecular Psychiatry*, July 2020.
Morin, Emily. *Beckett's Political Imagination*. Cambridge UP, 2017.
Morley, Paul. *The Age of Bowie*. Simon & Schuster, 2016.
Morley, Paul. "ZTT, Futurists and Me: The Lasting Legacy of Italian Futurism," Sothebys.com. 3/12/2021. https://www.sothebys.com/en/articles/ztt-futurists-and-me-paul-morley-on-the-lasting-legacy-of-italian-futurism. Accessed 13 May 2022.
Murphy, P. J. and Nick Pawliuk, editors. *Beckett in Popular Culture: Essays on a Postmodern Icon*. McFarland & Company, 2016.
Murray, Christopher. "Beckett Productions in Ireland: A Survey." *Irish University Review*, vol. 14, no. 1, Spring 1984, pp. 103–25.
Navaro-Yashin, Yael. "Affective Spaces, Melancholic Objects: Ruination and the Production of Anthropological Knowledge." *Journal of the Royal Anthropological Institute*, n.s. vol. 15, 2009, pp. 1–18.
Nietzsche, Friedrich. "On Truth and Lying in an Extra-Moral Sense," (orig. 1873) in Walter Kaufmann editor, *The Portable Nietzsche*, Viking Press, 1954.
Nixon, Mark. "Ruptures of the Physical: Beckett as Critic and Poet." *The New Cambridge Companion to Samuel Beckett*, Cambridge UP, 2015, pp. 73–85.
Nixon, Mark and Dirk van Hulle. *Samuel Beckett's Library*. Cambridge UP, 2013.
O'Brien, Eoin. "Zone of Stones: Samuel Beckett's Dublin." Eoin O'Brien.org, http://www.eoinobrien.org/wp-content/uploads/2009/01/zone-of-stones-samuel-becketts-dublin-journal-of-irish-college-of-phy-and-surg-041987.pdf. Accessed 11 Jan. 2019.
O'Connell, John. *Bowie's Books. The Hundred Literary Heroes Who Changed His Life*. Bloomsbury, 2019.
O'Connor, Sinéad. *Rememberings*. Penguin, 2021.
October, Dene. "The Becoming (Wo)Man Who Fell to Earth." *David Bowie: Critical Perspectives*, edited by E. Devereux et al. pp. 245–62.
Office of the Director of National Intelligence. CIA. USA. "Updated Assessment of Covid 19 Origins." Available at https://www.dni.gov/files/ODNI/documents/assessments/Declassified-Assessment-on-COVID-19-Origins.pdf. Accessed 13 November 2022.
O'Leary, Chris. https://bowiesongs.wordpress.com/2012/01/31/shades
Ølgaard, Daniel Møller. "Reflections on Naomi Klein's Pandemic Shock Doctrine." *E-International Relations*. https://www.e-ir.info/2020/09/15/reflections-on-naomi-kleins-pandemic-shock-doctrine/. Accessed 14 November 2022.

O'Neill, Joseph. "I'll Go On," *New York Times*, April 2, 2009, https://www.nytimes.com/2009/04/05/books/review/ONeill-t.html?action=click&module=RelatedCoverage&pgtype=Article*ion=Footer, accessed November 2022.
Oppenheim, Lois. *Directing Beckett*. University of Michigan Press, 1997.
O'Toole, Fintan. "Game without End," https://english.fsu.edu/fintan-o-toole-game-without-end, accessed November 1 2022.
Paraskeva, Anthony. *Samuel Beckett and Cinema*. Bloomsbury, 2017.
Pattie, David. "'God is in the House:' Beckett and Cave," *Pop Beckett*, edited by P. Stewart and D. Pattie, pp. 267–88.
Pegg, Nicholas. *The Complete David Bowie*. Titan Books, 2011.
Petrović, Gajo. "Marx's Theory of Alienation." *Philosophy and Phenomenological Research*, vol. 23, no. 3, Mar. 1963, pp. 419–26.
Pilling, John. "Introduction to Samuel Beckett, Le Concentrisme and Jean du Chas." *Modernism/Modernity*, vol. 18, no. 4, Nov. 2011, p. 881.
Pinter, Harold. *Beckett at 60: A Festschrift*. Calder and Boyars, 1967.
Plath, Sylvia. "Lady Lazarus." *Sylvia Plath: Collected Poems*, HarperCollins, 1992. Poem available at https://www.poetryfoundation.org/poems/49000/lady-lazarus. Accessed 11 Sept. 2019.
Proust, Marcel. *In Search of Lost Time*. Translated by D. J. Enright, C. K. Scott Moncrieff and Terence Kilmartin. Modern Library Classics, 2003.
Queer Theory. Wikipedia. https://en.wikipedia.org/wiki/Queer_theory
Radford, Tim. "Everything you Wanted to Know about Gravitational Waves." *Guardian* 11 Feb. 2016, https://www.theguardian.com/science/2016/feb/09/gravitational-waves-everything-you-need-to-know. Accessed 1 Apr. 2020.
Rancière, Jacques. *The Politics of Aesthetics*. Translated by Gabriel Rockhill, Continuum, 2006.
Rank, Otto. *The Trauma of Birth* (*Das Trauma der Geburt*, 1924). Dover Publications, 1993.
Redmond, Sean. "The Whiteness of David Bowie." *Enchanting David Bowie*, edited by T. Cinque et al. pp. 215–30.
Ridgway, Keith. "Knowing Me, Knowing You." *Guardian*, 19 July 2003, https://www.theguardian.com/books/2003/jul/19/featuresreviews.guardianreview19. Accessed 11 Jan. 2019.
Ridley, Matt and Alina Chan. *Viral: The Search for the Origin of COVID-19*. Harper, 2021.
Robinson, Jenefer. "Expression Theories." *The Routledge Companion to Philosophy and Music*, edited by T. Gracyk and A. Kania, 201–11.
Roeg, Nicholas (dir.), *The Man who Fell to Earth* (starring D. Bowie), British Lion Films, 1976.
Rogosin, Lionel (dir.). *On the Bowery*. Film Representations Inc. 1956.
Rollins, Henry. "When Rollins met Bowie." https://www.youtube.com/watch?v=D9ottHunvs4
Rosario, Vernon. *Homosexuality and Science: A Guide to the Debates*. ABC-CLIO, 2002.
Rousseau, Jean-Jacques, *Discourse Upon the Origin and the Foundation of the Inequality Among Mankind*, https://www.gutenberg.org/cache/epub/11136/pg11136-images.html. Accessed 12 November 2022.
Russell, Bertrand. "Interview on *The Listener*." BBC radio broadcast. Attribution uncertain.

Russell, Bertrand. "Philosophy for Laymen." *Unpopular Essays*, Routledge, 2009.

Russell, Bertrand. "Reflections on my Eightieth Birthday." *Portraits from Memory and Other Essays*, James Press, 2007.

Sagan, Karl. *Cosmos*. NBC 1980. https://www.space.com/1602-carl-sagans-cosmos-returns-television.html. Accessed 4 May 2020.

Salvo, Patrick. "David Bowie Interview," *Interview Magazine*, March 1973. https://www.bowiebible.com/songs/cygnet-committee/. Accessed 14 November 2022.

Sample, Ian. "Scientists struggle to stay grounded after possible gravitational wave signal." *Guardian*, 12 Jan. 2016, https://www.theguardian.com/science/2016/jan/12/gravitation-waves-signal-rumoured-science. Accessed 29 Apr. 2020.

Schneider, Alan. *Entrances: An American Director's Journey*. Proscenium, 1987.

Seinfeld, Gerry and Larry David. "The Big Salad." *Seinfeld*. Castle Rock Entertainment, 1994. www.youtube.com/watch?v=F2zTrBmI1nI

Shakespeare, William. *A Midsummer Night's Dream*. Oxford UP, 2009.

Shakespeare, William. *Hamlet*. Oxford UP, 2008.

Shakespeare, William. *King Lear*. Oxford UP, 2003.

Shakespeare, William. "Sonnet 60." (1609). https://www.poetryfoundation.org/poems/45095/sonnet-60-like-as-the-waves-make-towards-the-pebbld-shore. Accessed 14 November 2022.

Sharpe, Alex. *David Bowie Outlaw: Essays on Difference*. Routledge, 2021.

Sheehan, Paul. "Modernism: Dublin/Paris/London." *Beckett in Context*, edited by Anthony Uhlmann, Cambridge UP, 2013, pp. 139–60.

Sheen, Michael. "Foreword." *Recorder* magazine, no. 1, Sept. 2017.

Sheffield, Rob, editor. *Rolling Stone Special Editions: Bowie*, 2021.

Siebers, Tobin. "Disability and the Theory of Complex Embodiment," *The Disability Studies Reader*, edited by Lennard J. Davis. Routledge, 2016, pp. 270–9.

Simpson, Hannah. "Waiting for GOdoT: Samuel Beckett and HBO's *Game of Thrones*." *Pop Beckett*, edited by P. Stewart and D. Pattie pp. 227–46.

Smith, F. Joseph. *The Experiencing of Musical Sound: Prelude to a Phenomenology of Music*. Gordon and Breach, 1979.

Smith, T. V. *Philosophers Speak for Themselves: From Thales to Plato*. University of Chicago Press, 1956.

Smyth, David. "South African Township Happy." *The Guardian*, 1/8/2010, https://www.theguardian.com/world/2010/aug/01/south-africa-township-waiting-godot. Accessed 9 June 2022.

Sokal, Alan. "A Physicist Experiments." *Lingua Franca*, May/June 1996, http://linguafranca.mirror.theinfo.org/9605/sokal.html. Accessed 1 Jan. 2020.

Sokal, Alan. "Transgressing the Boundaries: Towards a Transformative Hermeneutics of Quantum Gravity." *Social Text*, no. 46/47, Spring/Summer 1996, pp. 217–52. https://physics.nyu.edu/faculty/sokal/transgress_v2/transgress_v2_singlefile.html. Accessed 1 Apr. 2020.

Solomon, Andrew. "The First New York Pride March was an Act of Desperate Courage." *New York Times*, 27 Jun. 2019, https://www.nytimes.com/2019/06/27/nyregion/pride-parade-first-new-york-lgbtq.html. Accessed 1 Mar. 2020.

Sontag, Susan. "Godot Comes to Sarajevo." *The New Yorker Review*, 21/10/93. https://www.nybooks.com/articles/1993/10/21/godot-comes-to-sarajevo. Accessed 9 June 2022.

Specktor, Brandon. "Dancing' star's weird, spirograph orbit proves Einstein right (again)." *Live Science*, 16 Apr 2020, https://www.livescience.com/star-orbiting-black-hole-proves-einstein-right.html. Accessed 4 May 2020.

Stanford Encyclopedia of Philosophy, https://plato.stanford.edu/entries/alienation https://plato.stanford.edu/entries/Marx. Accessed 13 November 2022.

Stark, Tanja. "Crashing out with Sylvian: David Bowie, Carl Jung and the Unconscious." *David Bowie: Critical Perspectives*, edited by E. Devereux et al. pp. 84–110.

Stewart, Paul. "A Rump Sexuality: The Recurrence of Defecating Horses in Beckett's Oeuvre." *Samuel Beckett Today/Aujourd'hui*, vol. 18, 2007, pp. 257–69.

Stewart, Paul and David Pattie, editors. *Pop Beckett: Intersections with Popular Culture*, Ibidem-Verlag, Stuttgart, 2019.

Stiegler, Bernard. *Acting Out*. Translated by David Barison et al., Stanford UP, 2009.

Storey, John, *Cultural Theory and Popular Culture: An Introduction*. Pearson Education, 2006.

"The Story of Tacheles". Berlin Street Art.com, https://berlinstreetart.com/kunsthaus-tacheles-berlin/. Accessed 1 Apr. 2020.

Thompson, Peter. "Negative Dialectics and the Frankfurt School," *Guardian*, 1/4/13, https://www.theguardian.com/commentisfree/2013/apr/01/negative-dialectics-frankfurt-school-adorno, accessed November 2022.

Tóibín, Colm. "My Darlings: Colm Tóibín on Beckett's Irish Actors." *London Review of Books*, vol. 29, no. 7, 5 Apr. 2007, https://www.lrb.co.uk/the-paper/v29/n07/colm-toibin/my-darlings. Accessed 1 Apr. 2020.

Trezise, Thomas. *Beckett: Into the Breach*, Princeton UP, 1990.

Troussé, Stephen. "Brian Eno on 'Heroes,'" *More Dark than Shark*. https://www.moredarkthanshark.org/eno_int_uncut-jun08.html, accessed November 2022.

Tynan, Kenneth. "Fin de Partie." *The Observer* 7/4/57, p. 15, in L. Graver and R. Federman, *Samuel Beckett: The Critical Heritage*. pp. 164–6.

Tyner, James A. *The Alienated Subject: On the Capacity to Hurt*. University of Minnesota Press, 2022.

Vandenberghe, Frédéric. *What's Critical About Critical Realism?: Essays in Reconstructive Social Theory*. Routledge, 2014.

Visconti, Tony. "We all Thought he had more Time." *Mojo*, Mar. 2016. Available at https://www.moredarkthanshark.org/eno_int_mojo-mar16.html. Accessed Jul. 2019.

Vorlicky, Robert, editor. *Tony Kushner in Conversation*. University of Michigan Press, 1998.

Waldrep, Shelton. *Future Nostalgia: Performing David Bowie*. Bloomsbury Academic, 2016.

Walmsley, Colin. "The Queers Left Behind." *The Huffington Post*, 21 Jul. 2015, https://www.huffingtonpost.com/colin-walmsley/the-queers-left-behind-ho_b_7825158.html. Accessed 1 Jun. 2019.

Walsh, Leighanna Rose. "Quest for Respectability: Leaving so many Trans Activists Behind." *journal.ie*, 21 Aug. 2015, https://www.thejournal.ie/author/leighanna-rose-walsh/3869/. Accessed 11 Jan. 2019.

Watson, Hunna J., et al. "Genome-Wide Association Study Identifies Eight Risk Loci and Implicates Metabo-Psychiatric Origins for Anorexia Nervosa." *Nature Genetics*, 15 July 2019, https://www.nature.com/articles/s41588-019-0439-2?utm_source=commission_junction&utm_medium=affiliate. Accessed 11 Aug. 2019.

Weiss, Lauren. "David Bowie's 100 Books." New York Public Library. https://www.nypl.org/blog/2016/01/11/david-bowies-top-100-books. Accessed 14 November 2022.

Weller, Shane. "The Unmaking of Homo Faber: Beckett and the Exhaustion of Technē," *Samuel Beckett and Technology*, edited by G. Kiryushina et al., pp. 13–29.

Whitelaw, Billie. *Who He?* Saint Martin's Press, 1996.

Wiene, Robert. *Das Cabinet des Dr. Caligari* (*The Cabinet of Dr. Caligari*). Goldwyn Pictures, 1920.

Wilde, Oscar. *The Picture of Dorian Gray*, https://www.gutenberg.org/files/174/174-h/174-h.htm, accessed November 2022.

Wilkinson, Judith. "When Alberto Giacometti met Samuel Beckett." tate.org, May 2017, https://www.tate.org.uk/art/artists/alberto-giacometti-1159/long-read/when-alberto-giacometti-met-samuel-beckett. Accessed 1 Apr. 2020.

Wilmer, Stephen and Audroné Žukauskaitė, editors. *Deleuze and Beckett*. Palgrave MacMillan, 2015.

Yeats, William Butler. "Lullaby." *Collected Poems of W.B. Yeats*. Palgrave MacMillan, 1989. Available at https://www.poemhunter.com/poem/lullaby-5/. Accessed 11 Sept. 2019.

Žižek, Slavoj, Judith Butler and Ernesto Laclau. *Contingency Hegemony, Universality: Contemporary Dialogues on the Left*. Verso, 2011.

Žižek, Slavoj. *The Courage of Hopelessness: Chronicles of a Year of Acting Dangerously*. Allen Lane, 2017.

Žižek, Slavoj. *Less than Nothing: Hegel and the Shadow of Dialectical Materialism*. Verso, 2013.

Žižek, Slavoj and Alain Badiou. *Philosophy in the Present*, edited by Peter Engelmann. Translated by Peter Thomas and Alberto Toscano, Polity, 2009.

Žižek, Slavoj. *The Ticklish Subject: The Absent Centre of Political Ontology*. Verso 2009.

Žižek, Slavoj. *Violence: Six Sideways Reflections*. Picador, 2008.

Zuboff, Shoshana. *The Age of Surveillance Capitalism: The Fight for a Human Future at the New Frontier of Power*, PublicAffairs, 2019.

Index

"1984" (Bowie) 153
2008 global recession 12

"Absolute Beginners" (Bowie) 8–9
Ackerley, Chris 76, 194, 195
"acting out" 105–7, 146
Addyman, David 69
Adidas 125–6
Adorno, Theodor 13–14, 29–30, 108, 126–7, 143
Aesthetic Theory (Adorno) 13–14
aesthetics 10–11
 and alienation 69–101, 139–64
 counterculture 23–8, 31–40
 engagement with death 187–8
 the generative, heteronormativity 119
 Jacques Rancière 40, 85–6, 99–100, 118, 133
 Pop Beckett 34–5
 regime of art 85–6
 ruination 33, 139–64
 tradition and theatre 26–7
affirmative vitalism 108–9
African American musicians 4–5
African Americans and police brutality 61–2
Agamben, Giorgio 6, 47
The Age of Bowie (Morley) 19, 57, 74, 112, 114, 166
agency 29, 50–1, 87–8
agōn (conflict) 12, 142
agriculture 170–1
Akademie der Künste 165
alcohol 20
The Alienated Subject (Tyner) 186
alienation 11–16, 36–7, 198–9
 and aesthetics of 69–101
 becoming quantum 186–7
 philosophy of 43–67
 ruination 139–64
 struggle/heteronormativity 111–37

The Alienist and Neurologist (Hughes) 111
"All the Madmen" (Bowie) 149
"All Strange Away" (Beckett) 119
"All that Fall" (Beckett) 75, 90–1
Anderton, Joseph 39
"The Angel of History" (Benjamin) 169–70
Anglo-Irish culture 152
"Anthem" (Cohen) 137
anthropomorphizing of exchange value 10
anti-capitalism *see* capitalism
Apple Corporation 32–3, 60–1
archetypal scapegoat 132–5
architecture, Italian culture 84–5
Aristotle 101, 103–4, 194
art
 aesthetic regime of 85–6
 for art's sake 40, 46–8
 classical Italian painting 93–4
 "deanthropomorphic" art 69, 79–80
 death as 177–8, 185
 deterritorialization 64, 69–70, 85, 108–9, 174
 expressionism 49, 81–2
 as form 74
 as inscribing "weakness" 152–3
 see also commodity; fetishism
Aryan supremacy 2, 33–4, 39–40
 see also Nazism/nationalism; Thin White Duke character
"As the Story was Told" (Beckett) 131
"Ashes to Ashes" (Bowie) 79, 193
asylum seekers *see* refugees
atheism 143–4
Atik, Anne 75, 173, 174
"atomistic" art 69, 79–80
Auerbach, Erich 183–4
Auerbach, Frank 83
Australia and racism 4–5
authenticity 17, 28, 37–8, 49–52, 156, 186–7

authoritarianism 5–6, 50–1, 140–2, 156–7
 see also hegemony; power
automated rhythm-analysis 158
avant-garde 20, 28, 36, 40–1, 48–9, 82
Avedon, Richard 33
awareness see consciousness

Baal (1982) 26
Badiou, Alain 139, 191–2
Bakhtin, Mikhail 124–5
Barbican Center, London 168
Barilar, Nic 130
Barnbrook, Jonathan 173–4
Barthes, Roland 40–1, 47, 52
A Basket of Roses (Fantin-Latour) 79
Basquiat (1996) 26
Baudelaire, Charles 46–8
Baudrillard, Jean 30–1
BBC (British Broadcasting Corporation) 8–9, 26, 35, 115–16
"Be My Wife" (Bowie) 91–2
The Beatles 186–7
Beauman, Ned 35
Beckenham Arts Lab 3
Beckett, Bill 75, 178–9
Beckett on Film 168
Beckett, May 144–5
Beckett in Popular Culture (Murphy) 32–3
Beckett, Suzanne 59
Belmont, Georges 48
Benioff, David 33
Benjamin, Walter 13–14, 29–30, 47–8, 77–8, 169–70, 190
Berlin, Germany 5–6, 28, 81–2, 165–73
Bevin, Nye 104–5
Bezos, Jeff 45
big pharma 150–1
Bignell, Jonathan 35
biological determination 118
 see also heteronormativity; transgender experience
biopolitics 127–9, 132–3
 and alienation 140–2, 147–51, 156–7, 162–3
 becoming quantum 187–8
 Michel Foucault 123, 127, 133
 necropolitics 61–2, 157–8
 plasticity differences 148–9

Birmingham School 29–31
The Birth of Biopolitics (Foucault) 123, 127, 133
Black Death plague 170
Black Lives Matter movement 61–2
Blackstar (★)/"Blackstar" (Bowie) 74–7, 172–4, 193–4
Blin, Roger 94
Bloom, Molly 186
Bottom (1991–1995) 34
Boxall, Peter 116
Boy George 123
Boyd, William 48
"Boys Keep Swinging" (Bowie) 117–18
Bracken, Pat 148
Braidotti, Rosi 126, 155, 157–8, 185–6, 187–8, 192
Brater, Enoch 94
"Breath" (Beckett) 98–9
Brecht, Bertolt 26
Britannia mascot, imperial England 87
British Broadcasting Corporation (BBC) 8–9, 26, 35, 115–16
Die Brücke 81–2
The Buddha of Suburbia (Bowie) 70
Burns, Terry 145–6
Burroughs, William 71–2, 192
Butler, Judith 120–1

The Cabinet of Dr. Caligari (1919) 49, 81
"The Calmative" (Beckett) 115–17
cancer, breast cancer 193–4
"The Capital of the Ruins" (Beckett) 131–2
capitalism 7–12, 40–1, 57–8, 87, 169–73, 181–2
 and becoming quantum 186–7
 cognitive capitalism 140–1
 commodity 40–1, 46–54, 99–100, 153–4, 198–9
 "creative capital" 54–5
 deforestation 170–1
 digital capitalism 140–2
 "disaster capitalism" 140
 Felix Guattari 108–9, 122
 Gilles Deleuze 72, 108–9, 166, 197–8
 glam 127–8
 global recession, 2008 12
 hegemonic meaning-making 16

"industrial capitalism" 45, 46–7
language games 189–90
philosophy of alienation 43–67
"point de capiton" 163
subject-object relation 100–1
surveillance capitalism 140–2, 156–7
see also Marx
Carnegie Endowment for International Peace 13
"Carnival and the Carnivalesque" (Bakhtin) 124–5
Carr, Eamon 80
"A Case in a Thousand" (Beckett) 75–6
Cash, Johnny 185
Catholic church 44, 114, 132
see also Christianity
Cave, Nick 14–15, 178
Cézanne, Paul 69, 79–80, 195
The Chair (2021) 33
"Changes" (Bowie) 104–5
chaos 70–1
see also insanity
Chapman, Ian 67
Checkpoint Charlie, Berlin 28
childhood trauma 132
Chile and Pinochet 140
"China Girl" (Bowie) 23, 56
Chopin, Frédéric 90
Christianity 9, 90
Christ's crucifixion 84–5, 183
Cinque, Toija 22–3, 151
Cinton, Hillary 136
"civilized-heathen/barbarian" dualisms 100–1
The Clash 27
classical Italian painting 93–4
classical notions of tradition and aesthetics 26–7
class-identity 37–8, 62–3
see also white privilege; working-classes
Cluchey, Rick 22, 165
Coconut Grove Playhouse, Miami 56
cognitive capitalism 140–1
Cohen, Leonard 137, 185
coming out 135–6
commercialism
mental health 150–1

of Pride parade 123–7
see also capitalism
commodity 40–1, 46–54, 99–100, 153–4, 198–9
Communist Manifesto (Marx) 10–11
A Companion to Samuel Beckett (Gontarski) 31
concentration camps 131
conceptualization of matter 103–4
consciousness 87–8, 147–8, 174–7, 183–8, 194
see also commodity; fetishism; Freud
Conservatism *see* Catholic church
control/power 140–3, 147–8
see also hegemony
Corey-Boulet, Robbie 136
counterculture 19–41, 46–8, 198–9
"A country road. A tree. Evening" (Beckett) 7
The Courage of Hopelessness (Žižek) 10, 127, 133–5, 139, 184–5, 206
COVID-19 pandemic 61–3, 85, 139–40, 153–7, 170–1
"Crashing out with Sylvian" (Stark) 147
Cratylus 105
"creative capital" 54–5
crisis narratives 140–3, 180
crisis of spirit 12
Critchley, Simon 51–2, 91, 112–16, 161, 186–7
"Critique of Hegel's Philosophy of Right" (Marx) 107
A Critique of Political Economy (Marx) 10, 147–8
Crowe, Cameron 55–6
Curb Your Enthusiasm (2000–present) 34
The Cure 112
"cut-up technique" 71–2
"Cygnet Committee" (Bowie) 3–4

D'Amado, Amadeo 6
Damned to Fame (Knowlson) 20, 22, 59, 94, 98, 144–5, 181–2, 187
Dance on the Pier, New York 124
"Dancing out in Space" (Bowie) 193
Dandyism 47
Dante 74–7, 79
"the dark", embracing of 145

Darsa, Alissa 81–2
data accumulation and free society 140–1
David Bowie: Critical Perspectives (October) 122
"David Bowie is" exhibition 145–6
David, Larry 34
Davis, Mike 170–1
"deanthropomorphic" art 69, 79–80
death 162–4, 172–81, 183–8
 "easeful death" 144
 see also memento mori; necropolitics
Death and the Maiden (Schubert) 90–1
Dechevaux-Dumesnil, Suzanne 90–1
deconstructivism 22, 69, 108–9
defamiliarization of the normal 114
deforestation 170–1
DeFries, Tony 55
dehumanization 157–8, 172
Deleuze, Gilles 72, 108–9, 166, 197–8
Democritus of Abdera 194
deracination 4
Descartes, René 100–1
deterritorialization of person 64, 69–70, 85, 108–9, 174
The Diagnostic and Statistical Manual of Mental Disorders (DSM) 121, 149
Diamond Dogs (Bowie) 108, 153
"Dig Lazarus Dig" (Cave) 178
digital capitalism 140–2
 see also crisis narratives
digital teaching "modalities" 139–40
Disabilities Studies 120
disabled experience 154
"disaster capitalism" 140
"disclosure of truth" 144
Discourse on the Origin and Foundations of Inequality (Rousseau) 44–5
"dispositif" and/or "apparatus" (Foucault & Deleuze) 72
diversity, Pride parade 123–7
Divine Comedy (Dante) 74–7
Dix, Otto 81
"DJ" (Bowie) 151
"'Do you really enjoy the modern play?': Beckett on Commercial Television" (BBC) 35
Dolls, Billy 98–9
Dowd, Garin 89

"Drive in Saturday" (Bowie) 172
Driver, Tom 70
DSM (*The Diagnostic and Statistical Manual of Mental Disorders*) 121, 149
dualisms, subject-object relation 100–1
Dublin, Ireland 20–1, 23, 75–6, 79–80
 Easter Rising of 1916 152
 Gate Beckett Festival 168
 Trinity College 40, 48–9, 55
Duthuit, Georges 84–5, 86, 93–4, 98
Dylan, Bob 4
dystopias 118, 153–4, 179

Eagleton, Terry 124–5, 189–90
"easeful death" 144
Echo and the Bunnymen 112
 see also McCulloch
economic performativity
 legalization of gay marriage 120–1
 see also capitalism
Les Éditions de Minuit 53–4
education 28–30
 see also universities
"Eh Joe" (Beckett) 83
"E-International Relations" 141
Elam, Keir 76
The Elephant Man 26, 168
Eliot, T.S. 77–8
elite cultural division 36–8
 see also white privilege
Elizabethan theatrical tradition 24–5
Elysian Fields 181
"emancipate time" 166
Enchanting Bowie (Cinque et al.) 22–3
"The End" (Beckett) 119–20, 154–5
Endgame (Beckett) 6, 74–6, 81–2, 94, 95–7, 119, 129
Engels, Friedrich 107
Eno, Brian 165–6
"Enough" (Beckett) 129–31
environmental collapse 153–4, 170–1
equal rights 136
 Gay Pride 123–7
eroticism 27–8, 113, 115–21
Esslin, Martin 64
"Estranged Labour" (Marx) 52–7
European Southern Observatory (ESO) 193

ex nihilo (out of nothing) 105–8
existentialism 24–5
"The Expelled" (Beckett) 154–5
The Expelled and Other Novellas (Beckett) 55, 115–16, 120, 154–5
Expositions (Hamon) 88–9
expressionism 49, 81–2
Extras television show 8–9

Facebook 35–6
factory farming 170–1
faith as concept 143–4
 see also Catholic church
The Falstaff, Montparnasse 20
"Fame" (Bowie) 59, 151
Fantin-Latour, Henri 79
fascism 2–3, 5–6, 33–4, 39–40, 44, 139
 see also Thin White Duke character
Fauvist painters 84–5
festivals 168
 see also Pride parade
fetishism 46–8, 129, 198–9
 see also commodity
Film (Beckett) 118–19, 160–1, 172
"First Love" (Beckett) 55–6, 154–5
Fiske, John 29
"Five Years" (Bowie) 51, 153–5
Fizzles (Beckett) 195–6
Les Fleurs du Mal (Baudelaire) 47
food insecurity 171
Foucault, Michel 50, 127–8, 140–1, 157, 163
 The Birth of Biopolitics 123, 127, 133
 "dispositif" and/or "apparatus" 72
foundational ontological dualisms 100–1
France
 during the Algerian war 160
 see also Paris
Frankfurt School 12, 29, 30, 107–9
 see also Adorno; Benjamin
free market economics 13
 see also capitalism
free society 127–8, 134–5, 140–1
 see also liberalism; neoliberalism
freedom of enjoying the physical 119–20
Freud, Sigmund 129, 146
 see also "acting out"

Friday, Gavin 112
Fripp, Robert 165
"Future Legend" (Bowie) 153
Future Nostalgia (Waldrep) 31–2, 46–7
futurism 161–2
 see also technology

Game of Thrones, "Mockingbird" episode (2014) 33
Gate Beckett Festival 168
gay identity 113, 115–21
 coming out 135–6
 homophobia 150–1
 marriage 120–1
 Pride parade 123–7
 Soho club scene 122–3
 as subversive 150
 Ziggy Stardust and the Spiders from Mars 153–4
 see also queerness
"Geist", or spirit 44–5
gender
 cancer, breast cancer 193–4
 discrimination 45, 127
 glam 127–8
 homoerotic/queer eroticism 115–21
 and sexuality 37–8
 transgender experience 117–18, 123–4, 128–9, 154
 see also LGBTQ+; queerness
gentrification 124–5
Germany
 Expressionism 81–2
 "German period" 71
 see also Berlin
Gestapo 22
"Ghost Trio" (Beckett) 74–5, 90–1
Giacometti, Alberto 20, 114
Gillespie, Dana 44
Gilman, Sander 183, 184
Gysin, Brion 71–2
glam culture 27–8, 127–8
 see also queerness
global recession, 2008 12
"God is in the House: Beckett and Cave" (Pattie) 14–15
Gontarski, Stanley 31, 76
Goodall, Howard 25

"Goodbye to Ziggy" (Bowie) 2–3, 5–6
good-evil dualisms 100–1
Goodman, Mark 4–5, 22
GQ Magazine 34
"Gravitational Waves" (Radford) 198
Guardian newspaper 193–4
Guattari, Félix 108–9, 122
Guggenheim, Peggy 20
gun culture 5

H5N1 (bird flu) 171
Haerdter, Michael 60, 70
Hall, Stuart 29–31
Hamlet (Shakespeare) 173
Hamon, Phillippe 88–9
Happy Days (Bowie) 74, 119
Harvey, Lawrence 83
Haydn, Joseph 90–1
Head of Gerda Boehm (Auerbach) 83
health care 61–2
Hebdige, Dick 37–8
Heckel, Erich 81–2
Hegazi, Sarah 136
Hegel, George Wilhelm Friedrich 44–5, 107, 134–7
hegemony 16, 83, 108–9, 129
Heidegger, Martin 70, 91, 144
Henriques, Julian 157–8
Heraclitus 105
"Heroes" (Bowie) 5–6, 79, 82, 165–6, 172
heteronormativity 23–4, 111–37
 see also white privilege
high culture 24–5
historical materialism 190–1
historicism 190–1
Hitler, Adolf 2, 33–4
"The Hollow Men" (Eliot) 77–8
Homeric death 183
"Homo Sacer", the "accursed" (Agamben) 6
homoerotic/queer eroticism 113, 115–21
homophobia 150–1
Hong Kong, H5N1 (bird flu) outbreak, 1997 171
How it Was (Atik) 75, 173, 174
Hughes, Charles H. 111
Hughes, Robert 28

Hulle, Dirk van 74
human nature 148–9
 see also consciousness
human rights see equal rights
"Hurt" (Cash) 185
Hurt, John 168

"I", authority of 50–1
The Idiot (Iggy Pop) 82
Iggy Pop 82, 168–9
Iliad (Homer) 183
Ill Seen Ill Said (Becket) 75
iMac 32–3
inclusivity 132–7
 see also diversity; queerness; subaltern
"indie" culture 27
indigenous Australians 4–5
"industrial capitalism" 45, 46–7
industrial revolution 62–3
industry, industrial development 46–7, 87
 subject-object relation 100–1
 see also capitalism; commodity; fetishism
Inferno (Dante) 74–7, 79
insanity 70–1, 145, 147, 149–51
 see also mental health
Instagram 25–6
instantiation of ruination 81
internalization 153
inter-racial empathy 153–4
intersubjective proxemics 98
Ireland
 War of Independence 152
 see also Dublin
"Is there Life on Mars?" (1972) 51, 87–8
Isolar tour, 1976 82
isolation see alienation
Italian classical painting 93–4
Italian neo-realist cinema 24–5
Italian Renaissance painting 84–5
ITV network 35

Jagose, Annamarie 117
James, Oliver 146
Jameson, Fredric 12, 150
"Jean du Chas" (fictional poet) 48–9
Jobs, Steve 32–3

"John—I'm only Dancing" (Bowie) 127–8
Johnson, Jan 22
Jones, Allan 2–3
Joyce, James 20, 27
Jung, Carl 147

Kafka: Towards a Minor Literature (Guattari) 122
Kafka, Franz 122, 183–4
Kardos, Leah 193, 197
Kaun, Axel 71
Keating, Ronan 168
Keats, John 144
"Keeping Space Fantastic: The Transformative Journey of Major Tom" (Lupro) 65
Kemp, Lindsay 173
Kennedy, Séan 119, 132, 157, 183–4
Kimmelman, Michael 81, 83
King, Joelene 4
King Lear (Shakespeare) 173–4, 177
Kirchner, Ernst 81, 82
Klein, Naomi 140, 156–7, 180
Knowlson, Elizabeth 144
Knowlson, James 20, 22, 59, 94, 98, 144–5, 181–2, 187
"Kooks" (Bowie) 8–9
"Krapp's Last Tape" (Beckett) 74–5, 145, 165–8, 172
Krauss, Werner 81
Krevel, Mojca 118

labor/laborers 28, 45–6, 52–7, 60–1, 63, 107, 156–7
 see also capitalism; Marx
Lacan, Jacques 146, 163
Laclau, Ernesto 9–10, 13
"Lady Lazarus" (Plath) 177–8
language games 189–90
Lazarus, Emma 177–8
Lazarus/"Lazarus" (Bowie) 26, 74–7, 172–4, 177–9
legalization of gay marriage 120–1
"Lesbians and Gays Support the Migrants" (LGSM) 126–7
Less Than Nothing (Žižek) 134
Let's Dance/"Let's Dance" (Bowie) 4, 22–3, 55–6, 59, 91

"Das Ietzte Band" (Akademie der Künste) 165
LGBTQ+ communities 62
 see also queerness
liberalism 122–3, 127–8
 see also neoliberalism
"Life on Mars?" (Bowie) 51, 79, 86–90, 117
Lincoln Center, New York 168
literary modernism 24–5
Lloyd, David 78–80, 152–3, 159–60
Loder, Kurt 4–5, 19–20
Lodger (Bowie) 92
London, England
 "David Bowie is" exhibition 145–6
 Gate Beckett Festival 168
 Pride parade 126–7
"The Lord Chamberlain's Men" 173
love 55–6, 116–17, 154–5, 186–7
Love Falls on Us: A Story of American Ideas and African L.G.B.T Lives (Corey-Boulet) 136
Lovell, Terry 7–8
"Lucky old Sun is in my Sky" (Goodall) 25
Lupro, Michael 65
Lust for Life (Iggy Pop) 82
Lyotard, Jean-François 11, 31–2, 189–92, 198

McCartney, Stella 34
McCulloch, Ian 112, 123
McGovern, Barry 33
MacGowran, Jack 20
Macherey, Pierre 149
McLuhan, Marshall 159
MAD (mutually assured destruction) 142–3
Magee, Pat 20
Major Tom character 25–6, 49, 65–7, 134–5, 174, 192–3
"Malacoda" (Beckett) 75
Malone Dies (Beckett) 114, 181
The Man who Fell to Earth (1976) 26, 161
Marcuse, Herbert 13–14
"margin people" (Beckett) 39–40
 see also subaltern
Marinetti, Filippo Tommaso 161–2
Marriot Bonvoy Hotels 125–6
Marx, Karl 1–4, 7–16

alienation and ruination 147–8, 149, 159
becoming quantum 185–7
coming out, dialectics and negative ontology 135–6
Communist Manifesto 10–11
"Critique of Hegel's Philosophy of Right" 107
A Critique of Political Economy 10, 147–8
deterritorialization in art, world-framing 108–9
epistemological/ontological intervention 137
"Estranged Labour" 52–7
free society 134–5
"industrial capitalism" 45, 46–7
maxim on consciousness 147–8, 174–7
The Poverty of Philosophy 45
revolution in the now 191
species being 8, 46, 57–61, 63–5, 79, 86–7
Stanford Encyclopedia of Philosophy 159
see also alienation; postmodernism
Mbembe, Achille 61, 157, 180
see also necropolitics
memento mori 173–7, 192–3
mental health 143, 145–6, 147–8, 149–51
see also *The Diagnostic and Statistical Manual of Mental Disorders*
Merrick, John see *The Elephant Man*
Merry Christmas Mr. Lawrence (1983) 23
Messianic time 14, 190
methodology 1–17
Middle Eastern Respiratory Syndrome (MERS) 170
A Midsummer Night's Dream (Shakespeare) 173
migrants 5–6, 28, 177–8
and Pride movements 126–7
Miles, Barry 72
military rhythm 158
Mimesis (Auerbach) 183–4
misogyny 45, 127
Mitte district, Berlin 168–9
mode of production 10
see also capitalism
Modern Languages Society 48–9
"Modern Love" (Bowie) 56

modernism, see also literary modernism; postmodernism; white privilege
Molloy (Beckett) 88–90, 104, 114, 116–17, 134–5, 145, 152
monastic lifestyle 19–20
Morley, Paul 19, 57, 74, 112, 114, 166
mortality see death
Mouffe, Chantal 9–10
"Move On" (Bowie) 92
MTV (Music Television) 22, 59
multiculturalism 150–1
see also diversity
Murphy (Beckett) 60, 75–6, 82, 104, 181, 195
Murphy, P. J. 32–3
Musk, Elon 45, 58
mutually assured destruction (MAD) 142–3

"Nacht und Träume" (Beckett) 14–15, 97–8
Nat Tate (fictional artist) 48
National Aeronautics and Space Administration (NASA) 193
nationalism, see also Nazism
Naumann, Hans 69–70
Nazism/nationalism 2, 33–4, 39–40, 44, 139
see also Thin White Duke character
necropolitics 61–2, 157–8
negative dialectics 12, 107–9
negative ontology 135–6
neoliberalism 50–1, 62–3, 133–5, 141, 198–9
Netflix 33
"New Afro/Pagan and Work" 74
New Deal, Roosevelt 4
New York Dolls 98–9
New York Times 81
New York, USA
City Pride 124–7
first production of *Godot* 33
New School 30–1
Newley, Anthony 91–2
"The Next Day" (Bowie) 74–5, 76
The Next Day (Bowie) 173–4, 193
Nietzsche, Friedrich 58
Nike 125–6

Nine Inch Nails 185
Nixon, Mark 74
Nolde, Emil 81
non-alienated labor 57
Not I (Beckett) 83, 115–16, 151
now, presentness 189–92

"objet petit a"/"point de capiton" 146, 163
O'Brien, Eoin 94
Ocean's 8 (2018) 33
O'Connell, John 143–4
O'Connor, Sinéad 150
October, Dene 122
Oedipus 132–3, 177
"Oh You Pretty Things" (Bowie) 147, 150
Ølgaard, Daniel Møller 141, 180
On the Bowery (1956) 20
On Bowie (Critchley) 51–2, 112–13, 115–16, 186–7
"On Popular Music" (Adorno) 13–14
Once a Thief (1996-1997) 34
online theater 85
"organization of chaos" 70–1
Orwell, George 153
otherness/outsiders *see* subaltern
O'Toole, Fintan 27
"ousia" (conceptualization of matter) 103–4
Overbeck, Lois 84

"Panic in Detroit" (Bowie) 172
paranoia, technological 153–5, 159–65
Paraskeva, Anthony 15, 81, 95, 159–60
Paris, France 20–1, 23
Pattie, David 14–15, 33, 34–5, 40–1
Pembroke University 33
peripatetic lifestyle 92
Petrović, Gajo 45
Phenomenology of Spirit (Hegel) 44–5
philosophy 99–101, 103–9, 191–2
 of alienation 43–67
 see also aesthetics; *individual philosophers…*
"Philosophy Notes" (Beckett) 194
Philosophy in the Present (Badiou) 191–2
Physics (Aristotle) 194

A Picture of Dorian Grey (Wilde) 47–8
Pinochet, Augusto 140
Pinter, Harold 27
plague 170
Plath, Sylvia 177–8
Plato 103–4
Play (Beckett) 80–1, 94, 159–60
"Play" (Beckett) 172
poiēsis 144, 162–3
"point de capiton" 146, 163
police brutality 61–2
politics 1–17
 see also biopolitics; philosophy
Pop Beckett (Pattie & Stewart) 33, 34–5, 40–1
pop(ular) culture 24–6, 32–7, 196–7
 see also capitalism; white privilege
"Posthuman Affirmative Politics" (Braidotti) 126, 192
The Postmodern Condition (Lyotard) 198
postmodernism 29–37, 189–90, 198
post-war experience 131–2, 143–4
Poulac, Michel 53
poverty 45, 93–4
 see also working-classes
The Poverty of Philosophy (Marx) 45
power 140–3, 147–8
 to kill 157
 see also hegemony
Power, Corruption, And Lies (New Order) 79
present(ness), the now 189–92
Presley, Elvis 54
The Prestige (2006) 26
"Pretty Bowie" Instagram page 25–6
Pride parade 123–7
Prince 185
privilege 103–4, 147–8, 156–7
 see also white privilege
propaganda films 2
prostitution 20, 53–4, 127–8, 135
proto-fascism 2–3
Proust (Beckett) 97, 98, 163–4
Proust, Marcel 92–3, 162
psychiatry 121, 149
 see also mental health

Quad (Beckett) 97–8
Quantum Leap (1989–1993) 34
"Queer Liberation March", Manhattan 126–7
"Queer Theory", Studies 113–15, 130–1
queerness 16–17, 19, 109
 eroticism 113, 115–21
 The Expelled and Other Novellas 154–5
 struggle/heteronormativity 111–37
 as subversive 150
 Ziggy Stardust and the Spiders from Mars 153–4
"The Question concerning Technology" (Heidegger) 144
"Quicksand" (Bowie) 58, 143–4

racism 4–5, 12, 39–40, 45, 59, 62, 127
 see also Nazism/nationalism
Radford, Tim 198
Rancière, Jacques 40, 85–6, 99–100, 118, 133
Rank, Otto 104
RCA Records 54
recession 12
Redmond, Sean 23
"Reflections on Naomi Klein's Pandemic Shock Doctrine" 180
refugees 131–2, 136–7, 155
 see also migrants
religious beliefs 143–4
 see also Catholic church
"revealing", or "Entbergen" 144
 see also poiēsis
"revolutionary time" (Benjamin) 77–8
revolutionary-becoming of people 189–92, 197–8
 see also Marx
Ridgway, Keith 114–15, 116
Riefenstahl, Leni 2
Roberts, Terry 4
Robinson, Jenefer 91, 92–3
"Rock 'n' Roll Suicide" (Bowie) 15
rock-and-roll hedonism 19–20
Roeg, Nicholas 26
Rogers, Nile 56
Rollins, Henry 8
Roman *res publica* 153
Roosevelt, Franklin Delano 4

Roquairol (Heckel) 82
Rothko, Mark 27
"Rough for Radio II" (Beckett) 75
Rousseau, Jean-Jacques 44–5
Rubin, Jerry 3
ruination 33, 139–64
RuPaul 118

sacred/profane dualisms 100–1
Sagan, Carl 197–8
Saint Valentine 5
"Saint-Lô" (Beckett) 143–4
Saint-Lô, France 131–2, 152
same-sex marriage 120–1
Samuel Beckett's Library (Nixon & Hulle) 74
Sartre, Jean-Paul 20, 33–4, 70
"Scary Monsters and Super Creeps" (Bowie) 149–50
Schiele, Egon 82
Schmidt-Rottluff, Karl 81
Schnabel, Julian 26
Schubert, Franz 90–3, 97–8
"Scream like a Baby" (Bowie) 150
"Screen New Deal" (Beckett) 156–7
Sean's Show (1992–1993) 34
Seinfeld (1989–1998) 34
"self-alienation" 45–6
self-identification *see* agency
sensible and sense perception 85–6
"serious music" (Adorno) 13–14
Severe Acute Respiratory Syndrome (SARS) 170
sexual trauma 131–2
sexuality, *see also* queerness
Seyrig, Delphine 94–5
Shakespeare, William 173–6, 177
Sharpe, Alex 72
Sheehan, Paul 81, 82
Sheen, Michael 177
shock doctrines *see* crisis narratives
Simpson, Hannah 33
Simulacra and Simulation (Baudrillard) 30–1
Siouxsie Sioux (and the Banshees) 112–13
Sleep Sound (Yeats) 80–1
Smith, Robert 112
"So You want it Darker" (Cohen) 185
social conformity 150–1

social media 25–6, 35–6
Social Text journal 189
Socrates 106–7
Sokal Hoax, 1996 189
solipsism 29–30, 185–6
sovereignty 71–2, 157
 see also agency; alienation; consciousness
"Space Oddity", *see also* Major Tom character
Spanish Inquisition 9
species being 8, 46, 57–61, 63–5, 79, 86–7
Stalin, Joseph 9
Stanford Encyclopedia of Philosophy 43–4, 159
"Star" (Bowie) 104–5, 194
Stark, Philip 47
Stark, Tanja 147
"Starman" (Bowie) 122, 123–4
Station to Station (Bowie) 2, 161–2, 172
stereotypes 38, 87–8
 see also archetypal scapegoat
Stewart, Paul 33, 34–5, 40–1, 129
Stiegler, Bernard 105–7
"still life" 79, 81–2
"Stimmung" (Heidegger) 91
"Stirrings Still" (Beckett) 76, 181–2
Storey, John 15, 25, 29, 83, 108–9
Storm und Drag 19
straightness *see* heteronormativity
student protest 29
subaltern, the 22, 38–9, 86–7, 132–7
 see also alienation
Subculture: The Meaning of Style (Hebdige) 37–8
subject-object relation 100–1
subversive value of poetry 47–8
"suffering of being" 98, 163–4
"Suffragette City" (Bowie) 115
super slums 170–1
surveillance capitalism 140–2, 156–7
 see also crisis narratives
sweat shops 60–1
"Sweet Thing" (Bowie) 15, 51, 117, 118–19, 153
Swine flu outbreak, 2009 170
symbolism

Blackstar (★) (Bowie) 193–4
 as mapped psychological terrain 146, 163

teaching online 139–40
technē 144, 162–3
technology 140–2, 153–65
teleology 187–8
television culture 34–5
temporal simultaneity 190
temporality 93
Tesla, Nikola 26
"têtes-mortes"/"still life" 79, 81–2
"Texts for Nothing" (Beckett) 50
"That Time" (Beckett) 74–5, 83
"Theses on the Philosophy of History" (Benjamin) 14, 190
Thin White Duke character 2, 5, 22–3, 39, 162
Thompson, Peter 12, 107
A Thousand Plateaus (Deleuze & Guattari) 108
"Time" (Bowie) 98–9, 117
"'Tis a Pity She's a Whore" (Bowie) 15
Tóibín, Colm 20
Top of the Pops 25–6, 114, 122, 123–4
torture scandals of war 160
tradition and aesthetics in theatre 26–7
transgender experience 117–18, 123–4, 128–9, 154
"Transgressing Boundaries: Towards a Transformative Hermeneutics of Quantum Gravity" 189
trauma 7, 104, 131–2, 143–4, 150–1
 see also mental health
The Trauma of Birth (Rank) 104
The Trial (Kafka) 183–4
Trinity College Dublin 40, 48–9, 55
The True Life (Badiou) 139
truth 51, 144
 see also authenticity
Twitter 35–6
Tynan, Kenneth 37
Tyner, James A. 61–2, 186

Übermensch ideology 2, 39–40
 see also Nazism/nationalism
Uhlmann, Anthony 94–5
unconscious *see* consciousness
United States

African American musicians 4–5
Coconut Grove Playhouse, Miami 56
The Elephant Man on Broadway, 1980 26
free market economics 13
Gate Beckett Festival, New York 168
gun culture 5
NASA 193
necropolitics 61–2
New Deal, Roosevelt 4
New School of New York 30–1
New York City Pride 124–7
New York, first production of *Godot* 33
New York immigration 177–8
police brutality 61–2
working-class identity 62–3
universal equality 187
 see also love
universities 28–30, 33
The Unnamable (Beckett) 50, 114, 145
unresolved conflict (Adorno) 143
Upping your Ziggy (James) 146
utilitarian homogeneity 143–4

Van Wagner, Estair 171
Velvet Underground 28
viral antagonism 141–2
The Virgin Prunes (Gavin Friday) 112
Visconti, Tony 122, 136, 165
"Visionary Artist", Jungian hypothesis 147
vital materialism 185–6

Waiting for Godot (Beckett) 6, 7, 35
 and aesthetics of alienation 72–3, 74, 80, 85, 90, 95–7, 99
 alienation as ruination 145, 152, 161
 first New York production 33
 the generative, heteronormativity 119
 philosophy of alienation 51, 53, 56, 63–6
 "Queer Theory" 114–15
 Seinfeld 34
Waldrep, Shelton 31–2
Walmsley, Colin 124
Walsh, Leighanna Rose 23, 120–1
war 131–2, 143–4, 150–1
Warhol, Andy 26, 47–8, 87
The Wasteland (Eliot) 77–8
Watt (Beckett) 38–9, 73, 76, 85, 94, 194–5

"We are the Dead" (Bowie) 153
Weill, Kurt 112
Weiss, D.B. 33
Wenders, Wim 172
Western Canon 24–5
"What is an Author?" (Foucault) 50
"What is the Word" (Beckett) 94, 152, 194–5
"What Where" (Beckett) 83, 160
"Where Are we Now?" (Bowie) 168–9, 172, 173, 176
"white dwarf" star 196–7
white privilege 21–4, 28–9
Whitelaw, Billie 94–5
"The Whiteness of David Bowie" (Redmond) 23
"Whoroscope Notebook" (Beckett) 75–6
"Width of a Circle" (Bowie) 74–5
Wiene, Robert 49, 81
"Wild is the Wind" (Bowie) 91
Wilde, Oscar 47–8
Williams, Raymond 29–31
Wings of Desire (Wenders) 172
Winterreise (Schubert) 92–3
working from home 139–40
"working through" *see* "acting out"
working-classes 37–8, 62–3
 see also labor/laborers
World Cup, 2022 60–1
World Pride Day 126–7
World War II 21, 22, 131, 143–4, 154–5
"Worstward Ho" (Beckett) 14–15, 34–6, 174–7, 195–8

"Yassassin" (Bowie) 92
Yeats, Jack 79–81
Yeats, William Butler 79–80
Young Americans (Bowie) 55–6

Ziggy Stardust and the Spiders from Mars (Bowie) 15, 52, 59, 69, 104–5, 153–4, 192–3, 194
Zika virus 170
Žižek, Slavoj 126, 137, 184–5, 191–2
 The Courage of Hopelessness 10, 127, 133–5, 139, 184–5, 206
Zuboff, Shoshana 140–1

www.ingramcontent.com/pod-product-compliance
Lightning Source LLC
Chambersburg PA
CBHW050326020526
44117CB00031B/1806